WHAT ARE YOU LOOKING AT?

150 Years of Modern Art in the
Blink of an Eye

Will Gompertz

PENGUIN BOOKS

PENGUIN BOOKS

UK | USA | Canada | Ireland | Australia
India | New Zealand | South Africa

Penguin Books is part of the Penguin Random House group of companies
whose addresses can be found at global.penguinrandomhouse.com.

First published by Viking 2012
Published in Penguin Books 2016
001

Copyright © Will Gompertz, 2012

The moral right of the author has been asserted

Typeset by Palimpsest Book Production Limited, Falkirk, Stirlingshire
Printed in Great Britain by Clays Ltd, St Ives plc

A CIP catalogue record for this book is available from the British Library

ISBN: 978-0-241-96599-3

MIX
Paper from
responsible sources
FSC
www.fsc.org FSC® C018179

Penguin Random House is committed to a
sustainable future for our business, our readers
and our planet. This book is made from Forest
Stewardship Council® certified paper.

To my wife, Kate, and children, Arthur, Ned, Mary and George

CONTENTS

LIST OF ILLUSTRATIONS

BLACK AND WHITE

Cartoons by Pablo Helguera

COLOUR PLATES

Inset 1

Inset 2

PREFACE

'The text is incomprehensible – it must be an exhibition catalogue.'

There are already plenty of excellent art history books covering the modern period, from E. H. Gombrich's classic *The Story of Art* to Robert Hughes's pugnacious and instructive *The Shock of the New*. My aim is not to compete with such learned tomes – I couldn't – but to offer something different: a personal, anecdotal and informative book that undertakes to tell the chronological story of modern art from Impressionism to now (for reasons of space and pace it has not been possible to cover every single artist involved in each movement).

My ambition has been to write a fact-filled and lively book; it is not intended as an academic work. There are no footnotes or lengthy lists of sources and at times I have taken flights of fancy, imagining, for instance, a scene where the Impressionists met in a café or Picasso hosted a banquet. These vignettes are based on accounts written by others (the Impressionists did gather in one particular café and Picasso

did hold a banquet), but some of the incidental details of conversations are imagined.

The inspiration for writing this book came from a one-man show I performed at the Edinburgh Fringe Festival in 2009. I had written an article for the *Guardian* newspaper in which I explored how the techniques of stand-up comedy could be used when explaining modern art in a way which engaged rather than bemused. To test the theory, I enrolled in a stand-up course and then went to the Edinburgh Fringe with a show called 'Double Art History'. It seemed to work: the audiences laughed a little, joined in and, judging by their performance on the 'exam' at the end, learnt quite a bit about modern art.

I will not, however, be trying stand-up comedy again. It is as a journalist and broadcaster that I come to the subject of modern art. The great writer David Foster Wallace compared his own non-fiction writing to a service industry in which a person of reasonable intelligence is given the time to investigate something on behalf of others with better things to do. I hope that in some small way I too can fulfil that service to the reader.

I also have the benefit of experience, having spent the last decade working in the strange and fascinating world of modern art. For seven years I was a director at the Tate, during which time I visited the great museums of the world and the less well-known collections that can be found off tourism's super-highway. I have been to artists' houses and perused the private collections of the wealthy, toured conservation studios and watched multi-million-dollar modern art auctions. I have immersed myself in modern art. I started by knowing nothing and now know something. There is plenty more for me to learn, but I hope that what I have managed to soak up and relay is useful to some extent in adding to your appreciation and knowledge of modern art. It is, I have discovered, one of the great pleasures of life.

INTRODUCTION

What Are You Looking At?

In 1972 the Tate Gallery in London purchased a sculpture called *Equivalent VIII* by Carl Andre, an American Minimalist artist. Made in 1966, it consists of 120 firebricks which, laid out as per the artist's instructions, were configured into a two-brick deep rectangle. When the Tate exhibited the work in the mid-70s, it proved rather controversial.

There was nothing particularly special about the light-coloured bricks; they could have been purchased by anybody for a few pennies each. The Tate Gallery paid over £2,000 for them. The British press had a collective meltdown. 'Wasting our national cash on a pile of bricks!' screamed the papers. Even the *Burlington Magazine*, a highbrow art periodical, asked, 'Has the Tate gone mad?' Why, one publication wanted to know, had the Tate squandered precious public money on something that 'might have occurred to any bricklayer'?

'Sweetie, "derivative" is not a nice word to say.'

Roughly thirty years later and the Tate once again acquired an unusual artwork. This time they chose to buy a line of people. Actually, that's not quite right. They didn't buy the people per se, that's illegal nowadays, but they did buy the line. Or, more precisely, a bit of paper upon which the Slovakian artist Roman Ondák had written the instructions for a performance artwork that involved hiring a handful of actors to form a line. He specified, on the piece of paper, that the actors create an artificial queue outside a doorway or inside an art exhibition. Once in position, or 'installed' in art-speak, they were all to adopt an air of patient expectation, as if waiting for something to happen. The idea being that their presence would intrigue and attract passers-by, who might then either join the queue (which, in my experience, they often did), or perhaps walk along beside it, eyebrows furrowed in quizzical inspection, wondering what they could be missing.

It's an amusing idea, but is it art? If a bricklayer could have come up with Carl Andre's *Equivalent VIII*, then Ondák's spoof queue could be considered to be at the more whimsical end of the Jackass genre. The media were bound to go nuts.

Yet there was not so much as a murmur: no criticism, no outrage, not even a selection of wryly mocking headlines from the wittier members of the tabloid press – nothing. The only coverage the acquisition received was a couple of approving lines in the more artily inclined upmarket newspapers. So what has happened over those thirty years? What has changed? Why has modern and contemporary art gone from being widely seen as a bad joke to something that is respected and revered around the world?

Money has something to do with it. A huge amount of cash has flowed into the art world over the last few decades. State finances have been lavished on smartening up old museums and building new ones. The fall of Communism and the deregulation of markets have led to globalization and the emergence of an international super-rich class, with art the sound investment of choice for the newly affluent. While stock markets have crashed and banks have gone bust, the value of top-end modern art has kept on rising, as has the number of people coming into the market. A few years ago, Sotheby's, the international auction house, would reckon on having bidders from three countries represented in the room for one of its major modern art sales. That number can now be well over forty, including new wealthy collectors from China, India and South America. Which means basic market economics have come into play: it is a case of supply and demand, with the latter far outstripping the former. The value of highly regarded work by dead (therefore unproductive) artists – such as Picasso, Warhol, Pollock and Giacometti – continues to go up like an elevator.

The price is being driven up by freshly minted bankers and shadowy oligarchs, ambitious provincial towns and tourist-orientated countries wanting to 'do a Bilbao' – that is, to transform their reputations and raise their profile by commissioning an eye-catching modern art gallery. They have all discovered that buying a mansion or building a state-of-the-art museum is the easy part; filling it with some half-decent art that will impress visitors is much harder. And that's because there's not a lot of it about.

'We just feel more comfortable working with dead artists.'

And if there's no high-quality 'classic' modern art available, the next best thing is 'contemporary' modern art (the work of living artists). Here, again, prices have risen inexorably for those artists deemed to be A-list, such as the American pop artist Jeff Koons.

Koons is famous for producing a giant flower-encrusted *Puppy* (1992) (see Fig. 22) as well as numerous aluminium cartoon figures that appear to have been made out of balloons. In the mid-1990s you could buy a work by Koons for a few hundred thousand dollars. By 2010 his candy-coloured sculptures were selling for millions. He had become a brand name, his art as instantly recognizable to those in the know as the Nike logo. He is one of many living artists who have become very wealthy in a remarkably short space of time on the back of this fine-art boom.

Once-impoverished artists are now multi-millionaires with all the trappings of movie stars: celebrity friends, private jets, and an insatiable media keen to report their every glamorous move. The booming glossy-magazine sector of the late twentieth century was delighted to help build the public profile of this new media-savvy generation of artists. Images of colourful creative people standing alongside their colourful art, which had been hung in glitzy designer spaces in which the rich and famous mingled, were the kind of voyeuristic visual feast

that the magazines' aspirational readers eagerly devoured (the Tate Gallery even employed the publisher of *Vogue* to produce their Tate Members' magazine).

These publications, along with newspaper colour supplements, created a new, trendy, cosmopolitan audience for new, trendy, cosmopolitan art and artists. It was a youthful crowd bored by all those brown old paintings the previous generation venerated. No, the swelling ranks of contemporary gallery-goers wanted art that spoke of their time. Art that was fresh, dynamic and exciting: art that was about the here and now. Art that was like them: desirable and modern. Art that was a bit rock 'n' roll: loud, rebellious, entertaining and cool.

The problem this new audience has faced, the problem we all face when encountering a new work of art, is one of comprehension. It doesn't matter if you are an established art dealer, a leading academic or a museum curator; anyone can find themselves at something of a loss when facing a painting or sculpture that is fresh out of an artist's studio. Even Sir Nicholas Serota, the internationally respected boss of Britain's Tate Gallery empire, finds himself confounded on occasion. He once told me that he can be a little 'daunted' when entering an artist's studio and seeing a new work for the first time. 'I often don't know what to think,' he said. 'I can find it very intimidating.' That is quite an admission by a man who is a world authority on modern and contemporary art. What chance for the rest of us?

Well, some, I'd say. Because I don't think the real issue is about judging whether or not a brand new piece of contemporary art is good or bad – time will undertake that job on our behalf. It is more a question of understanding where and why it fits into the modern art story. There is a paradox about our love affair with modern art: on the one hand we are visiting museums such as the Pompidou in Paris, MoMA in New York and Tate Modern in London in our millions, while on the other, the most frequent response I get when starting a conversation on the subject is, 'Oh, I don't know anything about art.'

This willing confession of ignorance is not due to a lack of intelligence or cultural awareness. I have heard it said by famous writers, successful movie directors, high-flying politicians and scholarly university academics. Of course they are all, without exception, wrong. They do know about art. They know Michelangelo painted the Sistine Chapel. They know Leonardo da Vinci painted the *Mona Lisa*. They almost certainly know that August Rodin was a sculptor and in most cases could name a work or two by him. What they really mean is that they know nothing about modern art. Actually, what they really, really mean is that they might know something about modern art – that Andy Warhol made an artwork containing some Campbell's Soup cans for example – but they don't get it. They can't understand why something that they perceive a child might be able to do is apparently a masterpiece. They suspect, in their heart of hearts, that it's a sham, but now that fashions have changed, find that it is not socially acceptable to say so.

I don't think it is a sham. Modern art (spanning roughly the period from the 1860s to the 1970s) and contemporary art (generally considered to be art produced by still living artists) is not a long-running gag being played by a few insiders on a gullible public. True, there are many works being produced today – the majority even – that will not stand the test of time, but, similarly, there will be some which have gone totally unnoticed that will, one day, be acknowledged as masterpieces. The truth is that the exceptional works of art created today, and over the last century, represent some of Man's greatest achievements in the modern era. Only a fool would denigrate the genius of Pablo Picasso, Paul Cézanne, Barbara Hepworth, Vincent van Gogh and Frida Kahlo. You don't need to be musical to know that Bach could write a tune or that Sinatra could sing one.

In my opinion the best place to start when it comes to appreciating and enjoying modern and contemporary art is not to decide whether it's any good or not, but to understand how it evolved from Leonardo's classicism to today's pickled sharks and unmade beds. As with most

seemingly impenetrable subjects, art is like a game; all you really need to know is the basic rules and regulations for the once baffling to start making some sense. And while conceptual art tends to be seen as the offside rule of modern art – the one that people can't quite get their head around or explain over a cup of coffee – it is surprisingly simple.

Everything you need to know to get a handle on the basics can be found in this story of modern art covering over 150 years in which art helped change the world and the world helped change art. Each movement, each 'ism', is intricately connected, one leading to another like links in a chain. But they all have their own individual approaches, distinct styles and methods of making art, which are the culmination of a wide variety of influences: artistic, political, social and technological.

It is a terrific story, and one that I hope will make your next trip to a modern art gallery slightly less intimidating and a little more interesting. It goes something like this . . .

1

THE
FOUNTAIN
1917

Monday, 2 April 1917. In Washington the American president, Woodrow Wilson, is urging Congress to make a formal declaration of war on Germany. Meanwhile, in New York, three well-dressed youngish men leave a smart duplex apartment at 33 West 67th Street and head out into the city. They walk and talk and smile, occasionally breaking into restrained laughter. For the thin, elegant Frenchman in the middle, flanked by his two stockier American friends, such excursions are always welcome. He is an artist who has not yet lived in the city for two years: long enough to know his way around, too short a time to have become blasé about its exciting, sensuous charms. The thrill of walking southwards through Central Park and down towards Columbus Circle never fails to lift his spirits; the spectacular sight of trees morphing into buildings is, to him, one of the wonders of the world. As far as he is concerned, New York City is a great work of art: a sculpture park crammed full of marvellous

modern exhibits that has more life and urgency than Venice, Man's other great architectural creation.

The trio ambles down Broadway, a shabby interloper between streets both rich and beautiful. As they approach midtown the sun disappears behind impenetrable blocks of concrete and glass, bringing a spring chill to the air. The two Americans talk across their friend, whose hair is swept back to expose a high forehead and bold hairline. As they talk he thinks. As they walk he stops. He looks into the window of a store selling household goods. He raises his hands, cupping his eyes to eliminate the reflection in the glass, revealing long fingers with manicured nails and powerful veins: there is something of a thoroughbred about him.

The pause is brief. He moves away from the storefront and looks up. His friends have gone. He glances around, shrugs and lights a cigarette. Then he crosses the road, not to seek his friends, but to find the sun's warm embrace. It is now 4.50 p.m. and a wave of anxiety has washed over the Frenchman. Soon the stores will close and there is something he desperately needs to buy.

He walks a little faster. He tries to close his mind to all the visual stimuli around him, but his brain is unwilling to comply: there is so much to take in, to think about, to enjoy. He hears someone shout his name and looks up. It is Walter Arensberg, the shorter of his two friends, who has supported the Frenchman's artistic endeavours in America almost from the moment he stepped off the boat back on a windy June morning in 1915. Arensberg is beckoning him to cross back over the road, past Madison Square and on to Fifth Avenue. But the notary's son from Normandy has tilted his head upwards, his attention now focusing on an enormous concrete slice of cheese. The Flatiron Building captivated the French artist long before he arrived in New York, an early calling card from a city that he would go on to make his home.

His initial encounter with the famous high-rise building was back when it was first built and he was still living in Paris. He saw a photo-

graph of the twenty-two-floor skyscraper taken by Alfred Stieglitz in 1903 and reproduced in a French magazine. Now, fourteen years later, both the Flatiron and Stieglitz, an American photographer-cum-gallery owner, have become part of his new-world life.

His reverie is broken by another plaintive call from Arensberg, this time laced with a little frustration, as the stout patron and art collector waves vigorously at the Frenchman. The other man in their party stands next to Arensberg and laughs. Joseph Stella (1877–1946) is an artist too. He understands his Gallic friend's precise yet wayward mind and appreciates his helplessness when confronted by an object of interest.

United again, the three make their way south down Fifth Avenue. Before long they arrive at their destination: 118 Fifth Avenue, the retail premises of J. L. Mott Iron Works, a plumbing specialist. Inside, Arensberg and Stella stifle giggles while their companion ferrets around among the bathrooms and door-handles that are on display. After a few minutes he calls the store assistant over and points to an unexceptional, flat-backed, white porcelain urinal. Joined again by his friends, the group are informed by a wary store assistant that the model of urinal in question is a Bedfordshire. The Frenchman nods, Stella smirks and Arensberg, with an exuberant slap to the assistant's back, says he'll buy it.

They leave. Arensberg and Stella go to call a taxi. Their quiet philosophical French friend stands on the sidewalk holding the heavy urinal, amused by the plan he has hatched for this porcelain *pissotière*: to use it as a prank to upset the stuffy art world. Looking down at its shiny white surface Marcel Duchamp (1887–1968) smiles to himself: he thinks it may cause a bit of a stir.

After buying the urinal Duchamp takes it to his studio. He lays the heavy porcelain object on its back and turns it around, so it appears to be upside down. He then signs and dates it in black paint on the left-hand side of its outer rim, with the pseudonym 'R. Mutt 1917'. His work is nearly done. There is only one more job remaining: he needs

to give his urinal a name. He chooses *Fountain*. What had been, just a few hours beforehand, a nondescript, ubiquitous urinal has, by dint of Duchamp's actions, become a work of art (see Fig. 1).

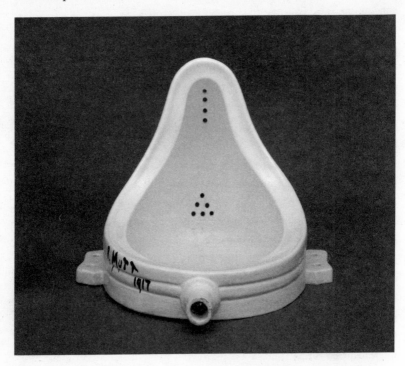

Fig.1 **Marcel Duchamp**, *Fountain*, **1917**, replica 1964

At least it had in Duchamp's mind. He believed he had invented a new form of sculpture: one where an artist could select any pre-existing mass-produced object with no obvious aesthetic merit, and by freeing it from its functional purpose – in other words making it useless – and by giving it a name and changing the context and angle from which it would normally be seen, turn it into a de facto artwork. He called this new form of art-making a 'readymade': a sculpture that was already made.

It was an idea he had been working on for a few years, starting

when he had attached a bicycle wheel and its front forks to a stool in his studio when still in France. At the time the construction had been for his own amusement; he liked to turn the wheel and see it spin. But subsequently he had begun to see it as an artwork.

He had carried on the practice when he arrived in America, at one time buying a snow shovel upon which he wrote an inscription before hanging it from the ceiling by its handle. He signed it with his real name, but said 'from' and not 'by' Marcel Duchamp, thereby making his role in the process quite clear: this was an idea 'from' an artist as opposed to a work of art 'by' an artist. *Fountain* took the concept to another, very public and confrontational level. He was going to enter it into the 1917 Independents Exhibition, the largest show of modern art that had ever been mounted in America. The exhibition itself was a challenge to America's art establishment. It was organized by the Society of Independent Artists, a group of free-thinking, forward-looking intellectuals who were making a stand against what they perceived to be the National Academy of Design's conservative and stifling attitude to modern art.

They declared that any artist could become a member of their Society for the price of one dollar, and that any member could enter up to two works into the 1917 Independents Exhibition as long as they paid an additional charge of five dollars per artwork. Marcel Duchamp was a director of the Society and a member of the exhibition's organizing committee. Which, at least in part, explains why he chose a pseudonym for his mischievous entry. Then again, it was Duchamp's nature to play on words, make jokes and poke fun at the pompous art world.

The name Mutt is a play on Mott, the store from which he bought the urinal. It is also said to be a reference to the daily comic strip 'Mutt and Jeff', which had first been published in the *San Francisco Chronicle* in 1907 with just a single character, A. Mutt. Mutt was entirely motivated by greed, a dim-witted spiv with a compulsion to gamble and develop ill-conceived get-rich-quick schemes. Jeff, his

gullible sidekick, was an inmate of a mental asylum. Given that Duchamp intended *Fountain* to be a critique of greedy, speculative collectors and pompous museum directors, it is an interpretation that would appear plausible. As does the suggestion that the initial 'R.' stands for Richard, a French colloquialism for a 'moneybags'. With Duchamp nothing was ever simple; he was, after all, a man who preferred chess to art.

Duchamp had other targets in mind when making the deliberate choice of selecting a urinal to turn into a 'readymade' sculpture. He wanted to question the very notion of what constituted a work of art as decreed by academics and critics, whom he saw as the self-elected and largely unqualified arbiters of taste. Duchamp thought it was for artists to decide what was and what was not a work of art. His position was that if an artist said something was a work of art, having influenced its context and meaning, then it was a work of art. He realized that although this was a fairly simple proposition to grasp, it could cause a revolution in the art world.

He contested that the medium – canvas, marble, wood or stone – had, up until this point, dictated to an artist how he or she would or could go about making a work of art. The medium always came first, and only then would an artist be allowed to project his or her ideas on to it via painting, sculpting or drawing. Duchamp wanted to turn this around. He considered the medium to be secondary: first and foremost was the idea. Only after an artist had settled on and developed a concept would he or she be in a position to choose a medium, and it should be the one with which the idea could most successfully be expressed. And if that meant using a porcelain urinal, so be it. In essence, art could be anything as long as the artist said so. That was a big idea.

There was another widely held view that Duchamp wanted to expose as bogus: that artists are somehow a higher form of human life. That they deserve the elevated status society bestows upon them due to a perception that they have exceptional intelligence, insight and

wisdom. Duchamp thought that was nonsense. Artists took themselves and were taken far too seriously.

The hidden meanings contained within *Fountain* don't end in Duchamp's wordplay and provocation. He specifically chose a urinal because as an object it has plenty to say, much of it erotic, an aspect of life that Duchamp frequently explored in his work. By turning the urinal upside down, it didn't take much imagination to see its sexual connotations. This allusion was totally lost on those who sat alongside Duchamp on the committee, and was therefore not the reason why his co-directors refused to allow *Fountain* to be shown at the 1917 Independents Exhibition.

When the artwork was delivered to the Grand Central Palace exhibition hall on Lexington Avenue a few days after Duchamp, Arensberg and Stella's shopping trip, it immediately created a volatile mix of consternation and revulsion. Although the accompanying envelope from R. Mutt contained the required six dollars (one dollar membership, five dollars to have the work exhibited), the feeling among the majority of the Society's directorate (there were some, including Arensberg and of course Duchamp, who were well aware of its provenance and purpose who argued passionately in its favour) was that Mr Mutt was taking the piss, which of course he was.

Duchamp was challenging his fellow Society directors and the organization's constitution that he had helped to write. He was daring them to fulfil the ideals that they had collectively set out, which was to take on the art establishment and the authoritarian voice of the conservative National Academy of Design with a new liberal, progressive set of principles: if you were an artist and you paid your money, then your work got exhibited. Period.

The conservatives won the battle, but as we now know, spectacularly lost the war. R. Mutt's exhibit was deemed too offensive and vulgar on the grounds that it was a urinal, a subject that was not considered a suitable topic for discussion among America's puritan middle classes. Team Duchamp immediately resigned from the board. *Fountain* was never

seen in public, or ever again. Nobody knows what happened to the Frenchman's pseudonymous work. It has been suggested that it was smashed by one of the disgusted committee, thus solving the problem of whether to show it or not. Then again, a couple of days later, at his '291' gallery, Alfred Stieglitz took a photograph of the notorious object, but that might have been a hastily remade version of the 'ready-made'. That too has disappeared.

But the great power of ideas is that you cannot un-invent them. The Stieglitz photograph was crucial. Having *Fountain* photographed by one of the art world's most respected practitioners, who also happened to run an influential modern art gallery in Manhattan, was important for two reasons: first, it was something of an endorsement by the artistic avant-garde that Duchamp's *Fountain* was a legitimate work of art and therefore warranted being documented as such by a leading gallery and greatly revered figure. And second, it created a photographic record: documentary proof of the object's existence. No matter how many times the naysayers smashed Duchamp's work, he could take himself off back down to J. L. Mott's, buy a new one and simply copy the layout of the R. Mutt signature from Stieglitz's image. And that's exactly what has happened. There are fifteen Duchamp-endorsed copies of *Fountain* to be found in collections around the world.

It is weird when one of those copies is put out on display to observe people taking the thing so seriously. You see hordes of unsmiling art-worshippers craning their heads around the object, staring at it for ages, standing back, looking at it from all angles. It's a urinal! It's not even the original. The art is in the idea, not the object.

The reverence with which *Fountain* is now treated would have amused Marcel Duchamp. He chose it specifically for its lack of aesthetic appeal (something he called anti-retinal). It is a 'readymade' sculpture that was never shown in public, that was really only ever intended as a provocative prank, but it has gone on to become the single most influential artwork created in the twentieth century. The ideas it embodied directly influenced several major art movements,

'The one on the left is a readymade, the centre one
is a lookalike and the other is just a wannabe.'

including Dada, Surrealism, Abstract Expressionism, Pop Art and Conceptualism. Marcel Duchamp is unquestionably the most revered and referenced artist among today's contemporary artists, from Ai Weiwei to Damien Hirst.

Yes, but is it art? Or is it simply a Duchampian joke? Has he made fools of us all as we scratch our chins and 'appreciate' the latest exhibition of conceptual contemporary art? Has he made Mutts out of the legions of chauffeur-driven collectors, the gullible 'moneybags' who have let avarice blind them into becoming proud owners of roomfuls of tat? And has his challenge to curators to be progressive and open-minded had the opposite effect? By proposing that an idea is more important than the medium, thus privileging philosophy over technique, has he constipated the art colleges with dogma and made them fearful and dismissive of craft? Or is he a genius who emancipated art

from the darkness of its medieval bunker as Galileo had done for scientific discovery 300 years earlier, enabling it to flourish and unleash a far-reaching intellectual revolution?

My view is the latter. Duchamp redefined what art was and could be. Sure, it still included painting and sculpture, but they were simply two media among countless others for communicating an artist's idea. It is Duchamp who is to blame for the whole 'is it art?' debate, which of course is exactly what he intended. As far as he was concerned, the role in society of an artist was akin to that of a philosopher; it didn't even matter if he or she could paint or draw. An artist's job was not to give aesthetic pleasure – designers could do that; it was to step back from the world and attempt to make sense or comment on it through the presentation of ideas that had no functional purpose other than themselves. His interpretation of art was taken to its extreme with the performance art of people such as Joseph Beuys in the late 1950s and 60s, who became not only the creators of the idea but the medium for it as well.

Marcel Duchamp's influence is omnipresent throughout the story of modern art, whether as an early follower of Cubism or latterly as the father of Conceptualism. But he is not the only star of this story, which is rich with larger-than-life characters who all played major parts: Claude Monet, Pablo Picasso, Frida Kahlo, Paul Cézanne and Andy Warhol. Plus names that might not be as familiar, such as Gustave Courbet, Katsushika Hokusai, Donald Judd and Kazimir Malevich.

Duchamp emerged from the story of modern art; he didn't start it. It began before he was even born, in the nineteenth century, when world events conspired to make Paris the most intellectually thrilling place on the planet. It was a city fizzing with excitement: the smell of revolution still filled the air. More than a whiff of which was being inhaled by a group of buccaneering artists who were about to overturn the art establishment's old world order and usher in a new age in art.

PRE-IMPRESSIONISM: GETTING REAL 1820-70

I t was an unusual incident. Made all the more so by the location.

It was New York's Museum of Modern Art (MoMA), shortly after opening time on a quiet Monday morning. I was the only person in a room filled with very special paintings and had quietly been preparing myself for some full-on art appreciation when an ugly commotion started at the entrance to the gallery.

Without warning and with alarming alacrity the gift of sight was forcibly taken from a young boy. He hadn't seen it coming and now he couldn't see. The assault was overwhelmingly physical, the assailant's intent purposeful and precise: the removal of the boy's visual faculties.

I watched with amazement as the little chap was brusquely marched past me and on towards the far side of the gallery by a wild-eyed – but exquisitely dressed – individual who was clearly working to a plan. The confused minor – off-balance and disorientated – tried to keep his

feet out of harm's way before being abruptly stopped and stationed with his nose barely an inch from the wall.

The boy was breathing heavily now: bewildered and bothered. Before he could decide what to do, two hands jerked back across his face. He blinked a few times, and stared nervously ahead. Then came the questions.

'So, what can you see?' the boy's captor demanded.

'Nothing,' he replied blankly.

'Don't be ridiculous, of course you can see something.'

'Nothing, really, everything's just a blur.'

'Take a step back, then,' snapped the domineering voice.

The boy extended his left leg backwards, and moved a pace away from the wall.

'And . . .?'

'Ermm . . . no, I can't make anything out,' the child said in a cracking, agitated voice. 'Why are you doing this to me? What do you want me to say? You must know I can't see anything.'

The increasingly frustrated adult grabbed the boy by the shoulders and dragged him back about three metres before inquiring with obvious irritation, 'Well . . . ?'

The boy stood motionless, facing the wall: he said nothing. After a long silence he could contain his emotions no longer. He turned his head slowly towards his assailant.

'That's totally awesome, Mom.'

His mother's face disappeared behind a huge smile that revealed a perfect set of teeth and an inner glow of happiness that was beyond restraint. 'I just knew you'd love it, darling,' she trilled while enveloping the kid in a category-A hug, the sort dished out to children after near-fatal incidents or an exceptional piece of parent-pleasing behaviour.

We were the only people in MoMA's gallery looking at their famous Monets, although I was beginning to wonder if I existed, such was the mother and child's obliviousness to my presence. But once she had

released the boy, his mother turned to me with the embarrassed smile of an adult caught dancing to Beyoncé's 'Single Ladies' by the lodger. She explained that I had witnessed the culmination of a plan that she had been hatching for months, ever since she had arranged to take her eldest son (he was ten apparently) on a trip to New York while her husband stayed home and looked after their other kids.

She had figured that this was her only chance of imbuing the child with her appreciation of the magnificence of Monet's three giant mural-sized *Water Lily* landscapes (*c.*1920), which dominated the room. It is an immersive experience for anybody, but for an uninitiated ten-year-old it could feel like being drowned in pinks and purples, violets and greens. Such is the overpowering nature of these late Monet 'landscapes' (there is not much land or sky to be seen, just reflections on water) that the little chap must have wished he'd brought along a snorkel.

Monet (1840–1926) painted the triptych, which measures nearly 13 metres across, towards the end of his life, having spent days and months and years studying his beloved water garden at his home in Giverny. It was the effects of the ever-changing light on the surface of the water that so captivated the elderly artist. His eyesight might have been fading, but his sharp brain and gift for handling paint were just as present as they had been when he was a young man. As was his inclination to innovate. Traditionally landscape paintings place the viewer in an ideal position with clear visual points of orientation. Not so with Monet's late 'grand decoration', where we are plunged into the midst of a pond without edges or corners, among iris plants and lilies, leaving us with little option other than to give in to his layers of mesmerizing multi-coloured paint.

Apparently the inspiration for the mother's eccentric plan was those irritating 3-D books of hidden images that kids were crazy about a while back but normal adults (me) could never fathom. It was her experience with these that prompted her decision to catch the poor boy unawares, wrap her hands around his eyes and march him as near

to the canvas as she dared. And then make him slowly retreat. The hope being that Monet's effervescent vision would gradually become clear in all its comprehensible glory, and thus stay with the boy for the rest of his life.

And who can blame her for having a soft spot for Monet and his fellow Impressionists? For once, familiarity has bred not contempt but contentment. We have all seen examples of their paintings where up close they are just individual brushstrokes, but with each retreating step the subject miraculously emerges. We've seen them on biscuit tins, tea towels and battered boxes containing 1,000-piece jigsaws. Edgar Degas's ballet dancers, Claude Monet's water lilies, Camille Pissarro's leafy suburbia, and the well-dressed Parisian bourgeoisie hanging out in the metropolitan sunshine in Pierre-Auguste Renoir's evocative paintings. No thrift store would consider itself adequately stocked without at least a smattering of such classic images reproduced on various cheap household items. The work of the Impressionists remains an omnipresent part of today's visual vernacular. Barely a month goes by without a headline proclaiming that a great Impressionist painting has broken yet another auction record or been stolen by a sophisticated and crafty cat burglar.

Impressionism is one modern art 'ism' with which the majority of us feel reasonably confident and comfortable. We accept, I think, that when compared with more recent modern art the paintings could be considered a bit passé, a tad safe and maybe suspiciously easy on the eye, but then, what's wrong with that? They are lovely objects that depict recognizable scenes in a figurative manner. It is with unabashed romanticism that we view the Impressionists' late-nineteenth-century pictures: the hazy, atmospheric and oh-so-French subjects, the romantic Parisian images of elegant picnics in the park, absinthe drinkers in bars, and steam-shrouded trains heading optimistically towards a sunny future. Within the context of modern art, the more traditionally minded consider the Impressionists the last group to produce 'proper art'. They didn't go in for all that 'conceptual nonsense' and those

'abstract squiggles' that came later, but produced paintings that are clear, beautiful and refreshingly inoffensive.

Actually, that's not quite right. At least, that's not what people thought at the time. The Impressionists were the most radical, rebellious, barricade-breaking, epoch-making group of artists in the entire history of art. They underwent personal hardship and professional ridicule in dogged pursuit of their artistic vision. They ripped up the rulebook, metaphorically pulled their trousers down, and waved their collective derrières at the establishment before setting about instigating the global revolution we now call modern art. Many twentieth-century art movements, such as 1990s Brit Art, have been billed as subversive and anarchic, but in truth were far from it. The respectable-looking nineteenth-century Impressionist painters, on the other hand, were the original outlaws; they really *were* subversive and anarchic.

Not in a predetermined way, but because they had no other choice. Here was a band of artistic brothers and sisters who had developed an original and compelling way of painting in and around Paris during the 1860s and 70s, but then found their path to artistic success blocked by an oppressive art establishment. What were they to do? Give up? Perhaps, if it had been another time and another place, but not in post-revolutionary Paris, where a spirit of rebellion continued to fire the souls of the city's inhabitants.

The trouble had started for the Impressionists when they fell foul of Paris's all-powerful and stuffily bureaucratic Académie des Beaux Arts (the Academy). The Academy expected artists to make work based on mythology, religious iconography, history or classical antiquity in a style that idealized the subject. Such fakery didn't interest this group of young, ambitious painters. They wanted to leave their studios and go outside to document the modern world around them. It was a bold move. Artists simply didn't wander off and paint 'low' subjects such as ordinary people picnicking, or drinking or walking; it wasn't the done thing. It would be like Steven Spielberg hiring himself out for wedding

videos. Artists were expected to stay in their studios and produce pic-
turesque landscapes or heroic images of human forms that harked
back in time. That was what the great and the good demanded for the
walls of their fine houses and the city's museums, and that is what they
got. Until the Impressionists came along, that is.

They changed the game by breaking down the wall between studio
and real life. Plenty of other artists had gone outside to observe and
sketch their subject, but they would then go back to their studios to
incorporate their observations into fictionalized scenes. The Impres-
sionists mostly stayed outside, where they started and finished their
paintings of modern metropolitan life. They had come to the conclu-
sion that their new subject matter demanded a new technical approach.
At the time the approved and accepted method of painting was in the
Renaissance 'Grand Manner' of Leonardo, Michelangelo and Raph-
ael, which had been exemplified in France by Nicolas Poussin
(1594–1665) among others. Draughtsmanship was all. Art was about
precision. A palette of earthy, tonal colours were to be blended and
applied to the canvas with precise brushstrokes that over many,
many hours and days of work could be honed to the point of imper-
ceptibility. Through subtle gradations between light and shade, the
objective was to produce a painting that gave the appearance of three-
dimensional solidity.

Which was fine when sitting in a warm room for weeks on end,
elaborately rendering a dramatized scene. But the Impressionists
were out painting *en plein air*, where the light changed constantly,
quite unlike the controlled and artificial conditions of the studio. A
fresh way of painting was called for – if they were to capture the sen-
sation of a fleeting moment with any sense of truth, speed was now
of the essence. There was no time to dwell on laborious gradations of
light, because the next time the artist looked up it would have
changed. Instead, urgent, rough, sketchily applied brushstrokes
replaced the studied, blended refinement of the Grand Manner,
brushstrokes that the Impressionists made no attempt to hide; quite

the opposite – they accentuated their brushwork by painting in thick, short, colourful, comma-like bursts that added a sense of youthful energy to their paintings, reflecting the spirit of their age. Paint, for the Impressionists, became a medium whose material properties were being celebrated as opposed to being disguised behind the artifice of a pictorial illusion.

Having committed themselves to working on location in front of their subject, it became the Impressionists' obsession to reproduce accurately the light effects they saw before their eyes. This requires the artist to banish preconceived notions about object and colour from his or her mind – such as ripe strawberries being red – and instead paint the colour hues and tones as seen at that particular moment in the natural light – even if that means painting a strawberry blue.

They pursued this agenda relentlessly, producing pictures that contained a range of bright colours the like of which had not been seen before. Today they look unremarkable, almost muted, in our high-definition world of television and cinema, but back in the nineteenth century they were as startling as a hot summer in England. The reaction from the sombre-minded Academy was predictable, condemning the paintings as infantile and inconsequential.

The Impressionists were derided and dismissed as artistic upstarts; condemned for producing art that amounted to nothing more than 'mere cartoons', and criticized for not making 'proper paintings'. The Impressionists were upset by the reaction but not defeated. They were an intelligent, belligerent and self-confident bunch; they shrugged their shoulders and carried on.

They chose their moment well. All the necessary ingredients were gathered in Paris to make a break with tradition possible: violent political change, rapid technological advances, the emergence of photography, and exciting new philosophical ideas. As the bright young things sat in cafés talking, they watched their city physically changing before their eyes. Paris was being turned from a medieval maze into a state-of-the-art city. Broad, light and airy boulevards were replacing

the old dark, dank and squalid streets. It was a visionary piece of urban regeneration led by a can-do bureaucrat called Baron Haussmann, who had been commissioned by Napoleon III.

'The Emperor of the French', as he styled himself, shared some of the military nous of his famous uncle and could see that Paris's makeover would not only provide a suitably sophisticated response to London's Regency splendour, but also give him a fighting chance of staying in power. Because with the urban regeneration came superb city-wide sightlines, providing the crafty autocrat with a tactical advantage should any dissenting Parisians fancy more civil disobedience laced with revolutionary intent.

And while it was all change in the city, so innovation was impacting on the technical side of painting. Until the 1840s artists using oil paint were largely limited to working in their studios, as there was no easily portable container for their colours. Then the idea of putting oil paint into small colour-coded tubes was introduced, which gave the more intrepid painter the opportunity to paint directly on to canvas outside on location. The compulsion to do so was heightened by the advent of photography, a new medium in which many young up-and-coming artists had taken an interest. Of course, in some respects this exciting, cheap, accessible image-producer posed a threat to artists, who had previously had an unrivalled position as picture creators for the rich and powerful. But for the Impressionists the new opportunities photography created were far greater than any threat. Not least the effect it had in stimulating the public's appetite for images of everyday Parisian life.

The road to the future was apparent, but it was being blocked by the Academy, whose intransigence would, ironically, provide the grit in the oyster for the modern art pearl to form. It excelled in its duty to protect the country's rich aesthetic heritage, but was hopelessly backward-looking when it came to nurturing its artistic future.

This was a major problem for the experimental young artists seeking to make paintings and sculptures that reflected their time: a problem

that was compounded by the Academy's dominance, which went beyond academia and into commerce. Their annual art exhibition, known as the Paris Salon, was France's most prestigious showcase for new art, putting the selection committee in the position of king-makers and career-breakers. If they chose to show a work by a new artist it could set him up for life, and conversely, their refusing to do so could ruin his chances of future success. Collectors and art dealers would attend the Salon en masse, wide-eyed and with bulging wallets, ready to snap up a painting by a hot new Academy-approved artist or to buy the latest offering from an established name; it was the place from which a large amount of newly created French art was bought.

The Impressionists were not the first artists to be frustrated by the Academy. As early as the first quarter of the nineteenth century, grumblings about the institution's suffocating conservatism could be heard. Théodore Géricault (1791–1824), a brilliant young painter, observed: 'The Academy, alas, does too much: it extinguishes the sparks of this sacred fire [gifted artists]; it smothers it, not granting nature the time to allow it to catch. A fire must be nurtured, yet the Academy throws on too much fuel.'

Géricault died too young, aged just thirty-three. But not without first painting one of the most important pictures of the century. *The Raft of the Medusa* (1818–19) depicts the real and horrific consequences of an incompetent French sea captain's decision to sail too close to the shoreline off Senegal. Géricault renders the grim human catastrophe of the resulting shipwreck with unflinching detail. He ups the emotional ante by using a theatrical style of painting much favoured by the likes of Caravaggio and Rembrandt called 'chiaroscuro', where bold contrasts between light and shade are accentuated to dramatic effect. At the centre of the painting, there is a muscular man lying face down. He is dead. But the model upon whom Géricault is said to have based this figure was very much alive and painting. He was a young artist from the upper echelons of Parisian society called Eugène Delacroix (1798–1863).

Delacroix's innovations were of great consequence to the Impressionists, who shared his determination to produce paintings that reflected the vivacity of contemporary France. Although his paintings tended to be of historical subjects, he had realized – before any of the Impressionists were born – that quick, energetic brushstrokes could, to some extent, recreate on canvas the intense energy of French revolutionary life: it was about capturing the mood of the moment. Or, as he put it, 'If you are not skilful enough to sketch a man jumping out of a window in the time it takes him to fall from the fourth storey to the ground, you will never be able to produce great works.'

It was a pointed remark aimed at his *bête noire* and fellow countryman Jean Auguste Dominique Ingres (1780–1867), an artist who slavishly toed the Academy's neoclassical line, sharing their fixation with the past and – as Delacroix saw it – their ridiculous favouring of draughtsmanship over painting. He summed his position up thus: 'Cold exactitude is not art ... the so-called consciousness of the majority of painters is only perfection applied to the art of boring. People like that, if they could, would work with the same minute attention on the back of their canvas.'

Delacroix started to use unmixed, pure colour pigment to add boldness and vibrancy to his pictures. He applied it with the swashbuckling élan of d'Artagnan, eschewing the Academy's much-loved clarity of line and concentrating more on the shimmering visual effect of having contrasting colours set against one another. At the 1831 Salon he presented a painting that would cause a sensation: a picture that was technically innovative while also portraying a subject containing enough political dynamite for it to be removed from public view for over thirty years.

Liberty Leading the People (1830) (see Plate 1) is now recognized as a masterpiece of the Romantic era and hangs in the Louvre in Paris. Back in 1830, though, its pro-republican message was thought so powerful as to be considered politically inflammatory by the French monarchy. The painting's main character is a strident woman, per-

sonifying Liberty, rallying rebel fighters in the midst of battle and leading them over the bodies of the fallen. In one hand she waves the *tricolore* flag of the French Revolution, and in the other she grips a bayoneted musket. The scene alludes to the overthrow of the last Bourbon king, Charles X (who had been an enthusiastic collector of Delacroix's art) in July 1830, an event about which the politically cunning Delacroix clearly took sides, writing in a letter to his brother, 'I have undertaken a modern subject, a barricade, and although I may not have fought for my country, at least I shall have painted for her. It has restored my good spirits.'

The subject was contemporary (some say that the man in the top hat to Liberty's right is Delacroix himself, supporting the insurrection), but the image is romanticized: the pyramidal structure (a compositional device that his friend Géricault had employed in *The Raft of the Medusa*) serves to elevate the heroism of Liberty (it was upon this, Delacroix's vision of Liberty, that the Statue of Liberty is based – the famous landmark having been a gift from France to America). And there's a classical allusion too: the spiralling drapery wrapping Liberty is a reference to the famous Hellenistic sculpture the Nike of Samothrace, which also served to give the picture its powerful pro-democracy political message (Delacroix, of course, would have been fully aware that the concept of democracy was of ancient Greek origin).

The po-faced academicians accepted the picture, ignoring, one assumes, Delacroix's subversive treatment of Liberty. Instead of depicting her body with classically clean lines, he added great tufts of underarm hair; a touch of truthful representation that is likely to have had the academicians reaching for the smelling salts.

Liberty Leading the People is a virtuoso display of modern painting techniques with its vivid colours, attention to light, and brisk brushstrokes, all of which would be central elements of the Impressionism movement some forty years later. But Delacroix's painting was a fictional scene, whereas the Impressionists were in search of the truth

and nothing but the truth. Their inspiration for that came from another, rather less sophisticated individual.

If Delacroix was France's greatest Romantic painter, then Gustave Courbet (1819–77) was her most accomplished Realist. The younger Courbet admired Delacroix (and vice versa), but had no time for all the whimsical make-believe and classical allusion found in paintings of the Romantic period. He wanted to get real, and paint ordinary subjects that the Academy and polite society considered to be vulgar, like the poor.

Mind you, if they found the realism of a painting featuring a peasant on a pathway crude, they would have choked on their fine wine had they seen Courbet's treatment of another subject. His painting *The Origin of the World* (1866) (see Fig. 2) is one of the most notorious works in art history, famed for its blunt, no-holds-barred portrayal of a naked female torso shown only from breast to thigh, with legs wide open, and cropped by Courbet to achieve maximum (porno) graphic effect. It is a sexually frank picture that is not for the squeamish now; back then it was for private eyes only. In fact, it remained that way for over 100 years, until 1988 when it was shown for the first time in a public exhibition.

Courbet delighted in his reputation as a rough, tough, hard-drinking artist with a fighter's taste for conflict. He was a proto shock-jock, a man of the people, who knew that his popularity among his fellow countrymen gave him a very large stick with which to beat and prod the establishment. When the academicians called him vain, he shrugged. When they criticized his work for perceived errors in scale and for showing scenes of downtrodden, common contemporary France, he went and painted more of the same.

Delacroix's Romanticism had introduced vivid colour and flair to painting, while Courbet's Realism brought the unfettered, non-idealized truth about ordinary life (he boasted he never lied in his paintings). Both artists rejected the rigidity of the Academy and the neo-classicist Renaissance style. But the conditions were not yet right

for the Impressionists. Before they could lead art into a new age, there first needed to be an artist who could combine Delacroix's painterly virtuosity with Courbet's unflinching realism.

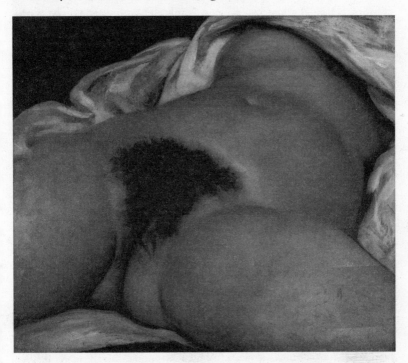

Fig. 2. **Gustave Courbet,** *The Origin of the World,* **1866**

That role fell to Édouard Manet (1832–83), the most reluctant of rebels. His father was a judge who had fostered in his son an inclination to stay on the right side of the law. But Manet's artistic heart ruled his conformist head – with a little help from a maverick uncle who took him to art galleries and encouraged his serious-minded nephew to take up the life of an artist. Which he eventually did, after a couple of failed attempts to pacify his father by joining the Navy. Oddly for someone who so desperately wanted his work to be recognized by the Academy – once saying the Salon was 'the real field of

battle' – he took a rather confrontational approach. If you were to list the attributes by which the academicians judged the quality of an art-work, we know what they would demand: muted, finely blended colours, classical allusions, an exquisitely drawn line, idealized representation of the human form and aspirational subjects. Manet's first stab at Academy approval failed to conform to any of those requirements.

The Absinthe Drinker (1858–9) is a portrait of a Parisian low-life: a down-and-out drunk living on the margins of society, a victim of the city's ongoing modernization. It was a subject the Academy would generally deem unworthy of portrayal. Manet made sure that was the case by painting the vagrant as a full-length portrait, a format usually reserved for the revered (a point Manet acknowledges with irony by dressing his vagabond respectably in a black top hat and cape). The Absinthe Drinker perches on a low wall, as does a full glass of the strong liquor to his right. He stares drunkenly over the viewer's left shoulder into the middle distance, the evidence of his intoxication made apparent by an empty bottle lying at his feet. It is a dark, menacing portrait.

That Manet had not chosen an appropriate subject was a mark against him as far as the academicians were concerned: a tally he doubled with its technical style. He had not painstakingly rendered his portrait in the approved Grand Manner of Raphael, Poussin and Ingres, but had produced a flat, almost two-dimensional image by applying large blocks of colour with barely a transitional tone between them. He optimistically entered The Absinthe Drinker to the Salon committee for consideration. Perhaps they'd have a sneaking regard for the modern way in which he had left unblended sections of colour that made for stark contrasts between light and shade? Could it be possible that they might admire his courage when removing fine detail in order to create a sense of atmosphere and coherent design? Surely they'd appreciate his unsentimental treatment of the subject and his method of painting, which was looser and bolder than the norm?

Maybe, Manet thought, the academicians would like his innovative picture?

They did not. It was dismissed with disdain.

Manet was deeply upset by the Academy's rejection, but he wasn't about to buckle under their dogma. He continued to pursue his own course and submitted further paintings for their consideration. In 1863 he put forward his painting *Le Déjeuner sur l'Herbe* (called *Le Bain* at the time) (see Fig. 3), which was brimming with art-historical references of which the Academy was bound to approve. The subject matter and composition derive from an engraving made by Marcantonio Raimondi (*c*.1480–1534), based on a drawing by Raphael (1483–1520) called *The Judgment of Paris* (a subject the Flemish artist Peter Paul Rubens also painted). There are similarities with *The Pastoral Concert* (*c*.1510) and *The Tempest* (1508), paintings that have been attributed to both Giorgione (*c*.1477–1510) and Titian (*c*.1487–1576). These earlier pictures, both of which feature a naked woman (or two) sitting on grass with a well-dressed man (or two) looking on, have an innocent air about them. They hark back to biblical and mythical stories and give no overt hint of sexual innuendo.

Manet's plan was to take these classical allegories and compositions and refresh them by adding a contemporary twist. With this in mind he brought the three principal characters within his composition – two handsome young men and a pretty woman of similar age – right up to date by making the central narrative idea a bourgeois picnic in the park. His two male sitters look splendid, dressed to the nines in fashionable clothes, their handsome coats and ties set off by well-tailored trousers and sombre shoes. The young woman is wearing nothing: not a stitch.

Manet might just about have got away with this tale of two well-dressed men out for a spot of something tasty with a naked young lady had the scene been wrapped within a mythologized narrative, as was the case with those earlier Renaissance paintings. But Manet hadn't done that, he had painted those within his circle: recognizable hipsters who

belonged to his fashionable Parisian set. The puritanical Academy were disgusted; they particularly deplored the way in which one of the

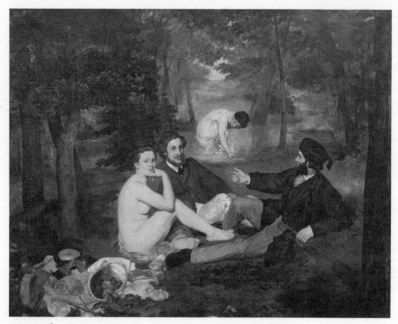

Fig. 3. **Édouard Manet,** *Le Déjeuner sur l'Herbe,* **1863**

men appeared to be staring at the naked woman, who in turn gazed directly at the viewer with a little too much knowingness. And then there was Manet's painting technique. They considered that inappropriate too. Again the artist had made no attempt at gradations between his blocks of bold colour and thus utterly failed to create a satisfactory three-dimensional illusion. Nor did it appear to the academicians that he'd spent very long producing the picture, which they felt was more like a saucy cartoon than a honed piece of fine art.

They rejected it out of hand.

There was, though, some consolation for the disappointed artist: he wasn't alone in being refused entry. The 1863 Salon had a vintage committee of naysayers. Out went Manet's efforts, but so did an

incredible 3,000-plus other works of art, including paintings by future stars like Paul Cézanne, James McNeill Whistler and Camille Pissarro. The temperature between the progressives and the Academy was beginning to rise and even Napoleon III had started to feel the heat. His own autocratic approach wasn't terribly popular either, so in an attempt to quell a possible rebellion he decided to show his more liberal side. He insisted that a second exhibition be set up in opposition to the Academy's Salon, so that the public could decide whose approach to art was better. The name of the opposing 1863 show was Salon des Refusés (Salon of the Rejected).

Napoleon III had unwittingly released the modern art genie: he had given the artists a state-approved platform and with it the notion that there was an alternative to the Academy. And although the public was largely unenthusiastic about what was on show at the Salon des Refusés, the artistic community was not. There was one painting in particular that caught the eye of an up-and-coming group of young artists looking for inspiration, which was *Le Déjeuner sur l'Herbe* by Édouard Manet.

One of those approving artists was a young Claude Monet, who saw in Manet's painting a new mode of representation. A little later he started work (later aborted, possibly because of unfavourable comments made by Courbet when he visited Monet's studio and saw the work in progress) on his own *Le Déjeuner sur l'Herbe* (he chose to fully clothe all parties and remove Manet's references to classical antiquity), partly as homage to Manet, but also as a competitive challenge. Meanwhile, Manet had completed his next work for possible inclusion in the Salon. Although replete with a title from ancient Greece, *Olympia* (1863) (see Plate 2) was to make the alfresco nudity of *Le Déjeuner sur l'Herbe* seem positively refined.

Again he had clothed the painting in art-historical references while presenting a naked subject. Under normal circumstances such a composition of a nude woman would have pleased the academicians, who considered the classical painting of an idealized nude to be a high

point in an artist's oeuvre. But Manet had not idealized his nude. In fact, he had taken Titian's mythical beauty *Venus of Urbino* (1538) and turned her into a harlot.

Surprisingly, Manet's *Olympia* was accepted for the Salon, but it immediately caused controversy and heated argument. Most who saw the painting were appalled. What was being depicted was quite clearly a modern prostitute presented with unabashed Courbet-like realism. The painting's dark background, coupled with Olympia's few decorative adornments such as a necklace and bracelet, only served to heighten her nakedness. And the painting was rife with references to sex beyond Olympia's come-hither stare. A black cat, a removed slipper (lost innocence), a bunch of flowers and an orchid placed jauntily in her hair all alluded to the sexual act. It was another bad day at the Salon for Manet, although he wasn't completely without supporters.

The year 1863 was a breakthrough one for modern art. The Salon des Refusés, Manet's *Olympia*, and the first stirrings of an artistic counter-culture all helped to create an environment where the ambitious young painters living in and around Paris could break free. There was one other important event that happened that year which was also to have a profound impact on the Impressionists. Charles Baudelaire, the French poet, writer and art critic, produced an essay called *The Painter of Modern Life*.

During tumultuous times there is often an individual, an intellectual talisman if you like, who watches events unfold and extracts the essence of what is happening into a text, which then provides a handbook for the oppressed. For the frustrated Paris-based artists battling with the Academy during the second half of the nineteenth century, Baudelaire was that individual, his essay, *The Painter of Modern Life*, the text. By the time it was published Baudelaire had already spent many years using his position as a respected poet and writer to champion the artists whom most others were scoffing at and rejecting.

It was Baudelaire who stood by Delacroix and described his painting as poetry while others dismissed the Romantic artist as a heretic.

It was Baudelaire who supported Courbet at his lowest moments; and it was Baudelaire who demanded that art of the present should not be about the past, but about modern life. Many of the ideas he set out in *The Painter of Modern Life* went on to be embodied in the founding principles of Impressionism. He claimed that 'for the sketch of manners, the depiction of bourgeois life . . . there is a rapidity of movement which calls for an equal speed of execution from the artist'. Sound familiar? The essay goes on to feature several references to the word '*flâneur*', the concept of a man-about-town, which Baudelaire was responsible for bringing to the public's attention, describing the role thus: 'Observer, philosopher, *flâneur* – call him what you will . . . the crowd is his element, as the air is that of birds and water of fishes. His passion and his profession are to become one flesh with the crowd. For the perfect *flâneur*, for the passionate spectator, it is an immense joy to set up house in the heart of the multitude, amid the ebb and flow of movement, in the midst of the fugitive and the infinite.'

There was no better provocation for the Impressionists to go out and paint *en plein air*. Baudelaire passionately believed that it was incumbent upon living artists to document their time, recognizing the unique position a talented painter or sculptor finds him or herself in: 'Few men are gifted with the capacity of seeing; there are fewer still who possess the power of expression . . . it is much easier to decide outright that everything about [modern life] is absolutely ugly than to devote oneself to the task of distilling from it the mysterious element of beauty that it may contain, however slight or minimal that element may be.' He challenged artists to find in modern life 'the eternal from the transitory'. That, he thought, was the essential purpose of art – to capture the universal in the everyday, which was particular to their here and now: the present.

And the way to do that was by immersing oneself in the day-to-day of metropolitan living: watching, thinking, feeling and finally recording. This was the artistic philosophy that gave Manet the courage to defy the Academy, a philosophy that has percolated through the story

of modern art. Duchamp was a *flâneur*, so was Warhol, as are many artists working today, like Francis Alÿs and Tracey Emin. But Manet was the first, and perhaps the greatest, *flâneur*, or, as he saw himself, a painter of modern life.

His two major paintings of the 1860s, *Olympia* and *Le Déjeuner sur l'Herbe*, are now prized as masterpieces that stand comparison with the very greatest art man has ever created. At the time, though, the Academy's negative response to them left Manet frustrated and bemused, a situation made worse when people leaving the Salon congratulated him on his pleasant seascapes (they had misread 'Monet' for 'Manet', much to the delight of the younger artist, who had two of his own seascapes exhibited).

Manet disliked being cast as an anti-establishment type; he saw himself as a discerning intellectual who wanted to emulate the Spanish artists Diego Velázquez (1599–1660), the leading painter of King Philip IV's court, who he considered to be 'the painter's painter', and Francisco Goya (1746–1828), the romantic painter and printmaker regarded as the last of the old masters. But art history had determined that it was in the role of rebel that Manet would be cast, and so with reluctance he became the leader of a circle of dissident artists that included Claude Monet, Camille Pissarro, Pierre-Auguste Renoir, Alfred Sisley and Edgar Degas; the group that would form the core of what is generally considered to be the first movement in modern art: Impressionism.

IMPRESSIONISM: PAINTERS OF MODERN LIFE 1870–90

laude Monet leant forward and stirred a cube of sugar into his coffee. He did not rush. Each ponderous revolution of the spoon, plunged deep into the hot drink, acted like a metronome marking his thoughts. And he had plenty on his mind. As did those gathered around him. Even Édouard Manet, who was not involved in the risk-taking exercise, was tense.

For the others, though, gathered that morning at the Café Guerbois, amid the hustle and bustle of northern Paris, there was much to contemplate. The following day, on 15 April 1874, they were opening an exhibition that could make or break their careers. Pierre-Auguste Renoir, Camille Pissarro, Alfred Sisley, Berthe Morisot, Paul Cézanne, Edgar Degas and Monet himself had gambled their careers by deciding to defy the Academy system and instead put on their own show.

For years this group of thirty-something artists had met at this, their favoured café, on 11 Grande Rue des Batignolles (today 9 Avenue

de Clichy), to discuss art and life (at this stage they were frequently referred to simply as the Batignolles Group). Manet, whose studio was nearby, would often join the young tyros and encourage them to believe in what they were doing. It hadn't been easy. Rejection by the establishment was an expensive business, and, for those who like Monet were not blessed with a private income, close to ruinous.

'Why won't you show with us?' asked Monet.

'My fight is with the Academy, my battleground their Salon,' replied Manet. He did so gently, as he had done umpteen times before, careful not to belittle his friends' efforts or suggest that he did not support them.

'It is a great shame, my friend. You belong with us.'

Manet smiled and gave a gentle, conciliatory nod.

'We'll be fine,' Pierre-Auguste Renoir said assertively. 'We are good artists; we know that. Remember what Baudelaire said before he died: "Nothing can be done except little by little." That is what we are doing, it is not big, but it is something!'

'Maybe it will amount to nothing,' said Paul Cézanne.

Monet laughed. Cézanne (1839–1906), the man from Aix, said little, and when he did speak it was likely to be negative. He had made his reservations about the exhibition known from the moment the artists had collectively helped found Société Anonyme des Artistes Peintres, Sculpteurs, Graveurs, etc., an independent group that aimed to establish an alternative annual exhibition to rival the Academy's Salon. They had chosen the April date because it came before the annual Salon and therefore could not be compared to the Salon des Refusés and all the negative connotations with which it was associated.

Together they had agreed the rules: no juries, all-comers were welcome as long as the subscription had been paid, and all artists would be treated the same (very similar to the model Duchamp would adopt in New York nearly fifty years later). The title of the exhibition was the same as the title of the Society, not very catchy, but the location was good. It was held at 35 Boulevard des Capucines, near the Paris

Opéra in the heart of the city, in the spacious studio that had recently been used by Nadar, a famous society photographer of the day and a daring balloonist.

They made for a slightly odd group, held together in part by the collaborative nature of Camille Pissarro (1830–1903), the intellect of Manet and the monumental talent of Monet. Edgar Degas (1834–1917) and Cézanne didn't really fit in, and would later be critical of the others' methods and doctrine. Berthe Morisot (1841–95), the only female in the group (at this stage) and an artist of enormous skill, was there because of her close friendship with Manet (she subsequently married his brother Eugène). Alfred Sisley (1839–99), born in France but of English parentage, completed the cast of those sitting at the café. He was always a bit of an outsider, although he had studied with, and was close to, Monet and Renoir (1841–1919).

But on this spring morning the differences and petty politics didn't matter; they were united in their fury with the Academy for having repeatedly rejected their work, and were determined to make their exhibition a success not just for themselves, but also for the many other artists who had been invited (mainly by Degas) to show their work. The mood at the café was one of mutual respect and support: even Cézanne wished his colleagues '*bonne chance*'.

When they met again, nearly a fortnight after the exhibition's opening night, their optimism had all but disappeared. This time Monet was not drinking coffee; he had swiped his cup and saucer from the table in a fit of anger, discharging the contents and smashing the receptacle. He was now thrashing the side of the table with a copy of the satirical newspaper *Le Charivari*, snarling more each time additional elements of its contents were revealed to him. Cézanne was nowhere to be seen; Renoir was – for once – silent, as were Manet and Morisot. Only Degas and Pissarro spoke. They too had copies of *Le Charivari*, from which they were reading extracts, giving small breaks in between for all those around the table to calm down.

'Wallpaper in its embryonic state is more finished!' Monet stormed, striking the table with *Le Charivari*. 'Who the hell does he think he is?' Thwack. 'How dare he?' Thwack. '"A sketch" I could live with, such an insult I have heard many times before. But "Wallpaper in its embryonic state is more finished" is too, too much. The man is an imbecile, a philistine: an oaf!' Thwack, thwack, thwack! 'Tell me again, Camille, what is the fool's name?'

'Louis Leroy,' replied Pissarro, before continuing to read the art critic's sarcastic review of Monet's painting *Impression, Sunrise* (1872) (see Plate 4), one of a handful of paintings the artist had exhibited.

'"Impression – I was certain of it. I was just telling myself that, since I was impressed, there had to be some impression in it."' Pissarro looked up. 'I think this critic Leroy is not being serious, Claude.'

'I know he's not being bloody serious,' barked Monet. 'Is that it?'

'Not quite,' said Degas, cutting in, struggling to keep a straight face. 'He commends you by saying, ". . . and what freedom, what ease of workmanship!"'

'He is not "commending" me, Edgar, he is condemning me, and you know it!'

Which, of course, he was. But history has a way of dealing with such cynics and it caught up with M. Leroy very quickly. His vitriol towards Monet made a good splash on the day, but very soon he found that his poisoned pen had not only failed to kill off Monet and his friends, but had in fact given birth to the most famous art movement to have existed since the Renaissance: Leroy gave Impressionism a name and an identity while at the same time diminishing the role of the art critic.

Monet's painting of the harbour at Le Havre, the port in northern France where he had spent his childhood as the son of a grocer, is an evocative and charming example of Impressionism. The scene shows a reddish-orange morning sun rising wearily from the sea and into the sky like an employee struggling out of bed on a miserable Monday in winter. The fiery ball is not quite bright enough to burn off the foggy

blue air that shrouds the sailing ships and rowing boats, but has sufficient energy to provoke the cold purple morning sea into producing a warming orange reflection on its surface not unlike a single heated bar on an electric fire. Beyond that there is very little detail. It truly is an impression of what the artist saw, possibly from the bedroom window of the house in which he was staying.

And there is no doubt that if you were used to seeing highly finished classical paintings, built layer by layer from detailed drawings, Monet's effort would come across as little more than the most preparatory of preparatory sketches. It is certainly not his greatest work (I'd go for his *Haystack* series), nor the epitome of Impressionism, but it does contain all the elements that would make the movement famous: the staccato brushstrokes, the modern subject (a working port), the prioritizing of the effects of light over any pictorial detail, and the overriding sense that here is a painting that is to be experienced and not just looked at.

That is what Monet had intended, as he explained unnecessarily to his friends in the café once he had recovered his composure. By this time Alfred Sisley had joined the group.

'Claude,' Sisley said mischievously, taking Degas's copy of *Le Charivari*, 'would you like to hear what the fool has to say about Cézanne's work?'

'Yes, why not,' replied Monet, with a little devilment.

'Well,' said Sisley, 'he has this to say about Paul's *Modern Olympia* [1873–4]: "Do you remember *Olympia* by M. Manet? Well, that was a masterpiece of drawing, accuracy, finish, compared with the one by M. Cézanne."'

Monet roared with laughter. As did Sisley. Manet did not. He got up, made his excuses and went back to his studio.

He knew Cézanne's picture very well. Leroy was correct to reference Manet's earlier *Olympia*, the picture that had caused such a scandal at the 1865 Salon. Cézanne's version was indeed a direct response to that painting: an homage to Manet. And to be fair to Leroy, Cézanne's version is a good deal more sketchy than Manet's,

and at first glance could be mistaken for a *New Yorker*-type cartoon. It has none of the rigour and structure that would underpin Cézanne's later work, but once you begin to look at it the artist's genius starts to become apparent.

As with Manet's painting, Cézanne's *Modern Olympia* is lying naked on a bed, attended by a dark-skinned servant – possibly also naked – standing behind her and preparing to place a white sheet over her body. Cézanne has his Olympia lying right to left – the mirror image of Manet's (and Titian's for that matter) – on a white-sheeted bed that is raised like an altar. This Olympia is much smaller, allowing Cézanne to add an onlooking male figure (a client perhaps?) in the foreground. The man is sitting on a chaise longue, dressed in a black frock-coat. His legs are crossed. In his left hand he holds a walking stick as he sizes up the vulnerable beauty who has only a tiny dog to protect her (no match for his stick). Manet had used this dramatic pairing – a well-dressed man sitting and staring at a nude woman – in *Le Déjeuner sur l'Herbe*. For that painting the artist had used his friends as models. I can detect only one recognizable figure in *Modern Olympia*: it is the lascivious, smartly dressed male onlooker in the boudoir, who, although he has his back to the viewer, bears a striking resemblance to the painting's creator.

It might look like a casual sketch, but in fact Cézanne has given us a thoroughly planned painting that pulses with an intense air of sexual tension, even more so than in Manet's *Olympia*. But, Cézanne being Cézanne, the compositional structure has occupied his mind as much as the subject. A huge vase, overflowing with green and yellow flowers, accounts for the entire top right-hand corner of the painting, which is balanced by a green and yellow carpet that dominates the bottom left-hand corner. The arm movements of the attendant, Olympia and the frock-coated man all correspond, as does the alignment of their bodies. It is a picture that does not appear, at first, to be, as Leroy said, a 'masterpiece of drawing, accuracy, finish', but spend a few minutes looking at it and the rewards come thick and

fast. It is not Cézanne at the height of his powers – that comes in a later chapter – but its intelligence and skill show Leroy up for being without either.

Monet, his rage now behind him, was starting to enjoy Leroy's barbed comments. 'My dear Camille,' he said with an unconcealed twinkle in his eye, 'tell me, did M. Leroy make any comments on your work?'

Before Pissarro could answer, Sisley started to read Leroy's review of Pissarro's painting *Hoar Frost, the Old Road to Ennery* (1873).

'"Those furrows? That frost?"' read a chuckling Sisley. '"But they are palette-scrapings placed uniformly on a dirty canvas. It has neither head nor tail, top nor bottom, front nor back."'

Monet hugged himself, rocking backwards and forwards in his chair. 'Brilliant, brilliant!' he roared. 'This Leroy is not an art critic, he is a comedian.'

Pissarro laughed too. He was happy enough with his picture, a bucolic scene in which an old man carrying a bundle of sticks on his back makes slow progress up a country path between two golden fields on a sunny but frosty winter's morning.

The mood of the gathered artists lifted still further when they spotted the figure of the art dealer Paul Durand-Ruel approaching. He was as much a member of the group as any of the artists, and, in a way, just as central to the development of Impressionism. It was Durand-Ruel's commercial courage and entrepreneurial vision that had emboldened the young artists to conceive of presenting their own exhibition. And it was because of the art dealer's immovable belief in their work that they knew that even if Leroy's attack was enough to damage them, Durand-Ruel would ensure their survival, single-handedly if necessary.

Durand-Ruel walked past Agnès, Café Guerbois's attentive head waitress, and sat down in the chair that Manet had vacated.

'We have come a long way, *non*?' he said, looking over the table to Monet.

'We have, Paul, we have. Do you remember that time in London when we first met: you and me and Camille . . .'

'And Charles,' Durand-Ruel interjected.

'Of course,' said Monet. 'And Charles.'

That had been back in 1870, when France was at war with Prussia and Durand-Ruel had left Paris for the sanctuary of London. The thirty-nine-year-old art dealer was in his prime: ambitious and energetic. He saw his London sojourn as an opportunity to expand the commercial art gallery business that he had inherited in 1865 from his father beyond its base in Paris. He was also keen to broaden the gallery's product range, concerned that it was over-reliant on the paintings of the Barbizon School – a mid-nineteenth-century group of like-minded landscape artists that had made the small village of Barbizon (about thirty miles south-east of Paris) their professional base. His father had built the gallery and its reputation on selling the group's naturalistic landscape paintings of rural scenes in and around the tranquil forest of Fontainebleau. Members of the group such as Jean-Baptiste-Camille Corot (1796–1875) and Jean-François Millet (1814–75) had developed a modern style of landscape painting – partly inspired by John Constable's non-idealized canvases depicting the English countryside – that concentrated on the accurate rendering of natural light and colour. They were pioneers of painting *en plein air*, in front of the subject, which as we know was made possible by the recent invention of portable tubes for oil paint.

Durand-Ruel Senior had helped support the careers of the Barbizon group by building a network of appreciative customers to buy their work. His son Paul wanted to do the same for the artists of his generation, but realized that in order to maintain the business and satisfy its existing clients he had to ensure that any new talent he brought on board had an aesthetic connection with the work of those artists already on the gallery's books. He was looking out for young, ambitious artists who were taking forward the innovations of the Barbizon group. He had combed France and much of Europe to find such paint-

ers, but was yet to discover what he was looking for. Until, that is, he ran into Claude Monet and Camille Pissarro, two young French artists who, like him, were in London avoiding the Franco-Prussian war.

Monet, who had started his artistic life as a caricaturist, changed his creative aspirations when he met Eugène Boudin (1824–98). Boudin had encouraged him to paint outside, saying that 'three brushstrokes from nature are worth more than two days' studio work at the easel'.

Monet shared his new approach with the friends he had met at, or through, art college. Camille Pissarro, Pierre-Auguste Renoir, Alfred Sisley and Paul Cézanne looked and listened and then followed the same path. Monet went to the suburbs of Paris to paint in this manner with Pissarro in 1869, and later in the same year went to La Grenouillère, a leisure resort to the west of Paris, with Renoir. Together they painted the bourgeoisie *en vacance*, boating and bathing in the summer sun.

Monet and Renoir both produced pictures called *La Grenouillère* (both 1869), which they had painted from exactly the same spot. It allows for a stylistic comparison to be made between the two artists, particularly as the paintings depict a near-identical scene. It is one of tranquil informality, in which a group of smartly dressed holiday-makers relax in and around a popular swimming spot. The centre of both paintings is taken up with a social gathering on a small round island, located a few metres from the shore, which is reached by a narrow wooden pontoon that comes in from the left. Others are chatting in a café to the right of the picture or enjoying a swim on the far side of the island. In the near foreground are moored rowing boats, bobbing gently on the water, the shallow ripples of which are given a silvery glint by the afternoon sun. In the background, creating a horizontal band that runs across both pictures, is a row of trees in full leaf.

Monet's picture was only ever meant to be a sketch (he described it as a 'bad sketch') in preparation for a much larger, more detailed painting that he hoped would be accepted by the Salon (it wasn't, and

has subsequently been lost). 'Bad sketch' or not, it is a good example of early Impressionism: crudely painted, brightly coloured, quickly executed and portraying a modern bourgeois subject. As is Renoir's version, for the same reasons.

But the pictures are quite different in style and approach. Renoir directs his attention towards the social aspect of the gathering, making the pleasure-seekers' clothes, countenance and interaction his primary pictorial concern. For Monet people are not the point; his interests focused on the effects of the natural light on the water, boats and sky. His painting is crisper, less romantic than Renoir's soft-focus evocation of a halcyon day, his colour palette more harmonious, his compositional structure more rigid. The biggest difference, though, is in the amount of rigour applied to accurate documentation. Monet's rendition of the event is a believable account, whereas Renoir's effort is sentimental and saccharine, a picture that owes as much to eighteenth-century Rococo as it does to Impressionism.

Neither artist had enjoyed much success with the Academy. Nor had Pissarro, who by the time he met Durand-Ruel in London was struggling financially; as was Monet, who had the burden of a mistress and young child to support. For both artists the encounter with the art dealer could not have been more welcome.

The feeling was mutual. Durand-Ruel's highly attuned visual antennae, developed over decades, could identify exceptional painterly talent in seconds. He inspected the artists' work, heard their story, and knew that he had found the elusive next step for his business. These two young painters, schooled in the artistic philosophy of the Barbizons, represented the future for his gallery and, possibly, for that of art. To the great financial relief of Monet and Pissarro, Durand-Ruel immediately purchased paintings from both of them for his gallery at 168 New Bond Street, London.

His entrepreneurial boldness did not end there. In a highly unusual move, he chose not to wait for the Academy's annual Salon to make the market for Monet and Pissarro (a wait that would probably have

been in vain), and decided that he'd get on with it and do it himself. He would, in effect, become the artists' representative, freeing them from the dead hand of the Academy by providing a monthly stipend on which they could live (neither Monet nor Pissarro were independently wealthy). Durand-Ruel committed not only to purchase outright much of their work but also to create a commercial demand for it, and in so doing to transform the way the art market operated.

His plan was gradually to add the new works to one of his regular exhibitions of Barbizon School landscapes, for which he had an established customer base. The idea being that Monet and Pissarro's paintings would, by association, be validated and understood to be the logical continuation of the much-admired work of Corot, Millet and Daubigny. Smart move. The ever-alert Durand-Ruel could also see that the market for modern art was changing. Revolution and mechanization had created a new social class known as the bourgeoisie. He guessed that this nouveau riche middle class would want a different sort of art.

The enlightened modern man and woman would want to acquire art that reflected their exciting new world, not stodgy brown paintings full of ancient religious iconography. Leisure was the big new thing, free time to hang out and enjoy oneself the great gift that new technology had given. And that, he predicted, was what the punters would buy: images of people similar to themselves enjoying the pleasures of city life: strolling arm-in-arm in the park, boating on the lake, swimming in the river or drinking in a café. Durand-Ruel even went so far as to encourage the young artists to paint smaller pictures that could fit on the walls of less wealthy collectors who had more modest apartments.

It was a plan based on a commitment to the type of work his protégés were making, aligned to a hunch that tastes were changing as quickly as the world in which they were all living. His instinct was to be proved correct on both fronts, his speculative but successful business plan going on to play a significant part in breaking the Academy's

iron grip on the careers of Paris-based artists. At last the talented but rejected or unproven had a commercial alternative. More, Durand-Ruel gave them the financial independence to pursue their creative goals without interference or financial worries. His actions led directly to the emergence and relatively quick development of modern art and the establishment of a commercial blueprint, based around knowledgeable, entrepreneurial art dealers, that thrives to this day.

By the time of the famous 1874 exhibition, Durand-Ruel was supporting and promoting the work of Monet, Pissarro, Sisley, Degas and Renoir, among others. And while the artists might have winced at the comments of Louis Leroy, the wise art dealer would have been delighted. He was a born impresario who understood, and leveraged, the power of the press: as Oscar Wilde would say a little while later, 'There is only one thing in the world worse than being talked about, and that is not being talked about.' Again, Durand-Ruel's instincts were right: if Leroy's defamatory words had not been printed, there would have been no brand name on which to build Impressionism.

Durand-Ruel was doing well. But life at the cutting edge is never easy. While his Parisian gallery enjoyed great success, his London enterprise was struggling, leading eventually to closure in 1875. That was a blow to the ambitious Durand-Ruel, but by providing the introduction to Monet and Pissarro his adventure in London would actually be the making of him, as it would, to a degree, of Monet.

Monet spent much of his time in the UK's capital city studying the work of the modern English landscape artists. He already knew of John Constable's paintings, as he did those of James McNeill Whistler, who was London-based. But it is likely that it was the atmospheric paintings of another artist that really fired his imagination. Although J. M. W. Turner (1775–1851) had died some years earlier, it was still possible to see several of his paintings in London and it is inconceivable that Monet would not have studied them in some depth. And Turner, like Monet, was a painter fascinated by the effects of natural

light, once being so moved by nature's luminous magnificence that he reportedly said that 'the sun is God'.

Hanging in London's National Gallery in 1871 during Monet's time in London was Turner's *Rain, Steam and Speed* (1844) (see Plate 3), a painting that makes the Frenchman's unconventional style look rather conservative. Like the Impressionists, Turner was interested in modern life and painted the sort of contemporary scene that would become their trademark: a speeding steam train barrelling across a splendid new bridge that spanned the river Thames to the west of London. It is the epitome of industrial modernity.

Turner's treatment is just as cutting-edge as the subject. A golden veil of sunlit rain washes diagonally over the picture, obscuring almost all pictorial detail. The black chimney rising from the front of the onrushing train is just about discernible, as is the bridge (painted in a dark brown) in the foreground; the rest of the scene is a blur. The hills in the distance, another bridge to the left, and the far banks of the river are only faint outlines as the sun, rain, river, train and bridge dissolve into one tumultuous mixture of blues, browns and yellows. It is a magnificent, expressive, freely painted celebration of life, a picture that still feels fresh and innovative today. Constable said of Turner that 'he seems to paint with tinted steam, so evanescent and so airy'. And so he did, foreshadowing not only the atmospheric pyrotechnics that the Impressionists would set off, but also the bursts of pure emotion for which the American Abstract Expressionists would become famous 100 years after Turner painted *Rain, Steam and Speed*.

Monet discovered in addition to finding some inspiring landscape artists in London that the city had other delights on offer, such as . . . smog. For a man interested in diffused light, London's thick, unhealthy, winter fog – made up of a chilly mist mixed with the coal smoke billowing out of the city's forest of chimneys – was a wonder to behold. He would spend hours on the banks of the river Thames near the Houses of Parliament in central London, perched on a small stool, painting a city at work. His efforts yielded a series of

hauntingly beautiful impressionistic paintings, which perfectly capture the mood of the time and place. The Paris Salon might not have liked them much, but I do.

The Thames Below Westminster (1871) might appear to be a traditional, almost hackneyed London scene to today's viewer, but at the time Monet painted the landscape, it was ultra modern. The ghostly blue-grey presence of the Houses of Parliament in the background, rising up out of the Thames like a distant gothic castle, was not yet a familiar sight, having only just been completed after fire had destroyed the old Palace of Westminster in 1834 (an event captured by Turner in his painting *The Burning of the House of Lords and Commons*). New too was Westminster Bridge (also in the distance), which cuts across the middle of the picture like a strip of dirty lace. In the foreground, to the right of the painting, workmen are building a new pier. It is being attached to the recently created Victoria Embankment, a pedestrian walkway running along the north side of the Thames, designed for London's burgeoning middle class to promenade along at the weekends. State-of-the-art steam tugboats are busy on the water. If Monet had visited London a decade earlier, much of what he depicted in 1871 would not have existed.

His painting technique was equally modern. Fine details are sacrificed in exchange for pictorial unification: Monet's aim was to produce a harmonious work of art, where forms and light and atmosphere blend into one resolved entity. A suffused glow washes over the picture like a net curtain, eliminating visual clarity. The pier and workmen in the foreground are rendered in dark brown paint, depicted with a few rough brushstrokes. The shadows they cast on to the river below are reproduced with comma-like stabs of paint that mirror the purple, blue and white, short, horizontal broken lines with which he has painted the rest of the river. The Houses of Parliament and Westminster Bridge are no more than silhouettes in the background, providing compositional depth and a visual signal as to the density of the fog.

The painting is sketchy almost to the point of being out of focus.

Which is Monet's great triumph. It has enabled him to fully realize the integrated effect he set out to achieve with *The Thames Below Westminster*: it is a model of Impressionism. No matter that the buildings, water and sky dissolve into one hazy landscape; such lack of intricate definition breathes life into the scene, firing the imagination of the viewer, who is drawn into the narrative of the painting as if it were a movie.

The influences on Monet were many: the Barbizon landscape painters, Manet, Constable, Turner and Whistler, to name a few. But, surprisingly perhaps, another source of inspiration came from the colourful, two-dimensional Japanese Ukiyo-e (meaning pictures of a floating world) woodblock prints. They started to appear in Europe in the mid-1850s after Japan had been encouraged to open herself up to the world. They were first exhibited at the World Fairs hosted in Paris (Exposition Universelle 1855, 1867, 1878) and could also be found in the less glamorous world of international freight, where they were used as packaging for goods sent from Japan.

Ukiyo-e masters such as Utagawa Hiroshige (1797–1858) and Katsushika Hokusai (1760–1849) had also been revered by Manet. It was under the influence of their flat graphic work, such as Hokusai's famous print *The Great Wave off Kanagawa* (*c.*1830–32) – in which Mount Fuji is dwarfed by a giant white-tipped blue wave – that Manet started to dramatically foreshorten the perspective in his paintings, as can be seen in both *Olympia* and *Le Déjeuner sur l'Herbe*. Now Monet was incorporating more of their methods. The asymmetrical composition of *The Thames Below Westminster*, where most of the subject matter is arranged on the right-hand side, was a standard Ukiyo-e technique to generate emotional tension. As was the privileging of a pleasurable all-round decorative solution over the accurate representation of a subject's specific characteristics, an approach that encouraged Monet to simplify the physical shape of the pier and Houses of Parliament in his painting.

Monet and Manet were not alone among modern French artists in painting under the influence of Japanese woodcut prints. All the

Impressionists had developed a taste for their stylized, comic-book simplicity. None more so than Edgar Degas, whose paintings owe much to the images produced by the Ukiyo-e artists. He was particularly admiring of Hiroshige, an artist who made hundreds of prints,

Fig. 4. **Utagawa Hiroshige,** *Station of Otsu,* **c.1848–9**

including a series that featured the fifty-three stations on the 290-mile highway between Edo (now Tokyo) and Kyoto. One of these works, *Station of Otsu* (c.1848–9) (see Fig. 4), shows an everyday scene of travellers going about their business, buying goods from market stalls and walking about carrying heavy bags on their backs in readiness for the onward journey. None of which is remarkable. But the viewpoint and composition are noteworthy.

Hiroshige has taken a bird's-eye view of the action, as if seen through a CCTV camera placed on top of a high building. The voyeuristic effect of the aerial position is accentuated by the structure of the image, which he has arranged along a diagonal line, running from the bottom left-hand corner of the picture to top right, creating a sense of motion that takes the eye beyond the frame to a single, imaginary van-

ishing point. To add yet more dynamism to the picture, Hiroshige has aggressively cropped the action that is taking place in the foreground,

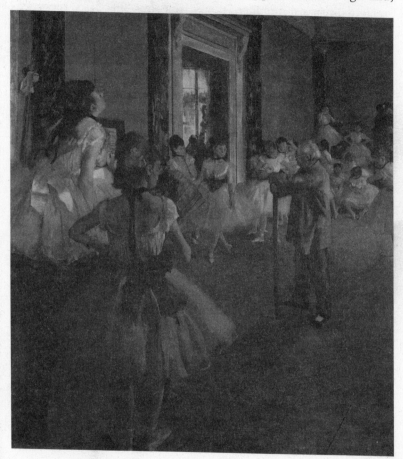

Fig. 5. **Edgar Degas,** *The Dance Class*, **1874**

a favourite technique of the Ukiyo-e artists. The result is an image that makes you, the viewer, feel strangely present – complicit even.

Now take *The Dance Class*, a picture Degas painted in 1874, the same year as (what would become known as) the First Impressionist Exhibition (see Fig. 5). It shows a dance studio full of ballerinas paying

scant attention to their elderly ballet master, who is standing, supported by the long pole he uses to mark time by tapping the floor. The young dancers are standing, leaning and stretching along the studio wall. All are dressed in white tutus, with a variety of coloured sashes tied in bows around their waists. A small dog peers round the ankles of the ballerina standing in the foreground to the left of the picture: she has her back to the viewer and is sporting a large red hairclip. On her left, at the edge of the composition, is the most inattentive dancer, who is scratching her back, eyes closed and chin raised in momentary relief.

For those of you who, like me, have worked backstage in a theatre and watched ballet dancers rehearse, it is a wonderfully accurate, evocative painting. It captures the feline nature of ballerinas, at once lazy and distant, while at the time emitting a poised physicality that is both sensuous and powerful. Degas has pulled off a great representational feat. He has done so by ignoring the traditional rules of the Academy and instead mimicking the compositional techniques of Japanese woodcut artists. Like Hiroshige's *Station of Otsu*, Degas has arranged his composition in a diagonal band running from the bottom left-hand corner to the top right. He has also chosen a raised viewpoint, an asymmetrical design, exaggerated foreshortening and severe cropping at the outer edges of the picture. For instance, the ballerina placed halfway up the picture to the extreme right has been cut in half. It is a visual trick, of course, but a very effective one. It animates what would otherwise appear to be a static scene. Degas's intention was to communicate to us that what we are seeing is a fleeting moment that he has frozen in time.

And yet, it was nothing of the sort. 'No art was less spontaneous than mine,' he once said. In that respect Degas wasn't really an Impressionist at all. He couldn't get as worked up as Monet and the others about the whole painting *en plein air* business, preferring to work in his studio from preparatory sketches. He was meticulous in his research and preparations, making hundreds of drawings, and taking an almost scientific interest in human anatomy, reminiscent of the

investigations Leonardo da Vinci had made into human physiology 400 years earlier. As for the depiction of nature's ever-changing light, well, that was not Degas's principal concern; his focus lay more in an artist's ability to give his or her subject the illusion of movement.

It was a preoccupation that can be seen in his painting *Carriage at the Races* (c.1869–72). Again Degas has used the compositional techniques developed by the Japanese print masters. This time, though, it is a horse-drawn open-top carriage, peopled by a wealthy middle-class couple out enjoying a day at the races, that he has placed along a diagonal angle (running from the bottom left-hand corner to top right in this instance). The carriage and horses in the foreground have been heavily cropped, with sections of wheels, legs and body (both horses and carriage) cut by Degas's severe and abrupt framing. The artist's intention, as it was with his vast output of paintings featuring ballet dancers, was to convey a sense of the beauty of movement; hence choosing lithe and supple subjects at the height of their athletic powers.

Degas's understanding and appreciation of what was needed to create the impression of immediacy and movement was not just acquired from studying the work of Japanese artists. He had also learnt a great deal from the rapidly evolving medium of photography, as had his fellow Impressionists. Degas was particularly knowledgeable about the pioneering photographic work of Eadweard Muybridge (1830–1904). The English-born, largely American-based Muybridge made his name with a (now very famous) series of frozen-moment photographs in the 1870s that showed, frame by frame, how horses and people really moved. They were a revelation to Degas, who studied and copied the images before proclaiming his artistic ambition as being the capturing of 'movement in its exact truth'.

Something, perhaps, he was uniquely able to do among his colleagues, because of his total commitment to the drawn line. It was another aspect of his art, beyond his practice of being studio-based, which differentiated him from the rest of the Café Guerbois crowd. He had met the traditionally minded artist Jean Auguste Dominique

Ingres – Delacroix's old foe – in his early twenties, an event that taught him the pre-eminence of drawing in composition. It was a lesson Degas would never forget. He became an excellent draughtsman, who now belongs in the rarefied company of Picasso and Matisse in the small, exclusive club of modern masters who could draw like old masters.

It was the outstanding feature of his painting *Carriage at the Races*. Both composition (dramatic) and colour (vivid and expertly handled) are excellent, but the draughtsmanship is exquisite. Even the acerbic critics who reviewed the exhibition had to admit that Degas could draw (sadly Leroy made no comment). He was congratulated on the precision of his drawing, the accuracy of his execution, and the sureness of his hand. In Degas maybe the critics saw some hope; that the art of the old masters could be successfully united with the art of the avant-garde.

That, after all, is what Degas was attempting to achieve. He considered himself a 'realist' painter and disliked being called an Impressionist, although he was a very active participant in that inaugural 1874 show, and contributed to nearly all of the seven subsequent Impressionist exhibitions that were held over the next twelve years. And while it is correct not to consider Degas an out-and-out Impressionist in the way one can Monet, Pissarro and Renoir, there was much in his approach that chimed with the art being produced by his colleagues. His motifs were modern, metropolitan, everyday and bourgeois. He used a colourful palette, he simplified his subjects, he painted with loose brushwork; he too wanted to make pictures that communicated the fleeting impression of a moment.

By the time of the last exhibition in Paris in 1886, differences in artistic philosophy, geographical location and individual character had led to the gradual break-up of the artist collective known as the Impressionists. By which time Impressionism had become as much a part of French cultural life as the Opéra and, ironically, the Academy.

Paul Durand-Ruel's business was thriving, although it hadn't been easy. Part of the reason for the first Impressionist exhibition in 1874

was because the art dealer was unable to pay the artists a stipend. But his persistence and belief in them eventually paid off. It was in 1886 that he and the Impressionists hit the big time when he staged a major exhibition of their art in America. Although their work had been shown in the US before, nothing had been presented on the scale of Durand-Ruel's 1886 show. It was a great success, after which he compared the Americans with the French, saying, 'The American public does not laugh. It buys!'

The Impressionists' names were made, and their future secure: theirs had become the art of the modern world.

POST-IMPRESSIONISM: BRANCHING OUT 1880–1906

Not one of the four artists whom we now know as the Post-Impressionists would have answered to the name. That's not because Vincent van Gogh, Paul Gauguin, Georges Seurat and Paul Cézanne were sniffy or disapproving of the term. It's just that it was coined some time after they were dead.

Roger Fry (1866–1934), the British curator, art critic and artist, invented the moniker in 1910. He needed a collective noun to unify this disparate group of artists, having selected them to form part of an exhibition he was putting on at the Grafton Galleries in London. It was a rare London outing for the work of this France-based avant-garde group of painters, and it was likely to cause a bit of a stir. Which would inevitably mean that the media's white-hot spotlight would fall on Fry. So coming up with a suitably publicity-friendly title that would also stand up to the scrutiny of his colleagues in the art world was important. And – as I know from experience – surprisingly difficult.

In the seven years I worked at the Tate Gallery in London about six and half were spent discussing possible exhibition titles. 'I Kid You Not', 'No Word of a Lie', 'It's a Material World', were all discussed at some time or another as potential names for a show. A typical 'titles meeting' would involve about fifteen people, thirteen of whom remained mute, other than to say 'no' or 'absolutely not', while a couple of optimistic individuals made suggestions. It was ridiculous, of course, but it does highlight a central tension in the art world: public engagement versus scholarship. Curators and artists recognize the helpful role the media plays in communicating their ideas to a sceptical, non-specialist public, but in all honesty most would rather not bother. And they would rather have rusty nails poked in their eyes than acquiesce to an exhibition title that might humiliate them in front of their peers by being remotely 'populist'. As a result, they have the habit of proffering exhibition titles that are so dry and lifeless one could only assume they'd lifted them from an obscure academic paper. Meanwhile bubbly marketing teams implore that words like 'masterpiece', 'blockbuster' or 'once-in-a-lifetime' be incorporated into the title. Cue stalemate and hours of coffee-fuelled discussion, normally followed by a torrent of emails that can often keep flowing until the last possible moment, at which point some half-hearted compromise is reached that might, or might not, catch the public's imagination.

The problem facing Roger Fry was the lack of an obvious common denominator with which to describe the four artists (not an unusual dilemma). He recognized that they represented the four corners upon which the twentieth century's modern art movements were being built, and knew that both Seurat and Van Gogh had been called Neo-Impressionists; that Cézanne had once been an Impressionist; and that Gauguin had been aligned with the Symbolist movement (in which paintings were full of symbolic references). But their painterly styles had developed in such different ways; they ended up having less and less in common, not more. Fry had already decided to include Édouard Manet in the show for art-historical and

commercial reasons. The London art crowd would be unfamiliar with most of the artists he was showing but would have heard of the Impressionists' forefather, who Fry hoped would have the pulling power to tempt the aficionados out of their houses on a chilly winter's day. Once there, he wanted to introduce them to a group of more modern painters, each of whom had taken Manet's ideas forward in a different way. So 'Manet' definitely had to be in the title, though the other names would not necessarily register. But the word 'Impressionist' would, as they were now a big draw. 'Manet' and 'Impressionist' worked, but wasn't strictly accurate. What to do? The solution, thought Fry, was to add a prefix – which is what he did. The exhibition was called *Manet and the Post-Impressionists*.

Fry's academic point when styling Van Gogh, Gauguin, Seurat and Cézanne as the Post-Impressionists was that they had all developed out of Impressionism, the art movement that Manet had inspired and supported. All four had started their individual journeys by adhering to the Impressionists' principles, which made 'post' – as in 'after' – the Impressionists, spot on. Or, to put it in another – slightly trite – way, they were rather like postmen: each had picked up Impressionism and delivered it to a new destination.

So, what does history tell us? Well, the title worked, but the show didn't. The term Post-Impressionist has stuck but Fry's exhibition received savage reviews, with the usual brickbats thrown. Shortly after the exhibition opened he wrote to his father saying that he had received a 'wild hurricane of newspaper abuse from all quarters'. A typical example of which was a review in the *Morning Post* which suggested that the show's Bonfire Night opening was darkly symbolic: 'A date more favourable than the fifth of November for revealing the existence of a widespread plot to destroy the whole fabric of European painting could hardly have been better chosen.' The abuse dished out in the reviews was similar to that previously hurled at the Impressionists and would be subsequently directed at several future modern art movements. 'Call that art?' was the general sneering tone of the

criticism. Fry was accused of being an oddball with spurious taste. But not everybody thought so. The artists Duncan Grant (1885–1978) and Vanessa Bell (1879–1961), and Vanessa's sister, Virginia Woolf, thought Fry was marvellous and invited him to join their set of bohemian intellectuals, which later came to be known as the Bloomsbury Group.

Some say that when Virginia Woolf wrote, 'On or about December 1910 human character changed' in her famous 1923 essay *Mr Bennett and Mrs Brown*, she was referring to Roger Fry's 1910 exhibition. Life had certainly changed for him. He mounted the Grafton Galleries show shortly after being sacked as a curator at the Metropolitan Museum of Art in New York, having fallen out with the then chairman, financier John Pierpont Morgan (as in J. P. Morgan), who had been responsible for hiring Fry in the first place. Up until then their professional relationship had been mutually beneficial. Fry's eye and Morgan's money worked in harmony. It was during this period that Fry discovered the avant-garde art scene in Paris. It changed him and his view of art. He ceased his curatorial work on past art movements and instead focused his efforts on the present. In 1909 he published his *Essay in Aesthetics*, in which he described Post-Impressionism as 'the discovery of the visual language of the imagination'.

Now, in the great scheme of things, that statement makes absolutely no sense, seeing that most of the art produced prior to the arrival of the Impressionists was make-believe. What is Michelangelo's Sistine Chapel ceiling if not the 'visual language of the imagination'? But in the context of an artistic movement that had developed out of the Impressionists' strict adherence to objectivity and everyday life, it does add up. In their own way, each of the four Post-Impressionists (Fry had also included Matisse and Picasso in his 1910 show but they came to be filed – at least for a while – under Fauvism and Cubism respectively) discovered a potent artistic concoction when mixing core Impressionist principles with 'the visual language of the imagination'.

Van Gogh and Expressionism

None discovered it more than the Dutchman Vincent van Gogh (1853–90). His story, perhaps more than that of any other artist in the modern art canon, is well known: the madness, the ear, the sunflowers and the suicide. The open-minded, talent-spotting, artist-nurturing Camille Pissarro summed up Van Gogh in one typically compassionate remark: 'Many times I've said that this man will either go mad or outpace us all. That he would do both, I did not foresee.'

Vincent's life began ordinarily enough in Groot-Zundert in the Netherlands. He was the eldest of the six children of the Reverend Theodorus and Anna Cornelia van Gogh. His uncle was a partner at the art dealers Goupil & Cie in The Hague and helped the sixteen-year-old Vincent to secure an apprenticeship with the company. He did well. Postings to the firm's international branches followed: first Brussels, then London. By this time his younger brother Theo had joined the company, which precipitated a regular correspondence between the two Van Goghs that lasted until Vincent's death. The letters would discuss art, literature and ideas, and would gradually reveal Vincent's increasing disillusionment with the materialistic nature of art dealing: feelings that were intensified by a growing obsession with Christianity and the Bible. It was this conflict of personal interests that led to his sacking and subsequent stay in the unglamorous English town of Ramsgate in order to teach. Things didn't go terribly well. Vincent was clearly a decent man, but his strong feelings were an acquired taste. After a spell of unpaid work as an evangelist he wrote to his brother Theo saying, 'My torment is none other than this, what could I be good for? Couldn't I serve and be useful in some way?' Theo came up with an unconventional, but prophetic answer: become an artist.

It was an expensive suggestion. Vincent loved the idea, Theo paid for it. From that moment on Theo financially supported his older brother. First Vincent spent five years learning his craft in the Nether-

lands, while Theo moved to Goupil's office in Paris. Vincent then took some fine art lessons (at Theo's expense), but to all intents and purposes he remained largely self-taught. Gradually he began to find his voice as an artist. By the mid-1880s he had painted what is now considered to be his first great work, but back then it aroused not a flicker of interest. *The Potato Eaters* (1885) (see Fig. 6) was an ambitious effort for a rookie artist. A five-person composition, set around a table in a small room, lit only by an underpowered oil lamp, would be a compositional challenge for any student. But Van Gogh wanted to raise the bar. At this stage he wanted to be a painter of 'peasant life' – a social documenter like the writer Charles Dickens. His peasants would not be sentimentalized, but naturalistic; the allusion to their humble life and meagre diet would be made subtly through Van Gogh's colour palette and treatment of the figures. The result is a painting of sombre browns and greys and blues, with peasants whose hands are the colour of earth, and fingers as rough as the potatoes they are eating. There are few straight lines in an image evoking a poor family that is exhausted but not yet beaten. He sent it to Theo. Theo sent him a letter. 'Why don't you come to Paris?' he asked.

In 1886 Vincent arrived in the French capital and . . . *vive la différence*! Theo introduced him to the Impressionists' work and Vincent had an epiphany. The lights had been turned on in his eyes and suddenly he saw colour. And lots of it. He wrote to a friend, saying that he was 'seeking oppositions of blue with orange, red and green, yellow and violet, seeking the broken and neutral tones to harmonize brutal extremes. Trying to render intense colour and not grey harmony.' He was up and running. Vincent practised the Impressionist skill of the spontaneous brushstroke, had his first dabblings with impasto painting (a technique where paint is applied so thickly to the canvas that it stands proud, resulting in a three-dimensional effect), and found that his love of Japanese woodblock prints, first developed in Antwerp, was shared by almost all avant-garde artists in Paris. It was all too much. Vincent was having a bit of a wobble. Theo suggested

a break in the countryside of southern France and Vincent thought it a terrific idea. He had a vision of a 'Studio of the South': an artist's colony to match the one his friend Gauguin had gone to in Brittany, in the north of the country.

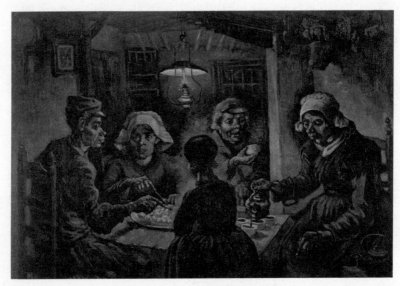

Fig. 6. **Vincent van Gogh,** *The Potato Eaters*, **1885**

Vincent went to check things out in Arles and had a second epiphany. For a lad from northern Europe, the southern sun was a revelation. He thought he had understood and appreciated colour in Paris, but that was nothing compared to the intensity of hues produced by the light from God's flaming orb in Provence. Everything was accentuated. Vincent had seen the light. In his fourteen months in Arles he produced 200 or so paintings, including masterpieces such as *The Yellow House* (1888), *Still-life with a Plate of Onions* (1889), *The Sower* (1888), *The Night Café* (1888), *Sunflowers in a Vase* (1888), *Starry Night Over the Rhone* (1888) and *The Bedroom* (1888). He said, 'I want to get to the point where people say of my work, "*That* man feels deeply."'

He could have added 'and whose works others feel deeply about'. When my eldest son was six we visited an art gallery that sold modern art posters. With the generosity of a dad on a day off I grandly offered to treat him to one poster and one postcard. I can't remember the chosen postcard, but I can remember the poster: it was of Van Gogh's *The Bedroom* (1888).

'Why?' I asked.

'It's relaxing,' my son said.

If Van Gogh had been in the same gallery I expect he would have rushed up and given the boy a hug. Because that is the feeling that Van Gogh was trying to project in the painting. He wanted every aspect of the picture to represent rest: the colours, the composition, the light, the mood and the furniture.

Arles was Van Gogh's kind of town. He thought it evoked the simplicity and beauty of the world presented in his much-loved Japanese woodcuts (To Theo, 1888: 'I envy the Japanese the extreme clearness which everything has in their work. It is never tedious, and never seems to be done too hurriedly. Their work is as simple as breathing, and they do a figure in a few sure strokes with the same ease as if it were buttoning your coat.'). The sun, together with his optimistic notion of creating an artist's commune, meant Vincent was on top form. But rather like the oddball at school whom everybody admires but tries to avoid, few would actually accept Vincent's invitation to join him in Arles. Paul Gauguin (1848–1903) did. The two self-taught artists were friends from Paris and shared an ambition to move on from the strictures of Impressionism. For six weeks they competed and cajoled, each pushing the other to greater and greater artistic heights. By the time of their infamous row and the ear mutilation episode (it is believed that Vincent fled to a brothel after a particularly heated argument and sliced off part of his own ear), both men had succeeded in their missions: Van Gogh had laid the ground for a new, more expressive movement, while Gauguin was heading for somewhere rather more exotic.

Van Gogh's art is as familiar to us as his life story, although it was largely unknown when he was alive. But familiarity does not prepare you for your first encounter with one of his paintings. It's like the first time you hear the Berlin Philharmonic play or visit Rio during the Carnival: another dimension is added by being in the presence of a great life force. Such entities can only be truly experienced unmediated: you have to be there. With the Berlin Philharmonic, it's the depth of sound that hits you, while Rio's energy is its irreproducible factor; and with Van Gogh it is the object. Because many of Van Gogh's great paintings are not simply pictures, they're more like sculptures.

From a few metres away some of his later paintings start to take on a three-dimensional quality. Move a bit closer and you can see that Van Gogh has shovelled great lumps of brightly coloured oils on to his canvas. He's caked on the paint like a drag queen on a Saturday night, and then shaped it, not using a brush, but with his palette knife and fingers. The technique wasn't new. Rembrandt and Velázquez had both used impasto. But in Van Gogh's hands its effects became more pronounced and dramatic. He didn't want the paint simply to depict part of the picture, but to *be* part of the picture. Where the Impressionists had sought to expose the truth by painting what they saw with rigorous objectivity, Van Gogh wanted to go further and expose deeper truths about the human condition. So he took a subjective approach, painting not just what he saw, but how he felt about what he saw (see Plate 5). He started to distort his images to convey his emotions, exaggerating for effect like a caricaturing cartoonist. He would paint a mature olive tree and emphasize its age by remorselessly twisting the trunk and disfiguring the branches until it looked like a gnarled old lady; wise but cruelly misshapen by time. He would then add those large clumps of oil paint to accentuate the effect, turning a two-dimensional picture into a 3-D epic: a painting into a sculpture. Van Gogh wrote to Theo, referring to a mutual friend who was questioning his move away from accurate representation: 'Tell Serret that I should be desperate if my figures were right . . . tell him

that I have a longing to make such incorrectness, such deviations, remodellings, changes in reality, so that they may become, well – lies, if you want – but truer than the literal truth.' And in so doing he inspired one of the most significant and enduring art movements of the twentieth century: Expressionism.

Of course, nothing comes out of nothing, even from Van Gogh's hyper-sensitive soul. Keith Christiansen of the Department of European Painting at the Metropolitan Museum of Art in New York had this to say: 'He made elongated, twisting forms, radical foreshortening, and unreal colors the very basis of his art. The difference was that he made these effects deeply expressive and not merely emblems of virtuosity.' He's talking about Van Gogh, right? Nope. He's talking about El Greco (1541–1614), who was distorting his images to communicate emotion 300 years before Van Gogh was born. The Spanish-domiciled, Cretan-born (hence El Greco, the Greek) Renaissance artist's fingerprints can be found throughout the story of modern art.

El Greco and Van Gogh shared several passions beyond art. Both were religious and disliked the materialism of their respective ages. Neither artist found launching his career very easy, and both had to move away from the country of their birth to find the inspiration and support they needed. But when it came to expressionistic painting there was a difference that sets them apart. El Greco's subjects tended to be mystical, aristocratic or religious, whereas Van Gogh was concerned with the more mundane aspects of modern life: cafés, trees, bedrooms and peasants. His expressionistic response to these everyday subjects, set firmly within his own experience, was the visionary formula for taking art into the future.

Although he died in 1890 largely unknown and unrecognized, Van Gogh's influence on modern art was almost immediate. Within three years the Norwegian artist Edvard Munch (1863–1944) painted his now famous *The Scream* (1893), a creation that owes much to Van Gogh. The Scandinavian artist had long wanted to make his paintings

more emotional, but couldn't work out how. It was on a visit to Paris in the late 1880s, where he saw the work of the Dutch Post-Impressionist, that he came to understand how his own artistic ambition could be achieved. Munch copied Van Gogh's method of 'warping' the image in *The Scream* to convey his deep inner emotions. The result is a picture that's the epitome of an expressionistic painting: the distorted horror on the figure's face, with its mix of terror and pleading, leaves the viewer in no doubt of the artist's anxiety-ridden view of the world. It is a prescient picture, perhaps even a modern *Mona Lisa*. Painted at the dawn of Modernism, it evokes future horrors and human unease at the prospect of a new age.

The motif of a human scream became central to the work of a more contemporary expressionistic artist: the great Irish painter Francis Bacon (1909–92). He often referred to a movie still that he kept, taken from Sergei Eisenstein's *Battleship Potemkin* (1925). It depicts a screaming nurse on the Odessa steps, with face bloodied and spectacles broken. The image helped inspire him to create one of the most important and valuable bodies of work in the second half of the twentieth century. No picture sums up the tortured pain Bacon spent his life trying to express better than his *Study after Velázquez's Portrait of Pope Innocent X* (1953). He was once dismissed by the British prime minister Margaret Thatcher as 'the artist who paints those horrible pictures'. He argued that it wasn't his pictures that were horrible but the world that politicians like her had created.

Francis Bacon didn't care for being called an Expressionist (he was), but he did care for Van Gogh. Passionately. Bacon once said that 'painting is the pattern of one's own nervous system being projected on canvas', words which could easily have fallen from the lips of Vincent van Gogh. In 1985 Bacon made a painting called *An Homage to Van Gogh*, an addition to the series of tributes to the Dutch genius he produced in 1956/7. They were based on Van Gogh's *The Painter on the Road to Tarascon* (1888). The original was destroyed during the war, but for Bacon it represented two important facets of his artistic

hero's work. The first was Van Gogh's painterly style and colourful palette: his Expressionism. The second was the romantic image that Bacon (along with most of us) felt compelled to create of Van Gogh: that of a penniless, unappreciated, sensitive genius, who forfeited all for art, making his own lonely way in the world: Modernism's first martyr.

Two years after painting *The Painter on the Road to Tarascon*, Van Gogh was dead. At just thirty-seven years old and in his creative prime, he died from wounds received when shooting himself in the chest two days earlier. By his side was his adoring younger brother, Theo. Within months Theo too was dead, having suffered a syphilis-induced mental and physical collapse. It brought to an end a decade-long partnership that produced some of the greatest art that has ever been – or will ever be – produced.

Not, though, in the mind of his old friend and tormentor, Paul Gauguin.

Paul Gauguin and Symbolism

'I am a great artist and I know it,' boasted Paul Gauguin. On another occasion he said that Van Gogh had 'profited from what I had to teach him. And every day he'd thank me for it.' Arrogant? I should say so. He was also a self-seeking plagiarist who left his wife and children to cavort with young girls in the South Seas, spreading his syphilitic poison in the process. He was a dandy, a bully, a cynic and a hard-drinking egotist. His one-time teacher and mentor Camille Pissarro called him 'a schemer', while reporting that Monet and Renoir found his work 'simply bad'. Even his friend the Swedish playwright August Strindberg told Gauguin, 'I cannot understand your art and I cannot like it.'

And how did Gauguin react to that last comment? He published it. Prominently. In a catalogue of his artworks. Because for all his faults – and I think we've established there were many – he was brave, physically

and artistically. It took courage to give up the life of a stockbroker who had collected the Impressionists' art, in an attempt to join their art gang. And not because of the financial risk. The stock market crash of 1882 saw to it that money would be no object to Gauguin, for when the young financier woke up the day after, he discovered he no longer had any. No, it was the risk of not being taken seriously as a painter by a group of artists he revered. Worse, the risk of being thought to lack artistic integrity: to be a charlatan who'd bought his way into a private club, like a rich man paying to perform with the Rolling Stones.

He was braver still when, in the late 1880s, he decided to challenge the Impressionists' strict adherence to naturalism, calling it an 'abominable error'. No wonder Monet and Renoir were unimpressed by his new 'everyday' paintings when they saw them. At first glance the two Impressionists might have thought the precocious Gauguin had followed their rules of choosing ordinary subjects and painting with spontaneous brushstrokes. But hang on a minute! Does nature really serve up such vivid oranges, or greens or blues? She does not. '*Mon dieu!*' Monet cried. 'This fellow is having a go at us.'

And he was. In the rational eyes of Monet and Renoir nature did not produce such colours, but she did in Gauguin's. Talking to another artist while standing in the Bois d'Amour in Brittany, Gauguin said, 'How do you see this tree . . . is it really green? Use green then, the most beautiful green on your palette. And the shadow, rather blue? Don't be afraid to paint it as blue as possible.' If his bright colours pointed to a departure from Impressionism, his subject matter confirmed that Gauguin had left the nest. His pictures were a Disney-distance from accurate representation, laden as they were with hidden meaning and symbolism. Vincent van Gogh, his partner in chromatics, had used heightened colour to express himself: Gauguin cranked up his painterly colour dial in the service of storytelling.

Vision After the Sermon, or Jacob Wrestling with the Angel (1888) (see Plate 6) is an early example of Gauguin in his Post-Impressionist

period. Unlike the modern-life paintings of Monet et al., this work by Gauguin is only partially set in the real world. The narrative basis for the work is a group of rural Breton women who are experiencing a holy vision shortly after hearing a sermon in church – the biblical tale of Jacob fighting an angel. The women stand in the foreground with their backs to the viewer, watching Jacob wrestle with God's messenger. They are realistically shown dressed in the ceremonial white headdresses and traditional black tunics of Breton peasants; nothing controversial about that. But there is when you realize that Gauguin has used such a sober palette in order to have some fun with the rest of the picture . . .

The artist has chosen a single, startling colour to describe the field in which the (gold) winged angel and Jacob struggle. In an attempt to reflect the religious reverie being experienced by the women he has painted the grass a livid orangey-red; a colour that dominates the composition like a screaming child in a library. Now Gauguin was in Brittany, northern France, when he painted *Vision After the Sermon*, a place where there are no bright orangey-red fields. His colour selection was made purely for symbolic and decorative purposes; Gauguin had elected to forfeit authenticity for theatrical allegory and design.

True, the subject of the painting is rooted in reality. It was not unusual for Bretons to gather round and enjoy a wrestling match between two young men. But the scene is exaggerated with the introduction of a biblical story, the layering of non-naturalistic colour, and an image rife with mythical allusion. Take, for example, the tree branch that runs diagonally across the picture, dividing it in two. It is highly unlikely that there was such a branch there in the first place, and even if there was, that it was in such a precise position. This is because it serves as a narrative device employed by Gauguin to separate the real world from fantasy. To the left of the tree is reality – a gathering of virtuous women – while to the right is the figment of their imagination: Jacob wrestling an angel. A disproportionately small cow can be seen on the left-hand 'realist' side, but Gauguin has the animal

standing on the fictional crimson grass, a combination that symbolizes the rustic ways of Breton life and the superstitious nature of those that live it. As for Jacob, well, he arguably represents Gauguin the artist, the angel his inner demons that are preventing him from fulfilling his own personal vision.

The American film director Frank Capra referenced this painting in his movie *It's a Wonderful Life* (1946). James Stewart plays George Bailey, a depressed, self-loathing businessman, who has come to the conclusion that he would be worth more to his wife and children if he were dead. He is on the verge of committing suicide, standing over a high bridge on a freezing winter's night, staring into the angry river below, when he sees another man fall into the swirling water. Instincts take over: the generous-spirited businessman forgets his own troubles and dives into the ice-cold river to save the life of another man, who, unbeknownst to George, is his guardian angel Clarence (Henry Travers). Cut to the next scene, in which George and Clarence are in a small wooden shack drying off. A washing-line cuts horizontally across the screen. Sitting down, below the line, is George struggling with all his earthly worries, while standing with his head above the line is the celestial presence of Clarence, dispensing wisdom from an imagined world.

The dreaminess of Gauguin's *Vision* would prefigure Surrealism. The modest nature of the Breton women's life is a precursor to the 'Primitivism' of Gauguin's Tahitian paintings, which inspired Pablo Picasso, Henri Matisse, Alberto Giacometti and Henri Rousseau. And the large flat areas of pure colour with all shadow eliminated – an idea Gauguin had appropriated, like many before him, from Japanese prints – would prefigure the expressive, symbolic ideas of Abstract Expressionism.

Vision After the Sermon contributed to Gauguin moving from being an amateur 'Sunday' painter into becoming a leader of the avant-garde. The art dealer Theo van Gogh had already shown an interest in his brother's friend; now he was convinced. He bought

some of Gauguin's existing paintings and committed to buying more in the future. By this time Gauguin was being seen within the broader Symbolist movement, which had started as a largely literary affair. The Symbolist writers were taken with Gauguin's diagonal branch, seeing it as an example in visual art of the allegorical motif. Instead of turning an object (the tree branch) into a subject (by painting it), he had taken something subjective (his idea) and turned it into the object (tree branch). Marvellous. Unless, of course, you happened to be from the 'tell it like it is' school of Impressionism.

Gauguin was unrepentant. He had come to the conclusion that the Impressionists lacked intellectual rigour; to him they were incapable of seeing beyond whatever reality happened to be in front of them. He thought that their rationalistic outlook on life denied art its most important ingredient: the imagination. His weariness with them didn't stop at their artistic outlook; he became tired of their principal subject: modern life. Like the reformed smoker who becomes an evangelical anti-smoker, Gauguin, the ex-money man, decided that materialism was evil. At first he went to the artists' colony in Pont-Aven, Brittany – it was cheap, he was broke – where he developed a taste for pretending he was a peasant. He wrote to his friend Émile Schuffenecker (1851–1934): 'I love Brittany. There is something wild and primitive about it. When my wooden clogs strike this granite ground, I hear the dull, muffled, powerful tone I see in my painting.'

Slightly pretentious perhaps, but he was on to something. He had done his time learning from others, such as the supportive Degas, from whom he took the idea of drawing a bold outline around his subjects, as well as the technique of dramatically cropping his images. He was now ready to establish his own bold, new aesthetic style. For Gauguin there was no such thing as half measures; so, if it was to be all change with a new approach to making art, then it would be all change in how he lived his life. He was off to Tahiti, to be 'a savage, a wolf in the woods without a collar'. He told Jules Huret from L'Echo de Paris: 'I am leaving to be at peace, to rid myself of the influence of

civilization. I only want to create art that is simple, very simple. To do that I need to renew myself in unspoiled nature, to see nothing but savages, to live as they do, with no other concern but to convey, as a child might, what my mind conceives, abetted only by primitive means of expression.' And, he might have added, to leave the wife and kids behind and live the high-life of a carefree bachelor.

Once in Tahiti, free from peer pressure and domestic troubles, he quickly found his artistic mojo. He produced a vast number of paintings inspired by the light, the locals and the legend of the Polynesian islands, the majority of which featured voluptuous young native women who were naked, semi-naked or wrapped only in a piece of patterned cloth. The pictures are erotic and exotic, colourful and simple: modern and primitive. Gauguin wanted to exist in and express a prehistoric, primal way of life, unfettered by the trappings and superficiality of the modern world. That he did so by using the most contemporary painting techniques is just another example of the contradictory nature of the artist, who discovered that the methods cultivated by the Parisian avant-garde actually aided him in his ambition to communicate the natives' unsophisticated naivety.

Making use of the two-dimensional block-colour system first explored by Manet and then taken forward by Degas gave Gauguin's pictures a flat, childlike quality. A callow characteristic that was amplified when he boosted, or completely falsified, natural colour; an expressive trick he and Van Gogh had experimented with when working together in Arles. The result was a series of stylized, decorative paintings that evoked a tranquil, tropical paradise, made by an artist who had gone native.

Except that Gauguin wasn't a native or a peasant. He was an artist on location – a tourist. The ex-banker from Paris was producing prurient pictures for a European market and a bourgeoisie that had developed a liking for idealized images of cultures exotic and primordial. He was a white, Western, middle-class, middle-aged man with a romanticized view of the South Sea islanders, and a highly developed

appreciation for the voluptuous bodies of the young Tahitian women.

Why Are You Angry? (No Te Aha Oe Riri), painted in 1896 on his second trip to Tahiti, is an archetypal Gauguin canvas from the period. There are no men for a start, which was usual, as was the setting, which is pleasantly pastoral. A palm tree in the middle distance divides the picture vertically. Behind it is a large thatched hut, around which a dusty earth path winds, the near edge of which gives on to a patch of lush green grass. Flowers, plants, pecking hens, roaming chicks, and some mountains in the far-off distance complete an alluring backdrop to the narrative action of the picture.

The painting features a cast of six native ladies. Three stand to the right of the tree, while the other three sit to its left. Of the three standing on the right, two are in the background preparing to enter the hut from the side. The first in line is young and attractive and has dropped the top of her dress to expose her breasts. The lady following her is much older and stoops as she cajoles the young woman to go inside. Also in the background, sitting on a stool to the left of the tree, is an old lady. She is wearing a white headscarf and a lilac dress and appears to be guarding the dark, imposing main entrance to the hut.

The suggestion that the hut is a brothel is made overt by the three young, nubile women in the foreground of the picture. The one to the right of the tree stands side on, dressed in a blue, lightly decorated sarong, superciliously peering down her nose at the other two, who are sitting together on the grass, to the left of the tree. The one furthest from the palm's trunk, to the edge of the picture, has her back to the viewer. She is dressed in a white singlet and a blue skirt; she appears to be whispering something to her friend, who sits facing the viewer. She is topless and coy, her eyes fixed on the ground to avoid the penetrating stare of the woman in the blue sarong. The body language between those two provides the title for the painting: an aggressive, accusative stance being counteracted with a sheepishly put enquiry.

The symbolism seems to be becoming clear. Those on the tree's right are yet to enter the hut and are therefore untainted by events going on

in its dark interior: they stand proud, with their honour intact. Not so the seated old woman looking on from behind – she is the brothel's madam – nor the two young women on the grass in the foreground. But who are the hidden customers? Tahitian men? Possibly. Gauguin? Probably. The colonizing forces from Europe? Certainly.

For while Gauguin was happy to trade off the innocence of Tahiti's native people, he also considered himself to be the islander's champion and advocate. And that is why the question posed in the painting's title is partly rhetorical. It is this scene, the one in which foreigners are 'raping' the island and its people, that makes Gauguin angry. The picture is a lament for an unspoilt way of life that he witnessed being rapidly corrupted and destroyed by his own countrymen. There is no doubt that his feelings were sincere, but as ever with this gifted, innovative and brilliant artist, they were also contradictory.

What he had, though – what all great artists have – was the ability to communicate ideas and feelings universal to us all in a unique way. To do that usually requires time for an individual's talent to develop before a signature style emerges that becomes recognizable. Once that is in place, when the artist has found his or her voice, a conversation can take place with the viewer; assumptions can start to be made, a relationship can develop. Gauguin achieved this benchmark in a remarkably short space of time, which is testament both to his ability and his intelligence.

You can spot a Gauguin canvas from a hundred paces. The rich palette of golden ochres, variegated greens, chocolate browns, bright pinks and oranges, reds and yellows, is contrasted and controlled with a sureness of touch that cannot be taught. His paintings, and his sculptures, are instantly attractive but also surprisingly complex. They are psychological dramas that expose the melancholy and trauma that torment his subjects – that torments us all. He rebelled against Impressionism and returned art to the realms of the imagination, for which generations of artists are thankful.

Seurat's Pointillism

Nowadays the word 'genius' is bandied around like a joint at a 1970s rock festival. A YouTube video of a baby biting his brother's finger is 'genius', as is the winner of *The X-Factor* and the iFart app. I'm not so sure they qualify, but I'm certain Jonathan Ive does. He is the man who has brought order and beauty to the Information Age in his role as Head of Design at Apple Inc. He has been responsible for the iMac, iPod, iPhone and iPad. And that, in my iBook, makes the British-born designer a genius. He has taken the world's least sexy products – computers and their hard drives – and turned them into objects of sweaty-palmed desire. That's some achievement. And how has Ive pulled off this feat of twenty-first-century magic? With simplicity.

That's not simplicity as in stupidity, or ease. The sort of simplicity that Jonathan Ive has brought to Apple products requires an in-built cranial hard-drive of several billion gigabytes and the perseverance of the clinically obsessed. Like the brevity of a Hemingway sentence, or the clarity of a Bach cello movement, his simplicity is the result of hours of work, days of thought and a lifetime of experience. He has – as those two geniuses did before him – achieved greatness by simplifying the complicated, by making sense of the inherent clutter and complexity of his subject, by unifying it into a design where form and function combine in aesthetic harmony.

It is the sort of simplicity that artists throughout the twentieth century would struggle to attain. As we will see later, the vertical and horizontal grids of Piet Mondrian's De Stijl movement (1917–31) and the 1960s minimalism of Donald Judd's rectangular sculptures are just two examples of a widespread preoccupation among the avant-garde: how to create order and solidity in the world through something as ambiguous as art?

It was a problem that also vexed Georges Seurat (1859–91), the third of the four Post-Impressionists. Here was a man who was as serious as Van Gogh but less emotional, and the very opposite of Gauguin,

the ebullient bon viveur. But although different in personality and background, the three were united in their determination to move art on from what they saw as the limitations of Impressionism. It's a great shame that one of the more striking traits the three artists shared was a propensity to die just as they were getting going. Gauguin did the best, making it to his mid-fifties. Next was Van Gogh, whose suicide aged thirty-seven devastated Seurat, who a year later was also dead. At just thirty-one years old, Seurat succumbed to suspected meningitis, which claimed his young son a fortnight later and his father shortly after that. His great friend and partner in Pointillism, Paul Signac (1863–1935), had a different diagnosis, saying, 'Our poor friend killed himself by overwork.'

And Seurat did work hard. Here was an artist who took himself, life and art very seriously. His father was a strange man who led a separate, secretive life away from his Paris-based family. He was not one for socializing. And it would appear that Georges had inherited some of his dad's quirks. He too was a highly secretive, antisocial individual who preferred his own company, hidden away from the throng of urban life. But for Georges, this was in order to take himself off to his studio. This was his true creative domain, not outside painting *en plein air*. He would make several preparatory sketches (he called them '*croutons*') *en plein air*, 'in front of the motif', but he would then make the main painting back at his studio.

Not for Seurat, then, the idea of popping outside and quickly knocking off a painting that would be finished by the time the first round of absinthe was ordered that evening. Unlike Monet he had little interest in capturing a fleeting moment; on the contrary, his aspiration was to capture timelessness. He wanted to take everything the Impressionist movement had taught him – brightly coloured palette, everyday subjects, the evocation of atmosphere – and give their ideas structure and solidity. For him the Impressionists were painting pictures that resembled a jumble of clothes carelessly thrown to the floor; he thought they should be folded into tidy piles. Seurat's aim was to

bring order and discipline to Impressionism: to take their innovations with colour and codify them, to bring more shape to their forms and scientific methodology to their objectivity.

Bathers at Asnières (1884) was his first major painting. It made quite a . . . splash. And not just because of its monumental size (2.01 by 3 metres), or Seurat's age – he was only twenty-four when he produced it. Set on a balmy summer's day, the atmospheric picture shows a group of working men and young boys, all of whom are in profile, relaxing by the river Seine. Two youngsters stand waist deep, cooling off in the water; the one nearest to the viewer is wearing a bright red bathing cap. An older boy sits watching on the bank, dangling his feet over the edge. Behind him, a man in a bowler hat lazes on his side, and further back still sits another gent surveying the river, with his head and eyes obscured by a larger panama. Sailing boats tack across the water in the distance and columns of industrial smoke bellow upwards from Paris's modern factories on the horizon. The restful, suburban tableau is mirrored by the serenity of Seurat's painting.

He painted the scene in a clear, figurative style, with none of the misty ambiguity found in the Impressionists' canvases. In Seurat's sparsely populated landscape the river and its banks have been turned into well-defined geometric shapes. Seurat's colours – the reds, greens, blues and whites – are just as vibrant as Monet's or Renoir's, but they have been applied with a machine-like precision.

Durand-Ruel took the picture to America as part of his highly successful 1886 exhibition, *Works in Oil and Pastel by the Impressionists of Paris*. It wasn't the most popular work on display. The *New York Times* described 'Bathing' [*sic*] as 'among the most distressing paintings shown . . . the blazing colors offering special offense'. Another American critic considered it the work of 'a vulgar, coarse and commonplace mind'. Now that was a bit harsh.

For someone so young to have his work shown alongside the revered and seasoned Impressionists was a remarkable achievement. As was *Bathers at Asnières*. It represents a starting-point on an artistic journey

that Seurat was undertaking, which would end with his famous Pointillist (also known as Divisionist) paintings, made from applying multiple dots of pure pigment to the canvas. At the time of *Bathers at Asnières* he had not yet arrived at his colour-separation technique, but he was well on the way. The white shirts, sails and buildings are all in the service of Seurat's overall design; they are there to bring to vivid life the colours around them, making the greens, blues and reds vibrant. He is beginning to work out that the more he separates the colours, the greater sense of brilliance they radiate. Hence the large canvas; it gave more room for his colours to 'breathe'.

Science was changing the lives of Parisians back in the 1880s, with Gustave Eiffel's extraordinary tower of iron symbolizing the city's completed transformation from a Dickensian shambles to a modern masterpiece built on mathematical precision. Seurat was simpatico with the prevailing mood; he too believed everything could be explained by science, even when it came to making art. He was a Delacroix fan, and shared the Romantic artist's interest in colour theory. But while Delacroix experimented through trial and error, Seurat's approach was more akin to that of a casting director. He wanted to know the character of the different colours in order to give him an understanding of how they would get along living side by side in the confines of a canvas. There was plenty of expert advice to hand.

Isaac Newton's book *Opticks* (1704) was (and still is) the standard starting-point for the student of colour theory. This is the one in which the great scientist explains how white light dispersed through a prism breaks down into a spectrum of seven colours. A hundred or so years later the German polymath Johann Wolfgang von Goethe published his take on the subject in a book called *Theory of Colours* (1810). And in 1839 a French chemist called Michel Eugène Chevreul wrote *The Laws of Simultaneous Colour Contrast*. Seurat studied them all and many others.

What modern art needed, he thought, was to combine the precision of the old masters with the Impressionists' study of colour and

modern life. Degas (who had nicknamed the conservatively dressed Seurat 'the notary') had the same idea but, as we know, came up with a different solution. Seurat's answer was to dispense with the improvised brushstrokes of the Impressionists and replace them with a series of meticulously applied dots of colour, which he would often select from opposite sides of the colour wheel (see Plate 8) to increase the vibrancy of both.

This was a trick he had learnt from reading all those books on colour theory. The idea being that although red and green sit opposite one another on the colour wheel, when placed adjacently on the canvas they become complementary, in that the red will appear redder, and the green will appear to be greener: they bring the best out in each other. Manet, Monet, Pissarro and Delacroix all knew this when they elected not to mix the contrasting colours on a palette, instead applying them directly to the canvas where they would touch each other unblended.

Seurat had his own theory. He had discovered that the contrasting colours (red and green, blue and yellow, and so on) could appear brighter still if they were slightly separated. The thinking being that when we look at a red or green or blue dot we don't just see the physical mark, we also see its colour glow around it. The optical illusion is heightened when the coloured dot is on a white background, which reflects rather than absorbs light. As is often the case when it comes to painting, Leonardo da Vinci was there first. When he was producing his masterpieces over 500 years ago he would start by applying a base layer of white paint, over which he would gradually add thin washes of colour to create his painting. The result when looking at the finished work is to see a picture that appears to have an uncanny inner luminosity, an effect caused by the light bouncing off the white undercoat.

Seurat had settled on his dotty vision. His small dabs of colour would not touch, nor would they be blended; that work could be undertaken by the viewer's eyes. He would add to the colour fest by

priming his canvas with a bright white paint, which would serve to increase the luminosity of the separated dots of pure pigment and give his paintings a shimmering, vibrating surface. And there was another bonus to the technique for the artist with a sense of order: its complexity demanded that Seurat simplified the shapes he was painting to an even greater degree. The effect was dazzling.

A *Sunday Afternoon on the Grande Jatte* (1884–6) (see Plate 7) is one of the most recognizable paintings in the world. It sees the beady-eyed Frenchman in his Pointillist prime, although he was still only in his mid-twenties. Again it is a huge canvas, measuring approximately 2 by 3 metres, allowing his meticulously applied dots to pulse in all their glorious colour. This is a much busier scene than *Bathers at Asnières* (Asnières is a suburb of Paris that is located just across the river Seine from the Grande Jatte). Here we have a cast of nearly fifty people, eight boats, three dogs, numerous trees and a monkey. The men, women and children in the picture have been arranged in a series of poses, the majority of which are in profile looking over the river. One woman, in a long orange dress and large straw hat, stands by the water's edge. She has her left hand resting on her hip, while her right hand is occupied holding a modest fishing rod. A handful of couples sit and talk; a little girl dances, a small dog leaps, while a sophisticated mother and her well-behaved young daughter walk absent-mindedly towards the viewer. Almost everyone is protected from the sun by a hat or a parasol or both. It is a beguiling, mesmerizing scene, but one not without complications.

The outcome of Seurat's Pointillism is interesting and unexpected. The image does indeed fizz like a glass of champagne as the contrasting spots of pure pigment sparkle before your eyes. But all those smartly dressed Parisians out for a pleasant Sunday stroll in the sun, whom Seurat has rendered dot by painstaking dot, do not. They are so still and lifeless that they appear to be no more than cardboard cut-outs. Seurat's masterpiece has a surreal spookiness about it that would make the filmmaker David Lynch smile.

A *Sunday Afternoon on the Grande Jatte* was shown at the eighth

and final Impressionist exhibition in 1886, a sign of how much the movement had changed. It is very much a Post-Impressionist painting. It has nothing of the Impressionists' 'fleeting moment'; it is more like a game of musical statues, where the characters have been frozen in time, holding forever their position when the music stopped. True, there's the use of the Impressionists' palette of primary colours, which Seurat has balanced perfectly to give the composition its sense of warm serenity. But there's nothing very impressionistic about the setting: it is not real or objective. Public parks such as this one in Paris are noisy places; people don't stand or sit in an orderly fashion looking sideways, with the occasional couple breaking ranks to walk forwards.

And although it depicts an archetypal late nineteenth-century modern scene of city life, the composition's harmony, the simple, repetitive geometric shapes and the block shadows all hark back to the Renaissance. The statuesque figures go even further back into art history, to classical antiquity and Egyptian friezes, where mythical scenes were carved in stone and mounted around a building or room. But then there is also something very 'now' about such a stylized image. The dots foreshadow our pixelated digital age; the geometrical harmony speaks to modern product design. There is something of Jonathan Ive about Georges Seurat's art.

As there is, albeit in a rather different way, about the paintings of the fourth and final Post-Impressionist. He was the oldest and crankiest of the bunch. The one who was there at the beginning of Impressionism, not at its tail end. The one who is – in my opinion – the greatest artist of the entire modern movement, the man Picasso called 'the father of us all'. Grasp the art of Paul Cézanne and the rest falls into place.

5
CÉZANNE: THE FATHER OF US ALL 1839–1906

'He was the first artist to paint using two eyes,' said David Hockney (b.1937). I smiled. The septuagenarian British artist has a refreshingly direct way of speaking about art. It is mid-January 2012, and we're discussing Paul Cézanne, the French Post-Impressionist painter, while walking around a show of Hockney's own work.

London was gearing up to host the Olympic Games that summer, and as part of the city's celebrations David Hockney had been given the vast spaces of the Royal Academy in Piccadilly to fill. A task he had completed by producing image upon image of the same subject: the hills, fields, trees and paths of East Yorkshire in the north of England. Now well into his seventies, he has refocused his attention on Britain's moody landscape having decided to leave behind the bright lights of Hollywood, where he has worked and lived for the past thirty years. The pictures – some oil paintings, others iPad printouts – are

fascinating and exciting. Fascinating because of the colours and shapes Hockney sees: paths are purple, trees trunks are orange, leaves become Technicolor teardrops. And exciting because it is the first time a recognized painter of Hockney's international standing has made a comprehensive attempt to re-imagine England's rural landscape in at least half a century.

I'll go further. Hockney's contemporary nature paintings are the most surprising, original and provocative landscapes produced since those painted over 100 years ago in France by the man who is the topic of our conversation, Paul Cézanne. And it is quite apparent that the British artist is greatly influenced by the Post-Impressionist, both in his art and in his mind. As we talked and then ambled around his exhibition, Hockney made several impassioned points about how images are made and perceived. They were his observations on observing, all of which can be traced back to the pioneering work of the man known as the 'Master of Aix'.

That was the nickname Cézanne was given by his contemporaries, after choosing to exchange the gaiety of Paris for nearly forty years of self-imposed isolation in the area around his family home in Aix-en-Provence in the south of France. Like Monet in Giverny, or Van Gogh in Arles, Cézanne became captivated by studying this particular landscape. Hockney has continued the tradition of total immersion by discovering his own inspiring location near to where he was born in Yorkshire: a special place in which he, like Cézanne, has spent years studying nature, light and colours, in an attempt better to understand how to represent what he sees and feels.

Maybe it's because of the time he has spent in Hollywood that Hockney feels so compelled to discuss the negative effects that he feels the camera has had on art. He directs a damning finger at the one-eyed monster in all its guises: photography, film and television. He believes it is the camera that has caused many of today's artists to forsake figurative art, having decided that a single mechanical lens can capture reality better than any painter or sculptor. 'But they're wrong,' he told

me. 'A camera cannot see what a human can see, there is always something missing.' If Cézanne were alive, he would have been nodding vigorously in agreement, pointing out that a photograph documents a split second in time that happens to have been caught on a camera. Whereas a landscape painting, portrait or still life might appear to be a moment immortalized in a single image, but it is in fact the culmination of days, weeks and in the case of many artists (Cézanne, Monet, Van Gogh, Gauguin and Hockney), years of looking at a single subject. It is the result of vast quantities of stored information, experience, jottings and spatial study that has eventually appeared in the colours, composition and atmosphere of a final finished artwork.

If ten people were to stand on a hill and take a photograph of the same view, using the same camera, the results would be near identical. If the same ten people sat down for a few days and painted that view, the results would be markedly different. Not because one individual might be a more accomplished artist than another, but owing to the nature of humans: we can all look at the same view, but we don't see quite the same thing. We bring our own unique mix of prejudices, experiences, tastes and knowledge to any given situation, informing how we interpret what is before us. We'll see the things we find interesting and ignore those that we don't. Given a farmyard to paint, one person might concentrate on the hens and another on the farmer's wife.

Given such a task, I'm fairly sure that Cézanne would have picked out a combination of static subjects: farm buildings, water trough, hay. That's because he preferred to paint entities that didn't move: motifs at which he could take a good long look, that afforded him the chance to have a proper think about what he was seeing. He was an artist determined to figure out how a painter could represent a subject with complete accuracy: not a fleeting moment like an Impressionist landscape, or the one-view-fits-all accuracy of a photograph, but accurate in the sense of it being a true reflection of a rigorously observed subject. It was an issue that tormented him. Asked what his

greatest aspiration was, he replied with just one word, 'Certainty.' The critic Barbara Rose got it right when she said that the old masters' starting-point was, 'This is what I see', whereas Cézanne's was, 'Is this what I see?'

Had this been the limit to his enquiries, Cézanne would have remained a part of the Impressionist movement to which he had belonged (his paintings were included in the first Impressionist exhibition in 1874). But the cantankerous Post-Impressionist chose to complicate matters further by also worrying about *how* he saw. He realized around 130 years ago that seeing is not believing: it is to question. It was a philosophical insight that links the end of the Enlightenment's Age of Reason with the twentieth century's Age of Modernism. And, in the recent work of David Hockney, to the art of the twenty-first century. It was the insight that would change the face of art. And like many flashes of genius, Cézanne's revelation is not only simple, but also staggeringly obvious.

We humans, Cézanne reasoned, have binocular vision: we have two eyes. What's more, our left and right eyes do not record identical visual information (although our brain amalgamates the two into one image). Each eye sees things slightly differently. Added to which, we have an inclination to fidget. When we examine an object we move about: we crane our neck, lean to the side, bend forwards, and raise ourselves up. And yet art was (and is) almost exclusively produced as if seen through a single, static lens. That, Cézanne deduced, was the problem with the art of his time and of the past: it failed to represent how we truly see, which is not from one perspective, but from at least two. The door to Modernism had been opened.

Cézanne tackled the issue head on by making paintings that presented a subject seen from two different angles (from the side and front, for instance). Take, for example, *Still Life with Apples and Peaches* (1905) (see Plate 9). It is typical of the hundreds of other still lifes he produced over his forty-year career, in which similar objects have been arranged in a comparable way and depicted by the artist in

his dual perspective style (or painting 'with both eyes' as Hockney put it).

In this particular picture he has placed several apples and peaches on the right-hand side of a small wooden table. Some have been stacked into a pyramidal structure on a plate, while others – positioned nearer the table's outer edge – are loose. An empty blue, yellow and white vase sits at the back of the table, behind the apples and peaches. Next to the fruit – covering the left two-thirds of the table's top – is a piece of draped cotton material (probably a curtain), on which a blue and muddy-yellow flowery pattern has been printed. The material is bunched up on the table, arranged to accentuate its deep folds and creases, in which one red apple nestles like a baseball in a catcher's glove. The cloth is weighed down by a cream-coloured jug at the back of the table, placed on the left-hand side, opposite the vase.

So far, so traditional. But then the artistic revolution begins. Cézanne has painted the jug from two different perspectives: one in profile at eye-level, the other from above looking down its neck. The same applies to the small wooden table, the top of which Cézanne has tilted towards the viewer by about twenty degrees in order to show more of the apples and peaches (also painted from two angles). If the rules of mathematical perspective as established in the Renaissance were applied, the fruit would be rolling off the table and tumbling to the floor. But perspective's loss was truth's gain. That is *how* we see. The view Cézanne is presenting is a composite of the differing angles we all enjoy when studying a scene. He is also trying to convey another truth about how we take in visual information. If we see twelve apples stacked up on a plate we do not 'read' what is in front of us as twelve individual apples, we register a single unit: a plate full of apples. Which meant, for Cézanne, that the overall design of the whole tableau was of more importance than the component parts.

The combination of looking at a subject from more than one angle while attempting to unify a design led to a flattening of the image. By tilting the table-top towards the viewer, Cézanne is increasing the

amount of visual information being provided at the expense of the illusion of three-dimensional space. So, having dispensed with the illusory 'box of air' in which to set his composition, he concentrated on presenting a holistic image. For Cézanne, the painting's individual elements and colours are like musical notes that he has painstakingly arranged to produce one harmonious sound: his every brushstroke leading to, and working in concert with, the next. It is an approach that requires a fair amount of planning.

Each apple, each fold in the material, is the result of a decision made during a period of meticulous preparation by an artist looking to create a rhythmical, rational composition. The colours of the objects and how they match, mirror and complement one another have all been carefully considered by a man who, like Seurat, was no slouch when it came to colour theory. He has applied unblended patches of warm and cool colours that sit side by side transmitting a quivering effervescence. Blue (cold) and yellow (warm) are diametrical opposites on the colour wheel, and in the wrong hands would present a horribly jarring image. But when applied with Cézanne's skill, a contrasting canvas emerges that radiates with a compelling richness. The two colours appear together throughout *Still Life with Apples and Peaches* in a series of echoes. There are the great swathes of blue and yellow patterned material, the delicate blue decorations on the vase against which the yellow apples lean; and then there are the small dabs of the same tone of blue that Cézanne has added to the table-top. These subtle marks complement not only the fruit, but also the table's front panel, the wood of which has been transformed into a warm yellow-brown by the gentle caress of a late summer sun.

He has then balanced this modern approach to colour with the traditional graduated tonality of the Grand Manner. The deep brown of the background wall blends with the lighter brown of the wooden table, which then mixes into the reds and yellows of the fruit, and finally, the creamy whites of the jug and vase. It is a supreme display of painterly control and chromatic sensitivity that serves to bind the

disparate elements into the desired cohesive whole: a harmonious image, with colours acting as chords.

Still Life with Apples and Peaches is a painting that demonstrates how Cézanne changed art for ever. His abandonment of traditional perspective in favour of a commitment to overall pictorial design and the introduction of binocular vision led directly to Cubism (where almost all illusion of three dimensions was abandoned in preference for maximizing visual information), Futurism, Constructivism and the decorative art of Matisse. But Cézanne wasn't done yet. His investigations into how we truly see led him to another discovery, which would eventually take painting into the revolutionary and highly contentious area of abstract art.

Cézanne had, like his fellow Post-Impressionists, eventually come to an impasse with Impressionism. Seurat had moved on because he yearned for discipline and structure. Van Gogh and Gauguin broke away because they felt restricted by the insistence on painting an objective reality. Cézanne, on the other hand, thought the Impressionists weren't being sufficiently objective. He thought they lacked rigorousness in their pursuit of realism. His concerns were not dissimilar to those held by Degas and Seurat, who felt that the paintings of Monet, Renoir, Morisot and Pissarro were slightly flimsy; that they lacked structure and a sense of solidity. Seurat, we know, looked to science to help him resolve the issue: Cézanne turned to nature.

He thought that all 'painters must devote themselves entirely to the study of nature'. Whatever the question, Cézanne believed that Mother Nature would provide the answer. His query for her was quite specific: how could he transform 'Impressionism into something more solid and enduring, like the art of the museums'? By which he meant combining the sense of seriousness and structure of the old masters' paintings with the Impressionists' commitment to sit in front of the motif, *en plein air*, and attempt to emulate real life on canvas authentically.

It was a task to which his character – one part conservative, one part revolutionary – was peculiarly well suited. He considered the

great Venetian painters like Titian to be superior to the Impressionists when it came to design, structure and form. But then he also thought that the work of Leonardo et al. was undermined by a lack of pictorial plausibility. In 1866, at the beginning of his apprenticeship with the Impressionists, he wrote to his childhood school-friend Émile Zola: 'I feel sure that all the paintings by the old masters representing subjects out-of-doors have only been done with skill because all that does not seem to me to have the true, and above all original, appearances provided by nature.' In other words, any painter with talent can fake a landscape, but accurately to represent nature on canvas is an altogether more testing endeavour.

'You know all pictures inside, in the studio, will never be as good as those done outside,' he proclaimed, before committing himself to a life in the open air at the mercy of the elements by concluding: '[In nature] I see superb things and I shall have to make up my mind only to do things out-of-doors.' Day after day, from dawn to dusk, he would sit before a mountain or the sea in his native Provence and paint what he saw. He thought the artist's task was to get 'to the heart of what is before you and express yourself as logically as possible'.

It turned out to be a bigger challenge than he had anticipated. Like a DIY dad taking on a minor household chore only to find himself knee-deep and helpless in unforeseen complications, Cézanne discovered that every time he overcame one problem associated with faithfully documenting nature, such as scale or perspective, he found that he had exposed a dozen more, such as misleading shapes or inaccurate compositions. The quest left him confused and exhausted and riddled with self-doubt. It's a wonder that he didn't end up in the same asylum as Van Gogh, which was just down the road from his home in Provence. But Cézanne was not cut from the same cloth as his Dutch colleague. As Zola wrote, 'He [Cézanne] is made of one single piece, obstinate and hard; nothing can bend him, nothing can wring a concession from him.'

It was a character trait his father discovered early on. Père Cézanne was a rich and successful man who knew a bit about getting on in the world. He didn't think his son's idea of being an artist was a very good one. It wasn't a proper job. After all, where were the tie, the smart three-piece suit, the polished shoes and the office with your name stencilled on the door? So he told the headstrong boy to become a lawyer. 'Non,' said Paul. Which seemed to do the trick, as his father (reluctantly) helped pay his son's way through art college and his formative years as an artist. But the relationship was always strained, a situation not helped by Cézanne omitting to tell his father that he had a mistress and a son. It wasn't until his father died in 1886, leaving Cézanne a large amount of money and the estate in Aix, that the artist finally found some peace and made Provence his home.

Mont Sainte-Victoire dominates the local landscape, a huge, brooding mountain that can be seen from miles around. Its immutability, its history, its sheer muscular presence had a magnetic effect on an equally obdurate artist looking to make pictures that had a sense of permanence. The way in which Cézanne chose to represent this treasured motif depended on his mood. While Van Gogh expressed his feeling for a subject through distortion, Cézanne did so through drawing and colour, as can be seen in his painting *Mont Sainte-Victoire* (*c*.1887) (see Plate 10), which is now owned by the Courtauld Gallery in London.

On this occasion Cézanne chose to paint the view from the west of Aix, near to his family home. A patchwork of green and golden fields (depicted from at least two angles) rolls towards the blue-pink mountain, which appears like a giant bruise on the landscape. The way Cézanne has depicted the mountain would suggest he was no more than a few fields from its base, when in fact it he was about thirteen kilometres away. This is what he means by expressing his own sensations through line and colour. He has not drawn Mont Sainte-Victoire in precise perspective, but has foreshortened the view to reflect that in

his mind and eyes it was the commanding feature. The cool palette with which he has then painted the mountain communicates its solid physical hardness against the softer, warmer colours of the fields.

Cézanne could see like a bat can hear: at a different frequency from the rest of us. He had solved some of the problems of accurately representing our visual perception with his dual-perspective technique, his harmonious compositions and his highlighting of specific, subjectively selected features. But he was still not satisfied. He told the young French artist Émile Bernard (1868–1941) that 'one must see nature as no one has seen it before you'.

Bernard had worked with Gauguin in Pont-Aven in Brittany, where the two artists had fallen out after Bernard made the (quite reasonable) allegation that Gauguin had stolen his ideas and style. But then he would have been the first to admit that he had not only taken Cézanne's advice but also copied his ideas, most obviously these words of wisdom from the usually taciturn artist: 'May I repeat what I told you . . . treat nature by means of the cylinder, the sphere, the cone.'

The point Cézanne is making, which he had discovered for himself when seeing 'nature as no one has seen it before', was that we don't really see detail when looking at a landscape, we see shapes. Cézanne started to reduce land, buildings, trees, mountains and even people to a series of geometric forms. A field would become a green rectangle, a house would be depicted as a brown cube box, and a large rock would take on the shape of a ball. You can see the technique in the Courtauld painting, which is really little more than a stack of shapes. It was a radical and revolutionary approach that had many traditional art lovers scratching their heads. Maurice Denis (1870–1943), a young French artist, tried to explain by saying that a painting could be judged on criteria other than the subject it depicts. He said, 'Remember that a painting, before it is a warhorse, a nude woman or some anecdote or other, is essentially a flat surface covered in colours arranged in a certain order.'

Twenty-five years later Cézanne's analytical approach to representation based around reducing visual details to geometric shapes would lead to its logical conclusion: total abstraction. Artists in Russia, Germany, Italy, France, Holland and eventually America (in the shape of the Abstract Expressionists) would start to make art that consisted of flat, monochromatic geometric planes: squares, circles, triangles and rhomboids. For some, the shapes were an allusion to the known world (a yellow circle for the sun, a blue rectangle for the sea or sky); for others the assembly of squares and triangles was nothing more than a formal design. In such cases the artist was asking for his or her work to be appraised on the basis of Maurice Denis's philosophical statement, above. It is quite astonishing to think that the hermit-like Cézanne, exiled in Aix, away from the avant-garde in Paris, would have such a profound effect on twentieth-century art. Even more surprising, then, to find out that Cézanne still wasn't finished.

There was one more logical progression that he felt was needed to achieve his aim of turning 'Impressionism into something more solid and enduring, like the art of the museums'. It was to take his idea of simplifying a landscape into groups of interconnecting shapes and move it one step further: to introduce something approaching a strict grid system. Or, as he put it rather more lyrically: 'The parallel to the horizon gives breadth, whether it is a section of nature or, if you prefer, of the show which Pater Omnipotens Aeterne Deus (omnipotent, eternal father God) spreads out before our eyes. Lines perpendicular to this horizon give depth.'

Again you can see the evidence of Cézanne putting his ideas into practice in the Courtauld's *Mont Sainte-Victoire*. He has built a structure of parallel horizontal lines, with the fields, the railway viaduct, the roofs of the houses, and at the point where the farmland ends and the foothills of the mountain begin. And then to give that sense of depth he has added an aggressively foreshortened and cropped tree trunk that runs from top to bottom on the left-hand side of the canvas. It works just as he said it would, by suggesting that the mountain

and fields are in the distance. You can prove his theory by removing the vertical tree trunk from sight (by placing an obscuring hand in front of it). Do so and you will experience the sense of three-dimensional space disappear. It completely changes how you 'read' the tree's branches, designed as a framing device by Cézanne. They still follow and echo the shape of the mountain's ridge, but with the tree trunk removed they appear to become part of the sky. And yet reintroduce the tree trunk and the branches form an imposing element of the foreshortened foreground, hovering, one imagines, just above the artist's head.

But there is one branch that sticks out halfway down the tree trunk that is unusual. Cézanne has used the leaves on the branch to merge background and foreground; to close a thirteen-kilometre gap by simply applying a few parallel, diagonal strokes of green paint. He has fused time and space by overlapping and integrating separate planes of colour in a technique known as 'passage' (a technique that led to Cubism). It is all part of his quest to produce canvases that reflect the 'harmony of nature' while being true to the way we see objects and space, which is neither from a fixed perspective nor without prior knowledge.

At the beginning of his journey into attempting to 'add a new link' to the art of the past, Cézanne inadvertently pushed the door to Modernism ajar. By the time he died it was swinging on its hinges. His ideas of grid-like structures and simplifying detail into geometric forms can be seen in the architecture of Le Corbusier, the angular designs of the Bauhaus, and the art of Piet Mondrian. It was the Dutchman who took Cézanne's ideas to the extreme with his famous De Stijl paintings, in which a grid of vertical and horizontal black lines with the occasional rectangle of primary colour was the entirety of the picture.

Cézanne died in October 1906 at the age of sixty-seven, from complications caused by a bout of pneumonia contracted after being caught in a rainstorm while out painting. A month before he had

written in a letter, 'Will I ever attain the end for which I have striven so much and so long?' The tone is desperate and frustrated and a mark of the man. His dedication to his art was total and unswerving. He had set himself intellectual and technical challenges that he clearly never felt he met, but in his determined efforts he had achieved more than any of his peers. By 1906 he had gained a near-mythical status. This was partly due to his self-imposed exile in Aix and a general lack of interest (and need) in selling his paintings (although when he did send them up to Paris they sold well). He had become the Cool Hand Luke of the Parisian avant-garde: the less he said the more he spoke to them. Many artists who would go on to be the famous names of their generation were already in his thrall, including Henri Matisse (1869–1954) and Pierre Bonnard (1867–1947). But few were more taken with him than a gifted young Spaniard called Pablo Picasso, who said, 'Cézanne was my one and only master! Of course I looked at his paintings . . . I spent years studying them.'

In 1907 the Salon d'Automne put on the Cézanne Memorial Exhibition. It was a sensation. Artists from around the world came to see the Master of Aix's life's work. Most stood in awe; many were overwhelmed, struck by how Cézanne had looked back to the old masters in order to help him move art forward. The exhibition had come at a time when several of the current crop of bright young artists were starting to become disillusioned with the superficiality of their modern world. Taking note of Cezanne's achievements, they began to mull over what could be learnt by looking even further back: to a time before modern civilization.

PRIMITIVISM 1880–1930 FAUVISM 1905–10: PRIMAL SCREAM

Primitivism runs through the story of modern art like the Thames through London. The term relates to modern Western paintings and sculptures that have copied – or appropriated – artefacts, carvings and images produced by ancient native cultures. It is laced with imperialistic connotations, a condescending term coined by enlightened 'civilized' Europeans to refer to the art of the uneducated and 'uncivilized' tribes of Africa, South America, Australia and the South Pacific.

The word presupposes a lack of evolution in these cultures and the art that they produce: a 2,000-year-old African wooden sculpture is indeterminable from one made last week – they are both deemed primitive. The irony that the modern version was probably produced for the tourist trade – a case of the canny 'primitives' exploiting the gullible Westerners – was probably lost on those who, early in the twentieth century, were enthusiastically trumpeting the values of these 'naive', unspoiled cultures peopled by noble savages.

The sentimental and idealized notion of the noble savage dates back to the Age of Enlightenment, which dawned towards the end of the seventeenth century. In modern art terms we know that Gauguin was an early-adopter. He was the one who left European decadence in 1891 to live among the natives of Tahiti, declaring that once there he would become a 'savage' and make art inspired by his 'primitive' surroundings (and, as it turned out, spread venereal disease). It was a back-to-basics policy that also informed the fin-de-siècle international decorative arts movement known variously as Art Nouveau (in France), Jugendstil (in Germany) and the Vienna Secession (in Austria). The artists and craftsmen involved made sensuous and curvaceous products and paintings that harked back to the elegance of ancient pottery and the simplicity of nature's motifs.

Gustav Klimt (1862–1918) is perhaps the best-known artist associated with this design-led movement, his painting *The Kiss* (1907–8) possibly its most famous image. The adoring couple in the picture could have been painted on to a cave wall, such is the two-dimensionality of the scene and its timeless quality. A man stands, head bowed towards the cheek of his kneeling lover, whose exposed feet nestle in a flower-covered meadow. They are wrapped in the golden glow emitted from their highly ornate clothes. He is wearing a full-length golden tunic decorated with an ancient mosaic pattern; she is attired in a golden dress adorned with geometric symbols that look like splendid prehistoric fossils. The background for what appears to be their ritualistic embrace is flat and bronze and perfect, as is the world they inhabit.

Klimt's painting certainly has the mystical air of Primitivism, but it is far more opulent and refined than the work that would be produced by Paris's modern artists who were similarly inspired by the distant past. While they shared many of the same ancient references, the Parisian artists had their own specific influences. The French had established a colony in West Africa, which had given rise to a flow of artefacts being brought back to Paris from the French traders who had travelled to Africa. They would return with all manner of 'exotic'

mementoes such as colourful textiles, carved figures and assorted items used in African village rituals. A particularly popular item, one which could be found in the city's bric-a-brac shops and ethnographic museum, was the carved African mask, an object that was to become an integral strand of modern art's DNA.

The young artists living in fin-de-siècle Paris thought that these carved totems achieved a simplicity and a directness that they could no longer attain, having had their own primal impulses trained out of them by their art colleges. They took a romantic view: 'native art' was produced by minds unsullied by materialistic Western culture, minds that could still access the inner child and create innocent, profoundly truthful works.

The artist Maurice de Vlaminck (1876–1958) is credited with setting the younger generation on this path. According to him, it began when he saw three African masks in a café in Argenteuil, a suburb to the north-west of Paris, in 1905. It had been a blisteringly hot day and the artist was on the lookout for a refreshing glass of wine as a reward after hours of painting *en plein air*. Whether or not the mixture of too much sun and too much alcohol had affected his state of mind is open to question, but the fact is that he saw these masks and was immediately struck by the expressive power of what he thought of as 'instinctive art'. After a good deal of haggling, he eventually purchased the masks from the café owner. He wrapped them up carefully and took them home to show a couple of friends he thought might share his fervour.

He was right. Henri Matisse and André Derain (1880–1954) were impressed. The three artists already shared an admiration for Van Gogh's vivid palette and Gauguin's primitive tastes. Now, when studying Vlaminck's African carvings, they could see that the masks had a freedom that their Western art did not. Their formal art training had taught them to reach for an idealized beauty, but these African artefacts made no attempt to do that – far from it; they often depicted malformations and were valued for their symbolism. What if the three Paris-based artists were to do the same? What if they were freed from

naturalistic depiction and instead made paintings that accentuated the inner characteristics of their subjects?

Within a short space of time, the conversation the masks provoked between them had motivated the three artists to take a new approach to painting that privileged colour and emotional expression over literal representation. That summer Matisse and Derain, old friends who had studied together in Paris, left the slightly irksome Vlaminck behind and headed off on a summer holiday to Collioure, in the south of France. There they discovered a sun so bright and colours so vivid that they were inspired to go into art-making overdrive, producing hundreds of paintings, sketches and sculptures. Their paintings were emotionally uninhibited and riotously colourful, blasting out an iridescent message that the world was a wonderful place. Derain's *Boats in the Port of Collioure* (1905) is typical of the pictures the two artists painted.

Natural colours, perspective and realism were all dispensed with, to capture what Derain felt was the essential character of the port. Instead of a golden stretch of beach strewn with small boats, Derain paints the sand a flaming red to signal the burning heat of its surface. He accentuates the rudimentarily built fishing boats by painting them with rough dabs of blue or orange. He makes no attempt to accurately record the far-off mountains, but simply dashes them off with a couple of brushstrokes of pink and brown paint to balance and frame his colourful composition. The sea is made up of short stabs of dark blue and grey-green paint, reminiscent of the early Impressionism of Monet or the Pointillism of Seurat, but with much less attention to detail: Derain's sea looks more like a mosaic floor. The result is an evocative picture that doesn't just show you Collioure, it lets you feel the place. The artist's message is clear: the port is hot, rustic, uncomplicated and picturesque. They were using colour like a poet uses words: to reveal the essence of a subject.

When Matisse and Derain returned to Paris they showed Vlaminck what they had been up to. Derain was nervous and unsure as to how the fiery Vlaminck might react, having witnessed the messy repercus-

sions of his friend's boisterous temperament when the two had spent time together during a stint in the army. Vlaminck took one look at the work produced by the holidaying artists and walked off. He went straight to his studio, picked up his easel, a canvas and some paints, and headed out.

A short while later he produced *Restaurant de la Machine à Bougival* (*c*.1905). The painting shows the fashionable village, west of Paris, on a sultry afternoon. It is deserted, presumably because the residents are in their houses, averting their eyes from the blinding scene outside. That is if they were seeing their village in the same way as Vlaminck. He has turned the colour-intensity dial up to maximum, transforming a tranquil environment into a tie-dye hallucination. In the artist's eyes, the streets of Bougival really were paved with gold (paint). Meanwhile, the pleasant village green has become a dazzling patchwork quilt of oranges, yellows and blues. The bark on the tree is not brown or grey as you might expect, but a kaleidoscopic mix of bright red, aquamarine blue and lime green. As for the houses that sit across from Vlaminck's yellow brick road, well, they have become simplified forms, their roofs shaped by simple strokes of turquoise blue paint, their façades rendered with splashes of white and pink.

The overall effect is like an ocular electric shock. Vlaminck has used unmixed paint directly from the tube to produce an image of extreme colour expressing his extreme sensations. He once said of his work during this period that he 'transposed into an orchestration of pure colour every single thing I felt . . . I translated what I saw instinctively, without any method, and conveyed truth, not so much artistically as humanely. I squeezed and ruined tubes of aquamarine and vermilion.' He did. *Restaurant de la Machine à Bougival* is a picture of real life, but not as most of us know it.

By the autumn the three artists thought that they had produced a sufficient number of good examples of their shockingly colourful work to enter into the 1905 Salon d'Automne. This was a new Salon

that had been established in 1903 in opposition to the Academy's increasingly out-of-touch annual exhibition, with the aim of providing avant-garde artists with an alternative place in which to show their work. Some of the Salon's hanging committee looked at their psychedelic offerings and advised against public display. But Matisse, an influential figure among the committee, insisted that not only would he and his two friends show their pictures, but they would also be hung in the same room so that the visitor could benefit from the full impact of their dazzling palette.

The response to their efforts was equivocal. Some were amused by the flamboyantly saturated colours, but most were unimpressed. The influential art critic Louis Vauxcelles, a man with conservative tastes, said disparagingly that the paintings were the work of Les Fauves (wild beasts). It was a comment of condemnation from a critic that was once again to provide the name and impetus of a new movement in modern art.

Derain, Matisse and Vlaminck had not set out to start a movement; they had no manifesto or political agenda. Their intention had been simply to explore the expressive territory uncovered by Van Gogh and Gauguin, and to try to tap into the same atavistic vein they felt was evident in Vlaminck's African artefacts. But then, in Vauxcelles's defence, their experiments had led them to develop a palette that would have appeared out of control and untamed to an art critic in 1905. His eyes would not have been used to seeing colour combinations that were consciously selected to jar in order to produce art that was as uncompromising and memorable as the tribal artefacts that were steadily taking over the artists' studios. To an art world still coming to terms with the Impressionists and Post-Impressionists, the heightened colour used by the Fauves must have seemed vulgar and garish in the extreme. About Matisse, however, there was nothing garish or vulgar at all.

He was a serious-minded, soberly dressed father of three, who still acted like the lawyer he had once been. The only 'wild' thing he had

ever done was to go against his father's wishes and give up the law for art. Other than that, he was as straight as an airport runway. He said that his ambition was to make art that was 'something a bit like a good armchair, which provides relaxation from physical fatigue'. That is not how the visitors to the 1905 Salon d'Automne felt about his work. It was one of Matisse's paintings that caused the most fuss. *Woman with a Hat* (1905) is a half-length portrait of his wife, Amélie, dressed in her Sunday best, peering over her shoulder and into the middle distance. We know the Impressionists and Post-Impressionists were all for informal paintings that evoked a mood, but even they would have drawn a line at Matisse's portrait. Matisse didn't. Draw a line, that is.

Woman with a Hat takes the prevailing spirit of nonconformity to new heights. It has such a loose bed of colours that it looks like a casual doodle on a well-used palette. Which, given that he was painting his wife, was approaching scandalous. He had started off conventionally enough, depicting his wife dressed in a chic, elegant outfit befitting a fashionable member of the French bourgeoisie. Her stylishly gloved arm is holding a fan, while her beautiful auburn hair is largely concealed under an elaborate hat. So far, so good. Madame M. would have been delighted. But she was not pleased when she saw the end result. Her husband has reduced her face to an African mask-like design, coloured in with sketchy brushstrokes of yellows and greens. Her hat looks like the work of a toddler attempting to paint a bowl full of tropical fruit, while her beautiful hair has been dashed off in a stroke or two of orange-red paint, as have her eyebrows and lips. As for her dress – well, Matisse has dispensed with that, and instead has her wearing something akin to a selection of clothes from a jumble sale: a mish-mash of casually applied riotous non-naturalistic colours. The background is almost non-existent, consisting of four or five loosely painted areas of colour. All in all, it could look to an uninitiated critic as if the work was knocked off in a hasty half-hour by a lowly decorator more accustomed to testing paint samples on a stripped wall than by a revered artist at the very top of his game.

Is it colourful? I should say so. Accurate? Not even a bit. When was the last time you saw someone with a green nose? Embarrassing for Madame Matisse? Very. Had Matisse treated a landscape in such a manner, it would have caused a fuss, but to portray a woman this way caused an outrage. To add insult to injury, when the artist was asked what his wife was really wearing, Matisse is said to have replied, 'Black, of course.' The painting is sketchier than an Impressionist work, more brightly coloured than a Van Gogh, and more flamboyant than Gauguin at his most effervescent. In fact, it most closely resembles the work of Cézanne. The way in which Matisse has structured his image, block of colour by block of colour, suggests that he had taken Cézanne's advice to paint what he really saw, and not what he had been taught to see. His vivacious colour-burst of painterly expression revealed the passion this reserved man felt for his wife.

After several days of dithering, *Woman with a Hat* was bought by an American expatriate called Leo Stein. He was one half of the formidable brother and sister double-act who had moved to Paris in 1903. Leo and Gertrude Stein's apartment on the Rue de Fleurus, in the fashionable Montparnasse area on the south side of the river Seine, became a central meeting-point for artists, poets, musicians and philosophers who either lived in, or were visiting, Paris. The regular 'salons' were *the* place to be and be seen. Leo was an art critic and collector, Gertrude a charismatic intellectual and writer. Together they had built an incredible collection of modern art and an influential network of friends. Their contribution to the story of modern art is significant. Not only were they prominent figures within the city's intelligentsia, they also acted as agitators to the artists in their circle. They spurred them on and backed up their words by purchasing their work – even when they didn't like it very much. As was the case with Matisse's *Woman with a Hat*, which Leo described as 'the nastiest smear of paint I had ever seen'.

In time he came around to the picture and the new approach being taken by Matisse. So much so that the following year he bought

another controversial work by the artist called *Le Bonheur de Vivre* (1905–6) (see Plate 11), also known as *Joy of Life*. The purchase demonstrates the Steins' belief in their artist friends, and in their own judgement. It is also an example of how an astute patron can play a crucial part in helping an artist to establish an important career, as was the case with Leonardo da Vinci in the fifteenth century, and more recently with Damien Hirst. Fortunately for the Steins, they had a large apartment in which to indulge their passion. *Le Bonheur de Vivre* is a capacious painting, measuring approximately 2.4 by 1.8 metres, which had to be squeezed in among all the other paintings they already owned by Cézanne, Renoir and Henri de Toulouse-Lautrec, as well as Matisse's *Woman with a Hat*.

Le Bonheur de Vivre was the quintessential Fauvist work. Matisse's starting-point is the pastoral scene, a long-established genre within traditional landscape painting. He has produced a picture of hedonistic delights – lovemaking, music, dancing, sunbathing, flower-picking and relaxing – which take place on a bright yellow beach dotted with orange and green trees. These bend gracefully to offer patches of shade over some cool purple-blue grass upon which lovers kiss and cuddle. The calm sea in the distance, which is the same extravagant colour as the grass, acts as a horizontal divide between the golden sand and the strangely pink sky.

The studies for this picture had been made on his recent visit to Collioure with Derain, but his references are a great deal older. They date back to the sixteenth century and a print by Agostino Carracci (1557–1602) called *Reciproco Amore*, which depicts an almost identical scene. Both pictures feature a group of joyous dancers in the near middle-distance, with a couple lounging in the foreground in front of them. Both have two lovers sitting in the shade at the bottom right-hand corner of the picture, and both are framed by overhanging tree branches that channel the eye into the very centre, towards a bright opening. Oh, and in both, nobody is wearing a stitch of clothing. The resemblance is remarkable.

Except that Matisse's version is a candy-coloured vision featuring crudely drawn, whimsical figures. It is a highly individual piece that sees Matisse coming into his prime, not only as a great colourist, but also as a master of design. The ease, the elegance and the flow of the lines he paints are a joy for the eye to trace. His ability to make a simple mark on canvas that makes an immediate and memorable connection with the viewer elevates him from the good painter to the great artist. The balancing effect of his contrasting shapes, and the coherence of his compositions, have been matched by very few artists in the history of painting. It just so happens that one of those rare talents who could stand comparison was living in Paris at exactly the same time.

Pablo Picasso (1881–1973) was a precocious young Spanish artist who had quickly made his mark on his first visit to Paris in 1900 when still a teenager. By 1906 he was a resident of the city, a star of the avant-garde, and a frequent visitor to the Steins' art-filled apartment. It was there that he saw Matisse's latest work and went as green as Madame Matisse's painted nose. The two men were outwardly polite to each other but inwardly voraciously competitive, and made it their business to keep a keen eye on the other's work. They privately recognized that it was going to be a straight fight between the two of them for the title of Greatest Living Artist, a title that had recently become available following Cézanne's death.

Pablo Picasso and Henri Matisse were not alike. Fernande Olivier, Picasso's lover and muse at the time, attributed to Matisse the remark that the two artists were 'as different as the North Pole is from the South Pole'. Picasso came from Spain's hot southern coast, Matisse from chilly northern France: each had the temperament to match his place of birth. Although Matisse was over a decade older, in professional terms he was the Spaniard's contemporary, as his early career as a lawyer meant he had made a late start to his life as an artist.

In her published memoir Fernande Olivier spells out the physical difference between the two artists. Matisse, she wrote, 'looked like a

grand old man of art', due to his 'regular features and his thick, golden beard'. She considered him 'serious and cautious', with an 'astonishing lucidity of mind'. Quite different from her boyfriend apparently, whom she described as 'small, dark, thick-set, worried and worrying, with gloomy, deep, penetrating eyes, which were curiously still'. She happily wrote that there was nothing 'especially attractive about him' before admitting that he had a 'radiance, an inner fire one sensed in him [that] gave him a sort of magnetism'.

When Picasso saw Matisse's Fauvist painting *Woman with a Hat* he responded with *Portrait of Gertrude Stein* (1905–6). The three-quarter-length portrait of the woman who was to become his chief advocate and willing customer is different in many ways. Picasso has used a palette of muted browns, not Matisse's vivid greens and reds. And it doesn't have the same feeling of spontaneity: it feels more solid, immutable. Seen together it seems odd that they were contemporaries. The attitude of the artists is so different. Matisse has made a work that suggests the speed and vibrancy of modern life, Picasso of the superstructure that supports it. Matisse's is a spur-of-the-moment outpouring of feeling, Picasso's a considered response. Matisse's is free jazz; Picasso's is a formal concert. Which is the opposite of what one would imagine.

The friendship both artists had developed with the Steins was to provide the catalyst for one of the greatest advances in modern art ever to take place. On one late autumnal day in 1906 Picasso dropped in at the Steins' for a drink. When he arrived he found that Matisse was already there. Picasso said hello and went to sit down opposite Matisse. As he leaned forward to talk to his fellow artist, he saw that the Fauvist painter was furtively clutching something on his lap. Picasso, sharp-eyed and quick-witted, was suspicious.

'What do you have there, Henri?' Picasso asked.

'Err, ah, hmm, n . . . nothing, really,' Matisse replied unconvincingly.

'Really?' queried Picasso.

'Well,' said the ex-lawyer, playing nervously with his glasses, 'it's just a silly sculpture.'

Picasso held out his hand like a schoolteacher confiscating a toy from a child. Matisse hesitated, then gave the object to him.

'Where did you find it?' murmured Picasso, transfixed.

Matisse, seeing the effect his object was having on the Spaniard, tried to play down its importance.

'Oh, I picked it up for a bit of fun from a curio stall on my way here.'

Picasso looked across the room. He knew his rival better than that. Matisse never did anything 'for a bit of fun'. Picasso did fun, Matisse didn't.

Several minutes passed as Picasso studied the wooden 'negro head' that Matisse had handed to him. Eventually he gave it back.

'It is reminiscent of Egyptian art, don't you think?' posited an intrigued Matisse.

Picasso got up and walked over to the window without answering.

'The lines and form,' Matisse continued, 'are similar to the art of the pharaohs, no?'

Picasso smiled, made his excuses, and left.

It wasn't his intention to be rude to Matisse; he was simply speechless – utterly spooked by what he had seen. For him the African sculpture was a fetish, a magical object designed to ward off unknown spirits. It had strange and dark powers that were unknowable and uncontrollable. The Spaniard was in a trance, induced by the object. He wasn't feeling cold and fearful, but hot and full of life. This, Picasso thought, is what art should feel like. After some persuasion from Derain, he knew what to do next.

He went to the ethnographic Musée du Trocadéro to look at their collection of African masks. When he arrived at the display he was disgusted by the smell and the lack of care given to the presentation. But once again he felt the power of the objects. 'I was all alone,' he said. 'I wanted to get away. But I didn't leave. I stayed. I stayed. I

understood something very important: something was happening to me.' He was frightened, believing that the artefacts were keeping mysterious and dangerous phantoms at bay. 'I looked at those fetishes, and I realized that I too was against everything. I too believe that everything is unknown and hostile,' Picasso said later.

There are many claims to 'big bang' moments in art, where the course of painting and sculpture supposedly dramatically and permanently changed. Well, it did in this instance. Picasso's meeting with the masks caused one of the most fundamental shifts of all. Within hours the artist had rethought a painting that he had been working on for some time. Much later he reflected that on seeing the masks 'he understood why he was a painter'. 'All alone,' he said, 'in that awful museum, the masks, the Red Indian dolls, the dusty mannequins, *Les Demoiselles d'Avignon* must have come to me that day, but not because of all the forms: but because it was my first canvas of exorcism – yes, absolutely!'

Les Demoiselles d'Avignon (1907) (see Plate 13) is *the* painting that led to Cubism, which in turn led to Futurism, abstract art and much, much more. To this day it continues to be regarded by many contemporary artists as the single most influential painting ever created. It is strange to think that it is a picture (one we will take a detailed look at in the following chapter on Cubism) that possibly wouldn't have existed had Picasso decided not to swing by the Steins' apartment that day in autumn 1906.

Yet while he enjoyed the Steins' hospitality and patronage, Picasso was just as happy entertaining at his studio in Montmartre. It was a basic space within a tenement block of artists' studios known as Le Bateau-Lavoir, meaning 'laundry-boat', a reference to the way in which the building creaked like a wooden ship in high winds. There he would throw parties for friends and host dinners to support and promote the careers of fellow artists. On occasion, he threw a banquet in honour of a particular favourite . . .

'*Merde!*' muttered a frustrated Picasso.

It was his own fault; he knew that, there was no point trying to blame anyone else. How could he have been so stupid? It was hardly a difficult thing to remember – the date of a dinner. Especially when you were the host! The small Spaniard with a growing reputation looked around his rickety studio for inspiration – a gift he normally had in abundance. But not today, on a dark November evening when the pressure was on and expectations were high.

In two hours' time the cream of Paris's avant-garde would walk up Montmartre's steep hill in the north of Paris and expect to be rewarded with a fine meal and a wild night. The poet Guillaume Apollinaire, writer Gertrude Stein and artist Georges Braque (1882–1963) were just a few of the names on an impressive guest-list. The expectation was that it was going to be a night to remember.

Picasso was the flamboyant artist and connoisseur who loved to conjure up an evening of haute cuisine and fine wines, washed down with absinthe and high jinks. But while the guests were at home getting ready, Picasso's plans were in disarray. He had given the wrong date to the food supplier, who, even after several minutes of pleading by the artist in distress, had refused to help him out of his predicament. Picasso had ordered the food for two days' time and that was two days too late. *Merde*, indeed.

But then again – so what? There was nothing Picasso and the rest of his young friends liked more than childish ineptitude and schoolboy pranks. Even if the night was a disaster it was sure to be a source of future amusement. They would recall the hilarious evening when Picasso's sixty-four-year-old guest of honour – the artist Henri Rousseau (1844–1910) – arrived expecting to find a red carpet leading to a banquet held in his name, but instead discovered that the event had been cancelled and all the guests had disappeared off to the Moulin Rouge down the road. Fortunately this didn't happen. Though the hopelessness of the younger generation would be a fitting tribute to a self-taught artist that the majority of the art establishment considered to be, well, hopeless.

Henri Rousseau was a simple, poorly educated man with an air of

innocent naivety. The Montmartre crowd gave him the nickname 'Le Douanier', meaning 'customs officer', referring to his job as a tax collector. Like most nicknames it had a loving, but mocking, undertone. The notion of Rousseau being an artist was faintly ridiculous. He had no training, no contacts, and had only taken up painting as a Sunday afternoon hobby when he was forty. What's more, he wasn't really the type. Artists tended to be bohemians, or academically minded individuals wishing to resolve formal artistic problems, or both. Rousseau was neither. He was an everyman: middle-aged, nondescript, and quietly living his humdrum life among the masses.

Forty-something oddball tax collectors don't become modern art superstars. Well, not very often. As it turned out, Rousseau was the Susan Boyle of his day. Remember how everybody thought the frumpy, greying Scottish singer was a joke: a misfit? And then she started to sing. At which point the cynics discovered that she had a great gift, which was not just a beautiful voice but also the ability to put over a song with honesty, a power that came from her own naivety. There might not have been an *X-Factor* in Rousseau's time, but there was an equivalent. The recently established Salon des Indépendants was a jury-less exhibition where all-comers were welcome to exhibit their work. In 1886 Rousseau took up the offer. By this time he was in his mid-forties and optimistically hoping to launch a new career as a bona fide artist.

It didn't go well. Rousseau was the laughing stock of the show. Critics and visitors sniggered while pouring scorn on his work, aghast that someone so inept should think his work worthy of public display. His painting of *Carnival Evening* (1886) came in for a dreadful bashing. The subject was just about okay: a young couple dressed in carnival costumes walk home across a ploughed field on a wintry night, lit by a full moon that hangs in the sky above a forest of leafless trees. But the unsophisticated way in which Rousseau had rendered the scene was unacceptable for a public brought up on Academy painting. They were still trying to digest the new ideas introduced by the Impressionists, and could not cope with the woefully amateurish

efforts presented by Le Douanier. They saw how the feet of the young couple hovered several inches above the ground, how Rousseau had failed to create a believable sense of perspective, and how the composition, as a whole, was hopelessly flat and awkward. It was an early instance of people saying, 'My five-year-old could have done that.'

But Rousseau's lack of technical skill and knowledge did make for a highly distinctive style: a cross between the kind of simplistic illustrations you see in a children's picture book, and the two-dimensional pictorial clarity of a Japanese woodblock print. It is a surprisingly potent combination that gives his paintings impact and individuality. A figure no less than the great Impressionist Camille Pissarro praised *Carnival Evening* for its 'precision of . . . values and richness of tones'.

Rousseau's guilelessness had the advantage of making him less susceptible to criticism. He believed that he was on to something from the moment he started his late-in-life career, and nothing could persuade him otherwise. So he did what architects do when faced with an ugly but immovable obstacle: he turned the problem – his naivety – into the main feature of his work.

By 1905 he had retired from his job as a tax inspector to dedicate himself to becoming an established artist. He entered his work *The Hungry Lion Throws Itself on the Antelope* (1905) (see Plate 12) into the prestigious Salon d'Automne. Technically it is still fairly inept. The antelope of the title looks more like a donkey; the supposedly fierce lion has all the viciousness of a glove puppet and the various creatures perching in the surrounding jungle watching the toothless action take place are straight out of an *I-Spy* book. It is one of several jungle-themed paintings that all follow the same pattern: centre stage is a predatory animal wrestling its unfortunate victim to the ground amid a lush jungle of exotic leaves, grasses and flowers. The sky is always blue; the sun – if in evidence – is either on its way up or down, but never casts light or shadow. None of the paintings in this series are remotely realistic or convincing, with good reason.

The likelihood of Rousseau having ever visited anywhere more exotic

than the local zoo in Paris is as remote as the places he said he had visited. Le Douanier was prone to fanciful ideas: he was a dreamer, a fantasist who was happy to perpetuate the story that these paintings were inspired by his time in Mexico, fighting with Napoleon III's men against the Emperor Maximilian. There is no evidence to suggest he ever saw action – or even left France for that matter. Which made him a laughing stock in the eyes of many. But for others, including Picasso, he was something of a hero. It wasn't his painterly ability; everyone was well aware that technically Rousseau didn't stand comparison with Leonardo, Velázquez or Rembrandt. But there was something about his stylized images that appealed to the Spaniard and his circle.

It was the callow innocence of Rousseau's paintings. Picasso, fascinated by the ancients and the occult, felt that Le Douanier's art went beyond portraying the natural world and entered the sphere of the super-natural. The young artist's suspicion was that Rousseau had a direct line to the netherworld; that his naivety gave him access to the core of what it is to be human buried deep within us all: a place of revelation that education had made inaccessible to most artists. Picasso's instincts would have been heightened by the circumstances in which he stumbled across *Portrait of a Woman* (1895), the Rousseau painting that would prove to be the catalyst for the banquet.

He did not find it in an upmarket art dealer's, or at a Salon, but by stumbling upon the painting in a junk shop on the Rue des Martyrs in Montmartre. It was being sold by the shop owner, a small-time art dealer, for the paltry sum of five francs, priced up not as an artwork, but as a second-hand canvas for an impoverished artist to re-use. Picasso bought the painting there and then and kept it with him for the rest of his life, recalling later that it 'took hold of me with the force of obsession . . . it is one of the most truthful French psychological portraits'.

If Rousseau had painted his *Portrait of a Woman* in 1925 and not 1895, it would have been ascribed as a Surrealist artwork, such is its dreamlike atmosphere, where normality is made to look strange. The

painting is a full-length portrait of a stern, middle-aged woman who stares coldly over the shoulder of the viewer. She is wearing a full-length black dress with a light blue lace collar and matching belt. Rousseau has her standing on the balcony of what would appear to be a bourgeois Parisian apartment, with a richly coloured curtain pulled aside to reveal window-boxes full of plants. Behind her, in the distance, are the fortifications of Paris, probably painted to mimic the background of Leonardo's *Mona Lisa* (Rousseau had access as a copyist to the Louvre, where the *Mona Lisa* is hung). Rousseau's woman holds a cutting from one of the pansies in her right hand, while her left hand rests on an upturned tree branch that supports her like a walking stick. A bird flies overhead in the middle distance (actually it looks as if it is about to fly straight into her temple, but that's Rousseau's lack of perspective for you).

Picasso gave the painting pride of place in his studio for Le Banquet Rousseau, removing his growing collection of African tribal artefacts to do so. That was a nice touch, but he was still without any food to feed the approaching army of avant-garders. As soon as Gertrude Stein arrived, he whisked her off into Montmartre on a last-minute food-shopping spree. Meanwhile, Fernande Olivier prepared a rice dish made with anything she could find in the kitchen, along with a plate of cold meats. As she frantically chopped and stirred, Picasso's compatriot and fellow artist Juan Gris (1887–1927) rushed to clear out his adjoining studio to make space for the guests to leave hats and coats.

The event had all the makings of a failure, but as things so often did when Picasso was involved, it turned out to be a legendary event. By the time Apollinaire arrived by taxi with a flattered but bemused Rousseau, the thirty or so other banqueters were seated and ready to welcome the guest of honour. Apollinaire knocked on the studio door with his usual theatrical flourish, then slowly pushed it open and gently ushered in the baffled Rousseau. The short, grey-haired painter stood agog as the hippest crowd in Paris cheered and clapped him to the studio's rotting rafters. With a mixture of pride and embarrassment, the painter of jungle scenes and suburban landscapes walked

up to the throne-like seat Picasso had prepared for him and sat down. He then removed his artist's beret from his head, placed the violin that he had been carrying down on the floor by his side and smiled more broadly than he had ever done before.

That, to some extent, the whole event was a gentle joke at his expense was entirely lost on Rousseau. Later that evening, with his lack of self-awareness even more diminished by alcohol, Le Douanier apparently went up to Picasso and told him that they were the two greatest painters of their time, 'you in the Egyptian style, I in the modern!'

Whatever Picasso's assessment of that particular comment, it didn't put him off increasing his collection of Rousseau paintings, which he found inspiring as well as pleasing. Picasso is said to have once mused that it took him four years to learn to paint like Raphael but a lifetime to learn to paint like a child. In this respect, Rousseau was his master.

Primitivism in Sculpture

The 'Customs Man' died in 1910. The Montmartre set, which had welcomed him into their fold as something of an amusement, were genuinely saddened by his passing. Apollinaire wrote an epitaph for his tombstone that read:

> Gentle Rousseau, you hear us,
> We salute you,
> Delaunay, his wife, Monsieur Queval and I;
> Let our luggage pass freely through the gates of heaven;
> We will bring you brushes, colours, canvases
> So that you can devote your sacred leisure in the real light
> To paint, as you drew my portrait,
> The face of the stars.

It was carved on to the stone by a sculptor called Constantin Brancusi (1876–1957), who had been one of the many attendees at the famous Banquet Rousseau. He, more than most, had an affinity for Rousseau's art and attitude.

Both men were outsiders. Rousseau, the Frenchman, was never fully accepted by the Parisian art establishment; Brancusi, a Romanian, was embraced by them, but chose to retain a certain detachment to protect his Balkan roots. The similarities didn't end there. Both artists were adept at wrapping themselves in self-mythology. Rousseau liked to talk of great overseas adventures that never were, while Brancusi presented himself as an impoverished peasant-craftsman who had undertaken an epic artistic pilgrimage by walking all the way from his rural home in the foothills of Romania's Carpathian mountains to Paris, the centre of the art world.

There were no marshals en route to confirm or deny the validity of Brancusi's claim, but we do know that he came from a family wealthy enough to send him to art college in Bucharest and give him land to fund his trip to France. There is also no doubt that he did come from rustic Romania. Or that the ramshackled wooden churches, which were dotted about in the hills where he lived, helped define the young boy's sense of beauty. Inside he would have seen crudely carved ornaments and listened to sermons derived from folklore, memories of which shaped him and his work.

With Gauguin long gone, Brancusi took up the mantle of artist-dressed-as-peasant. He wore clogs, smocks, white overalls, and sported a thick black (latterly grey) unkempt beard. Rough-hewn and unaffected was the rather contradictory message being transmitted by a man fully immersed in life in the world's most refined city. Still, it fitted with the mood of Primitivism at the time. As did Brancusi's art.

His talent as a sculptor was evident to the Parisian avant-garde from the moment the foot-sore Brancusi arrived in the French capital in 1904. Highly prized art college places were found for him, as were traineeships with established artists. One of these was with the august

Auguste Rodin (1840–1917), who as the father of modern sculpture had transformed the discipline from the classical output of past generations to works that were more impressionistic in nature. Brancusi, though, was frustrated. He felt that sculpture was still too literal and could be improved both in terms of aesthetics and production.

There had been some snide remarks made when people discovered that Rodin didn't actually make his own work. He would produce a model of what he wanted, but then hand it over to craftsmen to make it for him. Questions of authenticity and integrity were raised, despite the fact that artists as esteemed as Leonardo and Rubens had employed similar methods. This was conveniently forgotten as a moralizing art world furrowed their brows in Rodin's direction.

Brancusi's general position was clear: the end result is what matters, not the process of production. But his personal approach was hands-on. Unlike Rodin, he undertook his own work, and frequently removed the model-making stage by carving directly into his chosen material – stone or wood – to produce a sculpture. To do so was new, as was reverting to such 'low' materials instead of the more traditional methods of carving marble or making casts in bronze.

One of the many triumphs of Rodin's famous sculpture *The Kiss* (1901–4) (see Fig. 7) was its double illusion: a single hunk of marble that is at once the svelte bodies of two young lovers, while also being the rugged rock upon which they canoodle. When Brancusi produced his own *The Kiss* (1907–8) (see Fig. 8), he pulled off the same trick, but in a way that was far more modern yet much more archaic. He carved into a lump of stone (about 30 centimetres square) the shape of a couple kissing who appear as one entity. Unlike Rodin, Brancusi made no attempt to disguise the physical properties of the stone; in fact he purposely chose coarse stone for its rough surface. He then carved a basic representation of an amorous couple from the chest up. The composition is wonderfully simple. The two figures are sealed in a kiss, their arms embracing, their chunky-fingered hands wrapped behind one another's necks, gently pulling each other closer together.

If you saw the sculpture in a museum of tribal African art, or in some ancient ruins on the Nile, you would not consider it out of place.

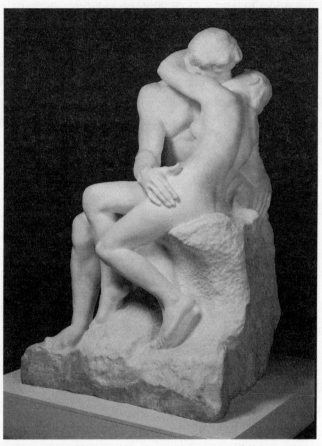

Fig. 7. **Auguste Rodin,** *The Kiss*, **1901–4**

But it was in Paris in the first decade of the twentieth century. Stone and not marble, unrefined 'direct' carving, not smooth beauty, and, to cap it all, an ordinary couple kissing, not a romantic meeting between two mythical figures. Brancusi was challenging convention by using lowly materials and portraying insignificant people. He was also set-

ting out a personal manifesto, which was to make sculpture with the humility of a craftsman, not the grandeur of a fine artist. To do so, he believed, would allow for a more honest relationship between artist,

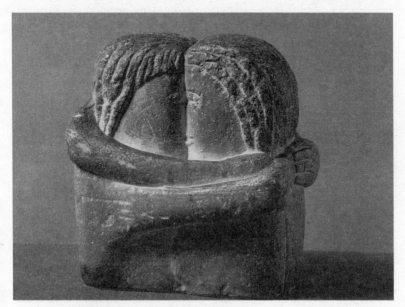

Fig. 8. **Constantin Brancusi,** *The Kiss,* **1907–8**

object and viewer. Abandoning model-making and carving directly into materials was, he said, 'the true road to sculpture'.

Brancusi made a series of life-sized stone and marble heads that variously resemble ancient Egyptian statues of sphinxes or kings, faces from African tribal art and even the strange expressions captured by medieval death masks. *Sleeping Muse 1* (1909–10), which he carved from marble, is an example where the essence of all three of these traditions seems to have been unified into a single object of perfection. Using the pure, cold white of the marble, Brancusi has delicately shaped a resting head lying serenely on its side. His *Sleeping Muse* has perfect skin, beautifully symmetrical features and elegant eyebrows that gently curve around the figure's resting eyelids. She is the ultimate sleeping beauty.

The Italian artist Amedeo Modigliani (1884–1920) was another man with a taste for the ancient and an eye for a sensual shape. When he moved to Paris in 1906 he devoured the art of Cézanne and Picasso, but it was not until 1909, when he met Brancusi and saw the Romanian's 'primitive' sculptures, that he put down his paintbrush and picked up a chisel. He spent the next few years devoting himself to making work in the style of Brancusi, mainly carving heads in limestone. Today Modigliani is best known for his decorative, sexy paintings of voluptuous nudes, whose protracted forms are reminiscent of a cartoon femme fatale. But it was with his *Head* sculptures that he found his style, which, if auction prices are anything to go by, continues to be popular. In 2010, *Head*, carved by Modigliani between 1910 and 1912, sold at Christie's in France for $52.6 million, breaking the then French auction record for the sale of a work of art.

But that was mere pocket money compared to the sale earlier in 2010 of another sculptor's work that had an element of Primitivism. Alberto Giacometti's (1901–66) *Walking Man 1* (1960) (see Fig. 9) sold for a staggering $104 million, a record at the time for any work of art to be sold at auction. Sotheby's – the auction house that sold the work – thought it might fetch $28 million if they were lucky. The price is a testament to the lasting power of Giacometti's expressive sculptures. His seemingly charred, frail *Walking Man* appears to be consumed by dread as he moves – bent slightly forward – towards an uncertain future. The stick-like figure, six feet tall, skeletal and emaciated, accentuates the vertical line, which, as Cézanne had pointed out half a century earlier, heightens the viewer's sense of spatial depth. In this case, it adds to the existential drama in which the isolated *Walking Man* is forever trapped: a prisoner of the modern world, starved of hope, and clothed only in an air of desolation.

Giacometti had moved to Paris early in his career. There he too discovered Brancusi's sculptures, which led him to follow the Romanian's interest in non-Western art. His attention was caught by the ritual spoons made by the African Dan tribe of the rainforests on the Ivory

Coast. These black wooden servers, or grain scoops, would often take the form of a woman's body, the shaft transformed into an elongated

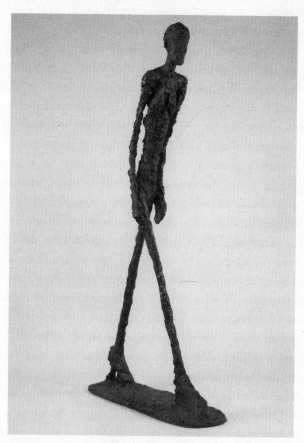

Fig. 9. **Alberto Giacometti,** *Walking Man 1,* **1960**

neck and head, the receptacle becoming the torso. In 1927, Giacometti made what is now recognized as his first major work, *Spoon Woman.* The bronze sculpture is clearly referencing the Dan's tribal spoons, but Giacometti has simplified the design and added a short tapering plinth at the bottom, which looks like a pair of skirt-swaddled legs.

This curiosity about the primitive and the associated desire to sim-
plify a sculpture's shape was not limited to artists living in Paris. In
England the sculptor Barbara Hepworth (1903–75) had been struck
from a young age by the prehistoric and the primitive. Her affection
for the art of the distant past had begun when her father drove her to
school across the untamed countryside found in the north of England.
The young Barbara was transfixed by the broad shoulders and shad-
owy recesses of the Yorkshire hills that rose up from the road and
commanded the landscape. However, the imaginative schoolgirl didn't
view the rain-soaked hills as a dark brooding menace, but as objects
of beauty: as sculptures.

After leaving school she went to art college in Leeds, where she met
a fellow student called Henry Moore (1898–1986), leading to a friend-
ship and shared artistic vision that would make a notable impact on
the world of sculpture. The two artists saw and felt the same primor-
dial power in the landscape of northern England: an affinity for large
rugged rocks that would go on to inform their work. They visited
Paris, became friendly with Picasso and Brancusi among others, and
started to incorporate some of the ideas they encountered on those
trips into their own work. The amalgamation of influences led to a
breakthrough in the early 1930s that opened sculpture to a new
dimension, when they introduced the idea of piercing a hole through
a three-dimensional artwork.

In 1931 Hepworth made an abstract alabaster sculpture – subse-
quently destroyed during the Second World War – called *Pierced Form*
(1931). The overall shape was rather like seeing someone trapped
inside a sack, through which a cannonball had been blasted. Moore
quickly followed Hepworth's innovation by declaring 1932 the 'year
of the hole'.

While Moore concentrated on figurative sculptures, which owed a
great debt both to Picasso and to primitive art, Hepworth pursued an
abstract path. Her smooth, rounded works focused on the material of
the sculpture and the space around (and through) it. She made several

two-tone painted wooden pieces – such as *Pelagos* (1946) – that are about the size of a small boulder, through which she had carved a hole, and then added some guitar-like strings to create a sense of tension in the piece (an idea first introduced by Vladimir Tatlin, the Russian Constructivist, whom we will come to in Chapter 10). *Pelagos* is entirely abstract, but its smooth surface, gentle hollow, and pleasing shape provoke a very tangible feeling of harmony and beauty.

In 1961 Hepworth was commissioned by the United Nations to produce a sculpture that would act as a symbol of peace to stand in the United Nations Plaza in New York. Her response was a bronze sculpture 6.5 metres high called *Single Form* (1961–4): a ship's sail design that she had made out of wood on a much smaller scale in 1937. In the original version she carved a concave dimple in the top corner of the sculpture, but in the UN piece she made a large round hole, through which the light of the world could shine.

When Barbara Hepworth was seven years old, her school headmistress gave a lecture on the art of the ancient Egyptians. It changed the young girl's life. She said later that it 'fired her off', and from then on the world was all about 'forms, shapes and textures'. Picasso, Matisse, Rousseau, Brancusi, Modigliani, Giacometti, Moore and many, many others have fallen under the spell of tribal and ancient art. They have been attracted by its unfettered directness and the emotive power of the simplified shape. It anchored those modern artists to a story as old as Man, and their art to the past as well as to the future.

7

CUBISM:
ANOTHER POINT
OF VIEW
1907–14

uillaume Apollinaire, the Italian-born French poet, play-
wright and champion of the artistic avant-garde, did not
always land his literary punches. His intellect made him sus-
ceptible to rhetorical showboating: an over-willingness to provide an
on-the-spot interpretive *bon mot* about modern art, which often con-
fused rather than clarified. But on occasion, his gift for language
enabled him to get to the heart of an artwork or an artist in a way few
others could.

Nobody has equalled Apollinaire's astute observation regarding
the true nature of Cubism, an art movement that can often appear
difficult to the point of being impenetrable. Speaking of his friend
Pablo Picasso, the co-founder of the movement, Apollinaire said,
'Picasso studies an object the way a surgeon dissects a corpse.' Which
is the very essence of Cubism: taking a subject and deconstructing it
through intense analytical observation.

It was an approach to making art that even the progressive Apollinaire took a while to appreciate. His first encounter came when he visited Picasso's studio in 1907. The Spaniard had invited the poet over to see his latest work in progress, for which he had made over 100 preparatory sketches. Almost complete, it was the culmination of Picasso's ambition to combine a vast array of artistic influences with his own pressing concerns, such as reasserting the pre-eminence of the drawn line that had been abandoned by the Impressionists. But when a proud Picasso showed his trusted friend his new painting, *Les Demoiselles d'Avignon* (see Plate 13), Apollinaire responded with shock and bewilderment. The writer found himself confronted by five naked women staring out from a giant canvas 2.5 metres square, their crudely painted bodies marked out from the palette of browns, blues and pinks by a series of razor-sharp angular lines applied in a way that shattered the image like a broken mirror. Apollinaire thought the painting would do the same for Picasso's career. He couldn't understand it. Why did Picasso feel the need to move away from the elegant and atmospheric figurative painting that had proved so popular with collectors and critics, to a style that appeared not only too primitive but too severe?

The answer lay to some extent in Picasso's competitive nature. He was shaken by the professional threat Matisse posed to his position as the most exciting up-and-coming artist of the day, a latent concern that had been turned into a real fear when the Fauvist painter produced *Le Bonheur de Vivre* in 1906. But he was also stirred by Cézanne's Memorial Exhibition, which had taken place earlier in 1907. It had left him inspired and determined to continue the Master of Aix's line of enquiry into perspective and ways of seeing.

Which he did to incredible effect in *Les Demoiselles d'Avignon*, a painting that built on Cézanne's ideas and led to a new art movement. There is little sense of spatial depth in Picasso's picture. Instead, the five women are two-dimensional approximations, their human bodies reduced to a series of triangular and diamond shapes that could have

been cut from a piece of terracotta-pink paper. Details have been simplified to the extreme: a breast, a nose, a mouth or an arm consists of little more than a short angular line or two (in much the same way that Cézanne would depict a field). There is no attempt to mimic reality – the two women on the right of this macabre, grotesque group have had their heads replaced by African masks; the woman on the far left has been turned into an ancient Egyptian statue; while the two central figures are little more than stylized caricatures. All their facial features have been rearranged as a multi-angle composite: their elliptical eyes misaligned, their mouths contorted.

The painting induces a feeling of claustrophobia in the viewer, due to Picasso's dramatic foreshortening of the background. We do not experience the traditional illusion of the image receding into the distance; instead the women aggressively jump out from the canvas like a scene frozen in a 3-D movie. This was the artist's intention. Because these women are actually propositioning prostitutes who have lined up in a 'parade' for you, the client, to make your selection. The *Avignon* in the title refers to a street in Barcelona known for its prostitutes (not the picturesque town in southern France). At their feet is a bowl of ripened fruit, a metaphor for the human delights on offer.

Picasso called it an 'exorcism painting'. In part this was because *Les Demoiselles* expunged some of his own artistic past and therefore represented a bold new direction, but he was also alluding to the stark messages contained within the picture, which were about the dangers of instant gratification and sleeping with prostitutes. They were temptations that some of his friends had paid for twice: once with their money and later with their lives. It is a dark warning of the perils of venereal disease, which was rampant in the artistic bohemia of fin-de-siècle Paris (it had already accounted for Manet and Gauguin). In his early preparatory sketches there was a cast of seven: the five prostitutes plus two men – a sailor (the client) and a medical student holding a skull (a symbol of death). Picasso's original intention was perhaps for a more obviously moralizing picture, demonstrating the 'wages of

sin'. But he found that removing narrative elements from the composition increased its visual power.

While Picasso was competing with Matisse, and evolving the work of Cézanne, he was also plundering art history's back catalogue for ideas. He has been widely quoted as saying that 'bad artists copy, great artists steal', which is an approach to art-making that we would call Postmodern nowadays. But back then it was a pithy one-liner that could reasonably be employed when comparing his 1907 proto-Cubist painting with the Spanish artist El Greco's Renaissance masterpiece, *The Opening of the Fifth Seal* (1608–14) (see Fig. 10), which Picasso had studied at length.

The Opening of the Fifth Seal is based on a biblical story in the Book of Revelation (6:9–11), in which those who had died doing the work of God were offered salvation. The blue cloak being worn by Saint John the Baptist, who can be seen pleading to the heavens with his arms aloft in the foreground, is a similar colour to the background curtain in *Les Demoiselles*. As is Picasso's rendering of the cloth, which would appear to owe much to El Greco's use of white paint, sharp lines and dramatic shading to make the creases and folds appear deep and rich. The three graces that stand naked in the centre of El Greco's picture are directly referenced on Picasso's canvas, even to the extent of portraying one of the figures in profile facing the other two. And the painting's tense, dark apocalyptic sky would not have gone unnoticed by a young artist attempting to evoke a similarly intense atmosphere.

Art historians have had over a century to scratch their chins and ponder *Les Demoiselles*: to draw the parallels and identify the influences. Hindsight was not an option for an unprepared Apollinaire. He wasn't to know that avant-garde artists working in the twenty-first century would be citing Picasso's 1907 painting as one of the most important works ever to have been produced. Or that within a year it would lead to Cubism. The poet had to judge what was before him, which was staggeringly and incomprehensibly different. His negative reaction to it was not unique. Even Matisse laughed at Picasso, and

then became angry, suspicious that the Spaniard was trying to destroy modern art.

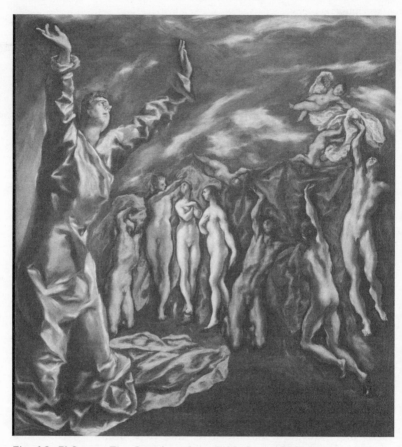

Fig. 10. **El Greco,** *The Opening of the Fifth Seal,* **1608–14**

Having heard the unfavourable opinions of his friends, Picasso stopped work on the painting, although he considered it unfinished. He rolled the canvas up and placed it at the back of his studio, where it remained for a very long time, gathering dust. It was eventually bought sight unseen by a collector in 1924, but even then it was largely kept out of view and rarely exhibited until the late 1930s, when it was

purchased by MoMA. The poor reaction to the painting was such that André Derain said that 'one day we shall find Picasso has hanged himself behind his great canvas'. Even the painter Georges Braque, who, like Picasso, had gone to Cézanne's posthumous show and been transformed and transfixed, could not see what the Spaniard was trying to achieve. But unlike the others, who came and saw and sniggered and then left, Braque returned a little while later to offer Picasso his thoughts and help.

In what he would describe as an artistic odyssey comparable to 'two mountaineers roped together', and that Picasso referred to as a 'marriage', the two young artists formed an intimate creative partnership out of which Cubism emerged. It was a partnership whose output would define the visual arts of the twentieth century, leading to the Modernist aesthetic of stripped pine floors and Anglepoise lamps. It was a partnership that began in 1908 and ended with the unwelcome arrival of the First World War.

Extraordinary, then, that they may never have reached the required momentum to force such a great change in art had it not been for the help of a visionary entrepreneur called Daniel-Henry Kahnweiler. The German-born businessman started out as a stockbroker in London, but found he had too much soul to be sated by a life in finance. He moved to Paris to try his luck as an art dealer, and soon visited Picasso's studio, where he saw *Les Demoiselles*. Unlike the others, Kahnweiler thought the picture magnificent and wanted to buy it immediately. Picasso demurred, so Kahnweiler instead undertook to give Picasso the money he needed to continue his artistic research and promised to buy his work as and when it emerged. When Braque joined forces with Picasso a little while later, Kahnweiler extended the deal to him (although on less generous terms). With their financial worries looked after, the two artists were free to take risks without fear of rejection by the establishment.

Their starting-point, as with *Les Demoiselles*, was Cézanne, whose innovations both artists had already been investigating. Braque, the

ex-Fauve, would often paint *en plein air* in L'Estaque, a small town near Marseilles that he chose because it had also been one of Cézanne's favourite places to paint. There he produced pictures that used Cézanne's techniques and his palette of greens and browns. But Braque's paintings were noticeably different. Take, for example, *Houses at L'Estaque* (1908), which is typical of those he produced on the trip. Braque has depicted a hillside scene dominated by houses, interspersed with the occasional tree and bush. He has done so as if pulling focus on a camera: by zooming in on a specific area, intensifying the view and eradicating depth of field. Elements one would expect to find in a landscape, such as the sky or the horizon, have been jettisoned in order to accommodate the artist's preference for an 'all-over' design.

This was Cézanne's objective too, but whereas Cézanne might bring background subjects further forward, Braque foregrounded the lot. Everything was brought to the front, like passengers thrown against a car window when the driver slams on the brakes. His hillside houses clamber on top of one another, but they have no windows, or doors, or gardens or chimneys. Detail has been sacrificed to concentrate on the composition, and on how the individual parts relate to each other. Like the work of Cézanne, only more extreme, the landscape has been simplified into geometric shapes: luxury real estate has morphed into a series of light brown cubes, with small patches of darker brown paint to suggest shadow and depth. The occasional patch of green shrub or tree gives the eye a rest from the boxy monotony, as one cuboid overlaps with another.

When Braque entered some of his L'Estaque works to the 1908 Salon d'Automne for consideration, the selection committee first rejected them and then scoffed. Matisse, who was one of the jurors, said sniffily that 'Braque has just sent a picture made up of small cubes.' The comment was made to Louis Vauxcelles, the man who had (sarcastically) coined the term 'Fauve' to describe Matisse's earlier work. And, as so often is the way with these things, that was that – the name stuck: Cubism was born.

Well, the name was, but the movement hadn't really started. Which is a shame, because the term adds a further complication to an already complicated art movement. Cubism might reasonably describe some of the Cézanne-influenced paintings Braque produced at L'Estaque in 1908, but it completely fails to reflect the nature of the pioneering work he and Picasso undertook from that autumn onwards. The term is a misnomer: there are no cubes in Cubism – quite the opposite.

Cubism is about acknowledging the two-dimensional nature of the canvas and categorically NOT about trying to re-create the illusion of three dimensions (a cube, for example). To paint a cube requires the artist to look at an object from a single perspective point, whereas Braque and Picasso were now looking at an object from every conceivable angle.

Think of a cardboard box. Braque and Picasso were metaphorically pulling it apart and opening it out to make a flat-plan: showing us all sides at once. But they also wanted to reflect a sense of the box's three-dimensionality on canvas, which a flat-plan does not. So they took an imaginary walk around the box and chose the views they felt best described the object before them. They would then paint and rearrange these 'views' or 'pieces' on the canvas in a series of interlocking flat planes. The order was a rough approximation of the box's original three-dimensional shape, so that it was still discernible as a cube but laid out in two dimensions. This way, they believed, their compositions would elicit in the viewer a much stronger feeling of recognition about the true nature of the box (or whatever the subject might be). It was about stirring our brains into action and prompting us to pay some attention to the everyday and the overlooked.

It was also about presenting a more accurate picture of how we really observe an object. Which is a concept we can put to the test by looking at Georges Braque's *Violin and Palette* (1909) (see Fig. 11). He produced the painting a year into his partnership with Picasso, during the first phase of Cubism, known as Analytical Cubism (1908–11) – named as such because of their obsessive analysing of a subject and the space it occupies.

Compositionally, *Violin and Palette* is a simple picture. A violin dominates the bottom two-thirds of the canvas, sitting beneath some

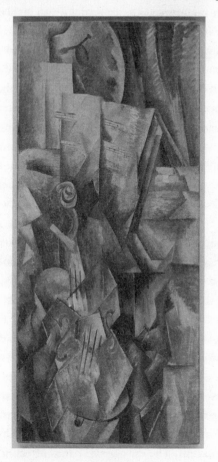

Fig. 11. **Georges Braque,** *Violin and Palette,* **1909**

sheet music that rests on a stand. Above that is a painter's palette hanging from a nail in the wall, to the side of which is a green curtain. Braque has continued with Cézanne's subdued palette of pale browns and greens. Not this time, though, as an homage, but out of necessity. He realized, as did Picasso, that only by using a muted palette could

he successfully blend multiple viewpoints of the same subject on a single canvas – a variety of bright colours would be impossible to configure for the artist and would present us with an indecipherable mess. Instead, they devised a technique where a straight line would mark a change of view, while subtle tonal shading would demonstrate to the viewer that a transition was taking place. The added benefit of this approach was an overall design that was balanced and coherent.

This is an important aspect of Cubism. For the first time, art was being produced whereby the canvas was no longer pretending to be a window – an instrument of illusion – but was being presented as an object itself. Picasso called it 'pure painting', meaning that the viewer was to judge the picture on the quality of the design (colour, line and form), and not on the quality of an illusory deception. The most important thing now was the lyrical and rhythmic pleasure to be enjoyed by the eye as it roamed the angular shapes laid out before it on the canvas.

Of which there are many in Braque's *Violin and Palette*. He has deconstructed the violin into several pieces and then reassembled it in loosely the correct shape, with each element depicting a different viewpoint. The violin can now be seen from both sides, from above, even from underneath: all at the same time. This is not the sort of straightforward representation a camera could produce, or the mimicry of previous art, but a totally new way of portraying and seeing the musical instrument. Braque has brought a static object alive. To me, it feels as if music really is being played from its shuddering edges and arrow-like strings. The enveloping pages of the score add to the sense of performance, as they dance off the stand and concertina out, following the rectangular shoulder of the violin.

So far, so good. But then Braque does something totally out of keeping with the rest of the picture. The nail in the wall from which the palette hangs has been painted in a naturalistic manner using traditional perspective. The back wall, which blended in with the sheets of music as part of the two-dimensional canvas, now becomes part of

traditional three-dimensional trickery. Why? What is going on? Has Braque lost his confidence? Is it a joke?

No. Picasso was the joker, not Braque. The French artist was simply trying to solve another problem. He was concerned that his painting had become a hermetically sealed unit, cut off from reality, existing in its own interior world. He figured that by adding an element of the 'real world' he could anchor the image in our mind by tapping into our visual memory bank and encouraging us to look at the picture more intently: it was what supermarkets call a 'loss leader' – a way of enticing us into the picture. The addition of the illusory nail was not a sign of defeat, an admission that the old-fashioned window-on-the world role of the canvas was better. Not a bit of it, he was using the classical technique to highlight the radical newness of his own approach. Just as colours that oppose each other on the colour wheel bring the best out in each other when placed side by side, so Braque was stressing Cubism's new way of seeing by the introduction of traditional perspective.

It was a new view of the world that reflected on, and responded to, recent groundbreaking developments in science and technology. In 1905 the precocious young German-born, Swiss-domiciled scientist Albert Einstein came up with his Theory of Relativity. Both Braque and Picasso were aware of this revolutionary work as well as Einstein's conclusions regarding the relative nature of time and space. Like many of their friends, the artists would enjoy long and animated conversations about the concept of a fourth dimension, and would happily discuss the ramifications arising from other scientific discoveries. Not least, the realization that the atom was not the full stop definitively concluding scientific knowledge, but was in fact merely the end of the prologue. It was a disconcerting piece of new information that turned what had been a reassuringly certain world into a disturbingly unknown quantity. It made their Cubist idea of breaking matter down into a series of interrelating fragments seem an entirely logical step to take, just as the arrival of X-ray technology had encour-

aged them to look beyond the superficial to depict what cannot necessarily be seen but is known to exist.

Outside the science lab there was the excitement of the Wright Brothers' fresh aerial perspectives, adding to the ferment of new thoughts percolating away in the cafés of Paris (Picasso called Braque 'Wilbourg' after Wilbur Wright) – an already heady brew made all the more intoxicating by news of Sigmund Freud's controversial psycho-analytical work into the unconscious mind. All in all, there has not been a time before or since when so many supposed truths upon which civilization had relied were being questioned or shown to be fallacies.

No wonder this atmosphere of ideas led two such ambitious, talented and inquisitive artists to pursue a more conceptual approach to art. For their work was not rooted in straightforward representation but in preconception. Braque and Picasso were attempting to devise a new formula for art that took into account not just what they saw but what they already knew of a subject: their prior knowledge. Apollinaire said they were 'painting new structures out of elements not borrowed from sight, but from the reality of insight'. They were intended to be a representation of how we truly see things and exist in the world. Each individual facet within a Cubist painting exists within its own time and space (having been observed by the artist at a different time, standing in a different space) and yet relates to, and is part of, all the other fragments laid out within the frame of the picture.

Although this led to highly complex montages, it was a strikingly modern way of making art that was starting to permeate beyond the privacy of their studio into the wider artistic community. An experimental group of Paris-based artists that included Fernand Léger, Albert Gleizes, Jean Metzinger and Juan Gris had picked up on Braque and Picasso's Cubism and from around 1910 had started working in the same vein. It was these artists, not Cubism's founders, who publicly launched the new art movement at the Salon des Indépendants exhibition in 1911 (hence being known thereafter as

Salon Cubists). The show did not include any work by Braque or Picasso, both of whom elected not to take part.

Their closest association with the exhibition was through the work of Juan Gris. Like Picasso, he was a Spaniard who had made Paris his home. He joined their close-knit Bateau-Lavoir gang and started to evolve his own form of Cubism, which was more stylized: smoother. Paintings like *Still Life with Flowers* (1912) have an almost metallic feel to them, as if made from sheets of steel. Gris uses the Cubist technique of fracturing objects and space and then blending them together again with little differentiation between the two. But in the case of this picture, the 'all-over' design is so dominant that only the neck and body of the guitar are easily recognizable as objects. The rest of the picture consists of an 'unreadable' series of geometric forms . . . the shapes of things to come.

Total abstraction was to be the inevitable legacy of Cubism. Within a few years the artists behind Suprematism and Constructivism in Russia, and De Stijl in Holland, would be producing paintings and sculptures consisting only of circles, triangles, spheres and squares. They would make no attempt to depict the known world. But that was not the intention of Cubism. Picasso once said that he'd never painted an abstract picture in his life. Part of the reason he and Braque chose to paint such everyday subjects – pipes, tables, musical instruments, bottles – was to make the various components of their complicated constructions easier to recognize. But as they continued along their Cubist path they realized that their paintings were indeed becoming increasingly 'illegible'.

By this stage in Cubism's development, Picasso had made another great innovative leap, which, although clever, was absolutely no help when it came to the legibility of his work. The Spaniard had 'pierced' the form. Meaning, instead of distorting and contorting the image in order to present a subject from multiple viewpoints, Picasso started to remove elements – a breast, say – leaving a hole (pierced) in the subject. The breast would then reappear elsewhere, on a shoulder maybe, which made the image even more disjointed than his previous Cubist pictures.

Braque's inclusion of the traditionally painted naturalistic nail in *Violin and Palette* was one step towards ensuring that Cubism didn't lose touch with reality. But he and Picasso needed to do more to help orientate and inform the viewer about the subject matter of their paintings. The solution, they figured, was to add letters and words to their paintings, an early example of which can be seen in Picasso's *Ma Jolie* (1911–12) (see Fig. 12).

Ma Jolie is a portrait of Picasso's lover Marcelle Humbert. The shape of her head and torso can just about be made out in the cluster of shapes that dominate the central panel of the canvas. To the right, nearing the bottom section of the painting, are the six strings of the guitar she gently strums. And then, near the base of the canvas, there are some elements that are much more clearly discernible. The words 'MA JOLIE' (my pretty girl) are spelt out in capital letters. It was the pet name Picasso gave Marcelle, one that he had taken from the chorus of a popular music-hall song. Picasso has alluded to this musical double meaning by placing a treble clef just to the right of the 'e' in 'Jolie' – the position of the squared sign in mathematical grammar.

The introduction of text was bold. Art had always been about images, not letters. To borrow from one form of communication to bolster another was a daring move. It was a literal quotation from everyday life, helping to make their paintings easier to decipher. But the letters were not a cure-all. Braque and Picasso had encountered other problems with Cubism. The most pressing of which was how to represent three-dimensional subjects on a two-dimensional canvas. The artists were worried that their pictures had become so flat that the viewer might be unable to differentiate between the medium and the image it carried. Of course, there is nothing wrong with a piece of material decorated by a design appearing as one united entity, but the word for that combination is not 'art', it's wallpaper. Okay, Braque might once have been a painter and decorator, but he was well out of that game. He was now a fully-fledged artist, as was Picasso. They were categorically not wallpaper designers. But then, what if . . .

What if . . . they sourced some wallpaper and pasted it on to their canvas? Hmmm . . .

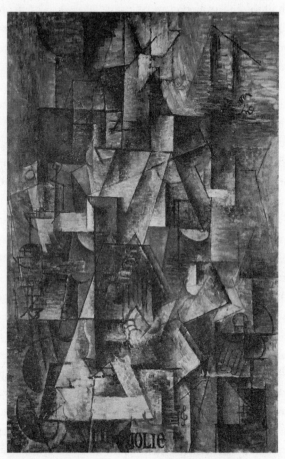

Fig. 12. **Pablo Picasso,** *Ma Jolie*, 1911–12

Braque began to experiment with the techniques he had learnt from his days as a decorator. He started to mix sand and plaster into his paint to give it more texture when applied to the canvas's surface and, occasionally, would swap his brush for a comb to create a trompe-l'oeil floorboard effect. While he mixed and combed, Picasso was kept

busy looking around the studio for inspiration. In the early summer of 1912 he produced a work called *Still Life with Chair Caning* (1912). The top half of the oval picture is pure Cubism. Cut-up pieces of newspaper, pipes and a glass intermingle like a pack of cards dropped on the floor. The second half of the picture, however, is very, very different. Picasso has pasted on a piece of cheap oilcloth, normally used for lining drawers or as an inferior substitute for wrapping paper. The pre-printed pattern on the oilcloth is of a crossed-hatched caned chair seat. He has framed the picture with a piece of twisted cord.

The inclusion of the oilcloth was a breakthrough. By 1912 people were well used to artists depicting everyday life: subjects from the real world that had been converted into art through brushstroke and paint. They were not, though, used to artists appropriating real elements of everyday life and incorporating them into their paintings: an action that totally rewrote the rulebook regarding art's relationship with life.

Picasso's inclusion of the patterned oilcloth had the desired effect of making his picture easier to understand. It becomes reasonably obvious pretty quickly that the oval canvas represents a typical café table-top. The pipe, glass and paper (indicated by the letters JOU, standing for Journal) are the items one would expect to find in such a situation. The oilcloth can be seen as either a chair that has been tidily pushed under the table, or a tablecloth. But Picasso's witty intervention is of much greater significance than simply making Cubist pictures more legible. By placing a fragment of oilcloth in his painting he had elevated its status as a worthless rag into the lofty realms of fine art. Picasso had taken a mass-produced product and transformed it into something unique and valuable.

Within months Braque had gone further still. In September of the same year he made *Fruit Dish and Glass* (1912), in which he cut and pasted wallpaper printed with a wood-panelling pattern on to a canvas. On top of this paper he sketched a Cubist-styled fruit dish and glass with charcoal. There is no painting in this 'painting'. The colour is provided by the wallpaper, which Braque bought in a store in Avignon,

in the south of France. Now we are deep into mindgames territory. Braque has taken a piece of wallpaper on which a pattern has been printed to make it look like wood. He has then placed that 'fake' image in his own picture, which by its very nature is a fabrication. But by doing so he has changed the status of the wallpaper, which is now the only 'real' thing in the picture. Complicated, I know. But worth acknowledging. Because this is where conceptual art started. Not with Marcel Duchamp, or with the performance artists of the 1960s. It was with Braque and Picasso in Paris, 1912.

Braque's wallpaper and Picasso's oilcloth might have been worthless everyday materials, but in terms of the history of art, they were like sticks of dynamite. Cézanne pushed the door to Modernism open; these two young adventurers blew it out of its frame. They weren't copying real life: they were appropriating it. Analytical Cubism was turning into Synthetic Cubism, which is the official term given to Braque and Picasso's introduction of *papier collé*, a term that derives from the French *coller*, to paste or glue. These two great pioneers of art had done it again: they'd invented collage.

Remember those rickety creations we made in art lessons at school? The ones where we'd cut up bits out of magazines and newspapers and stick them on to a piece of card? It seemed so obvious, so easy; so childish. But nobody, and I mean nobody, had thought of it before Braque and Picasso as a way of making fine art. Yes, people had previously cut things out and attached them to something else – collections of memorabilia in a scrapbook, for example. The ancients would even decorate their pictures with jewels, and Degas wrapped a piece of muslin and silk around the body of his *Little Dancer* sculpture (1880–81). But the idea that mundane everyday materials could be used at the high altar of the artist's easel was totally new.

And they had one more trick up their artists' smocks: the three-dimensional *papier collé*. In today's contemporary art-speak, these precarious compilations of string, cardboard, wood and painted paper would be called assemblages or maybe even sculptures. But back in 1912

the word assemblage didn't exist, and sculptures were grand pieces of modelled or carved marble or cast bronze that sat on plinths.

When the poet and critic André Salmon visited Picasso's studio in the autumn of 1912 and saw *Guitar* (1912) hanging on the wall he was nonplussed. The Spanish artist had made a three-dimensional likeness of a guitar by gluing together pieces of folded cardboard, wire and string.

'What's that?' asked Salmon.

'It's nothing,' replied Picasso. 'It's "*el guitare!*"'

'The' guitar, you notice, not 'a' guitar. Braque and Picasso had been making these three-dimensional models for a while to assist in the plotting of their Cubist paintings. Now they had simply promoted them from understudy to the lead role. It was a final break with tradition. Art could now be made out of anything.

For the next two years they were like a pair of jazz musicians, improvising with all manner of material and riffing ideas off each other. Their mixed-media inventions, where they fused lowly materials with the high-status heritage of fine art, had immediate and long-lasting ramifications. Marcel Duchamp, a one-time Parisian Cubist, went to America and promptly produced his own artwork made from an everyday material: *Fountain* (1917), a reconstituted urinal. The Surrealists revered Picasso's *Les Demoiselles*, with their leader André Breton credited for naming the work. And what are Andy Warhol's Campbell's Soup cans, Jeff Koons's balloon dogs and Damien Hirst's pickled sharks if not the appropriation of everyday objects by an artist in order to re-present them in a new, artistic context?

They are examples of just one side of the influential legacy left by Braque and Picasso's Cubism. It can be found in much of the art and design of the twentieth century. The angular, stripped-down, space-conscious Cubist aesthetic that Braque and Picasso evolved from Cézanne's example directly led to the angular, stripped-down, space-conscious aesthetic of Modernism. The elegant but austere architecture of Le Corbusier, the art deco style of the 1920s, and the cool design of

Coco Chanel all owe a debt to the two young artists. As do the frag-
mented modernist prose of James Joyce, the poetry of T. S. Eliot and
the music of Igor Stravinsky. If you lift your head from this book and
look around right now, you will see Cubism's legacy staring back.

The legacy of Cubism will probably live on for ever, although the art
movement itself barely lasted a decade. The Parisian scene and the world
from which Braque and Picasso had emerged – full of bohemian liber-
tines fuelled on caffeine and absinthe – was coming to an end. The Belle
Époque was about to be usurped by the greatest horror show Man had
ever conceived: the First World War. Many of the main players in Cub-
ism's story would be called up, including Braque. As would the poet and
critic Guillaume Apollinaire, a central figure and powerful advocate dur-
ing those early years of modern art. He was to die from influenza in 1918,
having been weakened by injuries sustained in combat. Daniel-Henry
Kahnweiler, the artists' visionary dealer and backer, was German and
therefore considered an enemy of the state. He was told to leave Paris.

The party was over. The First World War put an end to Cubism;
Picasso said he never saw his brother-in-art again. That wasn't strictly
true: he did. Braque survived the war and returned to Paris to con-
tinue his career as an artist; he regularly saw his old painting partner,
who had stayed in Paris. What Picasso actually meant was that their
artistic adventure was over: Cubism was finished. They had taken
their quest to discover a new way of representation as far as they
could go. By this time they were famous and so were their discoveries.

One can only wonder at the achievements of these two young art-
ists. Cubism never had a manifesto, nor were Braque and Picasso
politically motivated. Which cannot be said of the next art movement
that put their ideas in motion. Futurism had a very different agenda,
and a darker legacy . . .

8

FUTURISM:
FAST FORWARD
1909–19

The eight years between 1905 and 1913 saw modern art movements popping up like long-lost relatives at a billionaire's funeral; hitherto unheard-of parties staking a claim to be the new pioneers of art because they declared themselves to be a distant cousin of Monet's Impressionism or Seurat's colour theories. They came from France (Fauvism, Cubism, Orphism), Germany (Die Brücke and Der Blaue Reiter), Russia (Rayonism) and Britain (Vorticism). Some were greater than others; some influenced others: all made a contribution.

The rapidity of their arrival – and sometimes departure – reflected Europe at the time: a continent in flux, where change was the new status quo. There was a constant stream of life-enhancing new mechanical inventions to further improve life for a new middle class who took pleasure in leisure. Groups of artists, poets, philosophers and novelists would meet, drink and exchange thoughts in cities that were rapidly modernizing, vast metropolitan playgrounds teeming

with twenty-four-hour life in the wondrous glow of the new electric light. The disease and urban squalor of the previous century was a thing of the past. The cry ringing around Europe was: out with the old and in with the new.

At least it was from the mouth and pen of Filippo Tommaso Marinetti (1876–1944), a provocative Italian poet and novelist. Born in Egypt to Italian parents, Marinetti was brought up in Alexandria, where Jesuits from Lyons gave him a Franco-Italian education. It wasn't until he was eighteen that he actually visited either Italy or France, by which time he had developed a highly romanticized view of both places. He had also acquired a taste for argument and a flair for polemical statements. He had consumed the experimental words of the avant-garde writers living in Paris as if they were fine wine, swilling them around his head, intoxicated by their power. In his early twenties he settled in Milan, Italy, and decided that what his newly adopted country really lacked was a place at the high table of modern art. An issue he swiftly resolved by coming up with a new concept called Futurism.

Unlike previous movements, Futurism was overtly political from the start. The boisterous Marinetti wanted to change the world. And to a certain extent – for good and evil – he succeeded. He was a man of many faults, but being shy and retiring was not among them. Which meant that if Marinetti had a vision the world was jolly well going to hear about it. And you've got to admire his nerve. There he was, a poet and writer, not much known beyond the Italian avant-garde and the Symbolist movement, who decided to place his radical manifesto in a newspaper – on its front page. And it wasn't some piffling local rag, or even a paper based in his native Italy (which had already covered his Futurist proclamations). No, on Saturday, 20 February 1909, Marinetti presented his Futurist manifesto to the world via France's famous newspaper *Le Figaro*. It was a precocious, calculated and brilliant move. Marinetti knew that the only chance his ideas had of being noticed by the international artistic and intellectual elite was if he went into their back yard – Paris – and shouted

about them. Oh, and picked a fight. Which he did, with the biggest, baddest boys in town: Georges Braque, Pablo Picasso, Cubism in general, and their champion-in-chief, Guillaume Apollinaire.

Le Figaro's owners were clearly nervous before publication. To distance themselves from the Italian firebrand they introduced Marinetti's manifesto with a disclaimer: 'Is it necessary to say that we assign to the author himself full responsibility for his singularly audacious ideas and his frequent unwarranted extravagance in the face of things that are eminently respectable and, happily, everywhere respected? But we thought it interesting to reserve for our readers the first publication of this manifesto, whatever their judgement of it will be.' The manifesto text took up two and half columns of *Le Figaro*'s front page. It consisted of a title, *Le Futurisme*, followed by some explanatory text and then the eleven-point manifesto. It was punchy stuff; one can understand why the paper's proprietors were a bit jumpy.

By way of introducing himself, and his band of collaborators, he wrote, 'It is from Italy that we hurl at the whole world this utterly violent, inflammatory manifesto of ours, with which we are founding "Futurism", because we wish to free our country from the stinking canker of its professors, archaeologists, tour guides and antiquarians.' He went on and on about the country's rich artistic past. The idea being that contemporary Italian creativity was being blocked by the weight of the country's previous artistic golden ages, most notably those of ancient Rome and the Renaissance. He was protesting like a frustrated younger brother trapped in the shadow of a successful older sibling. Not that he put it quite like that: 'For far too long Italy has been a marketplace for junk dealers. We want our country free from the endless number of museums that everywhere cover her like countless graveyards. Museums, graveyards! . . . they're the same thing . . . Come on then! Set fire to the library shelves! Divert the canals so they can flood the museums . . . grab your picks and your axes and your hammers and then demolish, pitilessly demolish, all venerated cities!' All that before the main dish, the manifesto proper.

Point 2: 'We intend to glorify aggressive action, a restive wakeful-ness, life at the double, the slap and punching fist.' Okay, he's warming up, but the best (as in the most outrageous) was yet to come. By point 4 he was up to speed: 'A racing car, its bonnet decked with exhaust pipes like serpents with galvanic breath . . . a roaring motor car, which seems to race on like machine-gun fire, is more beautiful than the Winged Victory of Samothrace'. And then came point 9, where his rhetoric was now out of control. With these next iconoclastic words he guaranteed himself the attention he craved but also sowed the seeds of his and Futurism's own hideous future, as the precursor of Fascism: 'We wish to glorify war – the sole cleanser of the world – militarism, patriotism, the destructive act of liberation, beautiful ideas worth dying for, and scorn for women.' Blimey.

Still, it had the desired outcome. Within a day Marinetti had moved from 'Who's he?' to 'Who the hell does he think he is?' The response from the Parisian intelligentsia was swift and damning. One high-minded aesthete said, 'He should have called his manifesto not one of Futurism, but one of Vandalism,' while another commented, 'Mr F. T. Marinetti's agitation merely illustrates a great paucity of reflection or a great thirst for advertisement.'

'Send in the art activists.'

Well, as advertising strategies go it was slick, professional and very effective; his sophisticated manipulation of the media and public would have made Madison Avenue's finest ad men proud. The French critic Roger Allard wrote in 1913: 'With the help of press articles, shrewdly organized exhibitions, provocative lectures, controversies, manifestoes, proclamations, prospectuses and other forms of Futurist publicity, a painter or group of painters is launched. From Boston to Kiev and Copenhagen, this fuss creates an illusion and the outsider gives a few orders.' It was from Marinetti that the Dadaists, Marcel Duchamp, Salvador Dalí, Andy Warhol and Damien Hirst would all later learn how to play the publicity game to their own advantage.

But what was Futurism other than a manifesto? After all, Marinetti was a writer, not a visual artist, and nor, at the time of launch, were his followers. One year later, though, it had became an art movement. Marinetti had recruited the Italian artists Umberto Boccioni (1882–1916), Carlo Carrà (1881–1966), Gino Severini (1883–1966) and Giacomo Balla (1871–1958), who provided the pictures and sculptures to go with his wild pronouncements: they were the illustrators for his bombastic thesis. To portray the dynamism of modern life, or at least a sense of it, was the visual requirement. Marinetti talked of the beauty and aggressive movement of machinery: the artists pictured it. Their paintings were energetic and full of movement, picking up on the pioneering late nineteenth-century photography of the French scientist Étienne-Jules Marey and that of Eadweard Muybridge, who both produced sequences of still images of galloping horses. The Futurists said their paintings were not 'fixed in the moment' like the static, interior world that Braque and Picasso were so soberly pursuing, although it did copy the idea of seeing an object from multiple angles. Futurism was, in effect, Cubism on speed.

Sometimes it worked better than others. Giacomo Balla's amusing but faintly ridiculous *Dynamism of a Dog on a Leash* (1912) (see Fig. 13)

shows a dog and owner walking with multiple feet to suggest move-
ment. Nice, but silly. Whereas Umberto Boccioni's sculpture *Unique*

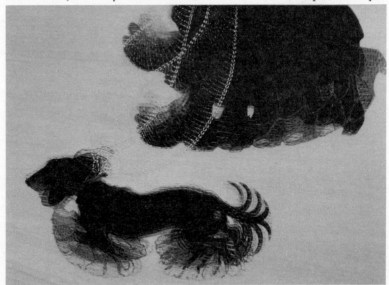

Fig. 13. **Giacomo Balla,** *Dynamism of a Dog on a Leash,* **1912**

Forms of Continuity in Space (1913) (see Fig. 14) is rather wonderful
and perfectly embodies the artistic aims of the movement – to fuse
man and his newly mechanized environment into an energetic image
of speed and progress. Made in plaster, it depicts a striding cyborg,
part human, part machine. It has no face and no arms, but its curved
and streamlined body is ready and able to fly and glide through the air
and into action at a speed unknown to mere mortals. It was pieces like
this that led to Futurism becoming the default adjective for anything
that imagined the technological excitements to come; known from
here on simply as being 'futuristic'.

The Futurist sculptures and paintings owed much to the technical
and compositional inventions of Cubism. They too were concerned
with collapsing time and space into one image, and adopted similar
techniques of overlapping and fractured planes to create the effect.
Yet while the Cubists considered the subject of their art to be their
art, the Futurists wanted to provoke raw emotional responses, make

political statements and create a dynamic tension between the real-world subjects depicted in their paintings.

The similarities between the Futurists and the Cubists became even more marked once team Marinetti had visited Paris in 1911 and seen Braque and Picasso's Cubist paintings at Kahnweiler's gallery and those of the 'Salon Cubists', including Robert Delaunay, Jean Metzinger and Albert Gleizes, at the Indépendants exhibition. The Italians took on board their modern art lesson and incorporated the ideas of the French avant-garde into their own work. The immediate impact of their visit to Paris in 1911 can be seen in Boccioni's triptych, *States of Mind* (1911).

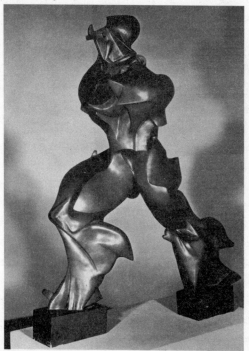

Fig. 14. **Umberto Boccioni,** *Unique Forms of Continuity in Space,* **1913**

He painted the series twice in 1911, once before the Paris trip and once after. In both instances the narrative idea was the same, a point Boccioni highlighted by giving each of the three paintings in both

versions identical titles: *Those Who Go*, *The Farewells* and *Those Who Stay*. The artist wanted to portray the psychological impact on man when he interacts with a machine, which in this case was a train. *Those Who Go* depicts people about to embark on a train journey. Boccioni described them as being racked with 'loneliness, anguish and dazed confusion'. *The Farewells* is as you would expect: passengers wave from a departing train. And *Those Who Stay* portrays the deep melancholy induced in those who have been left behind.

The pre-trip paintings all look very Post-Impressionistic, full of Van Gogh's Expressionism, Gauguin's Symbolism, Cézanne's palette and the colour-separation theories of Seurat. In fact, Boccioni's first versions of the paintings look more like something from the troubled mind of Edvard Munch, rather than a go-getting, forward-looking, speed-loving, devil-may-care Futurist.

Yet the triptych he painted *after* the trip to Paris is much more how we imagine a Futurist artwork. The angular, deconstructed geometric forms of *States of Mind: Those Who Go* are instantly recognizable as Cubist-inspired. The system of splicing and slicing the painting's subjects into overlapping sections echoes Picasso and Braque's Cubism, as does the electric tonal palette and splintered composition.

But the atmosphere is quite different and distinctly Futuristic. *Those Who Go* is emotional in a way that was alien to the sobriety of Cubism. Boccioni's dark colours and shard-like arrows of blue diagonal paint exude anxiety. The heads of the passengers are part human, part robot and must have been an inspiration for Fritz Lang's Machine-Man in his science-fiction film masterpiece *Metropolis* (1927). In fact the whole picture has a cinematic quality. Or maybe a movie poster with its blend of interior (the people dimly lit by overhead lights inside the train) and exterior (the sun-bathed city in the background), covering events that have happened over a period of time but are presented within one image. The Futur-

ists had a word for this action-packed, time-compression technique: simultaneity.

The second picture in the series, *States of Mind: The Farewells* (see Plate 14), employs similar stylistic tricks. This time the hero of the painting is obvious: the brooding power of the steam engine, on which Boccioni has included the train's number in the typographical manner developed by Braque and Picasso. The story in this picture is one of people meeting at a railway station to come and to go. There are embraces shrouded in steam, there are carriages and fields, and there are pylons framed against a setting sun. This is the future for the people congregating at the station as seen in their minds by the artist: a future powered by electricity and speeding machines, of transience and transcendence: a future on the move.

Those Who Stay has none of the colour and energy of the first two pictures. It is an almost monochrome image of defeat. Blue-green ghost-like figures trudge wearily away from the station partially obscured by a semi-transparent curtain of thick vertical lines, suggestive of cold, heavy rain. They are returning to the miserable past, without their loved ones who have taken the express train to the future. The wretched Cubist-inspired figures lean at forty-five degrees, as if about to collapse under the weight of their old-fashioned existence.

The *States of Mind* triptych is a quintessential Futurist painting that was one of the highlights of the Futurists' first show in Paris in 1912 at the Galérie Bernheim-Jeune. It seems odd that Boccioni should choose to present a triptych at all, given the format's association with Renaissance altarpieces and the Futurists' desire to banish all references to the past. But it was the more contemporary references that upset the French critics, one of whom said, 'Mr Boccioni's larvae are a dull plagiarism of Braque and Picasso.'

Indeed, artists on both sides – Cubist and Futurist – continued to look and learn and influence one another. The French Cubist

Robert Delaunay (1885–1941) was one who was clearly paying attention to the efforts of his Italian counterparts. His painting *The Cardiff Team* (1912–13) shows many Cubist and Futurist characteristics.

It depicts two sports teams playing a game of rugby in Paris. One of the players leaps to catch the ball high above his head, with his neck craned back to look skywards. The game is framed by motifs of more modern leisure pursuits: a Ferris wheel, a biplane and the city's great tourist attraction, the Eiffel Tower. The visual symbolism is clear: it's about upward momentum, reaching for the sky – the future. Multiple actions appear at different times and places, and are all conflated together: another example of the Futurists' simultaneity technique. The montage of images also recalls a Cubist collage (and latter-day poster advertisement). But the way in which Delaunay has painted the scene differs from both the Cubist and Futurist aesthetics. There's none of the fractured energy and dynamism of a Futurist artwork, and it's way too colourful to fit within Braque or Picasso's canon.

Which gave Apollinaire the opportunity he was looking for to distance his French friends from Marinetti's movement, which he did not rate. He called Futurism 'a grotesque frenzy, the frenzy of ignorance' and a 'silliness'. But it was catching on, even among his own crowd. So, not wishing to lose face to the man from Milan, Apollinaire simply came up with a new name for what was in effect a hybrid, a kind of Cubo-Futurism. He adjudged Delaunay's *The Cardiff Team* to be the start of (yet) another new art movement, which he labelled Orphism (from Orpheus, who beguiled the gods with music that connected with the soul).

But it was too late for the French intelligentsia to contain or appropriate Futurism or Marinetti and his tireless promotion of the movement. The Futurist's Paris show travelled around Europe: to London, Berlin, Brussels, Amsterdam and beyond. And at every stop, there was Marinetti, performing, postulating, persuading. From St

Petersburg to San Francisco, Marinetti pressed the flesh and assaulted the ears before unveiling the paintings that captured his mechanical, and increasingly maniacal, vision. And the world took notice. The Futurists had broken the vice-like grip Paris had held on the development of modern art. From 1912 onwards, the new chapters in the story of art would be written in different cities across the world, all of which had been put on an equal footing by their response to Cubo-Futurism.

In Britain, the artist and writer Wyndham Lewis (1882–1957) led a like-minded London-based group of painters and sculptors in a new art movement that came out of Cubo-Futurism called Vorticism. The Vorticists' name was given to them in 1913–14 by the American expatriate poet Ezra Pound, who said that the 'vortex is the point of maximum energy'. The intervention of the First World War meant that the movement was gone before it had properly arrived. Still, there was time for some memorable works of art to be produced, the most powerful of which was Jacob Epstein's *Rock Drill* (1913–15).

Epstein (1880–1959) was born and trained in America but came to Britain in 1905 and stayed. He visited Picasso in Paris, where he found the Spaniard to be 'a remarkable artist, both as a virtuoso and as a man of exquisite taste and sensibility'. Shortly afterwards Epstein made *Rock Drill*, a sculpture that looks totally futuristic now, never mind that it was made back in 1913. A 2-metre-high robotic reptile-cum-man-machine stands astride an enormous genuine rock drill high above the ground. The drill is supported by a tripod, two legs of which the menacing creature stands upon, with the black pneumatic drill poised between his legs pointing down like a huge phallus ready to plunge its steely tip into Mother Earth. The monster's head looks up like a praying mantis, his/its eyes hidden by a tapering visor, challenging all-comers to a fight. It is a celebration of the eroticism of machinery, a dream machine for Marinetti.

Epstein says he made it 'in the experimental pre-War days of 1913 . . . fired [by] my ardour for machinery . . . here is the armed sinister

figure of today and tomorrow'. Very soon his Frankenstein's monster was looking morbidly prophetic, as the vicious bloodbath of the First World War saw the horrendous downside to the union of man and machine. Epstein lost his interest in machinery and dismantled the work, instead remaking only part of the piece in the form of a bronze sculpture that consists of a now horribly amputated machine-man-monster, cut off at the torso, with half his/its left arm missing. The visored face, once that of an invincible warrior, now has the hangdog look of the permanently bewildered.

Epstein's art may have changed direction, but Marinetti's Futurism continued to march on, proclaiming, promoting and fighting. The Italian showman of art was never shy of a punch-up at one of his performances. He recognized that a decent altercation would lead to the oxygen his art movement needed for survival: publicity. But as the First World War came and went, Marinetti's brow-beating showmanship and rabble-rousing declamations began to look a little ominous. The political landscape was changing. Dissatisfied populations throughout Europe were more than happy to hear a Futurist-like chant of 'Out with the old, in with the new.' Communism was on its way. And so was Fascism.

In a move that runs counter to most people's perception that art has always been a game played by left-leaning liberals, Filippo Marinetti turned his literary skills to co-writing Italy's Fascist Manifesto in 1919, just ten years after he had published his *Futurist Manifesto*. He became friends with Mussolini and even ran for parliament in 1919 (unsuccessfully) on a Fascist ticket. It should be said that Marinetti's vision for Fascism is significantly different from the poisonous entity that it became. And those differences soon became apparent, resulting in Marinetti leaving to go off on another tangent. But he stayed loyal to Mussolini and resolutely defended him in public.

To say that Futurism led directly to Fascism would be to overstate the case. But then it would be to avoid an inconvenient truth if one

was to ignore those times when art has influenced politics in such a surprising and calamitous way. Futurism will forever be inextricably linked with Fascism.

KANDINSKY/ ORPHISM/BLUE RIDER: THE SOUND OF MUSIC 1910–14

'**A**bstract art' describes paintings or sculptures that do not mimic or even attempt to represent a physical subject, like a house or a dog. To do so would be a failure in the eyes of the abstract artist, who aims to produce an artwork that is a feat of imagination in which we are unable to recognize anything of our known world. It is sometimes called 'non-figurative art'.

You know the sort of thing, those seemingly random squiggles and squares that can cause one to think, 'A five-year-old could have done that.' Which might be the case, but is actually unlikely. It's a surprisingly tricky thing to pin down exactly what it is that makes those lines any different from the lines you or I might draw, but there is a difference. There's something about their fluidity, or composition, or shape that has millions of us flocking to modern art galleries to see abstract paintings by the likes of Mark Rothko and Wassily Kandinsky. Somehow they have managed to arrange their shapes and brushstrokes into

designs that can make a meaningful connection with us, without us quite knowing how or why. The truth is that abstract art is a bit of a mystery; one that plays havoc with our rational brains if we believe paintings and sculptures need to tell a story. It is a complex idea that is typically expressed in a simple way, which is what I'm going to attempt to do over the next few chapters.

FRANCESCO, AT FORTY, SUDDENLY REALIZES HE HAS WASTED HALF OF HIS LIFE IN MAKING HIS SIGNATURE ASTERISK CANVASSES

You could argue that Manet started it all back in the mid-nineteenth century when he began to remove (abstract) pictorial detail in his paintings such as *The Absinthe Drinker* (1858–9). Each subsequent generation of artists eliminated yet more visual information in an attempt to capture atmospheric light (Impressionism), accentuate the emotive qualities of colour (Fauvism), or look at a subject from multiple viewpoints (Cubism).

Looking back, it seems inevitable that this process of elimination would eventually lead to all detail being removed and the advent of abstract art. Manet and his successors had defined their role as artists in a post-photographic age as one of a social observer, philosopher and 'seer', who exposes the hidden truths of life. The camera had liberated them from the day job of producing likenesses and allowed them to explore new ways of representation that might provoke previously untapped thoughts and feelings in the viewer.

It was a role the pioneering painters and sculptors living in Europe enthusiastically and relentlessly pursued. Their new-found freedom and self-appointed right to roam led them to streamline their subjects, contorting features, and chopping up bodies into patchworks of geometric shapes, all in the name of artistic progress. And then, in 1910, forty years after the start of this revolution that had redefined the role of art and artists, the ultimate break with tradition was made.

František Kupka (1871–1957) was a member of the Paris-based Cubo-Futurist art movement that Apollinaire had called Orphism. In 1910 he began to produce canvases that were beyond obvious comprehension: colourful paintings that didn't provide any clues as to their subject matter. To all but the artist and his close circle they consisted of nothing more than nondescript shapes. Kupka's *First Step* (c.1910) is one of the earliest examples of his experimental foray into abstract art. The picture consists of a series of circles and discs painted on a black background. The most dominant circle is centrally placed in the upper half of the canvas; it is large and white and cropped at the top like a ready-to-dip boiled egg, with a bottom left-hand section that marginally overlaps a slightly smaller grey disc. Hanging in an arc around these two larger discs is a necklace of eleven and a half blue and red tablets. These small round shapes are each framed within a green circle. To the left of the picture is a large red ring that intersects with all the discs in the style of a Venn diagram. And that's it.

First Step is not a picture of anything; it is totally abstract. The painting is an investigation by Kupka into our relationship with outer

space and the universe: a visual allegory of the interconnectivity between the sun, the moon and the planets (making its title impressively prescient). Kupka is putting some thoughts down on canvas, not portraying a specific subject.

Two years later, Robert Delaunay, the artist credited with founding Orphism, made his move into abstract art with a painting that would prove to be extremely influential. *Simultaneous Disc* (1912) would go on to inspire the German avant-garde and, some time later, the American Abstract Expressionists. At first glance the picture looks like a multi-coloured dartboard. Again, as with *First Step*, there is no obvious physical subject. But there is a crucial difference to Kupka's work: in this instance there is no allusion to a physical object, interplanetary or otherwise. Instead, the artist has chosen to make *colour* his subject.

Like Seurat, Delaunay was fascinated by colour theory. He too was inspired by the work of Michel Eugène Chevreul, most particularly the French chemist's book *On The Law of the Simultaneous Contrast of Colour* (hence the name of Delaunay's painting), which was published in 1839. Chevreul demonstrated how colours that were adjacent on the colour wheel influenced each other (a recurrent theme thus far in the story of modern art). Seurat used the system in order to respond to Impressionism; Delaunay used it as a way of adding some colour to Cubism. He applied the deconstructive techniques of Braque and Picasso to the colour wheel, taking it apart and then rebuilding it as a round target divided into four slices, like a pre-cut pizza. Each quarter contains seven single colour segments, radiating from the centre in curved sections. The result is seven concentric circles consisting of four fragmented colours.

Delaunay chose colour as the sole subject of his painting after coming to the conclusion that reality corrupted 'the order of colour'. He was trying to make a picture that vibrated with harmony and tone: not unlike a piece of music. Which was the aim of Orphism, alluded to in the movement's namesake – the Greek poet and musician Orpheus. The mood among the avant-garde was that music and art were closely aligned.

Which is a helpful insight into understanding the work of these pioneers of abstract art. Their colourful dashes and daubs were not an attempt to fool the general public by dressing up decoration as fine art, nor were they trying to detach themselves from reality in order to be seen as some sort of prophetic or mystical figure. They likened themselves to musicians, their work to a musical score.

It explains their motivation to move into abstract art. Because music, when unaccompanied by singing or words, is a totally abstract art form. Soaring violins or thundering drums can transport the listener to an imaginary scene without ever needing to resort to direct representation. The listener is free to let his or her mind wander and personally inter-pret the music's meaning. If the listener is moved, it is because the composer has arranged the notes in a manner that has elicited such a reaction. The earliest examples of abstract art are very similar, except that the artists were making arrangements out of colour and form.

Richard Wagner, the great Romantic German composer of the nineteenth century, had seen the potential of marrying music and art more than half a century earlier. His vision was to make a *Gesamt-kunstwerk*: meaning a 'total work of art'. The idea was to unite art forms to create one sublime creative entity that had the power to transform lives and make a meaningful contribution to society. He was an ambitious man.

The concept was informed by his admiration for the German phi-losopher Arthur Schopenhauer (1788–1860), whose theories on music had impressed the composer. Schopenhauer was a misanthrope – life, he thought, was a futile exercise in which we are all slaves to our 'will', trapped by our basic, insatiable desires for sex, food and safety. He argued that the arts were the only way to relieve us from this monot-onous treadmill, as they could offer transcendence, intellectual escape, and a bit of light relief. And, in his opinion, the best art form to deliver this craved-for glimpse of freedom was music, because of its abstract nature – notes are heard and not seen, freeing your imagin-ation from the prison of your 'will' and reason.

Wagner picked up on this idea and divided the arts into two distinct camps. He placed music, poetry and dance on one side because, he argued, they came about solely through the efforts of 'artistic man'. He then put painting, sculpture and architecture on the other, declaring that they were dependent upon 'artistic man' shaping 'nature's stuffs'. The idea was to design a format that allowed each art form to reach its true (and glorious) potential by corresponding with the others.

The composer's ambition to realize a *Gesamtkunstwerk* must have found its way into the soul of his compositions, as it was while attending a performance of his opera *Lohengrin* at the Bolshoi Theatre in Moscow that a young Russian law professor found himself thinking along the same lines. Within a few bars of the opening of Wagner's epic tenth-century tale, Wassily Kandinsky (1866–1944) started to 'see' things. His imagination began to conjure up a vivid mental picture. It was of his beloved Moscow, stylized as a fairytale city, rooted in the folklore and folk art of Russia. 'I saw ... colours ... before my eyes. Wild, almost mad lines drew themselves in front of me.' It was enough to get Kandinsky, a keen amateur artist, wondering. Could he make a painting as emotional and epic as a Wagner opera? Not with the intention of replicating the maestro's music, but to produce a parallel experience where colours were the notes and their composition the tonality.

In the same year, 1896, Kandinsky's passion for the arts prompted him to visit a touring exhibition of French Impressionist art that had stopped off in Moscow. There he came face-to-canvas with Monet's series of paintings depicting haystacks in a field. It was a moment of epiphany for the young Russian. He said: 'Previously, I had known only realistic art, in fact only the Russians ... And suddenly, for the first time, I saw a picture. That it was a Haystack the catalogue informed me. I didn't recognize it ... I had a dull feeling that the object was lacking in this picture. And I noticed with surprise and confusion that the picture not only gripped me, but impressed itself ineradicably on my memory.'

The thirty-year-old Kandinsky was left with an irrepressible sense of purpose running through his veins. He resigned from his lecturing post at Moscow University's Faculty of Law, decided to leave Russia, and in December 1896 made his way to Munich, a major centre of European art and teaching. As soon as he arrived in the German city he enrolled on a fine art course. The new student quickly learnt the painterly ways of the Impressionists, the Post-Impressionists and the Fauves, and before long had become an established member of the German avant-garde.

Kandinsky's first professional paintings were a composite of Monet and Van Gogh. *Munich – Planegg 1* (1901) is an oil sketch that depicts a muddy lane running diagonally through a field before disappearing horizontally alongside the face of a large granite rock in the background. Kandinsky has applied his paint in a short, thick, staccato manner and manipulated it with a palette knife. The purple-blue sky is Van-Gogh-like Expressionism, and the sun-soaked field reminiscent of Monet's Impressionism.

A few years later his painting style was more in keeping with the vibrant colours and simplified shapes of Fauvism. He made the southern German village of Murnau his subject for intense study over several years. His painting *Murnau, Village Street* (1908) is typical of this period in the artist's development. Blocks of rich, bold colours define the scene, the individual pictorial characteristics of which Kandinsky has almost entirely eliminated in the manner of Matisse and André Derain. By the time he painted *Kochel, Straight Road* (1909) a year later, his reduction of detail was such that only the sight of three sparsely painted trees and a couple of stick figures allow the viewer to make sense of the painting. Without them as narrative guides the picture would be legible only as a patchwork of intense orange (a house), yellows and reds (fields) and blues (light blue for the road, dark blue for a mountain).

Throughout this journey towards total abstraction, throughout Kandinsky's whole career, music would retain its hold over his art and life.

In the same year that he painted *Kochel, Straight Road* he produced a series of works with the prefix '*Improvisation*', a word chosen for its musical connotations. The artist's intended purpose for his *Improvisation* pictures was to create a visual soundscape: canvases that enabled the viewer to hear the 'inner sound' of colour. Which meant the removal of even more references to the real world. Kandinsky reasoned that 'inner sound' could only be heard when a painting does not contain a 'conventional meaning' to distract the viewer-cum-listener.

Improvisation IV (1909) is not Kandinsky's first truly abstract work, although you need a couple of minutes to figure out that the blue structure in the middle is a tree, that the red base in which it sits is a field, and that the yellow upper right quarter of the picture is the sky. As for deducing that the cacophony of colours in the top left-hand corner represents a rainbow, well, that only comes with knowing that the prism-in-the-sky was a regular motif for the colour-fixated Kandinsky.

The Russian artist was now on the verge of cutting all ties with reality in his work. That he was doing this at exactly the same time that Kupka and Delaunay in Paris were pursuing Orphism with a similar abstract agenda was not a coincidence. The avant-garde art world of the early twentieth century might have extended beyond France to Germany, Italy, Russia, Holland and Britain, but it was still a small clique of artists that populated it, many of whom knew each other. They were (and still are) an itinerant crowd. For example, the Moscow-born Kandinsky was based in Munich but had spent time in Paris, where he got to know Gertrude and Leo Stein (and their collection of Matisse and Picasso paintings). Meanwhile, the Frenchman Delaunay had met and married the talented Ukrainian artist Sonia Terk (1885–1979), who had been educated in St Petersburg, went to art school in Germany and finally settled in Paris in 1905.

So, no matter that they were not in the same place at the same time, they were all breathing the same artistic air. Which was reverberating with the sound of music. It was Delaunay's explorations into the sonorous effects of colour combinations that provided his route to

total abstraction. Kandinsky would arrive at the same destination, but from a different direction. His great moment of realization came, once again, after attending a concert.

In January 1911 the artist travelled to Munich to listen to the atonal music of the controversial Viennese composer Arnold Schoenberg (1874–1951). Kandinsky was profoundly moved by what he heard and set out that night to paint *Impression III (Concert)* (1911) in response. Two days later the work was complete, with the impact of Schoenberg's concert plain to see. A large triangle of black paint in the top right-hand corner denotes the grand piano, the magnetism of which pulls the eager audience – standing in the bottom left-hand corner – ever closer. Together the piano and people form a diagonal line that divides the picture in two. To one side of the line is a mass of vibrant yellow paint, representing the wondrous sound being produced by the piano. The other side is more nebulous. It is much less dense, with plenty of white paint intermingled with purples, blues, oranges and yellows. It could feasibly allude to something, but you would be hard pressed to say what exactly.

The artist was getting very, very close to total abstraction. Within months he would finally produce a painting that contained no recognizable elements of the physical world – a breakthrough that Schoenberg helped to bring about. Kandinsky had found a kindred spirit. He wrote to the musician, sharing his theories about colour, and proposing that painting could 'develop the same energies as music'. Schoenberg responded encouragingly, leading to a lifelong friendship between the two great artists. In the ensuing exchange of letters they wrote about high-minded concepts such as finding a 'modern harmony' in an 'anti-logical way'. And (echoing Schopenhauer) the 'elimination of the conscious will in art'. The general thrust being that Kandinsky should free himself from representation and produce a painting that came from instinct and not from learning: a painting that roughened up and awakened the viewer's sensibilities by placing incompatible colours and paint strokes side by side. Or, in musical parlance: dissonance.

Picture with a Circle (1911) is Kandinsky's first completely abstract work of art. It is a canvas nearly 1.5 metres high by 1 metre wide, full of riotous colour that is undecipherable. The purples, blues, yellows and greens that resonate from its surface have no shape and make no literal sense. A pinky-mauve zigzag tumbles down the left-hand side of the canvas. On its way it runs through a series of broad, formless patches of colour not unlike those made by a DIY decorator testing paint samples on a wall at home. At the top of the picture Kandinsky has painted two circular shapes – one black, the other blue – which look like eyes, but such an interpretation is not what the artist had in mind.

Kandinsky intended *Picture with a Circle* to be analogous to a musical score: entirely abstract and all the more sonorous for being so. Even experienced Kandinsky-watchers, who know to look out for Cossacks, horses, hills, towers, rainbows and biblical stories, would be at a loss to pick out any of those familiar motifs. The artist painted it in the same year (1911) that he wrote a book called *Concerning the Spiritual in Art*, in which he discussed his many theories on art and colour. In one short passage he sets out the symbolism behind the musicality of his art: 'Generally speaking, colour is a power which directly influences the soul. Colour is the keyboard, the eyes are the hammers; the soul is the piano with many strings. The artist is the hand which plays, touching one key or another, to cause vibrations in the soul.' The rousing, emotional spirit of *Picture with a Circle* is Kandinsky's early answer to a Wagner opera. But he wasn't happy with the painting. He felt he could do better.

The year 1911 was proving to be as tumultuous in Kandinsky's life as the paintings he was now producing. First there was the Schoenberg concert, then the groundbreaking *Picture with a Circle*, after which came the early publication of his book. That's a lot in one year. But there was more to come. The Russian artist had fallen out with his German colleagues within Munich's avant-garde. He had been the leader of the art pack but went off his friends when they started to

question his move towards abstraction. He stormed off to set up his own club, a multi-disciplinary collective called Der Blaue Reiter (the Blue Rider).

Invitations went out to Robert Delaunay and Arnold Schoenberg, both of whom accepted. As did two German artists, Franz Marc (1880–1916) and August Macke (1887–1914), who had also fallen out with Munich's fashionable artistic set. The 'Blue' in Blue Rider was symbolically important to the group, who believed that the colour was imbued with unique spiritual qualities. Blue, they thought, could synthesize the inner nature of things – feelings and the unconscious mind – with the external world and the universe. The 'rider' was symbolic too. The artists shared a love of horses that came from their romantic interest in folklore. They associated the animal's primitive nature with their own artistic goals of adventure, freedom, instinctive action, and a rejection of the modern, commercial world.

The group gave Kandinsky the creative space he needed to continue work on what would be his most important series of paintings, once again prefixed with a musical metaphor. He had started work on his *Compositions* in 1910, with the ambition of making paintings that had the scale and structure of a symphony. His first three *Compositions* were destroyed during the Second World War, which today makes *Composition IV* (1911) the first in the series. It shows the continued influence of the Fauves on Kandinsky in what is a highly colourful canvas measuring an impressive 2 by 1.59 metres.

It also demonstrates how unhappy he must have been with the total abstraction of *Picture with a Circle*, because *Composition IV* – painted in the same year – is reasonably figurative. It shows a landscape of three mountains: a small purple one on the left, a big blue one in the middle, and an even bigger yellow one on the right. Atop the blue peak is a castle, while two towers adorn the side of its yellow neighbour. Three Cossacks stand in front of the blue mountain, holding two huge black lances that effectively divide the painting in two. To the right of the lances all is peace and harmony, with two

lovers reclining amid a palette of gently blended pastel colours. On the left-hand side of the lances, life is a good deal livelier. Two boats, with oars protruding wildly, struggle against a stormy sea. Black painted lines criss-cross in mid-air like swords in a fight, and a violent storm announces itself in the arch of a timid rainbow.

The painting is dealing with many of Kandinsky's concerns: the relationship between man and myth, heaven and earth, good and evil, war and peace. They are epic themes that were also close to Wagner's heart and to the spirit of German Romanticism. But it still wasn't the *Gesamtkunstwerk* that Kandinsky sought. It did not compare to the great German composer's own success in creating a total work of art, which he believed he achieved with the *Ring Cycle*. For that, Kandinsky had to wait another two years.

Composition VII (1913) (see Plate 15) is Kandinsky's *Ring Cycle*. It was the pinnacle of the series and of his career. Measuring 2 by 3 metres, it was one of his largest paintings and the triumphant culmination of years of study, preparatory sketches and artistic enquiry. Kandinsky now knew that abstraction was the magic ingredient when it came to making a painting that could stand comparison with a symphony. Leaving the viewer with no visual clues as to its subject, *Composition VII* demands that we confront it on its own terms.

The artist has placed an ill-formed black circle in the middle of the painting: an eye at the centre of his psychedelic storm. Around it colours explode like fireworks, randomly going off in all directions. The left-hand side of the picture is more chaotic, more frenzied, as multicoloured curved lines scar the surface, and patches of black and deep red suggest wounds inflicted and received. The right side appears calmer, with larger areas of paint merging more harmoniously. But as the eye travels to the edge of the picture, darkness descends amid a harrowing build-up of blacks, greens and greys.

The natural inclination to try and decode the image is thwarted by Kandinsky's steadfast refusal to provide any identifiable clues to known subjects. Which makes the painting both exhilarating and

exhausting to study. Remarkably, it succeeds in its desired effect: you do start to 'hear' the paint, to put sounds to his brushstrokes. Colours crash together like cymbals; the jagged yellow lines are the noisy blasts from a trumpet; the black centre evokes the intense whine produced by a bank of violinists. A big bass drum drones in the background. And then in the centre at the bottom of the picture is one thin black line, exposed and alone. That is surely the conductor; the person charged with bringing some order to the chaos.

Looking on and admiring Kandinsky's virtuosity was the Swiss-born German artist Paul Klee (1879–1940). Like Kandinsky, he had studied in Munich and experimented with German Expressionism and Symbolism. He also shared a similar outlook on life to the Russian, believing that art could help connect Man to his environment and his spiritual self. And he too had a profound love of music (Klee's parents were musical, his wife a pianist) and an interest in primitive and folk art. Kandinsky invited the younger artist to join the Blue Rider group. It was the making of the man.

Although naturally gifted, Klee had been struggling to find his artistic voice. He had studied the old masters, the Impressionists, the Fauves and the Cubist work of Picasso and Braque but had yet to settle on his own style. Kandinsky, Delaunay and other members of the Blue Rider group gave him the confidence and encouragement to pursue a personal vision. His moment of revelation duly arrived; however, for Klee it did not come through music, but through travel. In 1914 he went to Tunis to paint, an experience that changed him and his art. Before the trip he had mainly been producing graphic sketches, etchings, and black and white prints.

After a few days in Tunis his eyes were opened to the true potential of colour by the light of north Africa. A long personal struggle was over. A relieved and excited Klee announced, 'Colour and I are one. I am a painter.' A statement that is backed up by *Hammamet with Its Mosque* (1914), a watercolour he painted while in Tunisia. It is a picture of two halves bound together with a blend of delicate pinks. The

top half is a fairly straight skyline representation of the small town of Hammamet, to the north-west of Tunis. There's the mosque and some leafy trees lit by a light blue sky. The bottom half is closer to abstraction. An imaginary patchwork of pinks and reds, interspersed with a dash of purple and green, covers the canvas like a thin quilt.

The composition responds to the spirituality that lay at the heart of the Blue Rider group. Real life is represented in the top half, only to fuse with the ethereal world that Klee has laid out on the bottom half of the picture: internal and external worlds expressed and combined through colour. Klee, like Kandinsky, believed art wasn't there to 'reproduce the visible; rather, it makes [life] visible'.

The telltale signs of the mature Paul Klee are also visible in the painting: the informal and childlike style, the unrealistic and naive choices of colour that create a surprisingly sophisticated design, one in which tones support and define each other. Like all his work it is a hotchpotch of influences, from the two-dimensionality of Braque's Cubism, to Delaunay's lyrical Orphism and the contrasting palette of Kandinsky's abstraction, which is really the artist's subject. But the design is united by his own unique draughtsmanship.

Klee would start a picture with a point and then 'take a line for a walk'. He had no real idea what he would end up with, but reckoned all would become apparent after a while: an image would emerge, which he would then build with sections of flat blocks of colour. And as he painted he would hear music while he set down his palette, feeling the different sounds each shade represented as he constructed his image.

Kupka, Delaunay, Kandinsky and Klee marched towards abstraction with music ringing in their ears. They produced paintings that cut out the known world so that the viewer's senses and soul could be awakened and freed from the prison of reality. To achieve this they made colour and music the subject of their art. Surely that was the end of the journey to abstraction. I mean, where else was there to go?

10

SUPREMATISM/ CONSTRUCTIVISM: THE RUSSIANS 1915–25

One unconventional option for taking a non-musical approach to abstract art would be to abandon the notion of a subject – physical or imaginary – altogether. I know, it sounds daft. After all, how can you depict nothing?

The answer is, you can't. But you could make an artwork that is focused on the physical properties of the work itself. Instead of attempting to depict real life – landscapes, people, objects – its purpose could be an examination of the colour, tone, weight and texture of paint (or whatever materials have been used to create the artwork); and the sense of movement, space and balance of the composition. Art that rejects the pre-existing and aims to create a new world order.

To do that would require removing the element of anecdote from art, which seemed like a preposterous idea. Art is a visual language; description and depiction is its job. A painting or sculpture without allusion would be like a book without a story or a play without a plot.

Even the abstract art of Kandinsky and Delaunay offered the viewer some aspect of narrative, either in the form of musical symbolism and biblical allegory (Kandinsky) or a tangible starting-point such as the colour wheel (Delaunay). To focus purely on the technical and material aspects of an artwork and its relation to life, the universe and everything would necessitate a comprehensive re-evaluation of the role of art, and the expectations of the viewer. It would mean breaking with the artistic tradition of allusion that dates back to prehistoric cave paintings. And for that to happen would require a very particular set of circumstances.

Poppies, we know, grow in disturbed ground. Go to the fields of northern France, where the gruesome battles of the First World War were fought, and, if it is high summer, you will see an effervescent red glow like a morning mist hovering over the ground. It comes from the millions of poppies that now live on that land, the soil of which was ploughed by bombs and enriched with the flesh and blood of the dead.

Calamitous upheavals and seismic events also have a tendency to foster great art. It is no coincidence that modern art emerged from France, a country that had been embroiled in revolution and war. Or that this next big break from tradition – the abandonment of representation – would happen in a country similarly populated by an avant-garde intelligentsia that was caught up in the civil unrest being stoked by rebellious-minded leaders.

It was the artists of revolutionary Russia who wrote the next chapter in the story of modern art. The country had endured a traumatic start to the twentieth century. A war with Japan, begun in 1904, had ended in humiliation and defeat, the blame for which was laid at the door of the country's autocratic monarch, Tsar Nicholas II. The unpopular sovereign's problems were compounded by domestic strife. Russia's working class, which accounted for the vast majority of the country, were bitterly disillusioned with the bad conditions, poor pay and long hours that Tsar Nicholas and his aristocratic chums were

forcing them to endure. Their fury culminated on 22 January 1905, in a protest march that ended at the Tsar's sumptuous Winter Palace in St Petersburg. But once there they found the Tsar in no mood for compromise. The country's royal ruler ordered the police to attack the demonstrators, the result of which was the death of over 100 protesting workers at an event that came to be known as Bloody Sunday.

The Tsar's callous methods proved effective: the protesters were driven into the ground. But then, so were the seeds of the Tsar's eventual downfall. The workers left the scene, but they would not go away. In October 1905 a massive national strike led to something of a revolution, aided and abetted by the establishment of the St Petersburg Soviet (a workers' council) by, among others, Leon Trotsky. Soon there were fifty soviets around the country. Meanwhile Vladimir Lenin, the leader of the Bolsheviks, among whose number was Joseph Stalin, proclaimed that 'the uprising has begun'.

The Tsar survived by agreeing to set up the Duma, a parliamentary body in which the workers would have representatives. But he didn't really believe in it and nor did the plotting revolutionaries. The loathed monarch was saved by the advent of the First World War in 1914. The country united behind the Tsar, who added to his new-found allure by taking personal charge of what was widely perceived to be an under-performing army: not, it turned out, a good long-term plan for a bad leader. The army did no better with the sovereign in charge, the only difference being that the public now had someone at whom they could point the finger of blame. In 1917 Tsar Nicholas II was unceremoniously ousted from power, and he was murdered a year later. Lenin and his Bolshevik party were now in charge of Russia, declaring it a Communist republic fuelled by the power of the people's belief in a utopian ideal. Russia had changed beyond recognition and, by the time Lenin took charge, so had art.

While Trotsky, Lenin and Stalin plotted and planned to create a hitherto untried and untested form of egalitarian government, so the country's avant-garde artists thought to make a type of art that had

never been previously envisaged. The Bolsheviks settled for a Karl Marx-inspired system called Communism. The artists came up with a new type of art that was intended to be equally as advanced and democratic, called non-objective art.

In terms of global influence and longevity the Russian artists beat their politicians hands down. Communism caused a cold war with the West, could have ended in Armageddon, and eventually failed. Whereas non-objective art gave form to twentieth-century modern design and provided the basis for Minimalism to emerge in America around fifty years later, a development that is not without irony. While the politicians embarked on a cold war, art was demonstrating that the two countries influenced each other more than either cared to acknowledge.

The Russian painter Natalia Goncharova summed up the confidence surging through the Russian artists' veins in 1912 when she wrote, 'Contemporary Russian art has reached such heights that, at the present time, it plays a major role in world art. Contemporary Western ideas can be of no further use to us.' Which was a backhanded way of admitting that she and her fellow Russian artists had happily absorbed everything western European art had to offer and were now ready to go it alone.

Many Russian artists had travelled extensively throughout Europe in their quest for artistic inspiration and enlightenment. Even the indigenous artists who were unable to make the trip to Paris or Munich could see the finest examples of the most recent work by the international avant-garde at the Moscow home of Sergei Shchukin, a wealthy textile merchant and passionate collector of the very latest modern art. Every Sunday he would invite Russia's leading artists and intellectuals to his house to peruse his museum-quality collection of art.

By 1913 the progressive Russian artists had caught up with their western European counterparts. They had assimilated the ideas and styles of Monet, Cézanne, Picasso, Matisse, Delaunay and Boccioni and were now advocates and practitioners of Cubo-Futurism. The St

Petersburg set had become so confident in their artistic talents that they started to question the adventurousness of their friends in the West. Several Russian artists thought that Picasso et al. had gone so far, but not far enough.

Among them was Kazimir Malevich (1878–1935), a talented painter in his mid-thirties who was still working in a Cubo-Futurist style at the beginning of 1913, although his frustrations with the Franco-Italian art movement were beginning to show. Malevich had begun to toy with the idea of 'alogism' – an obscure 'ism' that derives from the word 'alogia', meaning absurd from a 'rational' point of view. The artist was interested in the intersection where common sense and absurdity come into conflict. He made a 'manifesto painting' called *Cow and Violin* (1913), which is largely a standard Cubo-Futurist painting featuring lots of overlapping two-dimensional planes with a violin placed front and centre. Nothing unusual about that. But there is about the short-horned cow he has painted bang in the middle of the picture, standing side-on and looking rather perplexed. It's funny, it's odd and it's whimsical – a moment of light relief from the self-conscious earnestness of modern art. *Cow and Violin* foreshadows both Dadaism and Surrealism and could quite easily be mistaken for the work of Terry Gilliam, creator of the surreal Big Foot illustration in *Monty Python's Flying Circus*. Malevich, like many great artists, was quick to read the signs of the time.

His experimentation with the absurd and the artist's right to self-expression was in keeping with the spirit of the Russian avant-garde, which had developed its own anti-establishment take on Futurism, summed up in the title of their 1913 Futurist manifesto, *A Slap in the Face of Public Taste*.

An artistic threat they carried out with an incomprehensible Futurist-themed opera called *Victory Over the Sun* (1913). The libretto was written by the Russian Futurist poet Alexei Kruchenykh (co-author of the *Slap in the Face* manifesto) in an invented 'transrational' language called *zaum*: a nonsensical version of Russian based on the emotive

sound of words and not their meaning – thus stripping them of their intended descriptive faculties. The plot was equally offbeat.

The Strong Men of the Future grab the sun from the sky and imprison it in a box, on the basis that it represents the decadent past, old technology and an over-reliance on nature. With the sun duly removed, the earth is free to blast gloriously through space and into the future. At which point a time traveller enters the fray, and zooms off into the thirty-fifth century to see how everybody is getting along in a new world powered by man-made inventions. He discovers that the New Men are doing well and loving the high-tech energies of their space-age life, but there are some – the Cowards – who are struggling to cope because they're 'not strong'. You get the drift.

Not so the audience who had gathered at Luna Park Theatre, St Petersburg, for the opening. They went home baffled and annoyed. The text was unintelligible, the story too 'far-out' and the opera's music failed to offer any respite. The score was composed by Mikhail Matyushin (1861–1934) and included tuneless passages and jarring quarter-tones, of which only small fragments remain. And that's a shame for hardcore Futurist fans and musicologists, but for most of us it's probably not a great loss. Either way, the music wasn't Maty-ushin's most important contribution to the production, or to the arts.

That came by way of his invitation to Kazimir Malevich. The composer asked his artist friend to design the production's sets and costumes. Malevich accepted and produced a Cubo-Futurist extravaganza of colourful, robotic-like bodysuits and backdrops decorated with geometric shapes. They were flamboyant and suitably futuristic, although in this context not particularly radical. Except for one piece of scenery that appeared towards the end of the opera. It was a plain white backdrop on which Malevich had painted a single black square. The intention was for this to be part of the overall scenery design, not an artwork, but that's not how it worked out.

The simple black square on a white piece of cloth would become one

of art's great seismic moments, to rank alongside the discovery of mathematical perspective, Cézanne's binocular experiments and Duchamp's urinal. Not that Malevich was aware of the significance of his composition at the time. But come 1915 and a second staging of the opera, the artist had fully grasped the implications of his black square. He wrote to Matyushin – who was working on the reprise – and asked: 'I'll be very grateful if you yourself would position my curtain design for the act in which the victory is won [and where the black square appears] . . . This drawing will have great significance for painting; what had been done unconsciously is now bearing extraordinary fruit.'

The 'fruit' to which he referred was a style of artistic expression that was genuinely original. He called it Suprematism, a form of pure abstraction: a totally non-descriptive type of painting. Malevich's Suprematist pictures consisted of either single or scattered two-dimensional geometric shapes painted on a white background. Each square, rectangle, triangle or circle was block-painted in black, red, yellow or blue (and occasionally green). The artist said he was removing all visual clues to the known world so that the viewer could enjoy the 'experience of non-objectivity . . . the supremacy of pure feeling'.

As was Malevich's way, he started out by making a 'manifesto' painting to epitomize this new direction in art. Inspired by his own piece of scenic design in *Victory Over the Sun*, he had selected a 2.5ft square canvas, painted the whole thing white, and then painted a large black square in the middle. He called the work *Black Square* (1915) (see Fig. 15). To choose such a bone-dry literal title was a provocative act. He was challenging the viewer not to look for meaning beyond the painting itself. There was nothing else to 'see' – everything they needed to know was in the title and on the canvas. Malevich said he had 'reduced everything to nothing'.

He wanted people to study *Black Square*. To think about the relationship and balance between the white border and the black centre: to enjoy the texture of the paint, to feel the weightlessness of one colour and the density of the other. He even hoped that these 'tensions'

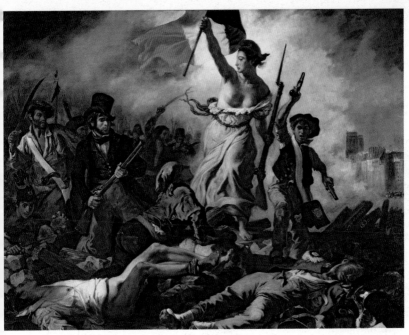

1. **Eugène Delacroix,** *Liberty Leading the People* (1830)

2. **Édouard Manet,** *Olympia* (1863)

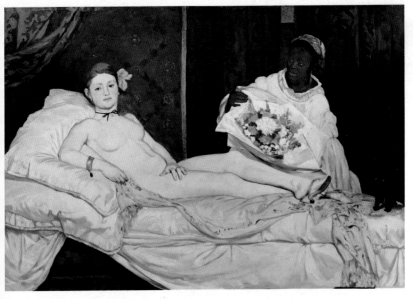

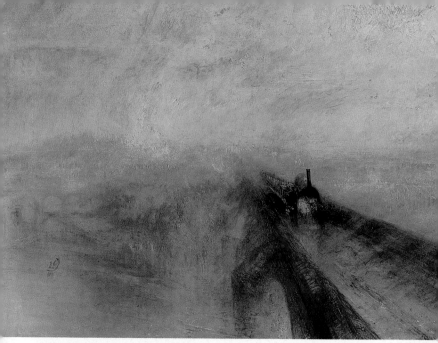

3. **J. M. W. Turner,** *Rain, Steam and Speed* (1844)

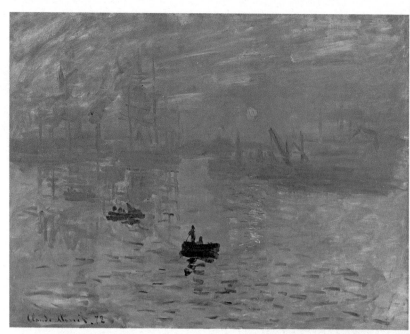

4. **Claude Monet,** *Impression: Sunrise* (1872)

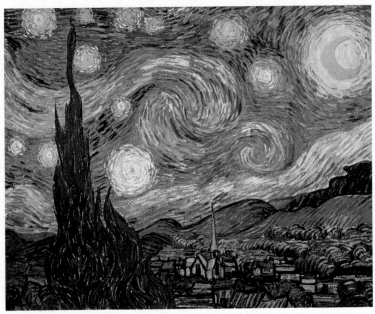

5. **Vincent van Gogh,** *The Starry Night* (1889)

6. **Paul Gauguin,** *Vision After the Sermon* (*Jacob Wrestling with the Angel*) (1888)

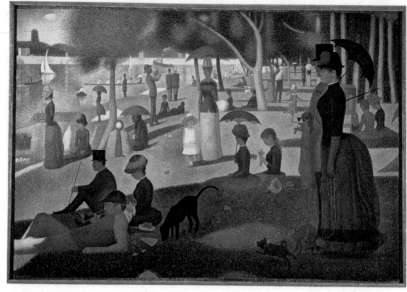

7. **Georges Seurat,** *A Sunday Afternoon on the Island of La Grande Jatte* (1884)

8. **Colour wheel**

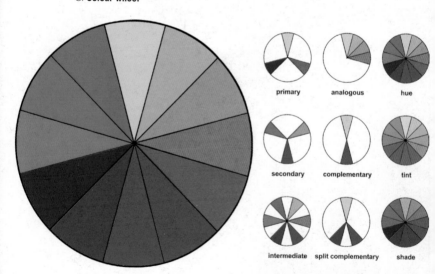

primary

analogous

hue

secondary

complementary

tint

intermediate

split complementary

shade

9. **Paul Cézanne,** *Still Life with Apples and Peaches* (1905)

10. **Paul Cézanne,** *Mont Sainte-Victoire* (*c.*1887)

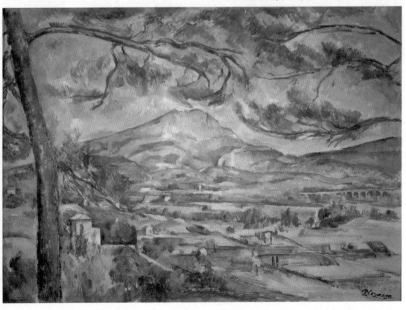

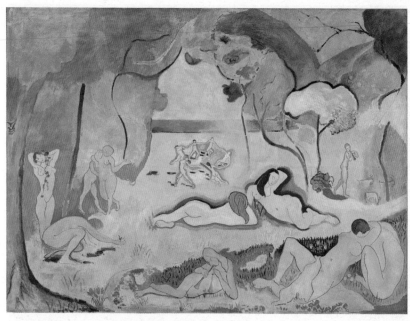

11. **Henri Matisse,** *Le Bonheur de Vivre* (1905–6)

12. **Henri Rousseau,** *The Hungry Lion Throws Itself on the Antelope* (1905)

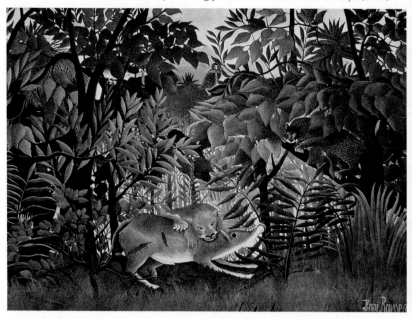

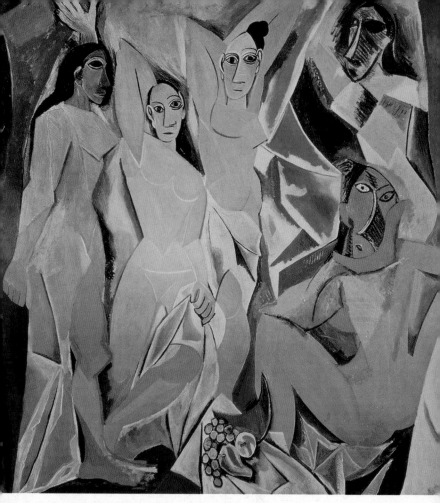

13. **Pablo Picasso,** *Les Demoiselles d'Avignon* (1907)

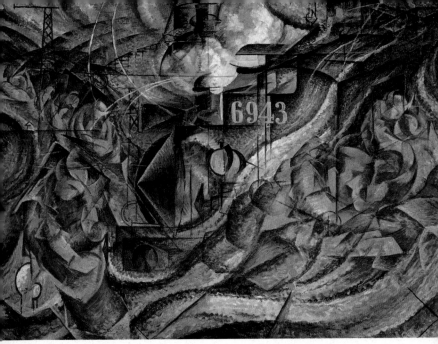

14. **Umberto Boccioni,** *States of Mind I: The Farewells* (1911)

15. **Wassily Kandinsky,** *Composition VII* (1913)

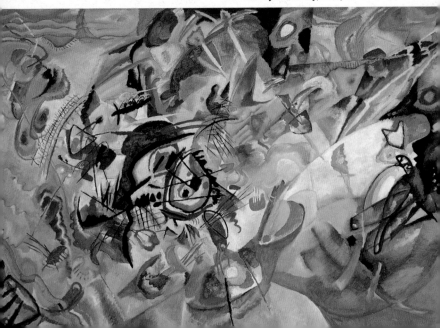

within his ultra-static image might give people a sense of dynamism and movement. All this was possible in Malevich's mind because he had 'freed art from the burden of the object'. We were now free to see everything and anything we wanted.

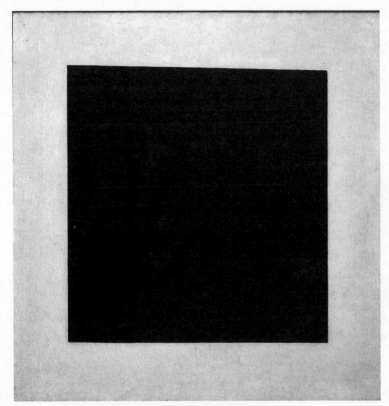

Fig. 15. **Kazimir Malevich,** *Black Square,* **1915**

Black Square might appear simplistic, but Malevich's intentions were complex. He knew that even though he had removed all reference to the known world, the viewer's brain would attempt to rationalize the painting: to attempt to find meaning. But what was there to make sense of? People would inevitably keep coming back to the essential fact that it was a black square on a white background.

Their conscious minds would be locked in a frustrated cycle like a Sat Nav searching for a signal. Meanwhile, as this confusion was going on, Malevich hoped that deep within the viewer's psyche their unconscious mind would get a chance to work its magic. And once it had escaped from its rationalist prison, the unconscious mind would be able to 'see' that the artist was presenting the entire cosmos, and all life within it, in his small, square, simple painting.

Malevich thought that his two-tone picture embodied the earth in the universe, dealt with light and darkness, life and death. And, as with all his Suprematist paintings, there is no picture frame surrounding this work because it would be too restrictive, too suggestive of terrestrial boundaries. Instead, the white background morphs into the white wall upon which the painting is hung to give a sense of infinity. The black square floats in space, unhindered by the pull of gravity: a sign of an ordered cosmos or a hole into which all matter has been sucked. Either way, it was a leap into the dark.

Suprematism was an audacious concept. At least Kandinsky's abstract paintings gave the viewer a visual treat, even if they were indecipherable. Nobody could stand in front of one of his giant *Composition* canvases and fail to be impressed by the beauty of the erupting colours dancing over the painting's surface. Love them or loathe them, there's no doubting that Kandinsky could paint like few others. Not so with Malevich's Suprematism.

A black square on a white canvas? Come on. We could all do that. Why are his efforts revered and worth millions of dollars when ours would be considered facile and worthless? Is it, as the contemporary British artist Tracey Emin once said when defending a similar accusation about her own work, simply a case of having thought of the idea first?

Yes, to a certain extent, it is. Original thought in art is important. There's no intellectual value in plagiarism. But there is in authenticity. Modern art is about innovation and imagination, not the status quo, or worse: pale imitation. And then there's the financial value we

place on rarity in our capitalist society, where the laws of supply and demand rule. Put all three together – originality, authenticity, rarity – and you have the reason why a Malevich *Black Square* is worth a million dollars and a version by you or me is not. His is a historically important, unique object that had a far-reaching impact across the visual arts.

When people say, 'That looks cool,' they are often referring to something that has been created by a designer seemingly influenced by Malevich's abstract art. Tom Ford's 'look', Bang & Olufsen products, the Factory Records' covers, the London Underground logo, Brasilia, infinity swimming pools: they all share the same blueprint, which is the geometrical abstract art of Suprematism. Remove the clutter, simplify the shape, reduce the colour palette and concentrate on the purity of form. We can't help feeling that the spare, minimal look is a sign of intelligence, thoughtfulness, modernity and sophistication.

Yet when we look back to the genesis of those designs, to Malevich's *Black Square*, there remains a suspicion that the painting was – and still is – a con, a tease: silly. I can see why (although that was never the artist's intention), because the artist is asking a great deal of the viewer. The scepticism that surrounds *Black Square*, and almost all the abstract art that has followed in a similar vein, is the result of Malevich turning the traditional relationship between artist and audience on its head.

Historically the artist's role was to be subservient. Painters and sculptors were there to document, inspire and beautify on behalf of the establishment and us. We enjoyed the privileged position of being able to decide whether or not the artist had made a decent fist of representing a church/dog/pope. Even when artists rebelled against the Academies and went their own way, leading to paintings becoming less and less clear, we retained the upper hand. It was still up to the artist to please or intrigue us with a portrayal of the known world. Kandinsky's abstraction took a higher-status approach by asking us to meet him halfway. The deal being that Kandinsky would paint a

lovely, vibrant picture in the hope that we would resist the temptation to translate the colours into known objects or themes, but instead allow ourselves to be transported into an imaginary world in much the same way as we would if listening to a piece of music.

Although, when it came to it, Kandinsky left enough narrative hints and exquisite colour combinations in his paintings for people to be able to enjoy the pictures for what they were, without having to go down the whole 'What does this all mean?' route. Malevich's non-objective art offered no such concessions. His was a blunt confrontation with the viewer, challenging anyone looking at *Black Square* to believe that it was more than a superficial black and white design. 'Colour and texture in painting are ends in themselves,' Malevich concluded.

He was, in effect, turning the artist into a shaman. And art into a mind game in which the artist sets all the rules. The person with the paintbrush or sculptor's chisel was now the dominant figure in the relationship, having thrown down the gauntlet to a newly subordinate and vulnerable viewer, daring us to take a leap of faith. Which remains the case today: abstract art puts us all at risk of looking like suckers, believing in something that isn't there. Or, of course, blithely dismissing a revelatory work of art because we don't have the courage to believe.

Malevich worked in secret on his Suprematist paintings during the two years that followed the 1913 premier of *Victory Over the Sun*. He said they were 'leading me to discover things still outside of cognition'. Which was a grand claim. As was his assertion that 'my new painting does not belong solely to the earth'. He went on to call himself the 'president of space', and pondered the idea of a Suprematist satellite that would 'travel in its orbit, creating its own path'. He then added to his busy intergalactic workload by setting himself the task of 'recoding' the world.

His comments, although eccentric, reveal the frame of mind in which many artists and intellectuals found themselves at the beginning of the

twentieth century. The notion of space travel was still a case of science fiction and not a matter of fact. Travelling beyond the earth was a thrilling prospect full of limitless possibilities that could be mulled upon by those optimistic souls blessed with a vivid imagination. But Malevich's statements have a moodier, less positive edge. They hint at a growing sense of disquiet among the avant-garde about the side-effects of modernization. The catastrophe of the First World War was unfolding before their eyes; communities were rupturing; millions were dying. Kandinsky, Malevich and many other artists identified society's obsession with materialism and a creeping selfishness as the reasons for the turmoil and bloodshed.

Malevich thought it time for a fresh start, to build a utopian ideal: a system in which everyone could live happily ever after. His contribution would be a new form of art that obeyed the laws of the universe and would bring order to the global unrest. His painting *Suprematism* (1915) combines many of the recurring themes of Malevich's new movement. It is a portrait-format canvas on which he has arranged a series of rectangles of varying widths and lengths – some so thin as to be more like a straight line – on a white background. The top half of the picture is given a downward diagonal trajectory by a large black rectangle that widens slightly as it makes its forty-five-degree descent. Smaller blue, red, green and yellow rectangles overlap the black shape. A thin black line divides the picture in two. Below it is a small red square on top of thick, rectangular strips of yellow and brown. There is no recognizable worldly subject; the picture is about the feeling it evokes in the viewer. And this feeling, due to the way the shapes interact on the white expansive background, might be a reflection of the constant motion of everyday life in the universe. Each individual block of colour in the painting affects the appearance of the others – in the same way that we impact on each other in our day-to-day routine. In Malevich's eyes, Suprematism was pure art, in which it was the oil paint that dictated colour and form, and not shapes copied from nature.

The canvases that Malevich produced between 1913 and 1915 were displayed in what has since become a legendary exhibition. It was a group show held in Petrograd (now St Petersburg) called *The Last Futurist Exhibition: 0,10*, which was an intentionally dramatic title. It was a message being sent to the world from the experimental artists of Russia, announcing the end of Italian Futurism (before the colon), and the beginning of a new phase in modern art (*0,10*) on the other side. The title *0,10* (or *Zero-Ten*) was Malevich's idea. It refers to the ten original artists chosen to exhibit (fourteen did so in the end), all of whom had gone to 'zero'. Meaning, in Malevich-speak, they had removed all recognizable subject matter: they were depicting nothing.

Malevich presented dozens of his Suprematist paintings, with *Black Square* given pride of place. It was hung near the ceiling, high up in a corner, positioned diagonally across the right-angle where the two walls meet. The location was important. It was an allusion to the iconic status Malevich was attributing to the painting, as it is the position in Russian Orthodox homes reserved for religious iconography.

Among the other artists exhibiting with Malevich was fellow Ukrainian Vladimir Tatlin (1885–1953). The two were respected figures in the Russian avant-garde art scene. They were both influential members of the Union of Youth, a society for new writers, musicians and artists based in St Petersburg. They had shown their work in the same group exhibitions. And it would be Malevich and Tatlin who led the way for non-objective art. They could have been the Braque and Picasso of eastern Europe, struggling heroically together to break new artistic ground. Instead, they were more like Tsar Nicholas II and the Bolsheviks. Jealousy, rivalry and artistic differences led to heated disagreements and great dislike. By the time of the *0,10* exhibition, they loathed the sight of each other.

As the opening of the show drew nearer, so their levels of hostility rose. They covertly prepared their works for the exhibition, lest the other should steal a march (and an idea) and therefore receive the greater acclaim. The pressure of the last-minute preparations added a

pinch of paranoia to their already poisonous relationship. A situation not helped when Tatlin discovered that Malevich had hung *Black Square* in a corner. Tatlin was furious.

The corner was his brainchild. He'd specifically created a sculpture to be hung in the corner of the room called, appropriately enough, *Corner Counter-Relief* (1914–15) (see Fig. 16). And now here he was, faced with his arch competitor stealing his idea and diminishing the impact of his work. It was the final straw. And so like all men in such moments – even avant-garde artists – they chose to resolve their differences in the time-honoured fashion and had a full-on fistfight (history does not relate who won).

As for the exhibition, it was indeed Malevich who stole the thunder. Suprematism was successfully launched, and *Black Square* was the star of the show – although most visitors were utterly perplexed. But that was then; today Tatlin's *Corner Counter-Reliefs* are rightly recognized for what they were: a sculptural revelation. Made out of tin, copper, glass and plaster, Tatlin made several of these curious constructions, which were strung across a corner at chest height. They had been inspired by his visit to Picasso's studio in Paris in 1914, shortly before the war started. There he saw the Spaniard's *papier collé* assemblages, including the famous *Guitar* (1912). Tatlin could see a way of using the technique to create his own art – not from bits and bobs found in the studio as Picasso had done, but by using modern building materials for his own constructions. For Tatlin this made sense artistically and politically. Glass, iron and steel represented the future in Russia's Bolshevik-inspired industrial age. He was convinced that he could piece them together (construct) in such a way as to make an artwork more interesting and powerful and honest than Malevich's stark paintings, laden with cosmic symbolism.

Tatlin's art had no such other-worldly pretensions. It was what it was and that was that. In an approach to aesthetics not dissimilar to that of an architect, Tatlin's interests lay in the physical properties of the materials he was using, and in their arrangement. His three-dimensional

Corner Counter-Reliefs aimed to draw attention to the fabric of the artwork's construction, the nature of the materials and the volume and the space they occupied. Unlike Picasso, he didn't much alter the oddments he used by way of paint or preparation, nor did he configure

Fig. 16. **Vladimir Tatlin,** *Corner Counter-Relief,* **1914–15**

them in such a fashion that they could be deemed to represent something. Although more practical than Malevich, his non-objectivity shared many of the same concerns: objects in space, defying gravity, texture, weight, tension, tone and balance.

Tatlin's suspended *Corner Counter-Reliefs* of 1915 still feel modern. The sheet-metal he manipulated into spheres and curves pre-empts of the architecture of Frank Gehry, most particularly the

rolling roof of his fêted Guggenheim (1997), in Bilbao. Then there's the taut wire that stretches across the intersecting walls, holding together Tatlin's assembly of materials, which brings to mind Norman Foster's spectacular suspension bridge spanning the Millau Viaduct (2004) in central France. And there's something of the satellite orbiting the earth in the way the incongruous *Corner Counter-Reliefs* hang in the air. And that's before acknowledging the influence they had on the future of art. Tatlin reconceived the notion of sculpture. Here was a three-dimensional work, which for the first time did not attempt to copy or caricature real life, but was an object in its own right, to be judged on its own terms. It wasn't on a pedestal, you couldn't walk round it and it had none of the solidity of stone or brass.

The DNA of Tatlin's *Corner Counter-Reliefs* can be found in the abstract sculptures of Barbara Hepworth and Henry Moore, in the Minimalist fluorescent light pieces by Dan Flavin and the stack of builder's bricks used so famously by Carl Andre. There is no doubt that the exhibition's title was correct; the show did signal the end of Futurism.

It launched Malevich's Suprematism and Tatlin's Constructivism into the world, although in the case of Tatlin's movement, it was not officially named and launched as such until 1921 in the Constructivist Manifesto. But the term Constructivism had been floating around from around 1917, when the mischievous Malevich referred to it unflatteringly as being 'construction art'.

The Russian avant-garde had put art on a new footing just as Lenin was doing the same for the world with the creation of his Socialist state. The opinionated politician had views on most things, including art. For starters, art as practised by the West was decadent, capitalist and bourgeois. In the new Soviet Russia, he proclaimed, art should have a purpose. It should be 'intelligible to millions', serving the people's needs and those of the regime. Tatlin, by now installed in a senior position within art academia, was fully on board. As were his

fellow Constructivists Lyubov Popova (1889–1924), Aleksandr Rodchenko (1891–1956) and Aleksandra Ekster (1882–1949).

In an unusual alliance in the story of modern art, the artists of Russia were wholeheartedly with the establishment, not against it. And what better way for the Bolsheviks to promote their radical and progressive new way of life than embracing the country's radical and progressive artists? The task given to the artists was straightforward: create a visual identity for Communism. The Constructivists accepted the brief and in so doing forever associated avant-garde art with the left.

They gave the utopian ideal of Communism a look that was instantly recognizable, confidently assertive and psychologically powerful. Building on Tatlin's non-objective artworks of 1915, the Constructivists went about defining the role of an artist within the community. The notion of an aloof intellectual producing arcane works that meant nothing to anyone bar a small self-selecting elite wouldn't do. Their role was to connect art with the people, to be at their service. Which meant being more than artists. In 1919 it was said that 'the artist is now simply a constructor and technician, a leader and foreman'. And to an extent they were, as well as being teachers.

Theirs was an egalitarian enterprise. And for once female artists were not relegated to the role of bit-part players, but had prominent positions at the heart of the movement. Lyubov Popova, Aleksandra Ekster and Rodchenko's wife, Varvara Stepanova (1894–1958), all played a major part in defining, developing and creating Constructivist art. Popova offered an early definition of their practice, saying 'construction in painting is the sum of the energy of its parts'.

They argued that even the role of an artist's canvas had changed and should now be appreciated for its own intrinsic artistic value: a 'concrete' material upon which their construction of geometric forms was painted. The Constructivists used the term '*faktura*' to describe their practice of accentuating and demonstrating the inherent properties of the raw materials of their paintings. The canvas, the paint, the

wooden stretchers upon which the canvas was attached, were all elevated in status as part of a constructed work of art.

Their passion for the materials and technology led them to take a keen interest in architecture. Some even called themselves artist-

Fig. 17. **Vladimir Tatlin,** *Monument to the Third International (Tower),* **1919–20**

engineers. Tatlin did. And it is for a building he designed, but that was never built, that the movement is now most famous. It is known now simply as Tatlin's Tower (see Fig. 17). If ever a project fully captured the ambition of an artistic movement it was his spiralling tower: a glass, iron and steel structure 400 metres high that was to be a statement to the world that the Soviet Union was bigger, better and much more modern than anywhere else (particularly Paris and its piffling 300-metre Eiffel Tower).

The size and the materials were just the beginning of the Russian artist's aspirational vision. It was to be called the 'Monument to the Third International': the global headquarters for Communism. The intention was to build it on the north bank of the river Neva in St Petersburg, with the building's tilting, tapering scaffold-like frame pointing up and out to the world at an aggressive, yet jaunty, sixty-degree angle. It had three levels, made out of typically Constructivist geometric shapes. At the bottom was the cube, which Tatlin said would revolve on its axis once a year. Above it he placed a smaller pyramidal structure that would rotate once a month. And on top of that the tower would have a cylindrical level, which would broadcast propaganda to the world. This was going to spin 360 degrees every day.

Tatlin did not consider his tower to be a work of art, but a serious proposal for a building. For which he got an A+ for effort and ingenuity, a B– for engineering (Could it actually be built? Probably not) and a straight 'Fail' for his timing. He completed the design in 1921, not a year for a Grand Project in Russia. The country was experiencing drought and crop failure and a catastrophic famine. Millions were dying, and Tatlin's Tower was not only a low priority, but possibly even a folly. It was placed on the back burner, never to reappear.

Meanwhile the other Constructivists were putting together an exhibition called $5 x 5 = 25$. Echoing Malevich's title of *0,10*, this 1921 Moscow show consisted of five artworks by five Constructivist artists. Tatlin's old cohorts Rodchenko and Popova were involved, but not the man himself. Rodchenko exhibited a triptych called: *Pure Red Colour, Pure Blue Colour and Pure Yellow Colour* (1921), which has the collective title of *The Last Painting* or *The Death of Painting*. Each monochrome canvas was simply covered in the colour of its title like a carpet tile. It was, Rodchenko said, what happens when you 'reduced painting to its logical conclusion'. 'I affirmed,' he declared, 'every plane is a plane and there is to be no representation. It's all over.' His description of the artwork was correct; his conclusion could not have been more wrong.

Those three monotone canvases are some of the earliest examples of what the world was going to see a great deal more of in the years to come: canvases painted with a single colour. In the future they would be presented under the guise of conceptual art, which was a different approach, but the result was the same. So what differentiates the finality of Rodchenko's monochrome canvases and those of the Abstract Expressionists that purported to contain a spiritual dimension which could stir deep, hidden feelings within the viewer?

Not much, is the answer. It is mainly an issue of the artist's intent. Rodchenko says his one-colour, all-over canvases are non-representational and no more than a piece of painted material, while Mark Rothko says that his monochrome canvas is much more; it has some mystical, emotional and spiritual depth.

Rodchenko's intention was to challenge the belief system that Malevich had instigated around his non-objective art. The Suprematist told the viewer that there was more to his triangles and squares than simply being pleasing pieces of graphic design; that his art contained hidden meaning and universal truths. As discussed earlier, this approach relies on the viewer believing that the artist is blessed with special talent and insight. But Rodchenko was saying that his Constructivist paintings were not special or transcendental works of art. In fact he downgraded them from art objects, saying that they were part of his ongoing research into the qualities of materials. The purpose of which was the construction of products.

In 1921 Rodchenko officially announced the arrival of the Constructivists with a manifesto. Almost immediately afterwards he produced another manifesto pronouncing a 'death to art', saying it was 'bourgeois'. To make his position clear – and that of his fellow Constructivist artists – a name change was required. Henceforth they were to be known as the Productivists. With that piece of administration complete, they abandoned the ivory tower of art and got on with the business of making stuff that was useful: they became designers, fulfilling Lenin's demand to broaden their contribution to society.

They designed posters, fonts, books, clothing, furniture, buildings, theatre sets, wallpaper and household products. Their output was prolific. They successfully reapplied the colour palette, the geometric shapes and the structural qualities they had developed in their Constructivist art to graphic design. The strident red, white and black colours of their posters are immediately recognizable. So are their bold, block-like fonts and patterned clothes.

Lyubov Popova designed some modish dresses decorated with green or blue circles that would not have looked out of place on the hedonistic flappers populating the jazz clubs from Montmartre to Manhattan (see Plate 17). Aleksandr Rodchenko became a master of print and graphic design. His cover for Leon Trotsky's book *Questions of Everyday Life* (1923) owes much to Malevich and Tatlin's non-objective art. A large red square on a white background takes centre stage. Through the middle of it are two question marks: a large version in black that runs from top to bottom, and a much smaller white version inside it like a faint echo. Thick red and black lines frame the top and bottom of the composition.

It's a striking image. But not quite as memorable as the poster produced by El Lissitzky (1890–1941), who had trained as an architect before falling under the spell of Malevich's Suprematism. The young Lissitzky was doing his artistic growing up amid the fervour of post-revolutionary Russia. The country had descended into civil war, with the anti-Bolshevik White Guard seeking to oust Lenin's Socialist government. Lissitzky wanted to do his bit to support the Bolshevik cause. He did so by producing a poster that used the geometric shapes, overlapping planes, and the black, white and red palette of Suprematism. *Beat the Whites with the Red Wedge* (1919) (see Plate 16) has since become one of the most iconic posters ever produced. Stark and clear, it is an exemplar of art being used for propaganda. Lissitzky divided the picture in half with a diagonal line, one side of which is white, the other black. On the white side is a large red, two-dimensional triangle, with its sharp point thrusting across the black/white

divide and penetrating the white circle that dominates the black side. Splintering away from the tip of the triangle are several red shards flying across the black space and surrounding the white circle.

It's interesting to see the shapes and style of non-representational art being used in a highly symbolic, representational manner. Lissitzky has incorporated them to tell a real world story with arresting directness, suggesting that Malevich and Tatlin were correct: these seemingly trivial shapes do trigger an emotional response from the viewer when arranged with poise and skill. Lissitzky's image and style have subsequently influenced many a graphic designer and several pop groups. Kraftwerk, the German electronic music pioneers, drew heavily on Suprematist and Constructivist aesthetics with their famous *Man-Machine* album cover (1978). And the Scottish band Franz Ferdinand went for a straight Rodchenko/Lissitzky pastiche when designing covers for many of their hits in the early 2000s.

The impact and lasting legacy of Lissitzky's poster demonstrates the power of non-objective art. In the hands of great artists it achieves its aim, to cut through the clutter of modern life and describe something deeper, more profound. That's why it affects us. There is something magnetic and attractive about the simplicity of those rigid shapes adorned with primary colours, which is impossible to explain or rationalize. Somehow, those Russian artists were able to reduce everything to nothing in order to expose more than we knew was there. It's about balance and optics, tension and texture. But more than that, it's about the unconscious. Art that we like but we don't quite know why. Malevich, Tatlin, Rodchenko, Popova and Lissitzky were brilliant visionaries, the pioneers of the first totally abstract art.

But they weren't alone . . .

11
NEO-PLASTICISM: GRIDLOCK 1917–31

There are times when those of us involved in the arts talk and write pretentious nonsense. It's a fact of life: rock stars trash hotels, sportsmen and women get injured, arts folk talk bollocks. Among the main culprits are museum curators, who have a tendency to write slightly pompous, wholly incomprehensible passages in exhibition guides and on gallery text panels. At best their talk of 'inchoate juxtapositions' and 'pedagogical praxis' baffles visitors: at worse it humiliates and confuses and puts people off art for life. Not good. But in my experience the curators are not trying to be deliberately obtuse; they are talented individuals catering to an increasingly broad constituency.

Museums are academic institutions full of very clever people, where it is not uncommon to discover that the security guards and café waiters have doctorates in art history from a leading university. The in-house atmosphere is intellectually competitive, where teasing and point-scoring over some esoteric painterly fact is part of the daily

banter. Detailed knowledge is the common currency; for example, knowing that Rothko used a glaze containing dammar, egg and synthetic ultramarine in his late works.

It is said that there is not enough art history to spread around all the art historians, which helps explain why those working in museums get so stuck in minute detail. Many artworks have had the life researched out of them: there is too much information. The poor museum curator has to assimilate all this info and then add his or her own thoughts in order to avoid being accused of plagiarism by fellow academics. The curator then has to put across that information in such a way that he or she is at zero risk of looking foolish in front of highly judgemental colleagues. That would be embarrassing and career-damaging. It is this tension, between professional standing and the needs of a first-time visitor, that causes the problem. Which is the reason the caption on the gallery wall, or essay in the exhibition handout, can be impenetrably full of arcane terms and phrases. The museum says the information is for the uninitiated visitor, but the truth is that, on occasion, it has been written for a handful of world experts in a language only art insiders would understand.

It is not unknown for the artist to fall into the same trap. I have interviewed brilliant artists who are rightly revered for the intelligence, insight and beauty of their work. And yet, when a microphone is placed under the artist's nose, all that clarity vanishes. It's not unusual to find that after listening to half an hour of sub-clauses, qualifications and meandering metaphor one is no nearer to understanding an artist's work: further away, in fact. It's like being in a world of Tristram Shandys, where people are chatty and amusing but never ever get to the wretched point.

But then, so what? Artists choose to communicate in a visual language, possibly because they find it hard to order their thoughts via the written or spoken word. And – at the risk of dipping my own toe into the pretentious pool – there is a paradox at play here. In my experience it is the abstract artists – those who spend their lives stripping

away detail to reveal a universal truth – that are the worse offenders when it comes to using flowery, imprecise language to describe their work. Malevich talked of spaceships and cosmological happenings, Kandinsky about hearing the sound of his paintings. Even the down-to-earth Tatlin would riff on notions regarding the materiality of volume, and the tension created by three-dimensional space. But first prize for bafflement when attempting to make sense of his own abstract art must go to the Dutch painter Piet Mondrian (1872–1944).

The man famous for his simple 'grid' canvases once chose to explain his work by employing the same convoluted, contrived narrative device used by the art critic Louis Leroy back in 1874, when he wrote his notoriously damning verdict on the first French Impressionist exhibition. Leroy's review consisted of a fictional conversation between himself and an invented (sceptical) artist. Mondrian cast his faux conversation differently: he played an intellectual modern artist, while he plumped for a singer (who might or might not have been real) to play the role of doubting observer, giving him licence to use musical references. Mondrian called it a 'Dialogue on the New Plastic' (1919); it starts like this:

A: *A Singer*

B: *A Painter*

A: I admire your earlier work. Because it means so much to me, I would like better to understand your present way of painting. I see nothing in these rectangles. What are you aiming at?

B: My new paintings have the same aim as the previous ones. Both have the *same* aim, but my latest work brings it out more clearly.

A: And what is that?

B: To express *relationships* plastically through oppositions of colour and line.

A: But didn't your earlier work represent *nature*?

B: I expressed myself *by means of* nature. But if you carefully observe the sequence of my work, you will see that it progressively abandoned the

naturalistic appearance of things and increasingly emphasized the plastic expression of relationships.

A: Do you find, then, that natural appearance interferes with the plastic expression of relationships?

B: You must agree that if two words are sung with the same strength, with the same emphasis, each weakens the other. One cannot express both natural appearance as we see it and plastic relationships with the same determinateness. In naturalistic form, in naturalistic colour, and in naturalistic line, plastic relationships are veiled. To be expressed plastically in a determinate way, relationships must be represented only through colour and line.

It goes on in this manner for quite a while, banging on about relationships and plastic. In his defence, Mondrian had set himself a tough task: to explain something that was entirely new and unknown. The structure and tone of the writing suggests that the Dutch artist did see himself as a teacher, an explainer – an individual whose job it is to make sense of life for the rest of us.

When Mondrian refers to 'plastic', he is talking about the plastic arts: a formal term used to describe painting and sculpting – where materials are shaped or moulded. His vision was a new (Neo) approach to the plastic arts (Plasticism), based on universal relationships. Like Malevich, Mondrian felt that he could develop a form of painting that would distil everything we know and feel into one simplified system and thereby reconcile the great conflicts of life. Malevich did so in response to revolutionary Russia; the impetus for Mondrian came from the bloodshed of the First World War. He formed his ideas for a new art – Neo-Plasticism – while the war raged between 1914 and 1918. His intention was to help society start afresh with a new attitude where unity, not individualism, was the priority. His aim was 'to express plastically what all things have in common instead of what sets them apart'.

He concluded that to achieve his ends would necessitate reducing

art to its bare essentials: colour, shape, line and space. And then, to simplify matters even further, he would present those bare essentials in their purest form: colour would be limited to the three primaries (red, blue and yellow); there would be a choice of two geometric shapes – squares and rectangles; and only horizontal and vertical straight lines painted in black would be used. There was to be absolutely no illusion of depth. With this irreducible kit of parts, Mondrian believed he could make sense of life by harmoniously balancing all the opposing forces of the universe. The rejection of any recognizable subject was essential to Mondrian. He did not think it was art's job to mimic real life: he thought art was *part* of real life, like language and music.

Composition C (No. III), with Red, Yellow and Blue (1935) (see Plate 18) is a 'classic' Mondrian. It has a plain white background (it was nearly always a white background), which the artist felt provided a universal and pure basis on which to construct a painting. On top of this he has painted a sparse grid of horizontal and vertical black lines of varying thicknesses. This is an important detail. Mondrian wanted to convey a sense of life's perpetual movement in his paintings, an aim he felt he could achieve subliminally by varying the width of the black lines. He reasoned that the thinner the line the quicker the eye 'reads' its trajectory and vice versa; so, if he altered the widths, he could use line like an accelerator pedal in a car. And that would help him succeed in his ultimate aim, which was to make paintings that possessed 'dynamic equilibrium'.

Balance, tension and equality was all for Mondrian. His art was a political manifesto calling for freedom, unity and co-operation. 'Real freedom,' he said, 'is not mutual equality, but mutual equivalence. In art, forms and colours have different dimension and position, but are equal in value.' In *Composition C (No. III), with Red, Yellow and Blue* – as in all his abstract works from 1914 onwards – the horizontal and vertical lines express the tensions between life's opposites: negative and positive, conscious and unconscious, mind and body, male

and female, good and bad, light and dark; discord and harmony: yin/ yang. Where the X- and Y-axes cross or join is the moment the relationship between the two is established and a square or rectangle is formed.

This is where the fun starts for Mondrian. His compositions are always asymmetrical, as it helped create a sense of movement, which set him the challenge of using his limited palette to balance the design. In the case of *Composition C (No. III), with Red, Yellow and Blue*, he has painted a large red square in the top left-hand corner, then counter-balanced it by placing a 'denser', but smaller, blue square at the bottom of the picture just to the right of centre. He has then added a thin yellow rectangle in the far left-hand corner, which acts as a counter-weight to the other two. The remaining white blocks, although 'lighter' than the colour sections, are given 'equivalence' by taking up more of the canvas than the three colours put together. No one element dominates: it's mutuality for all, on a flat surface, or, as the sporting cliché goes: on a level playing field. Mondrian said that 'Neo-Plasticism stands for equality because ... it is possible for each, despite differences, to have the same values as others.'

That's a revealing comment. It highlights the big difference between Mondrian's Neo-Plasticism and the abstract art of Kandinsky, Malevich and Tatlin. At no point in the Dutch artist's mature career do individual elements merge; they are always self-contained. There are no overlapping planes or tonal transitions. That's because Mondrian was concerned with unifying the relationships between the individual elements, and not the traditional romantic ideal of love, where two converge into one. He was defining a new social order.

Mondrian's journey to abstraction started in the same place as Tatlin's: Picasso's studio in Paris. Before his visit in 1912 the Dutchman was painting reasonably conventional naturalistic landscapes in a Fauvist and Pointillist style. But once he'd studied Braque and Picasso's Cubist paintings and earthy colour palette he returned home a changed man. Within a few years he too had invented a modern art

movement. Neo-Plasticism was to be the purest form of abstract art yet invented.

There is a terrific sequence of four paintings that show Mondrian's path from wannabe old master into pioneering modernist, all of which have a tree as the central motif. The first is *Evening, Red Tree* (1908). Mondrian has depicted an old, gnarled tree in midwinter. Dusk has fallen, leaving a blue-grey background against which the leafless tree appears to shiver. Its tangle of branches spreads across the entire span of the canvas like veins on the back of a hand. The tree's red and brown trunk leans heavily to the right, pulled over by the weight of its own branches as they reach down to sweep the ground. This painting is evidence of the influence the Romantic Dutch land-scape painters of the seventeenth century had on Mondrian at the time. Its expressive colours – the dark reds, blues, and blacks – suggest that the artist had also been taking notes from a more contemporary countryman: Vincent van Gogh.

The Grey Tree (1912) is the second picture in the sequence. Mon-drian's abstract awakening has started; the influence of his recent exposure to Cubist paintings is clear. Once again the tree is leafless, its trunk centrally placed, with branches extending horizontally across the breadth of the canvas, and vertically to the top. This time, though, the colour palette is far more sombre. The tonal graduations of grey ape the sombre hues favoured by Braque and Picasso in their Analyti-cal Cubism phase. Details of the tree have been simplified as Mondrian attempts to bring some compositional structure to a painting where spatial depth is all but eliminated.

Next up is *Flowering Apple Tree* (1912). In this painting Mondrian has gone even further down the road of abstraction. So much so, that if you didn't know it was a picture of a tree, you'd be hard pressed to guess. He has rendered his subject in Braque's ochre and grey palette. The tree's branches are now very stylized; all detail has been removed. Mondrian represents them with a series of short, thick, black, gently curved lines, some of which join to form a medley of elliptical shapes

floating horizontally across the canvas. He has added a few vertical black lines to anchor the picture and give it structure. It is an all-over, two-dimensional design.

And then, in 1913, comes *Tableau No. 2/Composition No. VII* (1913). The subject is still a tree (believe me), but it is far more abstracted than where the Cubists would have ever taken the motif. Mondrian has broken the subject down into tiny fragmented planes, leaving an image that looks like a dried-out, sun-cracked mud field in Africa. What's more, he has uprooted his tree and left it floating in space, which further reduces the visual clues as to its identity. The colours continue to be muted, except for a rich yellow, bursting out of the image. This is likely to be an allusion to the inherent spirituality he intended to portray in the painting.

Mondrian, like Kandinsky and Malevich (and much later Jackson Pollock), was heavily into a fashionable quasi-religious belief system called Theosophy, which espoused many of the tenets around which the artists built their philosophy. The idea of uniting the universal and the individual, the equality of elements, and unifying the internal and external, are all drawn from Theosophy.

Religion and spirituality is the subject of *Composition 6* (1914), a painting that shows Mondrian about to complete his journey to pure abstraction. A church is the subject, although it is impossible to make that deduction from looking at the image. The picture is in portrait format with a grey painted background, on top of which the artist has added a grid of black horizontal and vertical lines, which through planned intersections form a pattern of rectangles and squares. Some of these simple geometric shapes are 'open' frames placed over the background grey, while others are 'solid', having been filled in by the artist with a light pink paint. The indication that the image has a religious theme is provided by the presence of three capital 'T' shaped black lines in the centre of the canvas that could be read as Christian crosses. Otherwise this is a totally abstract painting. Before long Mondrian would cast off these last vestiges of visual reference to

known subjects and focus his attention solely on producing abstract images which he intended would communicate transcendental harmony.

It was at this point in his evolving career that the high-minded Mondrian met an ebullient Dutch artist, writer, designer and impresario called Theo van Doesburg (1883–1931). In 1917 they founded a magazine together, with Van Doesburg taking the role of editor. They gave it the title *De Stijl*, meaning 'The Style' (when pronounced in English it sounds like 'distil', which, fortuitously, describes their aesthetic philosophy). Unlike previous modern art movements, De Stijl had international ambitions from the outset, which the founders made clear by publishing their 1918 manifesto in four languages. They were motivated by a post-war desire to start afresh: to create an international style that would 'work for the formation of an international unity in Life, Art and Culture'.

Mondrian described how De Stijl would capture 'the pure creation of the human spirit . . . expressed as pure aesthetic relationships manifested in abstract form'. In other words, it would be an autonomous new art movement built around the primary-coloured grid compositions of his Neo-Plasticism. The vision was a sort of fine-art Lego for spiritually minded grown-ups: a kit of parts that could be used by allcomers in a collective endeavour designed to create and support a utopian future.

Natural forms would be 'eradicated', pronounced the De Stijl manifesto, as they were 'blocks to pure artistic expression'. The only thing that really mattered was to produce work that found unity through the relationships between colour, space, line and form. A concept, they concluded, that could be applied across art forms from architecture to product design.

As was proved by an early participant in the De Stijl movement: the Dutch cabinet-maker and architect Gerrit Rietveld (1888–1964). Rietveld was already working at the cutting edge of contemporary design, having been inspired by the angular architecture of the American

Frank Lloyd Wright and the work of the Scottish Arts and Crafts designer Charles Rennie Mackintosh. It was Mackintosh's famous *Ladder-back Chair* (1903), with its wooden-slatted back rising like wall bars in a gymnasium from the floor to several feet above the sitter's head, which motivated Rietveld to make his much simpler, but just as historically important, *Armchair* (1918).

Van Doesburg from the outset was a great admirer of Rietveld's austere, economic design, which consisted of a plank of wood for the chair's back and a shorter plank for the seat. Rietveld had supported these two utilitarian parts in a wooden, scaffold-like frame. As something to relax in after a hard day's work it looks decidedly unappealing. But creature comforts were not on Van Doesburg's list of important attributes when he included an image of it in the second edition of *De Stijl*. He described it as a sculpture that was a study of spatial relationships: an object that was 'Abstract-Real'.

Five years later, having fully immersed himself in the aesthetics of De Stijl, Rietveld made another version of the chair, but this time incorporated the primary colours and black lines of Mondrian's Neo-Plasticism. *Red-Blue Chair* (*c.*1923) (see Plate 19) looks like a three-dimensional Mondrian painting: it might still be uncomfortable, but it's far more appealing. The back panel is painted in a welcoming red, and the seat in an attractive deep blue. The black-painted wooden frame takes on a more playful air, aided and abetted by the yellow paint that the designer has added to the chair's sawn ends.

Rietveld went a stage further the following year and designed an entire house based on the principles of De Stijl. The Schröder House (1924) in Utrecht – named after Truus Schröder, the wealthy widow who commissioned Rietveld – is now listed as a Unesco World Heritage site. Truus Schröder's brief to Rietveld was to create a house that connected the inside with the outside; a home not divided into separate compartments, but one where areas interrelated. Hers was the philosophy of Mondrian, as was Rietveld's.

The Schröder House stands out from the rest of the street on which it is built like a torch in a cave. Its individual rectangular planes of whitewashed concrete walls dance around the building's backlit glass windows in a joyful architectural pas de deux that makes the dour brick houses it abuts appear funereal. The external structure seems to be held together by two thin horizontal metal bars that double up as balustrades on the first-floor balconies. On one side of the house a long, vertical yellow girder rises from the ground like a light beam. Behind it, in relief, are ground-floor and first-floor windows, each of which has a painted lintel: one in red, the other in blue. It's a Mondrian painting in which one can live.

The interior continues in the same Neo-Plastic/De Stijl way. Walls slide away to reveal vast spaces lit by natural light streaming through the many windows, some of which have blue blinds, some red, and (no surprises here) others yellow. The furniture (including a Red-Blue Chair) is made up of flat surfaces propped up on frames made from right angles. Even the wooden banisters have been constructed using horizontal and vertical lengths of wood which – of course – have been painted black. There is nothing in the Schröder House that was designed without the use of a set-square.

The power of Mondrian's aesthetic vision continued to influence the world of architecture and design. In 1965 the French fashion designer Yves Saint Laurent produced a sleeveless wool shift dress decorated in the block primary colours and black straight lines of Mondrian's *Composition with Red, Blue and Yellow* (1930). It was featured on the front page of French *Vogue* in their 1965 September issue, and led to a boom in Mondrian-decorated objects that continues today, in an unending array of applications from fridge magnets to iPhone covers. This popularity provides proof of the success of the Dutchman's artistic principles. His was a less-is-more philosophy, in which he wanted his art to be indestructible, irreducible, scrupulous, pure and virtuous. His aim was to defeat 'the supremacy of the individual' with a unifying concept accessible to all.

Yves Saint Laurent owned four Mondrians, which he hung in his spectacular Parisian apartment. Among them was *Composition No. 1* (1920), a painting that shows the artist on the threshold of the economical style that he would spend the rest of his career trying to perfect. Unlike later 'classic' Mondrian images, *Composition No. 1* does not have a white background, nor the sense of space of his mature work. It feels to me more like a design for a stained-glass window, which was a part of the De Stijl oeuvre (Van Doesburg produced many designs for stained-glass windows and both men were attracted by their latent spirituality). It is far 'busier' than later works. All the rectangular panels are painted – some in the blue, red and yellow, while others are in tones of grey or simply black. Most of the rectilinear lines stop short of the canvas's edge, and many of the blocks of primary colour are trapped in the centre, whereas in future works Mondrian tended to place them at the picture's edge where they could bleed off into infinity.

A few months later and Mondrian had cracked the code. *Composition with Red, Black, Blue and Yellow* (1921) is immediately identifiable as a 'Mondrian'. All the ingredients are there: the asymmetrical composition, the large open expanses of primed canvas, the blocks of primary colours emerging from the sides of the picture, counter-balancing each other on a strict grid of black vertical and horizontal lines of varying lengths. Yves Saint Laurent said that Mondrian produced art that 'is purity, and one can go no further'.

The ambitious Van Doesburg didn't agree. He thought one could at least have thrown in the odd diagonal line to add a little more dynamism. Mondrian categorically refused to entertain such a compromise, thinking that his pictures already had plenty of movement in them. And so, after a few arguments, the founder of Neo-Plasticism withdrew from the De Stijl project in 1925. Van Doesburg was ready for a change anyway, complaining that it was 'impossible to breathe any new life into Holland'. He went on a tour of Europe to preach the gospel of De Stijl. He would explain that the

geometric grid of black lines represented the 'immutability' of the world; the primary colours its 'interiorizing' quality. He defined the premeditated non-objective art of De Stijl, Constructivism and Suprematism as 'rational abstraction', whereas, he said, Kandinsky's more symbolist-based work was 'impulsive abstraction' (a similar distinction would be made in the 1950s regarding two different approaches to Abstract Expressionism: 'Action Painting' being instinctive, and 'Color Field' painting being preconceived).

Van Doesburg's succinct assessment was the culmination of an extraordinary decade in the history of art. Artists across Europe had trodden different paths but arrived in the same place: abstraction. They were motivated by a similar aim, which was to help create and define a new and better world. Now as the century entered its third decade, many of those artists, or others associated with their movements, would congregate in Weimar, Germany, to become part of Walter Gropius's fabled Bauhaus. Wassily Kandinsky and Paul Klee from the Blue Rider group gained teaching posts at the famous art college. Others, like El Lissitzky, came to contribute ideas and share their experiences of Russian Constructivism and Suprematism. And then there was Van Doesburg, championing and challenging in equal measure. Having failed to persuade Gropius to give him a job, the enterprising Dutchman established his own extra-curricular course to teach the principles of De Stijl, which was open to Bauhaus students. It proved to be popular, with Van Doesburg reporting: 'I'm having a lot of success with my Stijl course. Twenty-five participants already: most of them Bauhäusler.'

For a moment, between the two world wars, an air of optimism and adventure hung over this area of Germany, where artists, architects and designers worked together in an attempt to create a united visual shorthand for the world.

12
BAUHAUS: SCHOOL REUNION 1919–33

I once owned a ride-on lawn mower during a brief spell living in the countryside. It was bright yellow, never failed to start first time, and could cut grass that was as long and knotty as dreadlocks. Plastered across the back of the beast was the legend 'Built with Pride in America' – replete with Stars and Stripes. I scoffed at the boastfulness and pomposity of the statement: I mean, how crass; a British company would never do that.

Which, of course, it wouldn't. Mainly because nothing much is built in Britain at all these days. The once beating heart of the industrial world no longer makes stuff; everything is 'outsourced' or imported. According to Sir Terence Conran, the respected British furniture and household goods designer, such an approach will end in the creative and financial ruin of the country.

Things were different in the late nineteenth century, when the two European industrial powers were Germany and Britain. German

political leaders cast an envious eye across to Britain and saw a confident nation making it happen: a country creating wealth through artistic ingenuity and its commercial application. They decided to undertake a spot of espionage. In 1896 an architect and civil servant called Herman Muthesius (1861–1927) was sent to London as a cultural attaché in the German Embassy to find out on what basis Britain had built its industrial success. In due course, Muthesius delivered his findings in a series of reports that eventually became a three-volume book called *The English House* (1904), in which he identified a surprising 'magic ingredient' in the UK's booming capitalist economy. It was the recently deceased designer William Morris (1834–96), the founder of the Arts and Crafts movement and an avowed socialist.

Morris started his eponymous design company in 1861 with the architect Philip Webb and the Pre-Raphaelite artists Edward Burne-Jones, Ford Madox Brown and Dante Gabriel Rossetti. They wanted to take the values of fine art and reapply them to craft by producing handmade objects with all the individual love, attention and skill devoted to a landscape painting or marble sculpture.

The firm specialized in interior design, making stained glass, furniture, fittings, wallpaper and rugs – all of which responded to, and reflected, nature. It was an approach informed by John Ruskin, the nineteenth-century British art historian and left-wing intellectual, who was appalled by the industrial age. He declared a 'hatred of modern civilization', citing the divisive nature of capitalism and its compulsion to put profit before all else. He considered industrialization an evil that degraded the craftsman, turning him into a tool: a grubby lackey at the behest of a gleaming, soulless machine.

Ruskin advanced theories of social justice and backed up his rhetoric by giving away much of his own money. In 1862 he compiled a series of his controversial essays into a book, *Unto This Last* (1862), in which he demanded fair trade and workers' rights; a nationwide plan for industrial sustainability; and for more care to be taken of the

environment. It was perceptive stuff that attracted some notable fans. Mohandas 'Mahatma' Gandhi was so impressed by the publication that he translated it into Gujarati, saying that he had discovered some of his 'deepest convictions reflected in this great book'.

Ruskin and Morris believed that the past still had plenty to offer, and that there was much in the medieval lifestyle that should be applauded. Morris envisaged a brotherhood of workers based on the training system of the medieval craft guilds, where an individual would start as an apprentice, develop into a journeyman and eventually (if sufficiently talented) become a master craftsman. His was a welfare philosophy where people worked in humane, safe and respectful conditions and were paid a reasonable wage for their efforts. Morris believed in 'arts for all', the democratization of beauty and ideas: art made by the people for the people. It was a cry that would be repeated time and again throughout the twentieth century (and that continues today with the likes of the British artists Gilbert & George).

Herr Muthesius had formulated his own take on the British Arts and Crafts movement. What if, he mused, one applied the principles of William Morris on an industrial scale? He mentioned the thought to his masters back home. Soon craft workshops were popping up across Germany like tents at a pop festival. With them came a major overhaul of German arts education. And then in 1907 the German Werkbund was established. This was their killer app: an overtly nationalistic endeavour based on Morris's ideals. Its purpose was to add some style to the country's industrial ambitions: to help promote their efforts, increase consumer demand, and educate the public in matters of taste. A council was formed consisting of leading representatives from arts and business.

Among them was Berlin-based architect Peter Behrens (1868–1940), whose artistic sympathies lay with Morris's design principles based on individual craftsmanship. Behrens was a creative all-rounder who, like Morris, had designed his own house, along with all its contents.

In 1907 – the same year that Behrens joined the Board of the German Werkbund – the German electronics company AEG contracted him to be their 'artistic consultant'. His brief was to oversee every aesthetic decision made by the company: from corporate identity and press ads, to bulbs and buildings. Behrens was, in effect, the world's first brand consultant.

He explained to AEG that his work should not be seen as mere decoration, but as the outward expression of their products' inner 'character'. It was an intriguing standpoint, but not entirely original. In 1896 the influential American architect Louis H. Sullivan (1856–1924) had articulated the same thought in a text called *The Tall Office Building Artistically Considered*. Okay, it's not a blockbuster of a title, but it is a surprisingly exhilarating essay written by a man standing at the threshold of the modern world. Sullivan's practice was based in Chicago, a city expanding so rapidly that it had caused the thoughtful architect to contemplate whether there was any place for visual sensibility when designing buildings for the unsentimental, industrialized modern landscape. He was particularly concerned about the social and emotional impact on the city's inhabitants of the skyscraper: that emblematic beacon of economic progress, which had started to dominate Chicago's pavements like Gulliver in Lilliput.

Skyscrapers were Sullivan's specialty. So much so, in fact, that he was known as 'the father of the skyscraper' for his trailblazing work using new steel-frame construction techniques to produce very tall buildings. Brick alone, Sullivan realized, was a height-limiting building material, due to its weight and density: the higher you go with brick the harder it becomes for the base to bear the load. A steel-frame structure has no such restrictions, so up went his buildings: higher and higher.

Sullivan was content to be one of those behind the high-rise boom. But he was also aware that tall buildings like his were going to be around for a long time and would therefore define cities and nations. And yet nobody had given any real thought as to what would be an

appropriate and pleasing form for this new architectural technique to adopt. He argued that a style guide should be devised, to prevent America being blighted by bland and ugly architecture. His aesthetic starting-point was to consider the purpose of the building before deciding on how it should look, leading him to coin the now-famous phrase 'form [ever] follows function'. Which was the same point Behrens was making.

Sullivan pondered: 'How shall we proclaim from the dizzy height of this strange, weird, modern housetop the peaceful evangel of sentiment, of beauty, the cult of a higher life?' This is architectural expressionism: a building designer touched by the spirit of Van Gogh. His conclusion was that the vertical nature of the building should be accentuated, not its individual horizontal floors. 'It must be tall,' he said, 'every inch of it tall. The force and power and altitude must be in it, the glory and pride of exaltation.' To which end he devised a simple three-part format for the tall building, which consisted of a defined base, an elongated shaft and a flat-topped pediment. He was basically transforming the ancient Greek column into an ultra modern building.

Between 1890 and 1892 the Alder & Sullivan architectural partnership completed a new office property for a wealthy brewer based in St Louis, Missouri. The nine-storey Wainwright Building was one of the world's first skyscrapers, embodying Sullivan's design philosophy and setting a template for tall buildings across the globe: it was an uninterrupted rectangular form like a matchbox standing on end. Sullivan clad the Wainwright Building in terracotta and brown sandstone, with rows of height-emphasizing vertical brick piers marching up its perpendicular face in uniform fashion, like soldiers on parade. It is a beautifully restrained piece of office architecture that nods to the past but embraces a hi-tech, fast-paced future. Form had indeed followed function.

As it did when Behrens designed the monumental AEG Turbine Factory (1909): a modern architectural statement shaped like a massive subway train made out of masonry and fitted with colossal

steel-framed windows. The building was necessarily practical, but Behrens had added some less tangible aims during its conception. He wanted the architecture to have a positive effect on the workers; to offer them dignity in a brutal world; to inspire and encourage. Whereas he hoped the passer-by would see the building and note the confidence and ambition that was now at the heart of an industrial Germany. The AEG Turbine Factory was exactly the sort of artist-inspired propaganda the German Werkbund had been set up to deliver.

Behrens's growing reputation was attracting some of the finest young minds in architecture to his practice. The list of fresh-faced designers with a pioneering glint in their eye queuing up to work alongside and learn from the Great Man is not just impressive; it is a roll-call of the giants of modern architecture. Mies van der Rohe and Le Corbusier both worked for Behrens, as did Adolf Meyer, who would leave shortly after the AEG Factory project to start up a new firm with Walter Gropius (1883–1969), another of Behrens's protégés, who was destined to be the founder of the most famous art school in the world.

Gropius and Meyer observed the success Behrens was enjoying with his modern approach to design and materials and felt like giving it a go themselves with their own practice. It was the right move at the right time and they quickly made their mark. Early in 1911 the owner of Fagus – a shoe-last (the moulds around which shoes are made) company – commissioned them to build the façade of a new factory in Alfeld-an-der-Leine, about forty miles south of Hanover. Taking note of Behrens's AEG building, they got to work. By the winter the major part of the Fargus Werk was complete.

The two rookie architects had produced a design of startling modernity. They had hung what appeared to be a floating glass wall in front of the rectangular building's columns of yellow bricks: a diaphanous curtain providing light for the workers and a gleaming advertisement to the world (they had positioned the building so it could be seen by train passengers going to and from Hanover). The

building was a mission statement for a new Germany; a symbol of a country that could integrate modern art with the modern machine to produce goods that the world not only needed, but would find desirable. By 1912 the talented Gropius had been enlisted into the German Werkbund to be part of the establishment elite responsible for giving the country an image makeover.

And then came the war.

The Bauhaus

Initially several German artists and intellectuals were enthusiastic about the First World War, seeing it as a chance for a new beginning. Walter Gropius enlisted and fought on the Western Front, but was repelled by the merciless destruction he witnessed. The experience motivated him to do something that might help prevent a repeat of the horrific events that took place on the battlefields of Europe between 1914 and 1918.

His optimism was fuelled by the dawn of a new age in Germany. The unpopular Kaiser Wilhelm II had abdicated the throne, bringing an end to monarchical rule and paving the way to a newly democratic Germany, known between 1919 and 1933 as the Weimar Republic. Gropius wanted to do his bit to support the fresh start his war-ravaged country had made by establishing an institution that he hoped would benefit not only Germany, but also the entire world.

His previous experience with the German Werkbund had shown him the potential of arts and crafts to make a positive contribution to the emotional and financial life of the country. He formulated a plan to establish a new type of art college, the aim of which would be to equip a new generation of young people with the practical and intellectual skills to build a more civilized, less selfish society. It would be an art and design school, taking on the role of social reformer.

His institution would be democratic, co-educational, and teach an

unconventional liberal curriculum devised to stimulate the students to find their own inner-artist and personal rhythm. He was given the chance to put his ideas into practice when approached about a job in Weimar, the German city in which the country's democratic constitution had recently been signed. The offer was to be head of a teaching facility that was the conflation of two previous institutions: the Grand-Ducal Saxon Academy of Fine Art and the Grand-Ducal Saxon School of Arts and Crafts. Gropius accepted and named the joint entity 'Staatliches Bauhaus in Weimar'.

It was 1919 and the Bauhaus was born. Gropius announced that it would be a 'major institution of art education using modern ideas', which combined the 'theoretical curriculum of an art academy' with 'the practical curriculum of an arts and crafts school', providing a 'comprehensive system for gifted students'. He rejected the German Werkbund policy of industrialized mass-production, seeing it as a diminution of the individual: an attitude, he felt, that had led to the war.

He also insisted that fine-art students descend from their ivory tower and get down and dirty with the artisans, stating that 'there is no such thing as professional art . . . the artist is an exalted craftsman. Let us raise the arrogant barrier between craftsmen and artists! Let us . . . create the new building of the future together. It will combine architecture, sculpture, and painting in a single form.' This is an echo of Wagner's *Gesamtkunstwerk*: a total work of art where all art forms come together to realize one glorious, life-affirming entity.

The great composer considered music to be the highest form of human creative endeavour, and reasoned that it was therefore the natural environment in which to attempt to produce a *Gesamtkunstwerk*. Gropius thought differently. He argued that architecture was the most important art form, saying that 'the ultimate aim of all creative activity is the building'. Hence the name Bauhaus, which is German for 'building house' or 'house for building'.

Gropius devised the structure for his students' educational develop-

ment on William Morris's medieval-guilds-based apprenticeship model. Bauhaus students would start as apprentices, before progressing to journeymen, and eventually, if they were good enough, Young Masters. All students would be taught by established Masters, who were recognized specialists practising in an individual artistic area. Gropius saw the Bauhaus as 'a republic of intellectuals' that would one day 'rise towards the heavens from the hands of a million workers as the crystalline symbol of a new and coming faith'.

And, to an extent, he succeeded. The 'new and coming faith' of the twentieth century transpired to be voracious consumerism driven by technology, which, more often than not, was dressed up in the cool school of design that Gropius pioneered at the Bauhaus: an unfussy and tasteful aesthetic generically known as Modernist. The Volkswagen Beetle, Anglepoise lamps, early Penguin book covers, 1960s pencil skirts; the vast white spaces of MoMA, the Guggenheim and Tate Modern; and the streamlined beauty of the space age, all fit the Modernism bill.

His aesthetic successes extended to architecture, where, once again, his 'crystalline symbol' united the world. From the Communist East to the capitalist West, the mark of Bauhaus-inspired Modernism is evident in the clean-cut, concrete-clad, giant geometric structures that came to dominate the twentieth-century urban environment. From the Lincoln Center in New York City to the Ten Great Buildings framing Tiananmen Square in Beijing, the fingerprint of Gropius's spare, angular Modernism is readily detectable.

Which is astonishing, given that the Bauhaus lasted for only fourteen years. And even more so when you take into account that the austere, sober, elegant design it will forever be associated with was absolutely not the creative spirit with which the institution had started out; as the image on the front cover of its first prospectus in 1919 clearly demonstrates. It is a woodcut print by the artist Lyonel Feininger (1871–1965), a member of Wassily Kandinsky's Blue Rider group whom Gropius had appointed to be the Master in charge of

the graphic printing workshop. Feininger's composition is in a Cubo-Futurist style and depicts a three-spired gothic cathedral surrounded by jagged-edged rods of lightning that are sending powerful bolts of electricity out into the world. It is an illustration laden with symbolism.

Gropius conceived the Bauhaus as a cathedral of ideas that would spark energy and life into a depressed and drab world. The lightning stands for the dynamism and creativity of the students and masters. The mighty church represents a *Gesamtkunstwerk*: a building that unites the spiritual and the material, lovingly created by artists and craftsmen, and in which people gather, music is played, and choirs sing. This was the romantic spirit of the institution in its formative years, when peopled by idealistic students and masters, ready and willing to do their bit to build a modern utopia. At this early stage the place was more like a hippy commune than the professionalized institute of functional design it would later become.

Student life at the Bauhaus always started with a six-month preliminary course known as the *Vorkurs*, which was initially devised and run by a Swiss-born artist and theorist, Johannes Itten (1888–1967). He was an unusual man in many ways, not least being an experienced teacher, a rarity among the Masters at the Bauhaus. He subscribed to Mazdaznan, a spiritual movement that recommended vegetarianism, a healthy lifestyle, exercise and plenty of fasting. Itten's tutorials had a similarly new-age focus as he tried to help his students to intuitively find their artistic voice. While they delved deep and waited for inspiration, Itten would wander around the classroom – and Weimar – dressed in a dark tunic that foreshadowed Chairman Mao's eponymous suit. This he topped off by shaving his head and wearing round spectacles that made him look part Bond villain, part religious sect leader. Which was roughly how the students saw their teacher, some revering him to the point of an occult-like worship, while others couldn't stand the sight of his bald head and affected ways. Gropius tolerated him . . . to begin with.

Itten fitted in with the Bauhaus's original back-to-nature arts and crafts philosophy. Whereas other art colleges had their students slavishly copy the old masters, Itten would base his lessons around the primary colours and primary forms. He'd get the apprentices to mould various materials into geometric shapes in order to teach them about line and balance and substance. They would then work on their own ideas, which might consist of a poster-sized plaster relief made up of squares and rectangles, or perhaps a felt appliqué blanket of red and brown patches demonstrating an understanding of tonal transitions.

In those days the Bauhaus had a homemade-cum-medieval vibe. In addition to Itten's theoretical lessons, the apprentices learnt craft skills in workshops that ranged from bookbinding to weaving. Wood was the building material of choice, with Gropius planning to build an estate of timber houses on the campus to allow students and masters to live and work together in harmony. The mood was one of anti-materialism tinged with the gothic spirit of German Expressionism. Which is not altogether surprising, given the teaching staff. Both Johannes Itten and Lyonel Feininger had come from the Expressionist school that had been founded in pre-war Germany.

German Expressionism began in 1905 with the Dresden-based Die Brücke (The Bridge) group, who were followed a few years later by Kandinsky's Blue Rider gang. Both had been inspired by the Expressionism of Van Gogh and Munch, the Primitivism of Gauguin and the non-naturalistic colours of the Fauves, before adding a dose of German gothic tradition into the mix. The master of that particular amalgamation was the Die Brücke artist Ernst Ludwig Kirchner (1880–1938). Before the war he and his cohorts were producing carefree pictures of crudely painted naked ladies cavorting across psychedelically coloured landscapes. After the war, Kirchner's art took on a darker tone. His *Self Portrait as a Soldier* (1915) is an example of German Expressionism at its most bleak and poignant. The joyous bohemian attitude of Die Brücke has given way to distorted

figures, razor-like lines, and a palette with the pallor of death. Kirchner presents himself as a dead-eyed amputee in military uniform, holding up the stump of his blood-soaked right arm as evidence of an artist rendered useless by the butchery of war. Behind him stands a naked woman, painted with the sketchiness of a cave drawing. She is present but appears to occupy another world. The message is clear: the war has neutered the soldier; he will never love again.

This is the emotionally fraught world from which Gropius, Itten, Feininger and the Bauhaus had emerged. The misshapen images, mystic spirituality, libertarianism and gothic earthiness of German Expressionism were an intrinsic part of the original Bauhaus ethos. So when Wassily Kandinsky and Paul Klee arrived to take up teaching posts a couple of years later, they immediately felt totally at home.

Feininger was delighted to be reunited with his old colleagues, while Gropius must have seen it as a major coup for the Bauhaus. Can you imagine that today? Two of the most revered artists in the world rocking up at an art college to live on campus and teach full-time. Unlikely. But such was the pull of the place and the commitment of these artists to try to build a better future that Kandinsky happily became head of the mural-painting workshop, and Paul Klee took charge of the stained-glass workshop. Life at the Bauhaus was good and getting better. The only problem was that beyond the campus it was bad and getting worse.

Germany was struggling to fulfil its obligations under the Treaty of Versailles: namely the payment of war reparations to the Triple Entente (Great Britain, France and Russia). This arduous task was not made any easier by a lack of raw materials (part of the reason Gropius had become so keen on wood), which had either been used to fight the First World War, or subsequently plundered by the victors. Politically, Germany was in a fraught state. The new republic was divided and tense, with different political parties jockeying for position and power. Right-wing factions within the regional government that had funded the Bauhaus were beginning to see the institution as a

political entity. They were concerned that it had become a hotbed of sponging socialists and maverick Bolsheviks who produced nothing of value or merit. The pressure was on Gropius to prove its worth, to show that the Bauhaus was not an arty frippery, breeding left-wing radicals, but a sound financial investment by local government in a manufacturing future. The astute Gropius realized it was time for a change.

Out went the uncommercial, self-centred philosophy of intuition preached by Johannes Itten, and in its place came a fresh rallying cry from Gropius: 'Art and technology, a new unity.' It was a complete volte-face by the institution's founder and leader, who had previously declared the German Werkbund 'dead and buried' when it peddled a similar line.

To replace Itten, Gropius chose not to hire another Master with a background in German Expressionism. Instead he went for a Hungarian artist with a Constructivist ideology in order to introduce an element of rigour and rationality to the teaching staff. László Moholy-Nagy (1895–1946) took up the post of Master of Form and the metal workshop in 1923, and agreed to share the teaching of Itten's *Vorkurs* preliminary course with Josef Albers (1888–1976), the first Bauhaus apprentice to be made a Master.

Albers and Moholy-Nagy were to transform the Bauhaus into the wellspring of Modernism for which it is now legendary. They did so with help from an irrepressible artist, publisher, theorist and designer who knew his own mind and was at his most content when influencing those belonging to others. The Dutchman from De Stijl was back.

Theo van Doesburg had made his way over from the Netherlands to teach the principles of De Stijl to the Bauhäusler. Time to rid the place of all that 'Expressionist jam', he said. And although Gropius didn't actually hire Van Doesburg, the Dutchman soon made his presence felt at the Bauhaus. His off-campus De Stijl course became a magnet for Bauhaus students, who duly attended en masse. His teaching was the antithesis to Itten's 'anything goes' school of creativity. Discipline

and precision was the name of the De Stijl game – minimal tools, maximum impact: you can say more with less.

Gropius had now gathered in Weimar representatives from all the schools of abstract art: Kandinsky, Klee and Feininger from the Blue Rider group, Van Doesburg from De Stijl and Neo-Plasticism, and Moholy-Nagy and Albers championing the non-objective art of the Russians. This small, badly funded institution had attracted a pool of pioneering artistic talent that was akin to Florence during the Renaissance and fin-de-siècle Paris.

The new team made an immediate impact. The technology-loving Moholy-Nagy encouraged his design students to use modern materials and reference the compositions of Malevich, Rodchenko, Popova and Lissitzky. Within weeks the apprentices stopped producing misshapen, handcrafted earthenware pots, and instead started to make perfectly finished machine-tooled objects. Marianne Brandt (1893–1983), an internationally renowned designer whose work would be seen as the epitome of the Bauhaus look, was one of those students who came under the early tutelage of Moholy-Nagy.

While a young apprentice in 1924 she produced a near-flawless silver tea set that had a beguiling grace. The teapot takes the form of a perfectly rounded bowl, like a silver ball cut in half. It sits on a purpose-built stand made from two intersecting short lengths of metal. The gleaming spout materializes effortlessly from the apex of the pot's curving side and stops perfectly in line with its top. The offset handle mirrors the spherical shape of the pot, while acting as a frame for its circular lid. The lid has a thin, oblong handle that stands poised and upright like a ballerina.

Marianne Brandt's sophisticated response to Moholy-Nagy's programme of using modern industrial materials was not unique. Wilhelm Wagenfeld and Karl Jucker designed a stunning table lamp made out of glass and metal, now known as the *Wagenfeld Lampe* (1924). Its opaque glass bowl lampshade and clear glass stem and base give the object the appearance of a mushroom. Its simple geometric

shape is enhanced by subtle design details that lift it from being a mere light to an object of desire. The glass shade is edged with a chrome-plated metal rim; a couple of inches below protrudes a short pull cord with which to turn the lamp on and off, giving the object a clever asymmetrical twist. The clear glass stem and base are perfectly proportioned to complete a lamp (and a form) that has an alluringly uncomplicated stylishness.

The *Wagenfeld Lampe* has become a design classic and is seen as an early example of excellence in industrial design. But that is something of a misapprehension. The Bauhaus might by this time have become an exponent of art and technology, but the students were still hand-making their objects. When Gropius sent Wagenfeld off to a trade show to sell his lamp, the young student found that manufacturers were laughing too much to open their order books. Designing an object to look like it has been mass-produced, and designing an object for mass-production are two very different things.

When Albers and Moholy-Nagy weren't overseeing the apprentices, they were making their own contribution to the Bauhaus aesthetic. Moholy-Nagy was producing abstract canvases such as *Telephone Picture EM1* (1922) – a sparse image dominated by one thick black vertical line. Just over midway up, and to the right of the black strip, is a small yellow and black cross, underneath which is another crucifix shape in red turned on its head. It's a sort of Constructivist/Mondrian fusion.

Josef Albers was busy designing *Set of Four Stacking Tables* (c.1927). All four tables have a simple rectangular wooden frame into which Albers has seamlessly integrated a glass top. Each top is painted in one of the three primary colours – the fourth, and largest table, is finished in green. The tables get consecutively smaller, thus allowing a house-proud owner to stack them tidily away when not in use, one inside the other, like a Russian doll. You can still buy Albers's nesting tables.

Albers wasn't the only Bauhaus apprentice to become a Master.

Nor was he the only Master to produce a product at the Bauhaus that would succeed commercially and that continues to be available in shops today. Marcel Breuer (1902–81), a young Hungarian designer, followed Albers's path from apprentice to Master in 1925 when Gropius appointed him head of the furniture workshop. One day when Breuer was cycling to work he looked down at his handlebars and had an idea. Could the hollow tubular steel bar that he was gripping as he rode be used for another purpose? After all, it was a modern material, relatively inexpensive and capable of mass-production. There had to be the potential to use it in another way: a chair perhaps . . .

With some help from a local plumber, and after a prototype or two, Breuer came up with his *B3 Chair* (see Fig. 18): a chrome-plated, tubular steel frame that he had bent at curving right-angles and dressed with strips of canvas to provide a seat, arms and back-rest. Breuer had thought it his 'most extreme work . . . the least artistic, the most logical, the least "cosy" and the most mechanical', and had anticipated widespread criticism. The opprobrium never materialized. The chair was appreciated for what it was: a sophisticated modern design that would become a staple of boardrooms and business lounges across the globe. One of the first people to commend Breuer for his innovative design was fellow Master Wassily Kandinsky. In response to his colleague's kind words, Breuer called his chair the 'Wassily'.

Once again life was back on track at the Bauhaus. And once again it was undone by external events. In 1923 Germany defaulted on its war reparations. French and Belgian troops entered the country; hyper-inflation ensued, as did mass unemployment. An impoverished and belittled Germany took a lurch to the right. Funding to the Bauhaus was slashed; Gropius was told his contract would be ended and much political support was withdrawn, while artists and intellectuals from around the globe looked on in disbelief. But by the time the rapidly established Society of Friends of the Bauhaus had got its act together (Arnold Schoenberg and Albert Einstein were members), the days of the Bauhaus in Weimar were over.

And then, at last, a change of fortune: for the Bauhaus and for Germany. The Americans came up trumps and lent the German government enough money to get their country back on its feet. Unemployment went down; commercial activity went up. Confidence

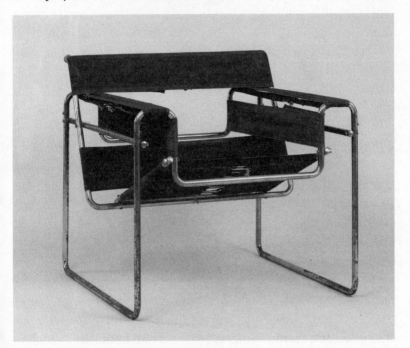

Fig. 18. **Marcel Breuer**, *B3 Chair/Wassily*, **1925**

returned, and industrial centres across the country approached Gropius offering the Bauhaus a fresh start in their district. These ambitious towns and cities wanted to encourage new businesses to their area but needed to be able to demonstrate that they had a ready pool of skilled staff and modern housing available. The Bauhaus and Walter Gropius's architectural practice could provide both. In 1925 the Masters and students of the world's most famous school of design set up shop in the town of Dessau, a little way north of Weimar.

And to welcome them there Walter Gropius had designed one of the great works of modernist architecture: a veritable Bauhaus. The complex of workshops, students' accommodation, theatres, common areas and Masters' houses was opened in December 1926 (see Fig. 19).

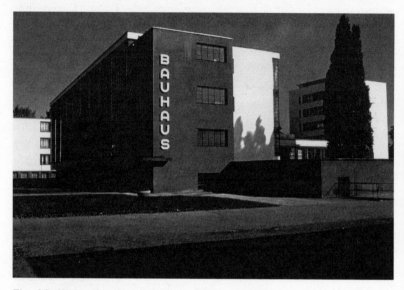

Fig. 19. **Walter Gropius,** Bauhaus, Dessau, **1926**

It was the realization of Gropius's dream for his institution: a genuine *Gesamtkunstwerk* created by the staff and students of the school. The fittings, furniture, signage, murals and buildings were all part of one coherent vision. The main building for teaching boasted a huge rectangular glazed façade, an epic glass curtain wall sandwiched between two thin horizontal lines of white concrete: one a raised plinth, the other a flat-topped pediment. Seen from above, the interconnecting Dessau Bauhaus buildings look like a Mondrian painting: an asymmetrical grid of vertical and horizontal lines that produce a balanced composition of rectangles.

The accommodation Gropius designed for the Masters was sited in a small wood not far from the new Bauhaus. There were four build-

ings in total: one detached residence for Gropius and three other properties divided into six semi-detached homes. They all share the same aesthetic sensibility, which is unapologetically modernist. Gropius has designed them on the same rectilinear De Stijl principles that were employed by Gerrit Rietveld on the Schröder House. Except that there are no primary colours to be seen adorning Gropius's Masters' houses, where the flat vertical walls have been rendered in plaster and painted a pure white. Into these stark elevations are cut rectangular and square windows, frameless and inset to accentuate the sharpness of their lines.

The aggressiveness of the houses' geometric form is emphasized with flat roofs and overhanging concrete canopies, which jar against the surrounding crooked tree trunks and their shapeless, leafy branches. There is something puritanical and hard about the Masters' houses: their machined appearance is unforgiving and uncompromising. In less competent hands they could easily have been brutalistic monsters, threatening and cold like so much of the soulless concrete constructions that have since been erected in the name of Modernism. But Gropius avoided that pitfall; he was far too sensitive to line and form and balance. Instead his Masters' houses have an intrinsic beauty (Gropius's house was destroyed in the war), although Kandinsky on moving in painted his interior in multi-colours.

Gropius resigned in 1928 to pursue his architectural career in Berlin. His departure left a vacuum that was promptly filled by an increasingly radicalized student-base with Communist sympathies. The politicians of Dessau who were funding the institution were not happy with the way things were going. They asked Gropius to help them find a new Director who would have the authority and reputation to bring some order. Gropius suggested Ludwig Mies van der Rohe (1886–1969), an avant-garde German architect with whom he had worked at Peter Behrens's practice in 1908.

Mies van der Rohe welcomed the approach and became Director in 1930. His international reputation as a leading practitioner of modern

architecture had been recently secured when his German Pavilion was revealed at the 1929 International Exposition in Barcelona. It is an architectural synthesis of all the abstract art movements.

A large, flat, low-profile roof overhangs the single-storey pavilion hovering like a spaceship, its white underside as pristine and uniform as an art gallery wall. Beneath it Mies van der Rohe has laid out a Mondrian-type grid system with a combination of luxury materials that would not have appealed to Tatlin. A steel frame supports a series of free-standing rectangular screens made out of glass, marble and onyx that divide the space without ever closing it off. Instead their non-uniform positioning ushers the visitor around the open-plan pavilion to witness interior and exterior views that had been meticulously planned by Mies van der Rohe. He is presenting a new, less aggressive face of Germany: a progressive, open, enterprising, rational and sophisticated republic.

He was told that the German government was to receive the King and Queen of Spain in his pavilion when they came to open the Exposition. The architect felt the occasion demanded some special seating for his prestigious guests, and so out came his pencil and paper and he got to work. The resultant design is reminiscent of a deckchair fixed in an upright position. From the side all one can see is two bars of chrome-plated steel, making an 'X' where they cross. One is longer and curves gently like a new moon, starting at the front foot of the chair and extending upwards to provide its back support. The other starts as the back foot and sweeps gently forward in an 'S' shape to offer a cantilevered frame for the seat. On to this simple, elegant design Mies van der Rohe added two cream leather cushions: one for the seat and one for the back.

In the end the King and Queen elected not to sit on his Barcelona chair or his accompanying Barcelona stool – but millions have since. No Manhattan loft apartment or upscale architect's office would be complete without Mies van der Rohe's Barcelona two-set. That he was the right man for the directorship of the Bauhaus is not in doubt.

Nor is the fact that he could do little about its demise. Gropius had many enemies with which he had to contend, but none as evil or powerful as Adolf Hitler. The one-time artist and author of *Mein Kampf* hated Modernism and intellectuals. Which meant he really, really hated the Bauhaus. In 1933, with his political position secure, he enforced the closure of the world's greatest ever college of art and design. And lest anybody should forget how passionately he loathed the institution and all those associated with it, he held an exhibition of *Entartete Kunst* (Degenerative Art) four years later in 1937.

Hitler ordered his henchmen to ransack the country's museums and remove all the modern art they held which had been produced after 1910. Work by Paul Klee, Wassily Kandinsky, Lyonel Feininger and Ernst Ludwig Kirchner (among many others) was seized, before being hung in a chaotic fashion and accompanied by sneering texts, aimed to encourage the public to laugh at the 'degenerative art'. Who knows what the many exhibition-goers made of it all, but the artists knew what was going on.

Another war was imminent. In the First World War artists had either joined up or returned to their native countries. This time around there were many who responded differently, choosing neither to fight, nor to return home. Several headed off en masse to the same place. They went to a country that had created beautiful cities in keeping with the spirit of Modernism: a place that they would one day help to become the epicentre of modern art. Walter Gropius, Ludwig Mies van der Rohe, László Moholy-Nagy, Josef Albers, Marcel Breuer, Lyonel Feininger, Piet Mondrian and many, many more went West, to the land of the free: to America.

13

DADAISM: ANARCHY RULES 1916–23

Maurizio Cattelan (b. 1960) has a big nose. I don't wish to be rude or personal, merely to report that it is the first thing you notice when meeting him, his stand-out feature, so to speak. But because he is tall and slender and Latin and charming, his considerable conk is rather attractive, an endearing and somewhat appropriate characteristic for a person who trades in the comical and the absurd.

Cattelan is an artist. His shtick, which has proved critically and commercially popular, is to make good-natured visual gags that have a pinch of pathos to give them intellectual weight. He is the Charlie Chaplin of contemporary art: acting like a clown to reveal some of life's harsh realities.

I met him a few years ago to discuss how he might contribute to a weekend of performance art that I was helping put together at Tate Modern. He suggested giving his creation Jolly Rotten Punk – or Punki for short – a run out. Punki, I discovered, was a diminutive, foul-

mouthed, tartan-clad puppet which was basically a mini-me version of John Lydon (a.k.a. Jonny Rotten), the lead singer of the iconic 1970s punk rock band the Sex Pistols. A puppeteer concealed in an enormous rucksack attached to Punki's back operated the evil little fellow.

Cattelan's instructions were that Punki should hove up to visitors in the gallery and routinely abuse them. You know, shake the punters out of their complacent and insular world. I thought it sounded amusing enough but wondered if it wouldn't be better to have the puppet walk around outside and 'greet' the customers. 'No,' said the artist firmly. That wouldn't do. 'Why not?' I asked. Because Punki 'doesn't work outside of the museum context', Cattelan insisted. 'It wouldn't be art.' At which point he must have seen a look of scepticism enter my eyes as he started to elucidate.

He said that all his work relied on being in a museum or in an art-gallery environment; that it wouldn't be effective otherwise. He referred to *La Nona Oralso (The Ninth Hour)* (1999), one of his better-known pieces, which is a life-sized waxwork model of Pope John Paul II lying crippled and pinned to the floor by a meteorite, desperately holding on to his processional cross for physical and spiritual support. It is a comical sculpture: violent in the same amusingly silly way as a *Tom and Jerry* cartoon. But the work's title betrays a darker side. The ninth hour is traditionally a time of prayer in many quarters of Christianity (around 3 p.m. in the afternoon) and is referenced in the Bible. In Mark 15:34, the apostle writes that it was at the ninth hour that the crucified Jesus looked up to the heavens and cried, 'My God, my God, why hast thou forsaken me?' and then breathed his last. Cattelan's prone Pope is having the same doubts.

The work's shock value and media-currency comes from it being classified as art: as a sculpture. Had the same object, made with the same materials, been used as a prop in a film, or for a store's window display, few people would have given it a second glance. But because *La nona ora* was exhibited in an art gallery – as a work of art – someone paid £3 million for the stricken Pope in 2006, and thousands

of column inches have been spent discussing its merits. Which, of course, is faintly ridiculous and nonsensical. It also creates the tension and controversy that Cattelan's art requires. He is trading off the elevated status modern art museums and galleries enjoy in our society.

Which, as an artist, is his right. Galleries are to artists what theatres are to playwrights and actors: they provide an environment in which the public is willing to suspend its disbelief, allowing for things to be said and done which in any other context would either be considered unacceptable or would go unheard. And that puts artists today in a privileged position based on trust that, as in any walk of life, is open to abuse, which is a constant worry to us, the audience, who want to like modern art but are constantly suspicious and on guard lest we should find ourselves being duped.

In *La Nona Oralso* Cattelan is playing on people's belief in God and their acceptance that the Pope is closer to Him than any other living person – a position once held by Jesus. But he is also questioning people's belief in art, and how it has become a form of worship in a secular society – he is questioning our new-found faith. His cosmic rock crushes an old and a new belief system in one strike.

Cattelan pokes fun at the world in which he trades and at the very people who are paying him handsomely to do so. Like his puppet Punki, and the Punk movement in general, his rebellious, irreverent and provocative work is most effective when operating within the establishment. Which makes him a modern-day torchbearer for Dada, the early twentieth-century art movement founded by a group of German-speaking intellectual anarchists, whose motivation was not to tease the art world, but to destroy it.

The original Dadaists were consumed with a rage that had been provoked by the hideous carnage of the First World War. They were seething with discontent and cynicism for what they saw as its causes, namely the establishment and its over-reliance on reason, logic, rules and regulations. Dada, they proposed, would offer an alternative based on being unreasonable, illogical and lawless.

It had all started rather gently when Hugo Ball (1886–1927), a young German conscientious objector and writer, fled to neutral Zurich in Switzerland during the First World War. Once settled, the theatrical and piano-playing Ball opened an arts club with the aim of providing a space for 'independent men beyond war and nationalism' to 'live for their ideals'. He rented a small room at the back of a tavern that happened to be on the same narrow Zurich street in which Vladimir Lenin was living and drawing up his own plans for a new club.

Ball named his venture after the satirical Enlightenment writer Voltaire, whose words had influenced the thinking of the French Revolutionaries. In February 1916, Ball sent out the following press release:

> Cabaret Voltaire. Under this name a group of young artists and writers has been formed whose aim is to create a centre for artistic entertainment. The idea of the cabaret will be that guest artists will come and give musical performances and readings at the daily meetings. The young artists of Zurich, whatever their orientation, are invited to come along with suggestions and contributions of all kinds.

Most notable among those who responded to Ball's invitation was a Romanian poet called Tristan Tzara (1896–1963), an intense, angry young man with a gift for oratory and the determination to make sure it was heard. It was while performing at the Cabaret Voltaire that Tzara became friendly with Ball, in a classic case of opposites attracting. Ball was quiet and subversive, Tzara noisy and nihilistic, making for a highly combustible mix. Between them (and with a little help from their friends) they created an anarchic art movement that led to Surrealism, influenced Pop Art, stimulated the Beat generation, inspired Punk, and provided the basis for conceptual art.

They promoted themselves as the juvenile delinquents of the arts, and they were anti-everything: anti-establishment, anti-social, anti-religion and, most of all, anti-art. They denied and despised the

Modernist movements, like Futurism, from which they had emerged. But for all their bombast and belligerence, the Dadaists would not have gained the notoriety and influence they did without ensconcing themselves within the very art establishment they were railing against. In just the same way that Maurizio Cattelan says that his work has to be in a gallery to be effective, so Dada needed to be in the art world for its message to have any impact. Those rebellious Dadaists knew how to play by the rules.

And back in 1916 that meant announcing the arrival of a new art movement with a manifesto, because that's what everybody did. Dada was launched on 14 July 1916 (Bastille Day) by way of a public reading at the Waag Hall in Zurich, a presenting job that fell to Hugo Ball. 'Dada is a new tendency in art. One can tell that from the fact that until now nobody knew anything about it, and tomorrow everyone in Zurich will be talking about it. Dada comes from the dictionary. It is terribly simple. In French it means "hobby horse". In German it means "goodbye", in Romanian "yes indeed" . . . an international word. How does one achieve eternal bliss? By saying dada. How does one become famous? By saying dada . . . till one goes crazy [and] loses consciousness. How can one get rid of journalism, worms, everything nice and right, blinkered, moralistic, Europeanized, enervated? By saying dada.'

Tzara had seen the effectiveness of Filippo Marinetti's inflammatory rants when it came to gaining attention and press coverage for Futurism. He had also noted how the Italian had matched a fevered lambasting of art history with a near-demonic championing of modern technology. Passion and perversion seemed to be a winning ticket. But in Tzara's case the target for furious castigation would be the war, and the subject for fanatical promotion would be the absurdist ideas originated by Paris's literary avant-garde.

Absurdism was an anti-rational trend that had started in the second half of the nineteenth century in Paris with the French Symbolist poets. Paul Verlaine, Stéphane Mallarmé and Arthur Rimbaud (a boy genius who died tragically young, having advocated the 'derangement

of all senses' in order to become 'a true seer') were among the movement's leading poets. They believed that intuition and richly evocative language could reveal life's great truths.

In their wake came Alfred Jarry (1873–1907), a student who had spent his schooldays inventing stories that ridiculed his fat mathematics teacher, Monsieur Hébert. Along with a couple of his classmates, he had developed the stories into an absurd play that they performed with puppets. After graduating from school Jarry moved to Paris, where he continued to refine his play while using his satirical wit and brilliant mind to earn a living as a writer, through which he made friends with Apollinaire and his crowd. After many iterations and false starts his play, now titled *Ubu Roi*, was eventually ready. Ubu Roi was the name of the play's anti-hero: a gluttonous, mean and stupid man who was meant as the comic personification of Paris's smug bourgeoisie. When the play had its public premiere in December 1896, the audience started by booing and ended up rioting. The play's first word was '*Merde!*' – which encapsulated the majority view of the play held by those watching. Nobody had seen anything like it. The fast-paced dialogue was offensive, bizarre, coarse and frequently incomprehensible. Almost everybody went home unhappy.

Except for a few open-minded souls who saw it for what it really was: a mould-breaking piece of theatre. Jarry had created an absurdist drama that would lead to an entire genre, named much later as the Theatre of the Absurd. *Ubu Roi* was not simply sending up French society; it was a sad lament on the futility of life. It would go on to inform the plays of Samuel Beckett (most notably *Waiting for Godot*) and the novels of Franz Kafka. And, before either of them, the Zurich Dadaists.

Tzara would appear with his arty agitators at the Cabaret Voltaire in strange costumes and primitive masks, to a backdrop of incessantly beating drums and Hugo Ball tunelessly thumping away on a piano. They would yell inexplicably and incoherently in any language that took their fancy, and hurl abuse at the world – and their audience.

They staggered about the place drunk and high on a potent cocktail of nihilism and fear, their deranged performances disintegrating into wild noise and random acts.

These were not, however, the tantrums of a spoilt child, but a celebration of childishness. The grown-ups had messed things up; worse, they had lied. The stability that society had been promised by the world's leaders based on political co-operation, hierarchies and social order was a mirage: a deception. The Dadaists wanted a new world order that took on a child's perspective, where selfishness was tolerated and the individual celebrated. Dada might have expressed itself by being stupid, but it was the most intellectual of art movements. And, as with Jarry's *Ubu Roi*, there was a great deal of meaning in their meaninglessness.

To read three different poems out loud, at the same time, in different languages seems – on the face of it – very silly. But their actions were intended as a biting critique of the war. The horrors of Verdun were unfolding as they spoke, where hundreds of thousands of men were being slaughtered. The Dadaists' simultaneity was a symbolic act; referring to those lives being lost in battle; men of different nationalities, on different sides, dying together in the same place at the same time, accompanied only by the horrific noise of war to write them on their tragic journey. As Hugo Ball said, 'What we are celebrating is at once buffoonery and a requiem mass.'

The Dadaists proposed the creation of a new system based on chance. It was given literary life in the form of Dada poems, which were generated by cutting out words from an article in a newspaper. The resulting scraps were then placed in a bag and given a good shake. After which, the fragments would be retrieved one by one and set on a piece of paper in the order that they had emerged. The result was gibberish, which was the Dadaists' point. Their argument being that a traditional poem (and the exalted status of the poet) was bogus by its very nature; it was an ordered structure that made perfect sense. Life, on the other hand, was random and unpredictable.

One artist who felt compelled to reflect this disorderliness was Jean Arp (1886–1966) – also known as Hans Arp – who was one of the co-founders of the Dada movement. He was the only established and well-connected artist among the original Dada cohort, having been part of Kandinsky's Blue Rider group before fleeing, like Hugo Ball, to Zurich during the war. Arp felt it important that the artist relinquished as much control as possible to enable him or her to create an artwork that was true to the randomness of nature, while rejecting Man's dangerous impulse to impose order.

His starting-point for making a Dada artwork was with the *papier collé* of Picasso and Braque, which he had seen during his time in Paris. He had been impressed by their inclusion of everyday 'low' materials into the revered world of fine art – an act that he felt had a Dadaist ring to it. Arp figured that all he had to do to turn a *papier collé* into a Dada artwork was to change the method of production. As opposed to assiduously applying the 'low' materials to the picture's surface as Braque and Picasso had done, he would simply drop them from on high and let chance define the composition.

Arp's *Collage with Squares Arranged According to the Laws of Chance* (1916–17) is an early example of this technique, where he spontaneously created his picture through the act of dropping. In this instance he tore up a piece of blue paper into a series of roughly rectangular shapes of differing sizes, then repeated the exercise with a cream-coloured sheet of paper. He then dropped the torn fragments on to a larger piece of card and glued them down where they landed. Or so he said. Because when you look at the finished work the interspersed rectangles and squares, *none* of which overlap, form a suspiciously well-balanced and pleasing composition. One has to think the hand of Arp has played a part. Either that, or he is a singularly gifted 'dropper'.

As the war came to an end, Arp travelled back across Europe to meet up with old friends from the French and German avant-garde. Along the way he bumped into an as yet unrecognized artist called

Kurt Schwitters (1887–1948) and introduced him to the Dada philoso-
phy. It proved to be the making of Schwitters, who had previously
been painting in a representational style with limited success. After
his meeting with Arp he began to see the artistic potential in what the
rest of the world had discarded as trash. In the winter of 1918–19
Schwitters produced the first of his collages – known as assemblages
– made out of odd pieces of junk.

Whereas Picasso and Braque had used bits and bobs from the stu-
dio to make their *papier collé*, Schwitters raided the local skip for his
assemblages. Tram tickets, buttons, wire, discarded bits of wood,
worn shoes, rags, cigarette ends and old newspapers were harvested
by the German to make his Dadaist art. *Revolving* (1919) is typical of
the pieces he produced at the time. It is an abstract picture that he has
constructed by tacking splinters of wood, slices of metal, bits of cord,
patches of leather and oddments of cardboard on to a painters' can-
vas. The end result is surprisingly elegant and refined, especially given
the paucity and randomness of the materials. On a painted back-
ground of earthy greens and browns, the artist manipulated his haul
of debris into a series of interlocking circles, which he then overlaid
with two straight lines in the shape of an upside down 'V'. It is a com-
position made out of rubbish that has the geometric refinement of a
Constructivist painting.

The plundering of skips and bins to make art was no more of a
gimmick for Schwitters than using modern building materials had
been for the politically active Tatlin. Schwitters considered trash to be
the appropriate medium for the time. Not only were fine-art supplies
hard to come by directly after the war – unlike the ever-present stock-
pile of garbage – but using fragments of refuse acted as a metaphor
for a broken world that, like Humpty Dumpty, the artist thought
could not be put back together again.

Schwitters went on to make hundreds of such collages, giving them
the collective name 'Merz', which was his personal take on Dada. He
invented the word when he discovered that the letters 'Merz' were all

that remained from an advert for Kommerz und Privatbank that he had ripped from a magazine to put into a collage. His aim was simple: to use discarded waste – or 'found' materials, as such matter is now referred to in the art world – in order to unite fine art with the real world. He believed art could be made from anything and anything could be art. A point he set out to prove by moving away from his assemblages – which although unconventional were still presented in frames and designed to hang on a wall – and into houses. Or, more precisely, into *Merzbau*, which is Schwitters-speak for a house made out of rubbish.

He constructed the first *Merzbau* (see Fig. 20) in his home in Hanover, Germany. It is a fantastical hybrid creation – part sculpture, part collage, part building. Nowadays it would be called an installation, but back in 1933 there wasn't a name for such things. It was a scrap-heap-cum-grotto filled with 'spoils and relics' gathered from anywhere and anyone (sometimes without them knowing . . .). It was a *Gesamt-kunstwerk* of sorts, in which pieces of wood hung from the ceiling like stalactites in a cave, creating narrow pathways between pairs of old socks and sheets of metal cut into geometric shapes. Schwitters considered it the culmination of his life's work and continued to make new rooms and add 'features' out of discarded and stolen materials until the mid-30s, when he had to flee from the Nazis.

The *Merzbau* was destroyed in the Second World War, but the potency of its legacy remains. Had Schwitters been alive in 2011 to take a quick trip around that year's Venice Biennale – the Olympics of the contemporary art world – he would have seen for himself that his efforts made of waste were not wasted. At least three of the national pavilions were forms of *Merzbau* – house-sized art installations constructed with discarded materials gathered by the artists from far and wide: each one an homage to the eccentric German artist.

As we know, Schwitters's practice of turning undesirable everyday objects into works of art was not new. Braque and Picasso had already

done it, and so had Arp. But Marcel Duchamp had taken the concept the furthest in 1917 when he transformed a urinal into his 'ready-made' sculpture *Fountain*, without making any effort to change either its physical appearance, or incorporating it into a larger work (which

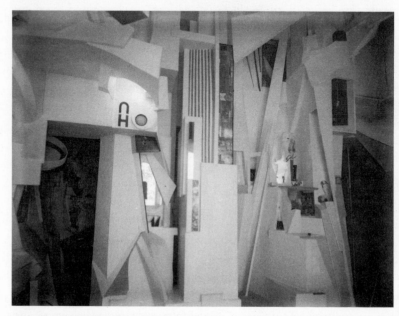

Fig. 20. **Kurt Schwitters,** *Merzbau*, **1933**

is what Schwitters, Braque, Picasso and Arp had done). It was an action that made Duchamp the daddy of Dada, a movement about which he was initially completely unaware.

While the German-speaking avant-garde had sought refuge in Zurich in 1915, Duchamp went in an altogether different direction: he travelled across the Atlantic to New York. Which is where he was in 1916, sitting in his apartment quietly thinking about a chess move, when his opponent, the French artist Francis Picabia (1879–1953), roared with laughter. Duchamp raised his eyes to see what had pro-voked his friend. Picabia handed him the source of his mirth, an

imported art magazine that featured the noisy antics and proclama-
tions of the Cabaret Voltaire crowd. Duchamp read about the
Dadaists, smiled conspiratorially and gave the magazine back to Pica-
bia. For these two men, finding out about Dada was like a drunk being
given the keys to a vineyard. Both had an unquenchable thirst for
anarchy and mischief.

They had met in Paris at an exhibition preview in the autumn of
1911, a happy event about which Duchamp later remarked, 'our
friendship began right there'. Like Ball and Tzara, Duchamp and
Picabia were an unlikely pairing. Picabia was a big character and an
ebullient showman, Duchamp reserved and bookish. But they shared
a fascination with life's absurdities, a taste for provoking the estab-
lishment, a keen eye for women and a love of New York.

The ideals of Dada chimed with both artists, but perhaps more so
with Duchamp, who had been thinking in a similar way to Ball and
Tzara for a while. Some time earlier he had produced an artwork
called 3 *Standard Stoppages* (1913–14), which he had made by strictly
conforming to the rules of chance. To create the piece Duchamp
painted a rectangular canvas blue, and laid it out flat on a table, face
up. From precisely one metre above he held a one-metre length of
white thread parallel to the canvas. He then dropped the thread and
glued it to the canvas exactly where and how it fell, in much the same
way Arp would do three years later with his *Laws of Chance*.
Duchamp repeated the exercise of dropping a one-metre length of
cotton on to the blue canvas twice more. He then cut the canvas along
the line of the individual threads to produce three separate templates,
with each wrinkly line representing a new unit of measurement.

The purpose of the exercise was a playful re-evaluation of the fixed
French system of measuring lengths in metres. Duchamp was ques-
tioning establishment doctrine and received wisdom. Having three
different versions of a standard length was an important aspect to the
work. To have had just one could be conceived as an artist imposing a
new type of measurement, but to have three different 'standard

lengths' makes any system unworkable. As with many of Duchamp's artworks, 3 *Standard Stoppages* is not so much about aesthetics, but ideas. He was not interested in stimulating the eye of the beholder; it was our mind he was after. He called it anti-retinal art. Two years later Tzara and Ball announced the same notion as Dada, while future generations would come to know it as conceptual art.

Duchamp returned to Paris in 1919 for a six-month stay, having spent the previous four years in New York. He met up with old friends, visited family, and wandered the streets of a city that had once been his home. When out on one such occasion he picked up a cheap post-card reproduction of Leonardo da Vinci's *Mona Lisa*. Later, when he sat down for a coffee, he retrieved the postcard form his pocket and drew a moustache and goatee beard on to Lisa's enigmatic face. He then signed it, dated it, and wrote L.H.O.O.Q. on the white border at the bottom of the postcard. It was no more than a doodle, a small amusement for a man interested in art and games.

But like so many of Marcel Duchamp's asides, his casual scribble was loaded with meaning. Then, as now, the painting of the *Mona Lisa* in the Louvre was treated like a religious icon painted by a genius. It is the sort of unquestioning reverence for art and artists that puzzled and annoyed Duchamp, hence his defacing of the 'sacred' image. He was using humour, like all good comedians, to say the unsayable, which in this case was: stop taking art so seriously.

He wasn't. The letters L.H.O.O.Q. are meaningless until read out phonetically in French, when they sound like 'elle a chaud au cul', which when translated into English means 'she has a hot ass'. It is a schoolboyish piece of wordplay to which the artist was more than partial. But what about the facial hair? Why has Duchamp turned her into a man? Is he alluding to Da Vinci's supposed homosexuality? Or, perhaps, his own penchant for cross-dressing? The Frenchman was rigorous in his breaking of social barriers, which made subverting one's own sexuality an obvious target. His cross-dressing feminine side came out in all her glory in 1920, operating under the pseudonym

Rrose Selavy, a name that he had chosen with his ear for a pun. When spoken it sounds like 'Eros, c'est la vie', which translated into English reads 'Love (or sexual desire), that's life.'

Duchamp immediately went to the studio of his friend and fellow New York Dadaist, the American artist and photographer Man Ray (1890–1976), to have Rrose's picture taken. Man Ray happily snapped away as Rrose/Duchamp posed in all his/her finery. A while later Duchamp cut out the face of Rrose from one of Man Ray's photographs to be part of another artwork laden with hidden meaning. Again his starting-point was a pre-existing object – a 'readymade'. In this instance it was an empty bottle of Rigaud perfume, from which Duchamp had removed the original label and replaced it with his own creation (making it an 'assisted readymade').

At the top of Duchamp's newly affixed label was Man Ray's image of Rrose Selavy staring out alluringly from beneath a mop of dark hair. Beneath Rrose is an invented brand name, BELLE HALEINE, meaning in English 'beautiful breath'. Below, written in an elegant italic font, are the words Eau de Voilette (as opposed to the usual eau du toilette) – meaning 'veil water' (i.e. the perfume is veiling a tantalizing promise or secret – in Duchamp's case his sexuality). At the bottom of the label Duchamp has listed dual places of origin, New York and Paris, a reference to the cities from which Rrose (and Duchamp) belonged.

Belle Haleine (1921) is a typical Duchampian Dadaist anti-artwork. Nothing about it is real; its promise doesn't exist. There is no perfume in the bottle. It won't give you beautiful breath, even if you are taken in by the magical claims of the 'veil water', and all its religious connotations. Duchamp could be referring to the 'veil' of the Virgin Mary and the water from Lourdes that is meant to be blessed with healing powers, or to the veil of mystique that conceals the emptiness of art. Either way it is a worthless piece of junk, an empty bottle with a fake label. It is a critique on materialism, vanity, religion and art, which in Duchamp's mind were false gods worshipped by the insecure, inadequate or ignorant.

Man Ray took a photograph of Duchamp's *Belle Haleine*, which the two artists subsequently chose to put on the front cover of the first, and only, edition of their *New York Dada* magazine. The magazine didn't last (Man Ray left New York to live in Paris), but *Belle Haleine*'s Dadaist spirit lived on. In an ironic twist that would have made Duchamp smile, the artwork was acquired by Yves Saint Laurent, the fashion designer and purveyor of expensive perfumes. After the designer died in 2008 much of his collection was sold, including *Belle Haleine*, to which Christie's gave an estimate of just under $2 million. That would have turned Duchamp's smile into a chuckle. But he would have been roaring with laughter when the hammer eventually came down to seal the sale for a staggering $11,489,968.

It goes to show that for all Dada's success in becoming an international anti-art movement with outposts in New York, Berlin and Paris, it ultimately failed. The fact is that we live in a far more avaricious society than the one that Ball, Tzara, Duchamp and Picabia were attempting to change. And the epitome of that is today's art world, which is more commercial than ever: artists tend not to starve in garrets in the twenty-first century, several are multi-millionaires jetting off around the world to promote themselves and their work at this or that biennale with an entourage of PAs and PRs. Art today is a business, a career choice. Which is not to say that there are no artists continuing to beat the Dadaist drum – Maurizio Cattelan does, for instance – but their motivation is not a furious reaction to the horrors of human conflict, more a comment from afar: detached observers – Baudelaireian *flâneurs*.

Dada needs conflict to exist in its purest form: Tzara against the bourgeoisie, the Sex Pistols against the stuffiness of the British establishment. Without it, the movement morphs into something slightly different: no less determined or radical, but subtler. In 1924 Dada became Surrealism.

SURREALISM: LIVING THE DREAM 1924–45

Of all the modern art movements, Surrealism is the one about which most of us feel we have a reasonable degree of knowledge. It's a stylized painting by Dalí of a melting clock (*The Persistence of Memory*, 1931) or his telephone with a lobster for a receiver (*Lobster Telephone*, 1936). Or it's one of Man Ray's X-ray-like black and white photographs: double-exposed, ethereal and sexy; the point where dream becomes reality or vice versa. Mixed metaphors and incongruous combinations, bizarre happenings and freaky outcomes, macabre locations and mystical trips; yup, we know about Surrealism.

And that's because its spirit has stayed the course unlike any of the other art movements. Generations of artists, writers, filmmakers and comedians have taken up where Dalí and Man Ray left off. We don't describe a current movie director as a Constructivist, or an author as an Impressionist. We don't even say an artist is a Cubist or a Fauvist

nowadays. But we will label them – if appropriate – as Surrealist. We say that Tim Burton, David Lynch and David Cronenburg, with their singing puppets, vivid dream sequences and man/housefly metamorphoses, are surrealist filmmakers. That the jarring fiction of Thomas Pynchon, the humour of Monty Python (*that* sketch about the Spanish Inquisition), even the music of the Beatles ('I am the Walrus'), all have Surrealist touches.

So why has this movement, which ended around the time of the Second World War, kept its place in the public consciousness? Part of the answer has to be our familiarity with the meaning of the word. Surrealism has entered the day-to-day lexicon, most often in its adjectival form: surreal. Children can be heard to say something is 'surreal': usually – in my experience – when watching one of Homer's flights of fantasy in *The Simpsons*. They know it means something a bit weird that comes into play when two seemingly incompatible elements meet (perhaps eating a doughnut while winning a beauty competition, in Homer's case). When it comes to art, 'surreal' is a catchall word used to describe an artwork that might be uncanny or strange or kooky – and there's plenty of that about. Louise Bourgeois's monumental 10-metre-high metal spider (*Maman*, 1999) (see Fig. 21), which is an 'ode to her mother' who was a great 'weaver', or Jeff Koons's giant puppy (*Puppy*, 1992) (see Fig. 22) made out of flowers, come to mind.

The French poet – and lover of most things modern – Guillaume Apollinaire invented the word in 1917. He used it twice in the same year: once for his play *Les Mamelles de Tirésias* (1917), which he described as a '*drama surréaliste*' – a subtitle that lived up to its billing. The play features a woman devoid of the maternal instinct who would rather be a soldier than a mother, and claims to be growing facial hair while remarking that her bosoms are becoming detached from her body. Her husband shrugs and declares that he will just have to have their babies on his own, which he does: producing 40,049 in a single day. A *drama surréaliste* indeed.

Apollinaire also used the word in his programme notes for *Parade*

(1917), a new ballet by Serge Diaghilev's legendary Ballets Russes which the poet described as *'une sorte de sur-réalisme'* – a sort of sur-realism, by which he meant 'beyond realism'. 'Beyond the pale' would have been a more appropriate description in the minds of the majority

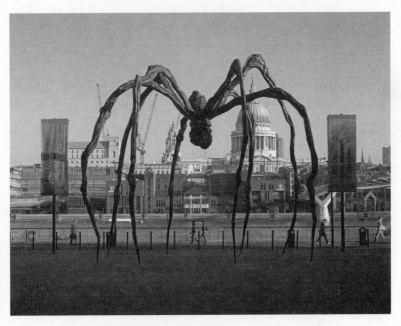

Fig. 21. **Louise Bourgeois,** *Maman,* **1999**

of the audience on the ballet's opening night. Parisian ballet-goers thought themselves broad-minded but found themselves perplexed by almost every aspect of the production. They adored and admired the Russian impresario Diaghilev, who was to dance in the early twentieth century what Harvey Weinstein is to movies in the twenty-first century. He dominated the modern scene by hiring the best dancers (Vaslav Nijinsky) and commissioning the best choreographers (George Balanchine), composers (Debussy, Stravinsky), and artists (Matisse, Miró) to design stage sets and costumes. All of which was done with maximum chutzpah on a minimal budget.

But his reputation had been built on the vitality and style of his productions, not on their avant-garde narratives. *Parade* was a departure for Diaghilev and his Parisian followers. It was a ballet conceived

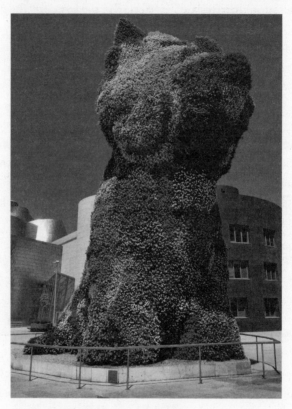

Fig. 22. **Jeff Koons**, *Puppy*, **1992**

as a piece of theatrical Cubism: a story to be told from different perspectives, covering different moments in time. The great impresario had gathered an all-star, cross-disciplinary cast to create the work. The writer and dramatist Jean Cocteau was employed to set the scene, the eccentric but brilliant musician Erik Satie was asked to compose the score, and the scenery and costumes were to be designed by Apollinaire's great friend, Pablo Picasso.

The creators based their production on the world of circus, a form of light entertainment that they all enjoyed. The tale of the ballet was to be one of three enterprising circus managers attempting to drum up business for their respective shows by parading their entertainments in three separate tents. One tent featured a conjuror, another an acrobat, and the final offering was an all-singing-all-dancing little American girl (probably based on the actress Mary Pickford).

There was nothing particularly outré about the story, but there was in Satie's music, which included inflections of jazz and ragtime, with aeroplane propellers and tickertape adding some unusual musical accompaniment for the dancers. Not all of whom were actually dancing. To the annoyance of the audience – who had paid to see the great Ballets Russes strut their stuff – some of the dancers were cast as jugglers, acrobats and – thanks to Picasso – the inside workings of a pantomime horse. The ensuing confusion, clashing sounds and rapidity of action were designed to reflect life in a modern city. The audience were unconvinced and largely unimpressed, adding booing and hissing to Satie's already unconventional score, although some did clap and cheer. I suspect, had any of them read Apollinaire's programme notes in detail, that they would have grasped what he meant by 'surreal' straight away.

A few years later André Breton (1896–1966), a thrusting young Parisian poet, was becoming increasingly disillusioned with the Dada movement he had once passionately supported. He felt Dada had run out of steam, although he still subscribed to its fundamental aims, which were a destruction of the systems and mannerisms of capitalist society. The ambitious poet was seeking to find a new form of artistic expression that would allow him to incorporate some of Sigmund Freud's psychoanalytical concepts into the Dada mindset. Breton was particularly interested in Freud's research into the role the unconscious mind played in human behaviour, as revealed through dreams and 'automatic' (stream-of-consciousness/spontaneous) writing.

By late 1923 Breton was ready to launch his new son-of-Dada

movement and was casting around for a name with which to christen his creation. Instead of looking forward, he looked back, to the work of his literary mentor, Guillaume Apollinaire, whom he had first met in 1916. Apollinaire had been sent home having suffered a severe head wound while fighting in the war, leaving him free to pick up where he had left off as the literary figurehead of the Parisian avant-garde. The admiring young Breton saw the great man regularly thereafter until, war-weakened, Apollinaire died from Spanish flu in 1918. Come 1924, when Breton was writing the manifesto for his new artistic movement, he reviewed Apollinaire's back catalogue and found the word '*surréalisme*' and knew immediately that he had found the answer to his nagging naming problem. 'In homage to Guillaume Apollinaire,' he subsequently wrote in his *First Manifesto of Surrealism* (1924), 'I baptized the new mode of pure expression . . . Surrealism.'

In typical fashion for a modern art movement, it started as an all-out assault on society. The left-wing Breton wanted to bring civilization to its knees by provoking a crisis in the heads of the bourgeoisie. His new idea was to tap into their unconscious mind in order to dredge up unseemly secrets that had been suppressed for the sake of decency. Once out in the open, the plan was to place 'rational' reality alongside this altogether nastier (and truer, according to Breton) version of 'reality' in an ill-matched union designed to create disquiet. Subversion – it was hoped – would lead to mass disorientation caused by the Surrealists' anti-rational thought, word and deed. Which, as Breton liked to say, would be marvellous.

He would also frequently quote from a demented prose poem by the nineteenth-century French poet Comte de Lautréamont, called *Les Chants de Maldoror* (1868–9). The whole piece luxuriates in evil and is full of ludicrous combinations like: 'as beautiful as the chance encounter of a sewing machine and an umbrella on an operating table'. Curious, for sure – which was Breton's point. He wanted to confuse with vivid images of madness presented as normality. He had

been a psychiatric orderly during the First World War, which had led to his interest in depravity and lunacy. He once said, 'I could spend my whole life prying loose the secrets of the insane. These people are honest to a fault.' He called Surrealism a 'new vice' with which to change the world.

We know that artists such as Kazimir Malevich, Wassily Kandinsky and Piet Mondrian had already explored the role of the unconscious in art. But whereas they wanted to provoke a subliminal sense of utopia in our minds with their abstract paintings, Breton's Surrealism aimed to confront us with shocking words and images to expose the depravity of our own minds.

While the Dadaists said they had no antecedents, Breton was the opposite: he was more than happy to claim many of the great artistic minds for Surrealism. His intention was to start the new movement in the same way as Dada had begun, with a literary bent. To which end he drafted in a couple of big names as 'marquee' signings. Dante, because of *The Divine Comedy*, the epic poem about the afterlife, and Shakespeare, included, I assume, because of the fairies in *A Midsummer Night's Dream*, were shamelessly claimed by Breton as Surrealist writers. With the 'big two' in the bag, he moved on to more modern literary stars, citing the Symbolist poets Mallarmé, Baudelaire and Rimbaud as proto-Surrealists, along with the English writer of nonsense verse Lewis Carroll, and the dark and troubled prose of the American novelist Edgar Allen Poe.

Breton was no less ambitious when appropriating artists to his cause, enlisting both Marcel Duchamp and Pablo Picasso, even though neither artist had signed up as Surrealists. Nor would they, although both would be supportive and interested in Breton's creation – Picasso initially more so than Duchamp. As can be seen when, a year after the young French poet launched his movement, Picasso painted *The Three Dancers* (1925) (see Fig. 23), an image that he allowed Breton to publish in his Surrealist treatise on painting. The poet had already included the primitive mysticism of Picasso's *Les Demoiselles*

d'Avignon in his Surrealist canon, and was delighted to be able to add another of the Spaniard's macabre masterpieces to the list.

The jazzy, semi-abstract painting is of three people, possibly two

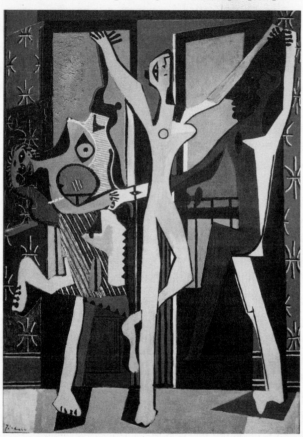

Fig. 23. **Pablo Picasso,** *The Three Dancers,* **1925**

men and a woman; it is not easy to be sure. Picasso painted the picture's three loose-limbed characters as two-dimensional, geometric forms in a manner similar to the Primitive-Cubist style he deployed to depict the prostitutes in *Les Demoiselles*. The dancers – painted in block pinks, browns and whites – hold hands as they cavort in a high-

ceilinged room in front of two glass doors that open out on to a balcony. It is a beautiful day with a cloudless blue sky. It would appear they are having a good time. But they are not. Theirs is not a jig of joy, but a dance of death.

Picasso had become immersed in the world of dance during the time he designed the sets and costumes for *Parade* in 1917. It was while working on the ballet that he had met and subsequently married Olga Kokhlova, a Russian ballerina and member of the Ballets Russes. By the spring of 1925 Picasso's enthusiasm for ballet had waned, as had his interest in Olga. The two bickered constantly and Picasso wanted out. The artist's already anxious state of mind was made worse by the news that Ramón Pichot, a great friend from his early days in Barcelona, had died unexpectedly.

Picasso was devastated. It was while in this extreme emotional state that he painted *The Three Dancers*, a work he once said that in hindsight he wished he'd called 'The Death of Pichot'. *The Three Dancers*, like F. Scott Fitzgerald's masterpiece *Tender is the Night* (1934), reveals the despair and tragedy that lurk beneath the surface in the lives of many seemingly carefree beautiful young people. It tells the tragic story of an unrequited love through the medium of dance; a reference to his own depressing domestic situation.

Back in 1900, when Picasso was still finding his way, he had gone to Paris with Carlos Casagemas, a friend from Barcelona and fellow artist. One night they went out with some good-time girls for an evening of guilty pleasures. But Casagemas fell deeply in love with his paramour, a femme fatale called Germaine. She did not reciprocate, leaving Casagemas upset and troubled. As a distraction, Picasso took his love-struck friend to Malaga for a boys' holiday. But Casagemas was determined to return to Paris. He did so in 1901 and went out for dinner with a group of friends, including Germaine. Once everyone was seated in the restaurant Casagemas stood up. He pulled a pistol from his belt and fired it at the cold-hearted Germaine. He missed. He shot again, this time at a new target which he hit with

unerring accuracy in the head. Casagemas died almost instantly from his self-inflicted wound. Germaine was unmoved; Picasso, when he heard the news, was distraught. So much so, it is said to have led to the artist's Blue Period (1901–4), during which time he painted several pictures featuring the recently deceased Casagemas. Now, a quarter of a century later, the death of Pichot, another dear friend, reawakened those unhappy memories of the fateful incident in Picasso's mind.

And that is because Pichot had married Germaine. It was a decision that had upset Picasso at the time, and one of which the artist was now reminded as he painted *The Three Dancers*. In fact the picture could be interpreted as the story of the doomed love triangle. The white and chocolate-brown dancer on the right of the picture is Ramon Pichot; his ghostly black head emerging like an Egyptian mummy to overwhelm the living body. To the left is Germaine, crazed and tortured. She is the depraved nymphomaniac who has used and abused her body to such an extent that it has broken and become repellent. Between the two stands the elongated figure of Carlos Casagemas. He has been crucified and is dying under the remorseless heat of the sun, his pink body turning white as the lifeblood drains away.

It's impossible to say whether or not that is a correct reading of the painting (Picasso had a habit of being oblique when discussing his work), but we do know that André Breton loved the picture. And you can see why, as it has some clear surreal touches – the representation of Germaine being the most notable. But it is probably too literal to be considered a true Surrealist painting. For that we need to turn to another Spanish artist who had come from Barcelona to live in Paris, and had also caught Breton's Surrealist eye: an artist to whom Breton gave a favourable review in his July 1925 edition of *La Révolution Surréaliste*.

Joan Miró (1893–1983) made his first trip to Paris in 1920, when he attended a Dada festival and visited Picasso in his studio. He returned

the following year and rented a studio. By 1923, when Breton was pre-
paring to launch his Surrealism movement, Miró had become an
established member of the Parisian avant-garde. And come November
1925, and the first Surrealist exhibition at the Galérie Pierre in Paris,
his work was to be found hanging alongside that of fellow Spaniard
Pablo Picasso. Joan Miró had arrived.

His painting *Harlequin's Carnival* (1924–5) (see Plate 20) was a
talking point at that inaugural Surrealist show and helped cement
Miró's reputation. The picture features many of the elements for
which Miró's paintings would become famous. There are the bio-
morphic shapes, the squiggly lines, and plenty of black, red, green
and blue – all rendered with what appears to be a childlike naivety.
Breton would say of him that he was the most 'surrealist of us all'.
Which, having taken a look at *Harlequin's Carnival*, is a reasonable
comment.

It is made up of an array of creepy-crawlies, musical notes, random
shapes, fish, animals, and the occasional unblinking eye. Most of
these are floating about in mid-air as if a room has been filled with a
collection of the world's most bizarre balloons. There's a party going
on; probably the carnival of Mardi Gras, the Christian festival where
everyone consumes what they can before fasting for Lent. The epony-
mous harlequin makes his appearance in the form of a mustachioed
ball, just left of centre, his rotund face painted in blue and red halves.
His elongated neck and stout body double as a guitar, the front of
which Miró has decorated with the diamond checks of a harlequin.

Harlequin's Carnival is the work of a man who was thinking differ-
ently. Or, perhaps, not thinking at all. Breton described Surrealism as
'psychic automatism in its pure state', by which he meant writing or
painting spontaneously, free from any conscious association, precon-
ception or specific intention. The idea was to take a pen and paper
and to write or draw the first thing that came to mind, without fore-
thought. Ideally this would be undertaken in a trance-like state where
the conscious mind was disconnected altogether, allowing access to

the deep unconscious, which would then reveal the dark and danger-ous truth of a brain awash with thoughts of sexual depravity and murderous intent.

Which accounts for the lack of obvious structure in Miró's paint-ing: although he did devise one. It was more a case of the elements within the picture determining the composition as each shape appeared on the canvas through the back door of Miró's mind, mak-ing *Harlequin's Carnival* something of a visual outpouring of the artist's unconscious, which I'll have a go at deciphering. Take the big green ball on the right, for example. That could represent the world, which Miró was determined to conquer. The ladder with an eye and an ear attached could allude to the artist's fear of being trapped, pro-viding as they do the sensory and practical means of escape. The black triangle in the window has the look of the Eiffel Tower, a land-mark in the city of Miró's dreams. Meanwhile, the insects, colours and shapes in the picture hark back to his Spanish roots. As for the musical notes, well, a party has got to have some sounds.

Miró's studio in Paris made him a close neighbour of Max Ernst (1891–1976), a German artist who was an influential figure in the emergence of Surrealism. Ernst had grown up in a small town in Ger-many with a disciplinarian father for company, which wasn't a lot of fun for a naturally inquisitive and rebellious boy. The young Max was constantly on the lookout for ideas and situations to broaden his hori-zon beyond life in the provinces. Salvation came in the form of Sigmund Freud's *Interpretation of Dreams* (1900), which the school-boy devoured with the zeal of a starving dog in a butcher's shop.

Shortly afterwards he met and struck up a friendship with the artist Jean Arp, a relationship that was rekindled after the war, leading to Ernst taking a prominent role in Arp's burgeoning Dada movement. Soon he was acquainted with Tristan Tzara and André Breton, who admired his work and approach, both of which are evident in his painting *Celebes* (1921). The title for the picture comes from a crude German rhyme in which the elephant from the island of Celebes,

Indonesia, is described as having 'sticky, yellow bottom grease' while the elephant from the nearby island of Sumatra is 'always f***ing his grandmamma'.

Ernst's grey elephant monopolizes the picture, taking the cylindrical form of an old-fashioned boiler or industrial vacuum cleaner. The great grey beast has two tusks for a tail, a hose for a nose, and sports a pair of horns and the frilly white collar of a dress at the end of its trunk. On top of the elephant's head is a hat made out of blue, red and green geometric pieces of metal, in which one all-seeing eye is embedded. The animal's mechanical and physical features resemble a military tank; the allusion is amplified by its location, which appears to be an airfield, a suggestion that Ernst embellishes with a puff of smoke in the sky suggestive of a plane being shot down. Mind you, I have never been to an airfield where two fish are swimming in the sky, as is the case in this picture. Nor one where the naked torso of a woman stands in the foreground with a metallic column sprouting from her headless neck. The decapitated figure has her right arm raised above her shoulder towards the elephant's trunk, against which her hand brushes in a sexual fashion.

It is a weird picture. And one that Breton considered to be marvellous. The poet was still at the stage of formulating his thoughts for his new movement back in 1921, the year when Ernst produced *The Elephant Celebes*. But they were developed enough for him to approve of the way Ernst had combined unrelated objects and settings to produce a disturbing picture that had the Freudian spirit of 'automatic' free association. Breton was so keen on the idea of mixing random subjects that he developed a game to play among his friends that would be guaranteed to throw up perverse combinations. It involved the first player writing a line of prose at the top of a blank sheet of paper and then folding it over just enough to hide the words. Player 1 would then hand the partially folded sheet to Player 2, who would write his or her line, fold the paper once more and hand it on to Player 3. And so on, until the bottom of the sheet was reached. At which point the paper

was unfolded and the disassociated lines read out from the top as one unified piece. Cue hours of serious analyses and a little light laughter at the nonsensical combinations and the telling insights that revealed the true personalities of the players . . . The Surrealists called the game 'Exquisite Corpse', after the occasion when the first line had read: 'The exquisite corpse will drink new wine.'

Ernst discovered his own way to make 'automatic' art, which he referred to as 'frottage'. It was an adapted form of brass rubbing that involved transferring the imprint of textured surfaces – a wooden floor, the spine of a fish, the bark of a tree – on to paper by making rubbings in crayon or pencil. Once transferred, Ernst looked at the result and waited for his mind to start seeing 'strange things'. A few minutes of peering at the knotty or knobbly shapes produced by the rubbing would trigger hallucinations, at which point Ernst would start to 'see' prehistoric creatures or wild stick-people. In *Forest and Dove* (1927) he has adapted a rubbing into an ominously dark forest reminiscent of the one into which Hansel and Gretel ventured. In the centre of the picture, trapped among the oppressive and forbidding trees, is a caged dove. This is Ernst as a child; the picture an image of a recurring nightmare in which he is overpowered by unknown dark forces. He didn't set out to produce the image; it is what came to him having studied his 'frottage' rubbing, which is a form of 'automatic' Surrealism.

While Ernst and Miró were producing their automatic images, Salvador Dalí (1904–89) was planning to take Surrealism in another direction. Forget the staged pranks, the television gameshow appearances, the statement moustache, the overt commercialism, and everything else the Spanish artist did to gain attention and destroy his reputation. Instead, let his work speak for itself; when seen at close quarters, it bears testimony to Salvador Dalí's considerable artistic talent.

His take on Surrealism was to 'systematize confusion and thus help to discredit completely the world of reality', by way of painting

'dreamscapes'. These weren't produced using Miró and Ernst's techniques of spontaneous association, but by putting himself into a trance in order to reach a state of 'critical paranoia'. His aim was to make 'hand-painted dream photographs'. He figured that the more realistic he could make his unreal images appear, the greater the chance they stood of freaking out the viewer. André Breton was a fan (until they fell out). Both he and Dalí followed Freud's line about the 'superior reality of dreams', arguing that it was in the nocturnal imaginings of the sleeping that the real truth of human existence resided.

Despite their ubiquity, many of the images Dalí created are powerful, memorable and expertly crafted. The best known of the lot, *The Persistence of Memory* (1931), is a case in point; Dalí painted it two years after joining the Surrealists. Many of us have come to know this picture having seen it as a poster, but that does not well serve the original, which is quite small (24 by 33 centimetres) and extremely intense. A close inspection of the painting reveals an intricate image created with meticulous care and skill, where Dalí has blended his paints with the subtlety of a Renaissance master.

What's more, he has succeeded in his intention to disturb anyone who looks at the work. It starts out as a regular landscape painting that shows the Mediterranean sea and cliff faces off the north-east coast of Spain, near the artist's home. But then a dark shadow looms across the shore, casting a menacing presence like a deathly virus. Anything caught within its grim embrace becomes flaccid and instantly starts to decay. Once-sturdy pocket watches droop like dead men, their faces as shapeless as overripe cheese. It is the end of time: the end of life. An army of black ants swarms over the carcass of a smaller timepiece while another slithers over a truly grotesque jellyfish-like creature. That is Dalí. Or, at least, an approximation of the artist's face when viewed in profile. He too has been enveloped by the suffocating shadow of death, leaving him limp, lifeless and disgusting as his innards ooze out of his nostrils.

The Persistence of Memory is a painting about sexual impotence

(Dalí's great fear), the relentlessness of time and the indignity of death. Dalí has set his painting in a recognizable paradise-on-earth in an attempt to spoil our enjoyment of such places by planting this hideous hyper-real image in our minds. It is not pretty, but it is clever. Rather like its creator.

René Magritte (1898–1967) took a slightly different approach to his lifelike dreamscapes. He was as conventional as Dalí was wacky, but perhaps inhabited an even stranger place: a world of the everyday and mundane where the ordinary is extraordinary – in a bad way. In Magritte's mind the next-door neighbour is a serial killer, and those cute schoolchildren skipping off to school are really evil delinquents slowly poisoning their teacher with mercury. With this Belgian artist nothing is ever quite as it seems; the air is always laced with uncanny omens that catch in the windpipe. His sinister paintings of suburban life make David Lynch look like a straight up-and-down guy. Magritte was the prince of paranoia, the doyen of dread.

He proved that early on in his Surrealist career when he painted *The Menaced Assassin* (1927) (see Fig. 24). It is a macabre, unsettling image with the mood of a Swedish crime thriller. Magritte has us looking straight through two interconnecting rooms of a house at the end of which is a doorless balcony offering a view of distant mountain tops. The rooms are sparsely furnished, with grey walls and bare floorboards. In the foreground two bowler-hatted men lurk with malicious intent on either side of the entrance leading into the next room: they are hiding from the inhabitants within. The men look like accountants but have the countenance of thugs as they prepare a violent attack armed with a fishing net and cudgel. Inside the room a dapper young man, dressed in a tailored suit, stands nonchalantly in front of a gramophone and looks appreciatively into its trumpet-like speaker. To his right are a brown leather suitcase, a hat and a coat: he looks set to leave. He appears happy and relaxed. Behind him, though, lying naked on a bed, is the corpse of young woman who has been recently murdered. Blood seeps from her mouth; her throat has been slit. Outside,

looking in from the balcony, are three men with tidy haircuts. They stand in a row with only their heads visible, making them look as if they have been planted in a windowbox.

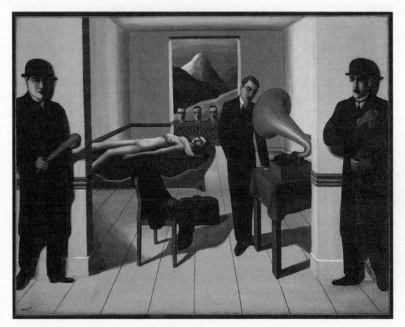

Fig. 24. **René Magritte,** *The Menaced Assassin,* **1927**

It is a mysterious image. At times it is banal, and at others traumatic and threatening. At first glance *The Menaced Assassin* seems real, but the more you look at it, the more theatrically dramatic it becomes: beyond real – or in French, as Apollinaire said, 'sur-réal*isme*'. Magritte, who once worked in advertising, knew all about infiltrating people's minds with images. He learnt that the most effective advertising posters are predicated on aspirational images combined with widely held assumptions. The everyday and the unobtainable are the tools of the ad man, which when applied by an artist such as Magritte can be transformed into the powerful metaphors of his 'magic realism'. He is telling us that life is an illusion; no image is

real – including those presented by your supposedly normal next-door neighbour.

The inspiration for his paintings came from popular culture: cinema, posters, magazines and pulp fiction. And, as with the majority of the Surrealists, from the Italian artist Giorgio de Chirico (1888–1978), a man who was making wildly Surrealist images while André Breton was still a schoolboy. As the word 'surreal' didn't exist at the time, he called his hauntingly bizarre paintings 'metaphysical'. And few De Chirico paintings are more strangely metaphysical than *The Song of Love* (1914). The stone head from a Greek statue hangs from a giant concrete wall that abuts the elegant arches of an Italian cloister. Next to the decapitated sculpture hangs a giant red rubber glove, pinned to the wall as if the concrete were a cork noticeboard. In front of the wall is a nondescript green ball; behind it, the silhouette of a steam train set against a perfect blue sky. De Chirico is taking elements from a variety of times and places (a piece of high art from classical antiquity, a lowly sanitary glove from modern life, images of night and day, and representations of new and old architecture) and bringing them incongruously together in one place at one time, causing meanings and relationships to change and unusual associations to be created.

De Chirico's game of fantasy mix 'n' match has an undercurrent of anxiety and a deep sense of loneliness and foreboding. The stylized images, illogical perspective and stark shadows engender an eerie feeling that is accentuated by the complete lack of people. There is plenty of evidence of human existence – the ball and train suggest recent activity – but nobody is there: the place is deserted. The sky is a brilliant blue, but the air is filled with a brooding menace and disquiet.

The work's tense, apprehensive atmosphere reminds me of the paintings of the American Realist painter Edward Hopper (1882–1967). He too had the ability to draw the viewer into a world of impending gloom and doom, with images of lonely and exposed figures in isolated and abandoned environments. He even made New

York – the city that never sleeps – into a ghost town in his famous painting *Nighthawks* (1942), in which three desolate, mute souls exist in a state of lifeless limbo in a late-night restaurant. We see the three defeated and depressed individuals through the diner's large glass façade: a window into the misery of their netherworld. A young barman gives them a pitying look, realizing that there is nothing he can do or serve that can save his tormented customers.

It is a timeless image that exposes an inescapable fear lurking in the unconscious of us all, one that we spend our lives trying to suppress and counteract. Beneath the bonhomie and dinner-party chat we are all ultimately alone and vulnerable: a truth that will eventually catch up with us in a private moment of terror. Hopper's images made that grim thought a stark reality. He had become interested in Surrealism after visiting an exhibition at MoMA in 1936 called *Fantastic Art, Dada, and Surrealism*. The show included the work of another American artist who, like Hopper, was a master of manipulating light effects in the pursuit of peculiar images: an artist who had won admirers from Manhattan to Montmartre.

Man Ray moved to Paris on 22 July 1921 and stayed there until 1940. It was during this time that he decided to concentrate his creative energies on photography, saying, 'I have finally freed myself from the sticky medium of paint, and am now working directly with light itself.' He might have given up paint, but he didn't lose his painter's sensibilities, which he transferred with great success to the medium of photography.

He would constantly experiment with the photographic process in an attempt to produce images that had the lustre and power of paint. His tenacious pursuit of photography's painterly potential led him to a technique that was rather different but just as potent, which he called a Rayograph. It was a form of photogram (a photograph made without a camera) that he discovered in his studio when he accidentally dropped a sheet of unexposed photographic paper into a developing tray in which there was already an exposed sheet. He discovered that when he put a

physical item on the paper (key, pencil, etc.) and switched on the light the object would imprint a negative version of itself on the black photographic sheet in the form of a ghostly white shadow. It looked as if he had taken a photograph of a dream. Soon he was making Rayographs with music stands (*Untitled Rayograph*, 1927), cigarettes with matches (*Untitled Rayograph*, 1923), and scissors poised to cut paper (*Untitled Rayograph*, 1927), all of which were transformed into disembodied objects. Man Ray described his approach to making his X-ray-type images as 'painting with light'.

André Breton was captivated by the phantom images captured on the Rayographs and pronounced them great Surrealist works of art. As he did again when Man Ray stumbled upon another innovative photographic technique. One day in 1929 he was in his studio working with his then assistant and lover, the American photographer Lee Miller (1907–77), when he chanced upon 'solarization'. Miller had inadvertently flicked the light on in the darkroom while some photographs were being developed. Man Ray shouted, killed the lights, and plunged his negatives into photographic fixer, hoping they might be saved.

He was out of luck. The negatives were ruined. But, he soon realized, they were ruined in an artistic way. In each case the subject of the photograph – a nude female model – had started to 'melt' at the sides, like an ice cream left out in the sun. Man Ray considered it a terrific discovery: he had made an image where reality morphs into a dreamlike state. *The Primacy of Matter Over Thought* (1929) (see Fig. 25) is a title and an image that reveals Surrealist thinking. The majority of the picture is taken up with a standard nude composition in which the model is lying on the studio floor, eyes closed as if asleep, with one arm over her head and the other to her side with her hand covering a breast. Her left leg is flat to the floor; her right leg is bent at the knee and slightly raised. This element of the picture is the 'primacy of matter'. But then the edges of her body and head are ill-defined, due to the melting effect of Man Ray's solarization technique. This is the

'thought' to which he alludes in the title, where the model's physical presence has liquefied into a pool of molten silver. Breton saw this as a strangely sensual effect, full of sexual innuendo and ethereal rhapsody.

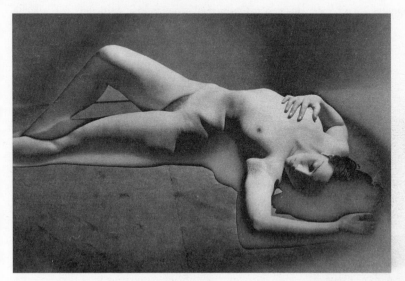

Fig. 25. **Man Ray,** *The Primacy of Matter Over Thought,* **1929**

The Primacy of Matter Over Thought deals with many of the Surrealists' preoccupations: sex, dreams and troubling combinations. They are themes that have cropped up one way or another throughout the story of modern art thus far, from Manet's *Olympia* to Magritte's *The Menaced Assassin*. But there is something wrong, don't you think? Something missing . . .

Here we are, *circa* 1930, and modern art as we know it has now been rolling along its rebellious road for over half a century. We have been around Europe; tipped our hat to Africa, Asia and the East. Taken in some architecture, design and philosophy. There has been a world war and the beginnings of America's emergence as an art superpower. We have met poets, collectors and a vast array of artists. We

have seen how each generation has been more radical, more adventur-
ous and more anarchic than the one before. We have touched on
politics and witnessed social unrest. And we have immersed ourselves
in the tidal flow of manifestos that have invited all and sundry to
come and join the no-holds-barred arty party. And yet, for all the
rhetoric about creating new utopian societies and smashing the old
elites, there has been one voice that has gone largely unheard.

Where, you might wonder, are the female artists?

Evidence suggests that if you were a female artist practising between
1850 and 1930 you might be tolerated, but you probably wouldn't be
venerated. There were established and respected female artists among
the Impressionists, such as Berthe Morisot and Mary Cassatt (1844–
1926). And the Russian Futurist/Constructivist and Fauvist movements
were bolstered by the exceptional talents of Sonia Terk, Lyubov Popova,
Aleksandra Ekster and Natalia Goncharova. But the truth is that these
female artists were the exception, not the rule.

That each modern art movement was founded and dominated by
men was, to an extent, a reflection of society at large. The Nineteenth
Amendment, allowing women throughout America the vote, was only
passed in 1920. In the UK women had to wait until 1928 to achieve
voting parity with men. The demoiselles of France were not given the
vote until 1944. It was a man's world. But then weren't the pioneering
artists and the movements they championed supposed to be challeng-
ing society and the status quo? The ratio of female-to-male artists
that broke through and were acquired with commitment by the top
museums and collectors has improved over time. A bit. But to this day
the vast majority of the modern art hanging on the white walls and
displayed on the pristine floors of the great museums is by men. It is
no coincidence that those same institutions are overwhelmingly run
by men. Of the three biggies on the world stage – MoMA, Pompidou
and Tate – only one (Pompidou, 1989–91) has ever had a female Direc-
tor in overall charge.

The reason I point this out is because the lack of female artists in

the recognized canon of A-list modern art has repeatedly crossed my mind as I've been writing this book, and so I imagine it has crossed your mind too. It is the establishment that has decreed and sanctioned the 'official' modern art canon: museums and their collections, the academic texts of (predominantly male) art historians, and the ever-increasing modern art courses being run by universities. They have been responsible for providing a very one-dimensional view of the world: it is life and art seen through the eyes of white, Western men. Back in 1936, few were alive to this issue. But one of them was the king of iconoclasm: Marcel Duchamp.

Late in 1942 he was asked by Peggy Guggenheim – a wealthy American collector and dealer of modern art – to organize an exhibition at her new Art of This Century gallery in New York. Duchamp made a surprising suggestion: why not put on a show featuring only female artists? Frankly, it is the sort of idea that is peddled as 'progressive' now; back then it was verging on the blasphemous. And was therefore perfect for Guggenheim. Her gallery would be the talk of the town and nobody would dare criticize her because it was Duchamp's idea; an artist who had taken on the status of a deity among Manhattan's chattering classes.

An Exhibition by 31 Women opened early in 1943 and featured an artwork that has since become one of the great icons of Surrealism. *Object (Le Déjeuner en Fourrure)* is a fur-lined teacup, saucer and spoon, made in 1936 by the Swiss artist Méret Oppenheim (1913–85). She was only twenty-two years old when she created the piece, having been inspired to do so by something Pablo Picasso said to her when they were casually talking in a Paris café. He had complimented the young artist on her fur coat and flirtatiously observed that there were many things he enjoyed that were improved when covered in fur. Oppenheim responded by asking 'Even this cup and saucer?'

Although young, Oppenheim was an established favourite among the Parisian set. She had been Man Ray's assistant, a job that always seemed to require nudity (and more) when the employee was young,

pretty and female. She had duly obliged – most memorably in a series of surrealist photographs by Man Ray called *Erotique Voilée* (1933), in which Oppenheim is seen standing naked by an etching press with one hand and arm covered in black ink: seductive yet repellent. André Breton and his Surrealist crowd cared little for equal opportunities; for them, the most useful role a young woman could offer to art was that of a muse. The boyishly beautiful Oppenheim was a perfect in-génue whose other-worldliness, the Surrealist men thought, allowed her more direct access to her unconscious mind. None of them expected one so young – and a woman at that – to produce a work of such impact.

The sexual connotations of *Object (Le Déjeuner en Fourrure)* are obvious: drinking from the furry cup is an explicit sexual reference. But there is much more to it than a saucy joke. The image of a fur-lined cup and spoon would not be out of place in the first chapter of any book about anxiety nightmares, in which any pretence of being in control is subverted by sinister happenings. In this instance, a cup and spoon has grown hair, turning objects from which one should derive relaxation and pleasure into something aggressive, unpleasant and faintly disgusting. It has connotations of bourgeois guilt: for wasting time gossiping in cafés and mistreating beautiful animals (the fur is from a Chinese gazelle). It is also an object designed to engender mad-ness. Two incompatible materials have been brought together to create one troubling vessel. Fur is pleasing to touch, but horrible when you put it into your mouth. You want to drink from the cup and eat from the spoon – that is their purpose – but the sensation of the fur is too repulsive. It's a maddening cycle.

Oppenheim was not alone in being a young female artist making waves within the Surrealist community. Frida Kahlo (1907–54) had been a precocious Mexican intellectual studying medicine at the National University until one day in the autumn of 1925, when she was travelling back from college in a bus that was hit by a tramcar. Rescuers initially left the grievously injured Kahlo for dead, but were

persuaded to take her to hospital by her uninjured travelling companion, Alejandro Gómez Arias. Kahlo spent many months in hospital recovering from the physical effects of the crash, which included a broken spine, ribs, collarbone, pelvis and legs. It was during this time that she decided to become an artist, not a doctor, and she soon started to paint what was to become a lifelong motif: herself.

Frida Kahlo refuted the suggestion – made by André Breton – that she was a Surrealist, saying once, 'I have never painted my dreams, I painted my own reality.' She did, however, allow her work to be shown in Surrealist exhibitions and even made a piece especially for such a show. And to be fair to Breton – whom we know would enlist anyone who took his fancy into the Surrealist family, with or without their blessing – when you look at a Frida Kahlo painting you can see where he was coming from when recruiting the fiery Mexican artist to his Surrealist cause.

In *The Dream* (1940) (see Plate 21), we see Kahlo sleeping peacefully in bed with the leaves of a bush growing around her like ivy up a tree. The branches of the bush that winds itself along her body are covered in thorns, referencing the near-constant pain she suffered throughout her life after the crash. The other figure she has painted makes that image of pain more explicit. A skeleton-like apparition sleeps above her as if on a bunk bed, clutching a bunch of flowers – possibly from its own early grave. Dynamite is strapped to its legs and body. The bed on which they both rest floats in the sky: death is in the air.

Kahlo's symbolism reveals the importance of folk art in her work. She was a proud Mexican who had grown up during a time when the great heroes of the revolution – Pancho Villa and Emiliano Zapata – battled to renew the country. The bush that she depicts in *The Dream* is a *tripa de Judas* ('entrails of Judas'), a popular plant in Mexico. The skeletal form above her is a Judas figure based on the life-sized papier-mâché creations strapped with fireworks that are made for exploding during Easter festivals in Mexico. Both recall the story of Judas's suicide after betraying Christ, when his entrails

'burst asunder'. In the painting, the Mexican tradition of blowing up the Judas doll is a metaphor for ridding the country of corruption. It is also a picture of betrayal.

As she slept alone and in pain, her then husband, the famous Mexican muralist Diego Rivera (1886–1957), was out and about behaving like a bachelor and sleeping with women. Rivera was twenty years her senior and had a character as big as his epic murals. When they got together, Kahlo's doting father said that it was 'like a marriage between an elephant and a dove'. Theirs was a tempestuous relationship, with infidelity a regular occurrence on both sides, including Kahlo frolicking with Leon Trotsky when he came to stay. She even came under suspicion for the Russian's assassination in Mexico in 1940 – as did Rivera, whom she had divorced in 1939, only to remarry him one year later.

Kahlo became the first twentieth-century Mexican artist to have her work collected by the Louvre when the French institution acquired *Self-Portrait: The Frame* (1937–8). Duchamp was quick to congratulate her on her success. She liked him very much, unlike the rest of the Surrealist crowd, an opinion she proffered with typical directness, saying Duchamp was 'the only one who has his feet on the earth among this whole bunch of coo-coo, lunatic sons of bitches of the Surrealists'.

Duchamp's involvement in the *Exhibition by 31 Women* was one of the reasons for Kahlo taking part, as well, perhaps, as the notion of sisters doing it for themselves. Today she is seen as a feminist artist whose intensely autobiographical work not only paved the way for Louise Bourgeois and Tracey Emin, but also foreshadowed the 1960s feminist slogan, 'The personal is political': evidence of the suppression of women expressed through individual experience. And yet as recently as 1990, Frida Kahlo – an artist fêted across the world in her lifetime – was not given her own entry in *The Concise Oxford Dictionary of Art and Artists*. Instead she gets a mention in the final sentence of Diego Rivera's biographical details. I think we know what she would have called the publication's editors.

Kahlo's friend, the British surrealist Leonora Carrington (1917–2011), doesn't even get a mention in the publication. This is the same Leonora Carrington that Salvador Dalí described as 'a most important woman artist'. By the time of the *Exhibition by 31 Women* she had moved to Mexico, which is where she met Frida Kahlo. Carrington's story is almost as complicated and dramatic as Kahlo's. She left England for Paris when she was twenty in pursuit of the Surrealist artist Max Ernst, whom she had met at a party in London. At the time Ernst was married and twenty-six years her senior. But for the extravagant and bohemian Carrington these details were mere trifles. She netted her man and later said, 'From Max I had my education.' He introduced her to the Parisian Surrealists, who adored a '*femme-enfant*' muse. But Carrington was far too outré to be branded a plaything. When an imperious Miró gave her some money to fetch him some cigarettes, she fixed him with a ferocious stare before telling the Spaniard he could 'bloody well get them himself'.

Like Oppenheim, she was only just into her twenties when she produced her first significant Surrealist work: *Self Portrait: Inn of the Dawn Horse* (c.1937–8), now owned by the Metropolitan Museum in New York. Carrington is perched on a chair looking like a New Romantic pop singer from the 1980s: all wild hair and a faintly androgynous dress sense. A female hyena mirrors Carrington's pose, its mane resembling the artist's. The analogy is clear – that Leonora turns into a nocturnal hunter in her dreams. A window framed by theatrical curtains allows us to see a white horse galloping through a forest. Its gait and colour are echoed by a white rocking-horse that is leaping over Carrington's head. It is a surreal mixture of the artist's real-life interest in animals and her strange imaginings, with a dash of the Celtic folktales she had read when she was young thrown in for good measure. She gave the painting to Ernst, who shortly afterwards was interned when the war started in 1939. He escaped and eventually made his way back to the house that he had shared with her near Avignon. But she was not there, having lost her mind worrying about his

arrest. Her mental breakdown had led her to Spain and her own imprisonment in a mental asylum.

Meanwhile Ernst had made his way to Marseilles and a safe house for artists where André Breton and many others involved in the Surrealist movement were staying. Peggy Guggenheim was around too, preparing for her own departure back to America, having travelled through France from England. The ever-lustful Guggenheim felt an instant craving for Ernst when she met the lovelorn artist in Marseilles. He reciprocated, she helped secure him safe passage to America and they married in 1942.

But it was not the happy-ever-after union for which Guggenheim had hoped. And it was her *Exhibition by 31 Women* that was partly to blame. Some time later she lamented that the show had included one woman too many. Max Ernst didn't think so. He went along to the opening and liked the art for sure, but not as much as one of the artists, with whom he fell hopelessly in love. Dorothea Tanning (1910–2012), a dark-haired American Surrealist artist, caught his eye and his heart. After his divorce from Peggy Guggenheim Ernst married Tanning in 1946 in a joint marriage ceremony with Man Ray and his partner Juliet Browner: a marvellous Surrealist coming-together.

Guggenheim was put out, but she had another interest to consume her. The European Surrealists and Dadaists had teamed up in America with refugees from the Bauhaus, De Stijl and Russian Constructivism. These artists, refugees from the war and intellectually curious adventurers, had successfully integrated into America's own indigenous avant-garde. The inevitable result of which was that New York was becoming the new centre of international modern art, and Peggy Guggenheim its powerful cheerleader-in-chief.

15

ABSTRACT EXPRESSIONISM: THE GRAND GESTURE 1943–70

Peggy Guggenheim was a passionate woman defined by her three great loves: money, men and modern art. Her love of money was inherited in the shape of a fortune that came to her as a child from her industrialist father, who perished on the *Titanic*. She developed her voracious appetite for men under her own steam, with a list of lovers running into the hundreds – if not thousands. When asked how many husbands she had been through, she replied, 'My own or other people's?' As for her love of modern art, well, that was acquired through an inquisitive mind and a taste for adventure: a combination that prompted her to abandon uptown, uptight New York for downtown, bohemian Paris when she was twenty-two.

There she met the Parisian avant-garde whose work, life and bodies she so adored. A few years later she moved to London and began to invest some of her good fortune in the latest art from England and France. She was up and running in moments, but the excitement of

dabbling in the art market and running a small art gallery soon paled: it didn't satisfy her thirst for influence and attention. She wanted to be seen and taken seriously. She had another idea. What about founding a museum of modern art in London to rival the Museum of Modern Art in New York, which had been a huge success from the day it had opened a decade earlier in November 1929?

From her base in the UK's capital city she went about enlisting the services of Marcel Duchamp and the British art historian Herbert Read – whom she had earmarked as the director of her new museum. Their job was to draw up a list of artworks that she would need to acquire to form the basis of her new institution's permanent collection. But just as she was getting the project moving, Hitler came along and threw a spanner, and several tanks, into the works: Europe was at war again. And even the ambitious and determined Ms Guggenheim, a woman used to getting her own way, could see that this was no time to start building an empire in a country that was at war and in the process of trying to save its own crumbling dominion. She abandoned her plans, leaving London to wait another sixty-one years for her idea of a modern art museum to come to fruition (which it eventually did at the beginning of the new millennium in the shape of Tate Modern). After such a disappointing career setback, most people would have admitted defeat and taken a first class ticket home to New York. Not Peggy, as she was commonly known.

Instead she travelled through Paris as the Nazi storm gathered to the east. On arrival at modern art's HQ she took her cheque-book from her handbag and systematically worked her way through the list of art and artists that had been drawn up by Duchamp and Read: 'Buy a picture a day' became her mantra. It was an art collector's version of a supermarket sweep. Most artists and dealers based in Paris were either leaving or shutting up shop and were more than happy to sell to the wealthy American (except Picasso, who sent her away with a flea in her ear). Her spur-of-the-moment purchases included Fernand Léger's Cubo-Futurist painting *Men in the City* (1919) and Constantin

Brancusi's elegant torpedo-like sculpture *Bird in Space* (1932–40). Whether her buying spree was an act of gross opportunism to acquire art at knocked-down prices, or a courageous adventure to save some of the best modern European art from the Nazis, is open to debate; the fact is, she returned to New York in 1941 with a huge stash of Grade A art, which had cost her less than $40,000, including works by Braque, Mondrian and Dalí.

Once settled back into Manhattan life she decided to modify her grand museum plan and instead open an uptown gallery on West 57th Street that would specialize in the contemporary. She called it Art of This Century. Here she would show her splendid haul of art alongside some new work that was for sale produced by her European artist friends, many of whom had fled from the war (several with her assistance) to the sanctuary of Manhattan. The job of designing the interior of the gallery was given to the voguish Austrian architect Frederick Kiesler (1890–1965), who interpreted the commission as an opportunity to create his own Surrealist work of art. Curved wooden walls, intermittent darkness, blue canvas sails, art that would pop up at the press of a button, and the occasional sound of an onrushing express train were all part of the Kiesler Art of This Century experience. Peggy was thrilled with the part theme park, part art gallery vibe.

As were Manhattan's intelligentsia and artistic community. The artist-émigrés from Europe, many of whom were Surrealists, used the gallery as a place in which to relax and meet a new generation of upcoming American artists, who were part of a hip Manhattan arts scene that came to be known as the New York School. The earnest young painters who belonged to the New York School were desperately seeking new ways in which to express the strange mixture of hope and anxiety brought about by the Great Depression, the Second World War and America's rise as the world's superpower. It was in Peggy's gallery that the art worlds of Europe and America met and produced a creative spark that would ignite a new movement in modern art.

But the heiress did more to facilitate the emergence of a new art movement than simply lay on some expensive wine and decent nibbles. Her high-profile, conspicuous wealth and accomplished networking skills meant she could attract the best brains in the business to help and advise her. And nobody's brain was better, or eye more attuned, than that of Marcel Duchamp, who was back in America and had already helped with the gallery's *Exhibition by 31 Women*. Now Peggy required his expertise for her next show, a *Spring Salon for Young Artists*, which would champion emerging American artists. Alongside Duchamp on an impressively high-powered advisory committee were Piet Mondrian (now also living in New York) and Alfred Barr, the influential founding director of MoMA.

On the eve of the exhibition Peggy went to the gallery to see how the preparations were coming along. She arrived to find many of the paintings still on the floor, leaning against the gallery's walls waiting to be hung. She looked around the gallery and saw Piet Mondrian crouching down in one corner staring intently at one of the artworks awaiting display. Peggy breezed up to the esteemed Dutchman, knelt beside him and followed his gaze towards the object of his attention. It was a large painting called *Stenographic Figure* (c.1942) by an unknown young American artist.

Peggy shook her head. 'Pretty awful, isn't it,' she said, embarrassed that such a hopeless picture could have slipped through the net. If shown, it would ruin her reputation in the art world, calling into question her good judgement. Mondrian continued to study the picture. Peggy criticized the technique of the painter who had produced it, declaring that the picture lacked rigour and structure. 'You can't compare this to the way you paint,' she said, flattering Mondrian and hoping to divert his attention away from the oily mess on the floor. The Dutch artist paused, slowly lifted his head and looked at Peggy's anxious face. 'It is the most interesting work I've seen so far by an American,' he said. And then, seeing the confusion in her eyes, he slipped into his role as art advisor and added, 'You should keep an eye on this man.'

16. (*above*) **El Lissitzky,**
Beat the Whites with the Red Wedge (1919)

17. (*right*) **Lyubov Popova,**
Model of a Dress (1923–4)

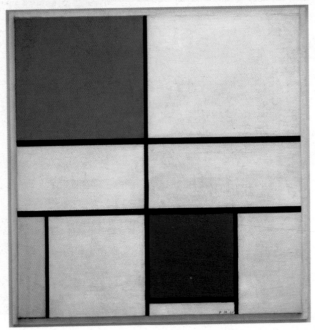

18. **Piet Mondrian,** *Composition C (No. III), with Red, Yellow and Blue* (1935)
©2012 Mondrian/Holtzman Trust c/o HCR International USA

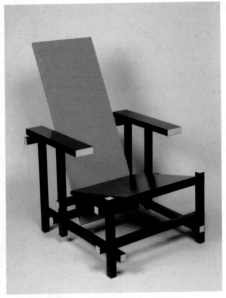

19. **Gerrit Rietveld,** *Red-Blue Chair* (1923)

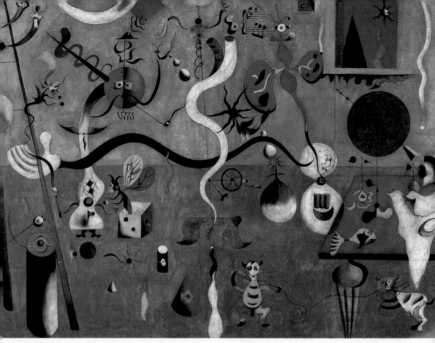

20. **Joan Miró,** *Harlequin's Carnival* (1924–5)

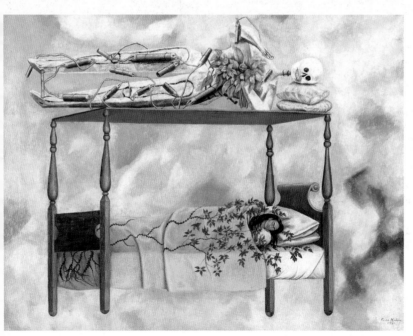

21. **Frida Kahlo,** *The Sleep (or The Dream)* (1940)

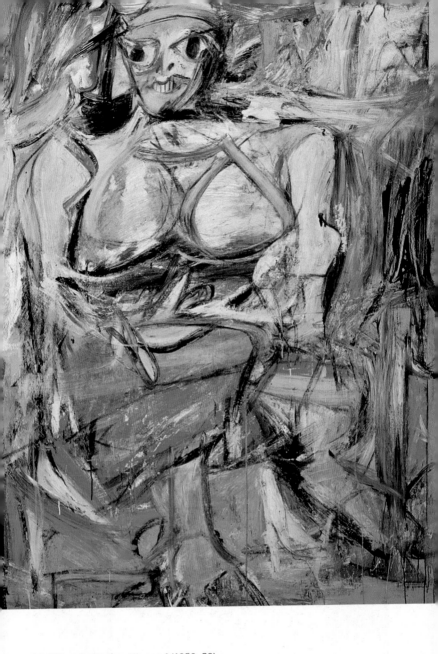

22. **Willem de Kooning,** *Woman 1* (1950–52)

23. (*opposite*) **Mark Rothko,** *The Ochre (Ochre, Red on Red)* (1954)

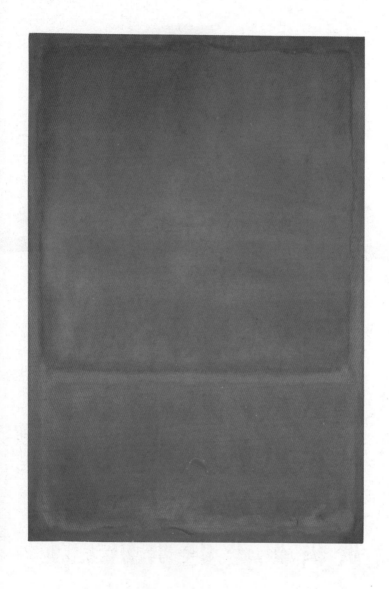

24. **Robert Rauschenberg,** *Monogram* (1955–9)

25. **Andy Warhol,** *Marilyn Diptych* (1962)

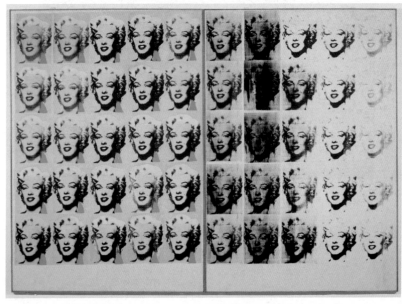

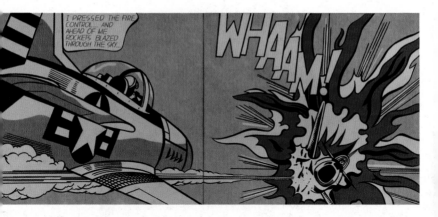

26. **Roy Lichtenstein,** *Whaam!* (1963)

27. **Donald Judd,** *Untitled* (1972)

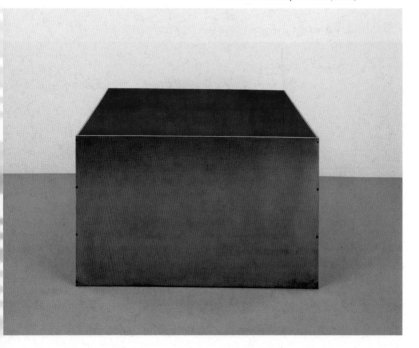

28. **Sarah Lucas,** *Two Fried Eggs and a Kebab* (1992)

29. **Tracey Emin,** *Everyone I Have Ever Slept With, 1963–1995* (1995)

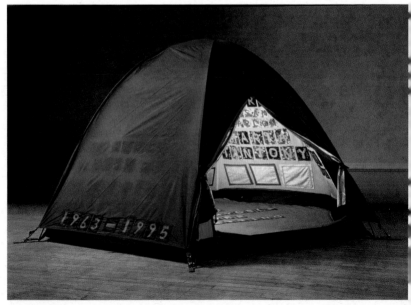

Peggy was astounded. But she was a good listener and knew when and from whom to take advice. Later on, when the exhibition had been hung and the private view was in full swing, she could be seen picking out favoured clients, taking them solicitously by the arm, and whispering into their ear that she wanted to show them something 'very, very interesting'. She would then lead them to *Stenographic Figure* and explain with the enthusiasm of an evangelical preacher just what an important and exciting picture it was, and how the man who produced it was the future of American art.

She, with a little help from Mondrian, was right. *Stenographic Figure* by Jackson Pollock (1912–56) is not an abstract work, nor did it feature any suggestion of the famous 'drip' painting technique that he would later develop and make his name with. It owed much to Picasso, Matisse and Miró – the three European artists Pollock most admired. It depicts two spaghetti-like figures sitting at a small table facing each other. They are having a heated debate, gesticulating wildly with their red and brown arms, which cut into the red edges of the table and the painting's light blue background. The way in which Pollock has tilted the table towards the viewer and formed his two elongated figures points to Picasso's influence. The American's regard for Miró can be seen in the scribbled letters ('stenographic' meaning the process of writing in shorthand) and the random shapes with which he has covered the image. They ape Miró's automatism – his stream-of-consciousness Surrealist painting technique. Matisse's presence can be felt in the bright Fauvist colour palette that Pollock has employed.

Within weeks, Peggy had signed a contract with Pollock and was providing him with a monthly stipend of $150 dollars. Not a lot, but enough for the young artist to give up his regular job, which happened to be at her Uncle Solomon's New York Museum of Non-Objective Painting, which would later change its name to the catchier 'The Guggenheim'. Pollock was not a natural employee – he struggled enough to cope with life and art without the added complication of having to be somewhere by 9 a.m. Still, his time at the Museum of

Non-Objective Painting was not wasted. He fully acquainted himself with the abstract paintings of Wassily Kandinsky, of which Solomon Guggenheim had built a large collection. Pollock shared Kandinsky's love of nature, mythology and the primitive. But while Kandinsky was a cool, calm intellectual, Pollock was a volatile, troubled force of nature, frequently unable to control his feelings. He had an emotional engine that was far too big for one person, leading to explosive outbursts that he tried to dampen with alcohol.

The booze made things worse, of course, but it did lead him inadvertently to find his artistic voice. Pollock's alcohol addiction was such that at the age of twenty-six he went to seek help. He saw a shrink who specialized in Jungian psychotherapy; an analytical form of psychology in which the therapist tries to harmonize the patient's conscious mind with the collective unconscious: a notion that there are universal but unrecognized feelings common to us all that can be triggered by imagery, most frequently experienced in our dreams.

The sessions didn't help with Pollock's alcoholism, but they worked wonders for his art. They introduced him to the Freudian/Surrealist idea of the unconscious being the place to find the inner man, which, from Jung's perspective, was a shared resource among humans and not a bespoke set of thoughts and feelings experienced only by one person. This was good news for Pollock, who was far more comfortable seeking to portray a universal truth through his art than making introspective images of an autobiographical nature. The subject matter of his work started to change from brooding American landscapes to more mythical and atavistic motifs, which often harked back to Native American art. He began to experiment with automatism and spontaneously depict whatever came into his head, applying his paint to the canvas in a much freer, more expressive way.

He had already developed a preference for working on a large scale, having been inspired to do so by the Mexican muralist Diego Rivera (husband of Frida Kahlo), who had been invited by several American cities to come and paint his giant wall-covering artworks. America

was in the mood for murals, with states across the country wanting their own piece of high-profile outdoor designer art. Pollock had found work via President Roosevelt's Federal Art Project – a wide-ranging post-Depression 'get back to work' scheme – to assist with painting some of these murals, during which time he came to the conclusion that size mattered. So, when Peggy commissioned him to paint a mural for her New York townhouse in 1943, Pollock was already thinking big.

The original idea had been for the artist to paint directly on to a wall inside the house, but Peggy changed her mind after Duchamp advised her that the work would be transportable on canvas. Pollock, who was delighted to have the commission, had no idea what to paint. He had artist's block. The months rolled by as he stared at his huge 6-metre-long blank canvas and waited for inspiration. He waited and waited and waited. Six months came and went and still there was not one mark of paint on his bare canvas. Peggy's patience had run out – she told Pollock that it had to be now or never. Pollock chose the former. And so, in one ferocious all-night session of painting and passion, he set to. By the end of the following morning he had finished the painting, and, without knowing it, had started a new art movement that would be called Abstract Expressionism.

Mural (1943) has many of the hallmarks of early Abstract Expressionism, which at this stage was all about the raw physical mark, or 'gesture', made when an artist applied paint to the canvas. Quieter, more contemplative styles would come later, but at the beginning it was Pollock's method of action painting that established the movement. His was an art made with a volcanic, instinctive power that erupted from deep within him and burst out in a fit of painting on to the canvas. An artwork like *Mural* was the result. It is both abstract and expressive. A swirling mass of thick white paint looks as if it has crashed into the canvas like a breaking wave. It is broken up by vivid patches of yellow that have been divided by loosely painted, but quite evenly spaced, vertical lines of black and green. There is no central

area to which the eye is drawn: this is an 'all-over' painting. Imagine what 100 raw eggs thrown against a concrete wall full of graffiti might look like and you'd be on your way to visualizing Pollock's *Mural*.

There is, though, a surprising sense of coherence and rhythm in the work given the speed at which it was made and Pollock's instinctive approach to painting. The integrated patches of white and yellow are divided like beats of a musical bar by the repetition of the wavy vertical black lines, while the evenly spread colour palette brings balance and harmony to the composition. It is not anarchic, it's improvised: a free-jazz session that's turned into an all-nighter and got a bit out of hand. The sheer size of the work adds to that feeling it has of being an event. At approximately 2.5 by 6 metres it is a huge artwork, wild and domineering. And unquestionably the result of an immense physical effort; there is a touch of a man wrestling a bear to the ground about it. Pollock had fought long and hard all through the night with this painting until it eventually succumbed to his will.

He described it as 'a stampede of every animal in the American West, cows and horses and antelopes and buffaloes. Everything is charging across that goddamn surface.' They are indiscernible, but their energy is not. This is a painting that is as dramatic as Munch's *Scream* and as expressive as Van Gogh's *The Starry Night*. It is Pollock's rebel yell from deep inside his tortured soul. He described it as 'exciting as hell', and of himself he said, 'I am nature.'

When Clement Greenberg, the leading American art critic of the day, saw *Mural* at Peggy's house he knew at once it was something special, declaring Pollock afterwards to be the greatest painter America had ever produced. Greenberg could see that the young artist had harnessed the ideas of Surrealism, the shapes of Picasso and even El Greco, the landscape art of America, and brought them together in one coherent image. But Pollock had done more than amalgamate the art of the past; he was also making a statement about the future. He thought easel painting was dead and that the way forward for artists was to paint directly on to walls like Diego Rivera. He considered his

practice of leaning a giant canvas against a wall or simply rolling it out on the floor as a staging post to what would be a mural-making future.

In November 1943 Peggy gave Pollock his first solo show at Art of This Century. The artist made several new paintings for the exhibition, together with some works on paper. Peggy priced his work from $25 for a drawing to $750 for a painting. The show started with all the paintings for sale and ended with all the paintings for sale. But it had attracted some notable potential customers. The most important of whom was Alfred Barr, the director of MoMA. He was particularly taken with Pollock's painting *The She-Wolf* (1943).

It is a work based on the myth of Romulus and Remus, the twins who founded Rome, having been suckled by a she-wolf when orphaned as children. Pollock has painted a version of the standard image of the ancient Capitoline wolf that fed the infants. The original is hardly sophisticated, but Pollock's effort is a far cruder rendition. The wolf's profile, which takes up the entire canvas, is outlined in white paint, underscored with black. The background is grey-blue with patches of yellow, black and red washing over the picture in a fairly random fashion. The she-wolf looks more like an old cow as seen by a caveman, which may have been a Jungian-like attempt by Pollock to tap into the collective unconscious and produce an image that reconnects us to our primal past.

Shortly after the exhibition had finished, Alfred Barr contacted Peggy and offered to pay somewhat under the asking price for the painting. Peggy refused. Which was brave, as the endorsement by MoMA would have increased the value of Pollock's (and therefore her) stock considerably. But for all her faults – including being mean with money and underlings – nobody could say Peggy Guggenheim lacked confidence or cunning. She would have known at the time of Barr's offer that an article was about to appear in *Harper's Bazaar* magazine titled 'Five American Painters', and in it would be a feature on Pollock illustrated with a colour reproduction of *The She-Wolf*.

A few weeks later Barr was back in contact offering to pay a figure at or around the asking price of $650. Peggy accepted, and MoMA duly became the first museum in the world to buy a work by Jackson Pollock.

Championing Pollock, commissioning *Mural*, selling *The She-Wolf* and putting on his 1943 solo show were among the greatest achievements to date in Peggy's career. They also proved to be a definitive moment in America's claim to be the new creative power in modern art. Peggy was to give Pollock two further solo shows, as well as introducing the world to other young American artists such as Clyfford Still, Mark Rothko, Robert Motherwell and the American-domiciled Dutch painter Willem De Kooning, all of whom would go on to play a significant role in developing Abstract Expressionism. Ironically, though, for all that Peggy Guggenheim had done to help America establish its first modern art movement, Abstract Expressionism didn't really get going until she closed her New York gallery and took herself and her collection off to Venice, where she would spend the rest of her life. The year was 1947.

It was the year that Jackson Pollock made his first batch of drip paintings. He'd moved out of New York with his wife, the artist Lee Krasner (1908–84), to a small homestead in East Hampton, Long Island. Peggy had (grudgingly) lent them the money to start a new life closer to nature but she didn't hang around long enough to reap the benefits. With Peggy gone, Pollock took his new work to her old friend and gallery-owning contemporary, Betty Parsons. She liked what she saw and in 1948, in her New York gallery, gave the world its first sight of Pollock's great innovation: huge canvases splattered with paint. There was no sign of any brushwork because there was none. He had laid his canvas on the floor and vigorously dripped, poured and flicked household paint all over it. He attacked the canvas from its four sides: walked across it, stood in the middle – became part of the painting. He manipulated the wet paint with trowels, knives and sticks, added sand or glass or cigarette butts – stirred things up, threw things down: made a mess.

Full Fathom Five (1947), one his earliest drip paintings, was included in the show. Now owned by MoMA, having been gifted by Peggy Guggenheim, it is described as 'Oil on canvas with nails, tacks, buttons, key, coins, cigarettes, matches, etc.' The debt Pollock owed to Braque and Picasso's *papier collé* and Schwitters's 'Merz' for using such materials is obvious. As is his use of Arp's Dadaist technique of 'chance' when making the picture. Pollock said, 'When I am in my painting, I'm not aware of what I'm doing.' But borrowing old ideas does not mean Pollock hadn't produced an astonishingly fresh and imaginative piece of work. *Full Fathom Five* – named after Ariel's song in Shakespeare's *The Tempest* – is as dense as one of Monet's *Water Lilies* paintings and as passionate as Picasso's *Guernica*.

The dark green background visibly bubbles – rising contours created by the detritus with which Pollock had primed the canvas. On to this coarse landscape he has dripped thick white globules of paint, interspersed with a broken cobweb of skinny black lines that dance lightly across the image. Occasional small patches of pink or yellow or orange appear unexpectedly, like torn garments in the middle of a hawthorn hedge. The splashes and splatters decorate a rugged surface that Pollock scraped with a palette knife and brush. It is comprehensively abstract and unquestionably expressive: a fury on canvas.

The critics were unimpressed, dismissing it as random, unrecognizable and meaningless. They were wrong on all counts. Take a good look at *Full Fathom Five* and you will see that it is not random at all, but has poise and shape and movement. Nor is it unrecognizable or meaningless. There are few more honest or revealing artworks expressing unfettered human emotion: the painting is raging with frustration, anxiety and power. It is as close to the life force as any painting, book, film or piece of music is likely to get: unsentimental and unapologetic.

Pollock knew that the idea of making art like this was not new. He took his inspiration from the tribal American Indian sand-painters of

the south-western states. And, more recently, from Max Ernst (Peggy's now ex-husband), who had experimented in a similar fashion by puncturing a hole in a full can of paint and swinging it over a canvas (after Duchamp's *Three Stoppages*). Pollock himself had been encouraged to throw enamel paint at a wall as an act of spontaneity back in the mid-30s by the mural artists with whom he was working. But like all great innovations, Pollock had taken these ideas and made sense of them for the time in which he was living. Not that anybody cared very much. Clement Greenberg continued to enthuse but few others did, including collectors. Peggy took a few of the works in lieu of the contract she had with Pollock, and he swapped another with a sculptor, but there was not much activity, even though you could buy one of his new drip paintings for just $150.

How tastes change. Buying *Full Fathom Five* would have been like investing in Google when it was still in start-up mode. One hundred and fifty bucks for a Pollock original drip painting? They now fetch north of $140 million. How did that happen?

The elevation of Jackson Pollock from the rebel of New York's art world to a star of the world stage was accelerated by a German-born photographer called Hans Namuth (1915–90). He, like many others, was not wholly convinced by Pollock's work, but was persuaded to meet him by a friend who thought the American artist a genius. Namuth approached Pollock and asked to photograph him at work in his studio. Pollock said yes (and to an accompanying film by Namuth). The black and white photographs (see Fig. 26) captured, for the first time, the painterly method and instinctive choreography of Pollock's technique (the images were to be a precursor to performance art). They also helped create a romantic mythology around the artist. In the moody, mid-motion shots, Pollock was cast as a passionate and pensive artist and an all-action-man. Dressed in jeans and black T-shirt, with rippling forearms and a cigarette dangling from his mouth, he appears more like a James Dean type movie star than the clichéd image of a cerebral and detached artist. He is depicted as a

heroic figure, working away on his own, desperately trying to express his feelings by marking the canvas beneath his feet with paint. People saw him pouring his heart out in his paint and felt his pain.

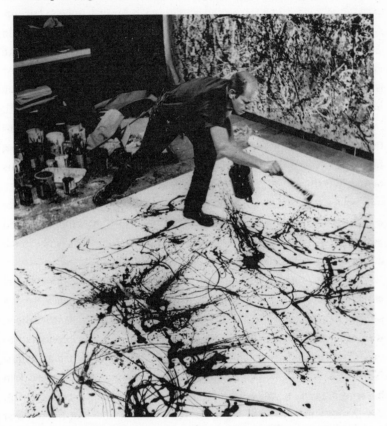

Fig. 26. **Hans Namuth,** *Jackson Pollock painting* Autumn Rhythm: Number 30, **1950**

The public and the media became fascinated by these images, and with him. By witnessing his painting process people started to re-assess his work as something more than drips splashed on a canvas. There was appreciation for his craftsmanship, for his honesty, and for the spontaneous energy of his paintings. Drip by drip, slowly at first

and then with unrestrained passion, the world fell in love with Jackson Pollock.

The artist found himself in the full glare of the public eye. He became one of the first global artist-celebrities, a poster boy for Abstract Expressionism. Fame and success followed for a few years, but Pollock was still a troubled man. Late in the evening on 11 August 1956, he was driving drunk a mile or so away from his home when he crashed his car. He was instantly killed, along with one of his passengers.

Jackson Pollock was just forty-four when he died, bringing a premature end to a brilliant career. It was the same age that another artist, one whom Pollock both admired and envied, reached before his own career had even got going. He was an artist, like Pollock, who had been employed in the Murals Division of the Federal Art Project, a man similarly blessed with film-star good looks and cursed with a liquor habit, whom Clement Greenberg also fêted (much to Pollock's annoyance), and who shared Pollock's near-mythical status and credit for being an originator of Abstract Expressionism. Although, to give credit to Willem De Kooning (1904–97), he did say at his fellow artist's funeral in 1956 that 'Pollock broke the ice for Abstract Expressionism [to begin].'

De Kooning left Rotterdam, Holland, in 1926 on a one-way trip to New York, a place he had romanticized in his dreams. Even after two decades getting by as an odd-job man and part-time commercial artist, the city retained its hold on the artist. Eventually New York reciprocated De Kooning's love. In 1948 the Egan Gallery in Manhattan gave him his first one-man exhibition, at which De Kooning displayed ten of his black and white abstract paintings. Greenberg went along and put his pen and considerable reputation behind the forty-four-year-old Dutchman, declaring him 'one of the four or five most important painters in the country'. Nice words that caused the art world to show up in numbers to see the show. But nothing was sold.

At least not immediately. But shortly afterwards MoMA stepped in and acquired *Painting* (1948), a picture made from enamel and oil paint on canvas. It has the look of a chalk drawing on an old school blackboard, one on which somebody has written balloon-type graffiti. That's before you see how the white paint De Kooning has used to outline the interlocking black shapes – some of which could be letters – has been allowed to run to grey. That draws you in. And then, willingly or not, you are caught up in the artist's mysterious ability to mesmerize with his compositional harmony, as a hypnotist might do by looking into your eyes. There is a visual poetry to De Kooning's paintings, which in a way – albeit rather differently – chimes with the work of Piet Mondrian. Maybe it's a Dutch thing, but both artists make such perfectly balanced, visually satisfying paintings that you are left wanting to stay in their presence. It's like hearing a beautiful chord sung, and then held, or the sensation of a good wine on your palate. Mondrian's style was rigid and exact, De Kooning's more of a reggae beat.

As can be seen in his Abstract Expressionist painting *Excavation* (1950), which was shown at the Venice Biennale in the summer of 1950. This time it is the lightly coloured overlapping shapes that have been picked out with black paint in a picture that has a calligraphic quality. Unidentifiable forms bump into each other in a teeming atmosphere reminiscent of a dance floor full of euphoric bodies, divided only by the occasional flash of blue, red or yellow paint. It appears to be a joyful, if claustrophobic scene. Until, that is, you take a closer look at the image, whereupon a sense of foreboding arises. This is often the way with Abstract Expressionism: it's not always the quick hit you think it's going to be, but a slow build with twists and turns. *Excavation* exposes De Kooning's European roots, and his knowledge of the dark drama of Rembrandt, the tormented expressiveness of Van Gogh, and the post-First World War angst of Kirchner's German Expressionism. Behind the image's lyricism is a macabre undertone. Some of those shapes he painted have teeth; many look like limbs. Could it be that *Excavation* is an anti-war

painting? Could it be that it depicts a mass grave of human remains?

That sense of the dark side of life is part of De Kooning's art: a counter-balance to its harmonious beauty. He said, 'I always seemed wrapped up in the melodrama of vulgarity.' Which was certainly the case in his most famous series of six paintings, which he produced between 1950 and 1953. They are all vividly expressive, with looser, rougher brushstrokes than he used in either *Excavation* or *Painting*. They are also markedly different in that the *Woman* series is not abstract. They all clearly portray the same subject: a woman, who is either sitting or standing, presented front-on, with her heavy breasts and broad shoulders accentuated by thickly applied layers of paint. 'Flesh,' De Kooning said, 'is the reason oil paint was invented.'

His starting-point in each case was the mouth – that was his anchor, his 'point of reference'. He would search through glossy magazines looking out for adverts featuring young women with beautiful mouths in order to study them at length and then cut them out as source material. His motivation for the *Woman* series was to revisit and update the idea of the female nude, a standard subject in the history of art. He wanted to make a painting in the spirit of Abstract Expressionism that could relate to classical pictures of the past such as Velázquez's *The Toilet of Venus* (1647–51) or Manet's *Olympia*. Both of those had met with disapproval when they were first painted: a tradition De Kooning was destined to carry on.

When the *Woman* series was shown in 1953 at the Sidney Janis Gallery in New York, De Kooning was attacked from all sides. Those involved in the Abstract Expressionist movement couldn't believe that one of their highest-profile exponents had gone back to figurative work. Others saw the primitive style in which De Kooning had painted the series and wrote them off as technical failures. But it was the way in which the artist had depicted women in his paintings that caused the most controversy. The figure in *Woman I* (1950–52) (see Plate 22) confronts us with the toothy grin of a hungry cannibal. Her huge black eyes and demonic stare re-enforce the ferocity of her desire. She

sits surrounded by a background of thick unmixed colours out of which her pink and orange legs emerge. They are set slightly apart in a no-nonsense fashion, while her white upper body, dominated by a mighty bosom, is bluntly exposed, suggesting a lack of self-awareness. She is a savage who has been painted wildly. *Woman I* is not a turn-off, she's a turn away and run.

De Kooning was accused of misogyny, disrespect and doing a great disservice to the modern American woman. How could he, a revered artist who was painting America into the story of modern art, present such a negative view of the female sex? And with such expressive violence? De Kooning talked of seeing the Mesopotamian figurines at the Metropolitan Museum of Art, of challenging the Western cliché of the idealized woman, and of his own interpretation of art history, in which he had explored the notion of the grotesque on several occasions. Whether you think the *Woman* series good or bad (there's still plenty of debate), they can't be criticized for being impetuous works of art. Pollock might have produced his mighty *Mural* in one night of painterly passion, but De Kooning spent ages working and worrying about *Woman I*. After a year and a half he gave up, took the painting off its stretchers and placed the canvas in storage – unfinished.

You can feel the artist's physical effort and liveliness in both De Kooning's *Woman* series and Pollock's enormous drip paintings. It was their way: to announce their presence to the viewer through bold painterly gestures and aggressive brushstrokes, an unrestrained approach that led people to label them action painters. Which was one side of Abstract Expressionism. The other side was populated by a group of artists who were doing precisely the opposite. These were the Color Field painters of Abstract Expressionism, who produced canvases that were as smooth and calm as Pollock's and De Kooning's were rough and boisterous. While Pollock's drip paintings had the surface texture of a dirt track, the large expanses of evenly spread monochromatic paint applied by the Color Field artists gave theirs the look of a satin sheet.

Barnett Newman (1905–70) was one of the leaders of the Color Field pack: an intellectual whose interests ranged from ornithology and botany to politics and philosophy. He had been immersed in the New York art world for years, respected both as a writer on art and as a part-time curator and lecturer at the Betty Parsons Gallery. But it wasn't until he was well into his forties that he found a style of painting with which he felt satisfied. His breakthrough came on his forty-third birthday when he produced *Onement I* (1948). It is a small red rectangular painting, down the middle of which Newman placed a vertical strip of masking tape as part of his early preparations for the canvas. He painted either side of the tape in a maroon colour. After which he took a step back. In a moment of spontaneity he decided not to remove the masking tape as he had planned, but to paint over it in a light cadmium red, applied with a palette knife.

He took another step back to have a look. And then he sat down to have a think about what he had done. For eight months.

Newman came to the conclusion that he had at last made a painting that was, he said, 'completely me'. He felt that the vertical line down the middle didn't divide the painting, but united it, and he said, 'That stroke made the thing come to life.' Newman had found the device for which he would become famous. Pollock had his drip; Newman now had his 'zip'. A vertical line that he said represented 'streaks of light'.

In his mind, he saw it as an expression of mood and feeling, imbued with the mythical spirituality of primitive art. The critics thought otherwise and, in a familiar and unimaginative barb, said it was something a house painter could have produced during his lunch break. One particularly damning and sarcastic reviewer remarked that when he entered the Betty Parsons Gallery to see Newman's 'zip' paintings he was disappointed to find only the walls of the space to ponder. Until realizing that 'Oh no,' he was indeed looking at Newman's paintings, which, to be fair, were on enormous canvases.

Vir Heroicus Sublimis (1950–51) was one of the paintings on show

at the Betty Parsons gallery in 1951. It is a canvas 5.5 metres long, 2.5 metres high, covered in a monochrome bright red paint with five 'zips' placed at various points. Newman's instructions to the gallery's visitors, which he had written on a piece of paper and stuck beside the work, were to get close: 'There is a tendency to look at large pictures from a distance. The large pictures in this exhibition are intended to be seen from a short distance.' He wanted the smooth red surface, on which his brushstrokes were undetectable, to have a profound effect on the viewer's psyche: to be a quasi-religious experience. He thought that by being up close the viewer would be able to experience the feeling of saturation and volume he had created with his multiple layers of red paint. *Vir Heroicus Sublimis* is Latin for 'man, heroic and sublime'. That is the subject of this painting: it is intended to represent and evoke an emotional response of being overwhelmed by a transcendental landscape.

While we were getting carried away in Newman's field of red, his 'zips' were hard at work doing two jobs. The first, as Newman said, was to represent light: a vertical line suggesting illumination that was to influence the Minimalist artists in the 1960s. But the 'zips' were also performing a practical, functional role for Newman; they were his signature. Because if you're in the Color Field game, where you are covering canvases mainly in one tone, you really need something to identify the painting as your own work. Which is a function Newman's zips were performing for him: they differentiated his largely monochromatic red canvases from those being produced by Mark Rothko (1903–70).

Rothko is the best known of the Color Field painters, the one who is most likely to have posters of his work on bedroom walls and in school art rooms across the world. Born in Russia, he left in 1913 with his family, the Rothkowitzes (as they were then), to escape the atmosphere of anti-Semitism that had returned to the country. They emigrated to America, where, in due course, Mark went to art college, shortened his name and started to build a career as an artist. He,

like Newman, was late to find his Abstract Expressionist groove, not fully doing so until the late 1940s when he was unarguably middle-aged. In 1949 he produced an early example of what would become his mature style with *Untitled (Violet, Black, Orange, Yellow on White and Red)*. It features horizontal rectangles of colour tone blended softly together in a way that would be as much his trademark as the 'zip' was to Newman.

Rothko's treatment of the geometric shape in an abstract painting is markedly different from those produced by the Russian Constructivists and Suprematists. Whereas their lines were hard-edged, his were soft and blurred. Nor did he seek to create tensions between the shapes, but a harmony of colour, the range of which was far greater than the Constructivists' reliance on the primaries.

Untitled (Violet, Black, Orange, Yellow on White and Red) is a large rectangular painting, measuring nearly 2 metres high and 1.5 metres wide. The top half of it is dominated by a rectangle of red, underneath which is a thick black line marking the central section of the image. The bottom half starts with an orange rectangle that then blends to a yellow one. A white board frames the shapes that have been placed on a creamy-yellow background. All the shapes are loosely painted with frayed edges, merging with the forms that surround them. The bold colours are reminiscent of the Fauves' palette, the luminosity of the painting's surface suggestive of the Impressionists.

But for Rothko this image is not a study into form or colour, but into basic human emotions. He said his paintings were about 'tragedy, ecstasy, doom and so on'. I imagine that this painting of vibrant colours was more on the 'ecstasy end' of the Rothko scale. As, I would have thought, was *The Ochre (Ochre, Red on Red)* (1954) (see Plate 23), which, compared to his 1949 painting, is a far more refined execution of the same idea. This time Rothko has painted an ochre-coloured rectangular panel that covers the top two-thirds of the picture. It is framed by a thin red border, which goes on to form the rectangle taking up the

bottom third of the image. The areas where the colours meet are feathered in such a way as to soften the contact between the two and retain the painting's overall sense of melodic rapport.

At over 2 metres high and 1.5 metres wide, *Ochre, Red on Red* is once again an enormous painting. Rothko insisted that the purpose of making his work on such a large scale was not ego, pomposity or grandeur, as it had been with the great paintings of the past, but the exact opposite. He was attempting to make paintings that when you stood before them felt 'very intimate and human'. He saw us as 'companions' to his paintings, the ingredient that allowed them to 'perform'. Such was his belief in the ability of his artworks to provoke a spiritual reaction in the viewer that he started to make strict rules as to how they would be shown and who could see them (non-believers in the art of Rothko were not welcome). Marjorie and Duncan Phillips, two collectors of whom Rothko approved, purchased *Ochre, Red on Red*. They subsequently made a special room in which to view it alongside two other paintings of his they had bought. Rothko went to visit and was pleasantly surprised by what they had done. The room was relatively small, meaning that his paintings could be seen in the 'scale of normal living'. Of course the pernickety artist did take the opportunity to make a few changes to the lighting, while suggesting that all furniture should be removed save a single bench on which to sit. Rothko went home a contented man, enlivened with an even greater passion for how his work should be experienced.

He said that he felt 'a deep sense of responsibility for the life [his] pictures [would] lead out in the world'. He would refuse to show his work surrounded by the paintings of other artists in group exhibitions, or in spaces he thought unbecoming (he had accepted a commission to make paintings for the Four Seasons Restaurant at the Seagram Building in New York, but eventually backed out because he thought the environment not conducive for 'experiencing' his art). Soon he started to think in terms not just of making paintings, but of making 'spaces'.

In 1964 he got the chance to live his dream when Dominique and John de Menil, a Texas-based power-couple with an art-collecting habit, decided they wanted to build an inter-denominational chapel in Houston. They went to visit Rothko in New York and asked him if he would like to make the paintings that would be hung in the chapel, on the understanding that he could dictate, shape and control a 'total environment to encompass his work'. Rothko accepted, moved to a bigger studio where he installed a pulley system to move about his enormous canvases, and got to work on producing the fourteen paintings (plus four alternatives) to hang on the octagonal walls of the chapel. By the summer of 1967 he had completed the task and delivered the paintings to the De Menils, who placed them in storage until the chapel was completed.

Rothko's art had changed by this time. Not the style, which was still abstract rectangles painted in closely matching colours on large canvases, but the tone. He was now working on the 'doom and tragedy' end of the human emotional scale. From the latter half of the 1950s his palette had taken on a darker, more mournful appearance: deep purples mixed with blood reds; solemn browns merging with bleak greys. While he had started out with the life-enhancing colours of Matisse, he was now using a palette more suited to the Grim Reaper.

The paintings that he made for the De Menils' chapel were suitably sombre for a building designed for religious contemplation. All fourteen mural-sized artworks were designed to hang from floor to ceiling, enveloping the visitor in a Rothko-instigated shroud of bleakness. Seven of the paintings are black-edged with a dark maroon background; the other seven are tonal transitions through a series of deep purples. The subtleties of the floating rectangles for which he was famous are almost impossible to pick out in his fields of dark and dense colour – a situation made no easier by Rothko's insistence that the chapel only be lit naturally by a skylight in the ceiling.

The Rothko Chapel was finally opened in 1971, its eight walls covered in the artist's mournful paintings, making for an eerie

atmosphere. It was, and is, made all the more so by knowing that Rothko never saw his great works installed, having committed suicide a year earlier. He had been suffering from ill health and depression for some time, a situation not helped by a marriage that was falling apart and a world that had moved beyond his Abstract Expressionism and into Pop Art, which he loathed. Rothko had said that his art constituted a 'simple expression of the complex thought', which is as good a way as any to explain Abstract Expressionism.

At least it is when dealing with two-dimensional Abstract Expressionism, but adding a third dimension can lead to the opposite happening: a simple thought can appear quite complex. *Australia* (1951), by David Smith (1906–65), is a sculpture made out of rods of steel that look like a scribble in the air. Generally the word sculpture makes us think of big heavy lumps of stone or bronze; not so with Smith's *Australia*, which seems to be as light as straw, an effect that is amplified by the artist's decision to mount the work on a square cinder block base, which although small adds to the work's sense of weightlessness. Its twisted metal lines and primitive form are said to resemble a bounding kangaroo or a leaping sheep: images that Smith had seen in a magazine sent to him by Clement Greenberg. Apparently, the art critic had been looking through the publication and spotted illustrations of aboriginal cave drawings; he immediately thought of Smith and posted it to him with a note saying, 'The one of the warrior reminds me particularly of some of your sculpture.'

Australia is not unlike a three-dimensional Jackson Pollock, with its unpredictable lines carving through the air just as Pollock's dripped black paint did across his canvases. Abstract Expressionism was certainly on Smith's mind, having associated closely with De Kooning and shared a passion for Picasso with Pollock. Like both of them, Smith was a 'gestural' artist, who had experienced a tough start to his working life as (rather usefully, it turned out) a metal welder. His abstract collages of soldered steel and iron were perhaps the most original sculptures of the age, with *Australia* providing evidence of

his willingness to challenge the figurative traditions associated with the medium. He once said that he did not 'recognize the limits where painting ends and sculpture begins', a complex thought expressed in his complex sculptures.

It was an idea he passed on in 1960 to his English protégé Anthony Caro (b. 1924), who was impressed by Smith's work and advice. When Caro arrived back in Britain he stopped making representational sculptures in a manner taught to him by Henry Moore, for whom he had worked as an assistant, and turned forthwith to Abstract Expressionism. Two years later he made *Early One Morning* (1962), a misshapen, scaffold-like construction of metal poles and beams which at first glance appears to be the sort of twisted configuration a young child might make out of pipe-cleaners and cardboard. But look again, and you will be amazed.

The artwork stands at 3 metres high, 3 metres across and is over 6 metres in length. It is bright red and extremely heavy. And yet it seems as light as air. Walk around the work, peer through its jutting arms and flat panels, and you will be utterly convinced that *Early One Morning* is a sculpture made from paint frozen in time, not steel. It has the delicacy and poise of a ballerina, the resonance of a hymn and the tenderness of a kiss. It is one of those works of art that makes you tingle with excitement. All the more so because Caro had taken the radical step of not putting his work on a plinth but placing it directly on the floor. He wanted us to be able to interact with it on our own terms, at our own scale, in much the same way as the Abstract Expressionist painters aimed to do with their huge canvases.

As with a Rothko painting, *Early One Morning* is about intimacy and experience, aiming to make a connection with us by way of something elemental and universal. That it succeeds is both surprising and magical, which is always the case when one encounters a great Abstract Expressionist work.

16

POP ART: RETAIL THERAPY 1956–70

Eduardo sat at the table and observed his father. Signor Paolozzi was busy assembling a homemade transistor radio from the scattered jumble of components that littered the family room at the back of the shop. The boy knew his father would eventually make the contraption work – Papa Paolozzi loved to solve technical problems; it just always took him rather longer than planned. Even as he tinkered away now he could hear that the shop was getting busy: soon his wife would need help serving the customers. He sighed and looked up, and noticed for the first time that his son was sitting quietly watching him. He smiled warmly.

'Hey, Eduardo, help your mother, would you, she's dying out there.'

Eduardo pushed his chair out, making sure its legs screeched on the floorboards to let his mother know he was coming, then ambled through the adjoining door and into his parents' ice-cream parlour. He was big for a ten-year-old: tall and chunky.

It was an unusually hot Scottish day and the dock-workers of Leith were queuing with good-tempered patience as Mama Paolozzi doled out frozen scoops of her delicious homemade ice cream. Eduardo walked behind his mother and on to the far counter, where the confectionery and cigarettes were sold. Although he was a big lad and heavy-set, Eduardo had no great interest in the sweets or the children who would mull them over for hours before spending a ha'penny on a small bag. But he liked the men who came in for their packet of cigarettes. And they liked him.

'Hae ye collected all the Players cards yet, laddie?' the craggy-faced workman asked.

'Not yet,' Eduardo replied hopefully.

'I see,' the man said. 'I'd betta go fur a packet of Players then; I'll hae the fags, ye tak the card.'

Eduardo beamed and handed over the packet of cigarettes, having removed his prize. Before the next customer could give his order, the young boy sneaked a peek at the small card that lay in his palm. It was a silver Airspeed Courier: a stubby-nosed aeroplane famed for its speed and dogged reliability, which was driven by a single black propeller. A bright red ring of colour outlined the propeller and seamlessly curved away to form a 'go-faster' stripe running down the length of the plane. It was fantastic. And much sought after. When the rush of customers was over, Eduardo made his way up to his bedroom, card securely in hand.

It was a small room, neat to a fault, which happened to be his mother's way. When they had left Italy for Scotland in search of a better life, his mother felt that she needed to bring order to their lives: tidiness was her solution. Eduardo didn't mind, they had a pact – his room could be her domain as long as the inside of the wardrobe that stood against the far wall could be his. Even then, when you opened the doors and peered inside, all would seem normal: ordered and pristine. But cast your eyes to the side, where the doors leant back on their hinges, and you would be confronted by total chaos. Plastered, seem-

ingly randomly, over every available inch of the closet's inner panels were cigarette cards, cuttings from comics, sweet wrappers and newspaper advertisements. It was as if the contents of a wastepaper basket had been blown against them. But what might have appeared incoherent to the casual observer made perfect sense to Eduardo. It was his world, a scrapbook-like collage of all his favourite things, to which he was now adding the picture of a silver Airspeed Courier. He didn't know it at the time – any more than Malevich did when he originally painted his *Black Square* on a piece of theatrical scenery – but it was here, in the Leith district of Edinburgh in 1934, in that small room inhabited by a young Italian-Scots boy, that the seed of Pop Art was sown.

Six years later, in 1940, the family sat around Papa Paolozzi's handmade radio listening to the crackle and pop of the newsreader's voice informing them that Italy had joined the war on the side of the Germans. Within hours the natives of Edinburgh had turned on the many Italian businesses that had been serving the community and attacked their premises. Some men came and arrested Eduardo's father, later returning for the hapless sixteen-year-old boy to take him away for internment. Meanwhile, his mother was transported thirty miles inshore to prevent her from spying on the British Navy's activities at sea. The humiliating incident ruptured the family and frightened Eduardo. It would be the last time he was to see his father. Shortly afterwards Papa Paolozzi was killed when a ship transporting him to a prison in Canada was torpedoed.

It was a tragic event, but Eduardo's father had taught him much before he died. Okay, he had sent him to Fascist holiday camps in Italy, where his son developed his interest in aeroplanes and badges, but he had also imbued Eduardo with a passion for making things, a pioneer's spirit and a love for technology. And working in an ice-cream and confectionery shop had given the boy a lifelong interest in the colourful designs of commercial products and advertising. It was a combination that led to his decision to become an artist when he grew up.

In 1947 the twenty-three-year-old Eduardo Paolozzi (1924–2005) went to Paris to follow his dream. There he met many of modern art's leading players, including Tristan Tzara, Alberto Giacometti and Georges Braque. He immersed himself in the ideas of Dada and Surrealism, and went to as many exhibitions as time would allow, including a show of Max Ernst's collages, and a visit to a room that had been plastered in magazine covers by Marcel Duchamp.

It was the year in which he produced *I Was a Rich Man's Plaything* (see Fig. 27): a collage made up of images cut from glossy magazines given to him by the American servicemen he had met in Paris. Paolozzi mounted the hastily made collage on to a tatty piece of card. The cover of a magazine called *Intimate Confessions* takes up three-quarters of the image. Unsurprisingly, given the publication's title, the cover features a foxy, dark-haired 1940s pin-up girl sitting on a thin blue velvet cushion, dressed in high heels and a short low-cut red dress. She is wearing matching red lipstick and heavy black eyeliner; her head rests coquettishly on her shoulder as she hugs her long legs to her chest, revealing the top of her stockings and bare thighs. Pointed towards her face, obscuring the magazine's tag line 'True Stories', is a cutting from another magazine that the artist has overlaid of a handgun firing a puff of smoke.

The right-hand side of the picture features the promotional headlines for the magazine's main contents: 'I was a Rich Man's Plaything' – 'Ex-Mistress' – 'I confess' – 'Daughter of Sin' – and so on in this manner. Paolozzi has covered the final headline with a cut-out photograph of a slice of cherry pie, and below that he has pasted the logo for Real Gold, a popular brand of orange juice. The final two elements of the collage are mounted below the *Intimate Confessions* magazine cover: a postcard of a Second World War aeroplane emblazoned with the words 'Keep 'Em Flying', and to its right an advert for Coca-Cola.

The collage is crude in every way. The collection of magazine cuttings and postcard are attached with little sense of permanence, while the tone of the picture is cheeky and full of innuendo – the slice of

cherry pie refers to female genitalia, and the handgun pointing towards the smiling face of the wannabe movie-star has obvious phallic overtones, made explicit by the cloud of white smoke discharged

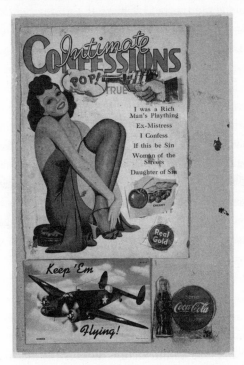

Fig. 27. **Eduardo Paolozzi,** *I Was a Rich Man's Plaything,* **1947**

by the pistol. This is not a collage that would be worth a mention if it were not for a number of historically important factors.

Inside the bubble of white smoke emanating from the handgun is the word 'POP!' written in bright red letters. This is a very early instance of the word being used in a fine-art context, and, given the consumer culture nature of the subject matter, can be considered the first example of Pop Art. The collage has all the hallmarks of the movement that would not become officially established for another decade: the saucy magazine and the comic-type font Paolozzi used for

the word 'Pop' both point to Pop Art's fascination with the young and fashionable, popular culture, casual sex and mass media. The postcard of the military aeroplane acknowledges a deep-lying interest in technology, and connects the commercial with the political. Paolozzi has identified the power of celebrity, branded goods and advertising in a new era of consumerism. One in which such delights would be the opium of the masses: the crack cocaine of capitalism.

The collage's fascination with American culture would be the predominant theme of Pop Art, with the Coca-Cola bottle becoming a recurring motif, seen by artists as the epitome of the mass-market promise of instant gratification. But more than that, Paolozzi's collage embodied the fundamental spirit of Pop Art, which was the belief that high and low culture were one and the same thing; that images from magazines and drinks bottles were just as valid as art forms as were the oil paintings and bronze sculptures being acquired and displayed by museums. It was the intention of Pop Art to blur the line between the two.

Paolozzi's *I Was a Rich Man's Plaything* was one of several collages he used to illustrate a lecture he gave at the Institute of Contemporary Arts (ICA), London, in 1952. He called the talk 'BUNK!' after Henry Ford's assertion in the *Chicago Tribune*, 'History is more or less bunk. It's tradition. We don't want tradition. We want to live in the present.' It's a statement with a ring of Marinetti's Futurism about it, which is perhaps what stirred Paolozzi's Italian blood. He was not alone in his fascination with consumer culture; it was an interest shared by some of his British friends – a close-knit group of artists, architects and academics based in London that became known as the Independent Group.

Among their number was Richard Hamilton (1922–2011), a gentle man who was central to defining the ideas and scope of early Pop Art in Britain. Hamilton was an enthusiastic contributor to the 1956 exhibition *This Is Tomorrow* at the Whitechapel Art Gallery in east London, which was a show that set out to look forward to life after

the austerity of the post-war years. Hamilton made a collage intended to be a promotional poster for the show and an illustration for its catalogue. But in a twist that is very 'Pop' in its nature, it went from being a commercial piece of design into one of the defining artworks of the late 1950s.

Just What Is It That Makes Today's Homes So Different, So Appealing? (1956) is made in a similar way to Paolozzi's earlier collage, in as much as Hamilton has pasted magazine cuttings on to card. But instead of Paolozzi's scrapbook effect, Hamilton used his sourced material (mostly images from aspirational lifestyle magazines) to create a single coherent image of what the living-room of the future might look like. Standing at the threshold of this new life, we are welcomed by a stripped and toned body-builder posing at the foot of his stairs, while his 'perfect' naked wife takes up a risqué pose on a chic Bauhaus-inspired couch with a lampshade for a hat. The couple are surrounded by the latest home comforts: a television, an extendable vacuum cleaner (with maid attached), tinned ham, and a state-of-the-art tape player that is placed on the floor.

Hamilton said that he based his now-famous collage on the story of Adam and Eve, and simply transported them from the paradise of the Garden of Eden into the new and exciting paradise of post-war twentieth-century easy living. And it is a much better place than that boring old biblical garden, where you can look but not touch. In Hamilton's spick-'n'-span world temptation must NOT be resisted, it is your duty to consume and indulge. If you want an apple, take two – one for now and one for later. And have some ham with it, and why not have a suck on Adam's lolly, which you will find provocatively placed by his groin and boasting a Paolozzi-like 'Pop' at the business end.

Hamilton had tapped into society's optimism for a high-tech future. One where everybody (at least in the West) would live a life of plenty enabled by flashy modern products and the leisure time to enjoy them. Life was changing from hard graft to light entertainment. The future

was to be filled with movies and pop music, fast cars (alluded to in the collage by the Ford logo on the lampshade) and loose morals, gadgets and gaiety, food in cans and televisions in boxes.

In 1957, with remarkable foresight, Richard Hamilton defined popular culture as: 'Popular (designed for a mass audience), Transient (short-term solution), Expendable (easily forgotten), Low Cost, Mass Produced, Young (aimed at youth), Witty, Sexy, Gimmicky, Glamorous, Big Business.' This made clear that Pop Art wasn't a foolish phase in which artists made facile artworks for a puerile public, but a highly political movement, acutely aware of the demons and pitfalls lurking within the society it was portraying. The Pop artists, like the Impressionists in the 1870s, had looked around them and documented what they saw.

In America two young artists shared similar ideas. They had already lived the 'dream' of consumer culture in New York, and seen its darker sides too. So it didn't come as a surprise that they approached Pop Art from a less romanticized standpoint. Initially, Jasper Johns (b. 1930) and Robert Rauschenberg (1925–2008) only wanted to offer an alternative to what they considered to be the overpowering, testosterone-fuelled Abstract Expressionists. If Hamilton and Paolozzi were reacting to the austerity of post-war Britain, then Johns and Rauschenberg were reacting to what they saw as the dominance of Rothko and De Kooning.

Both Johns and Rauschenberg felt that the Abstract Expressionists had lost touch with reality. They had become too wrapped up in themselves and had abandoned real subjects in favour of grand pronouncements of their own feelings. The two young Americans represented a new generation that wanted to reflect and discuss the reality of the humdrum life around them, which was modern America in the 1950s. From their New York studio they worked together, shared ideas, and critiqued what they produced. It was a partnership of two likeminded artists who helped each other reach new heights and break new ground in their own individual styles. The work that Johns and

Rauschenberg produced paved the way for Andy Warhol (Warhol bought a drawing of a light bulb by Johns in 1961) and Roy Lichtenstein: the two high priests of American Pop Art. But at this stage – New York in the mid-50s – Rauschenberg and Johns were known as Neo-Dadaists.

That's not unreasonable. Johns's famous early painting *Flag* (1954–5) owes plenty to Duchamp for the everyday, ubiquitous nature of the subject – the American flag. A cursory glance at *Flag* tells us that, yes, we are indeed looking at the Stars and Stripes, but go closer and look properly (something you have to do in front of the object in MoMA, as it is not possible to reproduce the effect in print) and you will see that Johns has not painted the image solely on to a canvas. It is actually a patchwork of layers, mounted on plywood, made from scraps of newspaper and canvas, painted using an ancient encaustic technique where molten wax is mixed with pure pigment. The combination of the different materials and textured paint gives the picture a lumpy, bumpy, bubbling surface, an effect that Johns has heightened by allowing his paint to drip down the canvas like wax from a candle.

It is a picture with a Dadaist twist. By painting the entire surface of the picture as the American flag, leaving no border or frame, Johns is playing a mindgame, questioning whether it is actually a flag or a painting of one. After all, a flag is only fabric that has had pigment added, so why can't Johns's work – a base material with colour added – be the emblem of America itself? This is a philosophical seam that runs throughout Pop Art – at what point does art become a commodity, and commodity become art?

Johns would often choose everyday subjects – maps, numbers and letters – so familiar to us that they had become invisible. His paintings force us to re-examine the mundane, to pay attention to the world in which we exist. He foregrounds the overlooked and makes it unavoidable, using a meticulous method of layering paint that demands we take a closer look. His art, in this way, was outward-looking, and the antithesis of Abstract Expressionism's bold statements about our inner feelings.

As was Rauschenberg's, whose response to what he saw as the pseudo-heroism and achingly dull seriousness of Rothko and Co. was to produce art that was not only rooted in the discarded offcuts of consumerist America, but was made from them. 'I feel sorry for people,' he said, 'who think things like soap dishes or Coke bottles are ugly because they're surrounded by things like that and it must make them miserable.' Rauschenberg's deep appreciation for such lowly mass-produced items led to him finding his artistic voice in artworks like *Monogram* (1955–9) (see Plate 24). It is one of a series of works he produced between 1953 and 1964 that mixes fine-art oil painting with sculpture and collage: a conflation to which he gave the name 'Combine' (combination). Rauschenberg said he wanted to work in the 'gap between art and life', in order to find the point where they either met or merged into one. Nobody has summed up the essence of Pop Art more concisely or precisely. His starting-point was Duchamp's 'readymades' and Schwitters's concept of 'Merz' – high art made from low culture. The American artist would walk a few blocks around his New York studio looking for 'found' objects – scraps, fragments and oddities that he could turn into an artistic expression. For Rauschenberg the street was a palette, the floor of his studio an easel.

These scavenging exercises would frequently take him past a second-hand office supply store that had a stuffed Angora goat in the middle of its window display. Rauschenberg felt sorry for the dead animal – it looked so pitiful and dirty under a blanket of dust, with only a murky window out of which to stare, seemingly for eternity. He thought, 'I could do something about that,' and went in and offered to buy the beast. The shop owner wanted $35 but the artist only had $15. They agreed that Rauschenberg could take it away for $15 and come back and pay the rest later, once he had earned some money (when he did return with the balance some months later the shop had closed down).

Back at the studio he tried putting the goat against a panel, as if it were a picture mounted on a wall. It didn't work; the goat was 'too

big' – not in terms of size, according to Rauschenberg, but of 'character'. He experimented with all sorts of other ways to display the beast but couldn't find a satisfactory method, saying 'to start with it [the goat] refused to be abstracted into art – it looked like art with a goat'. That was until he went back to his studio floor and picked up an old car tyre that he had gathered on one of his city sweeps. He placed the old piece of rubber around the goat's midriff like a saddle, and presto! In Rauschenberg's eyes the goat had now become art.

Next he built a low square wooden platform with a small wheel on each corner and placed the goat/tyre in the centre. He then added to this an assortment of painted pieces of paper, canvas, a tennis ball, a plastic heel, a shirtsleeve and a drawing of a man walking a tightrope. The goat got a makeover too: Rauschenberg decorated its face with thick brushstrokes of multi-coloured oil paint. And, as he built, so emerged an artwork that was as far from the signature brushstrokes of Rothko, Pollock and De Kooning as it was possible to get. This was an ugly (Duchamp's term 'anti-retinal' could be applied) but amusing work of art that could be the equal of a large Abstract Expressionist canvas when it came to commanding space and attention in a gallery.

It can be a baffling experience when you first come across Rauschenberg's *Monogram*. Like a single malt whisky, or a spicy curry, it takes a bit of getting used to. But it's worth the effort. The work is chock full of symbolism and anecdote, starting with its title. A monogram is normally a combination of interlinking letters representing the initials of an individual's name that can be printed on anything from stationery to a shirt. This *Monogram* is a statement about the artist. At its most elementary the goat is an expression of Rauschenberg's love of animals; that he has in his own way given new life to a forsaken creature. The fleece from an Angora goat is made into mohair wool, a reference, perhaps, to the artist's time in the US army when he wore their uniforms that contained mohair. The goat also points to Rauschenberg's interest in the past: it is an ancient creature that has been valued for centuries, but perhaps no longer; hence the tyre

strapped to its back (running it over?), representing a new, more callous age. The tyre too is autobiographical, referring back to the artist's childhood when he was living near a tyre factory. And then there's the combination of the two elements (goat and tyre), which is itself a monogram. As for the thick paint applied to the goat's face, well, that could be read as a critique of the Abstract Expressionists – bold brushstrokes obliterating the natural expressiveness of the goat's features leaving a falsified image that hides the truth.

The other objects embedded in *Monogram* are no less meaningful. The shirtsleeve again harks back to Rauschenberg's childhood when the living was frugal. Instead of buying new clothes his mother would make do and mend, stitching together odds and ends of old shirts to make a new one – a thrifty approach that stayed with the artist and can be seen in this work. The embedded heel could refer to the amount of walking Rauschenberg has undertaken to make the piece; the tennis ball a nod towards the physical effort it took to construct. You can speculate for hours on the autobiographical insights and hints Rauschenberg was communicating through the elements that make up *Monogram*, but one thing is for sure – it was a radical departure from the sort of art he had been taught to make at college.

Rauschenberg had attended Black Mountain College in North Carolina – perhaps the most progressive art school in the world at the time. Willem de Kooning and Albert Einstein were connected to the institution, as were Bauhaus legends Walter Gropius and Josef Albers, the latter being one of Rauschenberg's tutors. The rebellious American and the disciplinarian German did not see eye to eye – Rauschenberg describing him as a 'beautiful teacher and impossible person'. The student began to question his master's modernist ways (although Albers's insistence that Rauschenberg appreciate the value of materials stayed with him always).

In a partially sarcastic response to Albers's insistence that his pupil manipulate colours and shapes in a way that challenges the norm, Rauschenberg went off and produced a series of completely mono-

chrome paintings in black that he referred to as 'visual experiences . . . not art'. He also produced a series of *White Paintings* (1951) that were at once a spoof on Abstract Expressionism, a tilt of the cap at Malevich's famous *White on White* (1918) Suprematist painting, and an exploration by Rauschenberg into 'how far you can push an object and yet it still mean something'. *White Paintings* consisted of identical rectangular or square canvases covered uniformly in white paint that were hung next to each other like soldiers on parade. They weren't intended as anxiety-ridden Expressionist painting but as artworks that were activated by incident and chance, such as dust landing on the canvas, or the shadow of someone looking at them, or a ray of light splashing on to the surface.

He called them 'icons of eccentricity', which when shown publicly won some plaudits, plenty of derision, and a general feeling that Rauschenberg was an unusual artist. A suspicion that was confirmed when he approached Willem de Kooning in 1953 with an impertinent question. It is worth bearing in mind that at the time De Kooning was one of the most respected artists in the world – one whose very presence filled people with awe. Rauschenberg, by comparison, was an upstart: a nobody.

Armed with a bottle of Jack Daniels whisky for comfort and courage, Rauschenberg walked up to the entrance of the revered artist's studio and knocked on the door. Every fibre of his body was willing De Kooning to be out. But he wasn't. He answered the door and invited the young, callow artist into his studio. Once inside, with adrenalin coursing through his veins, Rauschenberg asked his question. Would the Dutchman please give him one of his drawings so that he, Rauschenberg, could destroy it by rubbing out the image with an eraser?

De Kooning listened to the bizarre request, and then removed the painting that was on his easel and placed it in front of the door through which they had entered the studio, thereby cutting off any means of escape for Rauschenberg. De Kooning narrowed his eyes

and stared at the brazen young man, who by now was visibly shaking. The Dutchman said nothing for a while, and then, after what seemed like an age to Rauschenberg, he spoke. He said he understood Rauschenberg's request, but didn't think it a good idea. Nevertheless, he was going to go along with it, to support the ambitions of a fellow artist. But, he announced, it would have to be a work that he, De Kooning, would personally miss – and something very difficult to erase.

De Kooning selected a small drawing on paper that he had made with crayon, pencil and charcoal, on which there were also traces of oil paint. He gave it to Rauschenberg and told him provocatively that he would struggle to get rid of the image. He was right; Rauschenberg laboured away for a month, painstakingly removing De Kooning's marks with an eraser, until eventually he succeeded: the image had gone. He asked his friend Jasper Johns to produce the typography for the work's title – *Erased de Kooning Drawing* (1953) – and declared the new work of art complete. The point of the exercise, he said, was not a Dadaist act of destruction, but to see if he could find a way of making a drawing part of his all-white series.

Rauschenberg's courage in thinking and acting differently at a time when critics and collectors were in the thrall of the Abstract Expressionists should not be underestimated. Nor should his influence. *Erased de Kooning Drawing* is seen as an early piece of performance art that would inspire a generation of artists in the 1960s. And the *White Paintings* acted as a precursor to Minimalism, while giving the composer – and Rauschenberg's great friend – John Cage the impetus to write his famous piece of non-music 4′33″: four minutes and thirty-three seconds of the sound experience Cage said he preferred over all others: silence. The same *White Paintings* were surely in Richard Hamilton's mind when he was asked by the Beatles to design the cover for their *White Album* (1968), which was a plain white sleeve on which the band's name was embossed and barely visible. As for *Monogram* and his other 'Combines', well, their impact can still be felt today. A

stuffed goat has led to pickled sharks and unmade beds, and before them, the Fluxus art movement of the mid-60s (which we will come to in the next chapter).

Rauschenberg and Johns – friends and lovers – succeeded in the task they had set themselves in their New York studio during the 1950s. They had determined to free American modern art from the chilly grip of Abstract Expressionism, and that they had done. Their images of, and appropriations from, popular culture stopped being seen as a joke and started to be taken seriously. Influential curators from MoMA would make their way to Manhattan's leading art galleries – such as Betty Parsons and Leo Castelli – to see at first hand the latest work by these two young Americans. There they would quietly peruse and identify pieces to purchase and add to their impressive collections of modern art. Many others would also go and browse: the Manhattan intelligentsia, collectors and other artists. Among the regular visitors was a fey man in his early thirties who had already made a name for himself as a fashion illustrator, but who now desperately wanted to break into the art world.

Andy Warhol (1928–87) would stand and look at the work of Rauschenberg and Johns and despair. What could he – a mere commercial artist working in advertising – do to match the impact being made by those two bold artists? He had found a degree of fame as a designer of pen and ink drawings of shoes, and made good money creating alluring shop window displays. But that was as far as it went. For years he had experimented with pop motifs. He had produced a very basic drawing of a dead James Dean (1955) with his overturned car in the background, and a line drawing of the author Truman Capote (1954), as well as a Surrealist-inspired picture of a chess player – a reference to the importance of Marcel Duchamp to the emerging artist. And yet, by the end of the 1950s Warhol still hadn't discovered his own subject or style on which to build his fine art career. He only had his illustrations or poor pastiches of other artists' works: he remained an outsider looking in.

In 1960 he followed in the wake of Paolozzi, Hamilton and Rauschenberg and made an artwork featuring a Coca-Cola bottle, although his approach was different. While the other artists had used the brand and bottle as a part of their artwork, Warhol made it his sole motif, just as Johns had done with his subjects.

In *Coca-Cola* (1960) Warhol simplified the bottle into a graphic representation and placed beside it a disc of the brand's famous logo, as if he had cut both out of a magazine and magnified the image. The effect was stark and detached, and more powerful as a painting than it would have been as a piece within a collage. But it wasn't quite right. It was too subjective. Warhol couldn't resist adding some painterly brushstrokes to his design, marks that were in keeping with the emotional dramatics of Abstract Expressionism, but that undermined the potency of his otherwise coolly disconnected image. The problem was that there was too much Andy Warhol in the painting to make it a distinctly Andy Warhol painting. He was, though, very near to finding a signature style. He came closer still with some black and white paintings of small ads that he had removed from the back of a newspaper. *Water Heater* (1961) studiously mimics the advertisement for a water heater, but Warhol yet again over-embellished the image by incorporating into the picture drips of paint running down from some of the lettering. And then, in 1962, he cracked it.

Having asked anyone who would listen to him for an opinion of what he should paint, he struck gold when one person suggested that he plump for the most pervasive piece of pop culture he could identify, like money in the form of a dollar bill or a stick of chewing-gum. Now, that was a good idea. While Johns mainly chose objects so familiar that they were overlooked, Warhol would take images so popular that they already had mass appeal – he would be as bold and brash as the adverts and products surrounding him in Manhattan. He figured that one could interpret the icons and artefacts of the consumer boom in two ways. The idealized images of perfect people and faultless products could be seen as either clichés or classicism; they

could either be viewed as a crass and exploitative picture of a woman in lipstick, or they could be read as celebrating the ideal of perfection, just as the Greeks had done with their revered artworks. It was a psychological tension that was rife with possibilities. Warhol went back to his mother's place for lunch to have a think about a suitably 'low' motif. When he arrived there he sat down and consumed the same meal he had been eating for the past twenty years: a slice of bread and a can of Campbell's soup.

He still couldn't find a New York gallery to show his work, but he did in Los Angeles. In July 1962, at Irving Blum's Ferus Gallery in LA, thirty-two paintings by Andy Warhol of *Campbell's Soup Cans* (1962) were exhibited. They were presented on thirty-two separate canvases, each depicting a different flavour in the Campbell's range. Irving Blum had wittily hung them in a single horizontal line supported by a shallow white shelf, as if they were still in a food store. The intention was to sell each canvas individually for $100, but by the end of the show there were only five takers, one of whom was the movie star Dennis Hopper. By this time Blum had developed a taste for Warhol's *Campbell's Soup Cans*. He liked seeing them en masse, and started to think that they worked better as an overall piece rather than as single units: the sum, he thought, was greater than the parts.

He put it to Warhol that the work should be reconceived as one entity featuring thirty-two canvases. The artist agreed. Which makes Blum a co-creator of one of the twentieth century's most famous artworks. And a member of a fast-expanding club of Andy advisers, a motley band of which he was happy to be a part. A willingness to listen to other people and, when appropriate, to take advice was among Warhol's greatest gifts. He would often solicit ideas, politely ignoring the suggestions that he thought to be off-beam, but quickly acting on any that he considered had merit.

Irving Blum's recommendation was such an instance. With Warhol's agreement, the art dealer went about buying back the five previously sold *Campbell's Soup Can* canvases – all of which had

remained in the gallery awaiting collection once the exhibition had finished. Reportedly he had varying degrees of difficulty – Hopper is said to have been the most intransigent – in persuading his clients to take back their money and to allow him to keep the canvases. It was worth the effort. As a unified work *Campbell's Soup Cans* would not only define Warhol as an artist, but they would also define Pop Art, and the movement's overriding obsession with mass-production and consumer culture.

Warhol had succeeded in removing almost all evidence of his presence from the paintings; there are no stylistic ticks, no look-at-me flourishes in any one of the thirty-two canvases. The power of the work was in its dispassionate coldness, communicated by the apparent absence of the artist's hand. Its repetitive nature parodies the methods of modern advertising, which aims to infiltrate the public's consciousness in order to indoctrinate and persuade by bombarding us with multiple exposures of the same image. Warhol is also challenging the convention that art should be original with his studied uniformity of his *Campbell's Soup Cans*. Their sameness goes against the traditions of the art market, which places value – financial and artistic – on perceived rarity and uniqueness. Warhol's decision not to create his own graphic style but to mimic that of the Campbell's soup cans has a social and political dimension. It is a Duchampian rebuke to the art world for elevating artists to the role of all-seeing geniuses, as well as being a comment on the diminished status of individual workers in the homogenized world of mass-production (a concern that had been raised by John Ruskin and William Morris in the nineteenth century).

Warhol presses that particular point with his method of production. Although the thirty-two *Campbell's Soup Cans* appear identical, they are in fact all different. Go up close and you will see that the brushwork is not quite the same on any one of the canvases. Look even closer and you'll notice that at times the label's design has been changed. Behind the apparent soullessness of the repeated motif is the

hand of the artist, an individual whose task it was to make the work. Just as it is the efforts of individuals unknown and uncredited that are behind the creation of a can of Campbell's soup.

The Chinese artist Ai Weiwei was making a similar point at Tate Modern in 2010 when he filled the institution's cavernous Turbine Hall with 100 million porcelain sunflower seeds. As a unit they formed a dull grey landscape, but pick a few up in your hand and you could see that each and every one had been hand-painted and was markedly different to any of the others. The artist was referencing the vast Chinese population and reminding the world that his fellow countrymen are not one singular mass that can be thoughtlessly trampled upon, but a collection of single people with their own hopes and needs.

Warhol was intrigued by the workings of big business and the mass media and our responses to their messages. He was fascinated by the paradox that an image of a soup can, dollar bill or Coke bottle could become so familiar as to be desirable; a visual shorthand saying 'come and get me' when shopping in a crowded store. And yet an image of something horrific like a plane crash or an electric chair would lose much of its power through being seen repeatedly in newspapers or on television. No artist understood or captured the contradictory nature of consumerism better than Andy Warhol.

And few have harboured the dual fascinations of celebrity and morbidity with such passion. A combination he brought together with his *Marilyn Diptych* (see Plate 25). Warhol produced it in 1962 – the year that his career took off and the movie star's came to an end with her death. It is a very early example of a Warhol silkscreen, a much-used commercial printing technique that he introduced to the world of fine art. It was the last triumphant step on the road to Warhol finding his artistic style. He had already established that his art would be based on mimicking the visual language of American consumerism – so to borrow from that world once more made all sorts of sense. His aim was to remove his hand altogether from the making of an artwork, to find a more 'assembly line' effect, which would help

close the gap between his images, their production, and those they were imitating. Silkscreen printing did this, and more. It allowed Warhol to employ the garishly bright artificial colours used in the commercial sphere. He didn't wish to do so in order to express his inner feelings for a subject, as had been the case with the Fauves and their vivid colours, but so that he could ape the palette of pop culture.

The *Marilyn Diptych* began life as a publicity photograph of the actress taken while she was filming the movie *Niagara* (1953). Warhol acquired the image and then followed his silkscreen procedure of transferring the photograph in glue and on to silk, after which he said he would 'roll ink across it so the ink goes through the silk but not the glue. That way you get the same image, but slightly different each time.' He enjoyed the process, saying it was 'all so simple and chancy. I was thrilled with it.' It was an act of spontaneity and chance dating back to the ideas of Duchamp, Dada and Surrealism, with his penchant for repetition and celebrity added to the mix.

The work is made up of two panels, each consisting of a silkscreen version of the original image that Warhol has repeated twenty-five times and arranged in rows of five across like a sheet of postage stamps. The left-hand panel has an orange background against which the yellow-haired, fuchsia-faced Marilyn Monroes smile at the viewer with teeth showing through parted red lips. It is the very essence of the celebrity illusion packaged by movie moguls and glossy magazine editors: a world apart, where perfect beauty and carefree happiness co-exist. It is in stark contrast to the right-hand panel, which Warhol has printed in black and white.

The twenty-five Marilyns on this side, although taken from the same image, are as grimly haunted as the ones on the left are brightly cheerful. These Marilyns are smudged and blurred: faded and barely visible. The panel alludes to her death just a few weeks before, as well as being a comment on the price of fame, a dangerous game in which you end up losing your identity, your sense of self, and, in Monroe's case, your lust for life. There is something of Oscar Wilde's story of

The Picture of Dorian Gray about the *Marilyn Diptych*. On one side the image of Marilyn never ages – she is young and gorgeous, sensual and vivacious. Meanwhile, on the other side – in the attic, so to speak – is a picture of her deterioration from a (silk) screen beauty to a ghostly lady who has lost her looks.

It is one of Warhol's most iconic artworks, and, once again, one not entirely the product of his own brilliant mind. An art collector called Burton Tremaine had gone along to Warhol's New York studio with his wife to take a look at what the artist was up to. Warhol showed them his work, dispersed within which were two separate Marilyn Monroe silkscreens: one in colour, and one in black and white. Mrs Tremaine suggested to the artist that he should put the two together as a 'diptych', to which she says Warhol replied, 'Gee whiz yes.' Such was the alacrity with which he responded that the Tremaines felt they had little alternative but to buy them both – which they duly did.

The word 'diptych' was a clever thought, as it is so strongly associated with altarpieces in churches, thereby memorializing the adored film goddess as a figure now worthy of true God-like worship. On the other hand, the picture represents a parasitical piece of opportunism by Warhol. He was trading on the reputation of a recently deceased film star and the warm feelings the public had towards her, at a time when emotions were running particularly high because of her fatal overdose. The artist has turned Marilyn Monroe into a piece of merchandise. Which, for Warhol, was a desirable outcome. It fitted with his goal to reflect the machinations of the commercial mass-market right down to the last detail. Sure he had turned the actress into a product, but then so had the purveyors and consumers of pop culture. Warhol was fascinated by money and by his country's attitude to it. He once infamously said that 'good business is the best art'. It is clearly a comment designed to arouse and provoke, but it makes perfect sense in the context of his work.

Andy Warhol was a remarkable artist who chose consumer society as a theme, which he then exploited using the methods of consumer

society. He even went to the extreme of turning himself into a brand. He became the personification of everything that he was trying to say about the avaricious, celebrity-obsessed world in which he was living. He must have been amused when he heard people talking about 'buying a Warhol'. Not this or that painting by Andy Warhol, but 'a Warhol'. Implying that the work of art, the object they had acquired, was irrelevant in intellectual or aesthetic terms; the only thing that mattered was that it was a branded product that had social cachet and made financial sense: it was a good buy. The fact that Warhol probably hadn't made the piece mattered not, as long as he had authenticated the work on the way out of his studio, which he bluntly and cheerfully called 'The Factory': a direct reference to his commercial methods of production.

Before settling on using images made ubiquitous through or by the media for his subject matter, Warhol had experimented with making paintings of characters from comics. Pictures such as *Superman* (1961) were large-scale copies of scenes that he had taken from comic strips and reproduced mimicking their graphic style. There was little difference between the approach he took in making his comic-book paintings and the one that led him to fame and fortune soon afterwards. In fact, it is possible that he would have found success earlier via his comic-book pictures had there not been another artist doing the same thing, in the same city, at the same time . . . but better.

Roy Lichtenstein (1923–97) had been involved in art for a while. He had studied fine art, taught fine art and produced fine art of varying types and quality for many years. But, like Warhol, he had not found a style with which he was comfortable or that was recognizably his. Until he happened upon cartoon comic strips in 1961. His approach was to find a dramatic scene in a comic, cut it out, make an exact coloured drawing of it, enlarge it by projecting it on to canvas, draw it again in the bigger format, make some compositional adjustments, and then colour it in. The result was a large-scale painting that looked almost identical to the original small panel he'd cut from the cartoon strip.

Comics were obvious territory for the artists of the fast-emerging

Pop Art movement to explore, which explains why he and Warhol (and another painter called James Rosenquist) arrived at the same idea almost simultaneously. The difference between them, though, was Lichtenstein's technical approach. Yes, he mimicked the graphic style, lettering and speech-bubbles of comic strips, but he also copied the printing process by which they were made.

In the 1960s, colour comics used a printing technique called Ben-Day Dots. It is based on the same principles as Georges Seurat's Pointillism, whereby dots of colour are applied to a white surface with space left around them. The human eye detects a colour 'glow' surrounding each dot and takes on the task of mixing it with the other coloured dots in the vicinity. This was beneficial to printers and their comic clients. If the printer wasn't covering all the paper in ink, but just dotting it with colour, there was a decent financial saving to be had.

Lichtenstein copied the system and in doing so happened upon a style that made his paintings instantly recognizable. In the autumn of 1961 he went to show his new work to Leo Castelli, the influential New York gallery owner. The astute Castelli liked what he saw. He knew Warhol was pursuing a similar path and therefore mentioned to the artist that he had just seen Lichtenstein's dot paintings. Warhol immediately went to take a look at Lichtenstein's canvases, studied them for a while, and decided to move away from comic-strip art for good.

You generally only need one really good idea to succeed – Facebook, Google, James Bond – and Lichtenstein had arrived at his. He either destroyed or forgot about all his previous work and concentrated on producing his distinctive Ben-Day style comic-book re-enactments. A few weeks after his meeting with Leo Castelli he delivered his first consignment of comic-strip inspired paintings to the art dealer.

Lichtenstein was as instantly successful as the heroes of popular art he was portraying. Castelli sold the first consignment quickly. He followed that up the next year by selling all of the paintings displayed in Lichtenstein's first show at the gallery before the exhibition had opened.

Were people buying his work because of its deep philosophical under-currents? Did the wealthy collectors of Manhattan ponder on how the artist was commenting on their world by exaggerating the modern ideal of perfection? Would they still have bought the pictures if they knew that they were a critical comment on their thoughtless, blasé way of life; that Lichtenstein's pictures always portrayed the drama and the heroics, but never the consequences? Were they struck by the irony that they had paid a lot of money for a copy of an object that is worthless and mass-produced? Or did they flock to acquire Lichtenstein's paintings because they were fun and brightened up a room?

Lichtenstein's paintings (see Plate 26) were a very long way from Abstract Expressionism. Where the art of Pollock and Rothko had been all about existential feelings, Lichtenstein and Warhol focused purely on the material subject; removing all trace of themselves in the process. Lichtenstein even made a painting called *Brushstroke* (1965), parodying Abstract Expressionism, where he turned the symbol of their personal expression, a big gestural brushstroke, into an imper-sonal, detached object of mass-production. Americana was their subject, as it had been largely for Paolozzi and Hamilton, and would be for the next generation of British Pop Artists.

Peter Blake's (b. 1932) most famous piece of Pop Art isn't a paint-ing or a sculpture, nor is it a readymade or an assemblage. In 1967 the most famous pop group on the planet asked the British artist to create an artwork for their forthcoming album. Blake said yes, the Beatles were delighted, and his *Sgt. Pepper's Lonely Hearts Club Band* album cover design became an instant icon of the age. It featured film stars and novelists, philosophers and poets, sportsmen and explorers – and slap bang in the middle, the Beatles. The bright colours, wry humour, and appropriation of images of celebrities from far and wide are all traits of Blake's Pop Art. And of Pop Art in general, which was to cri-tique art and business by way of an artistically brokered merger.

That concept of blurring the boundaries between art and com-merce was ingeniously realized by the Swedish-born American artist

Claes Oldenburg (b. 1929). Having grown up and studied in Chicago (with a stint at Yale), he moved to New York in the mid-1950s and became a player in the avant-garde art scene. In 1961 he rented premises down on the Lower East Side for one month, in which he installed *The Store* (1961). At the back of the premises he made the 'products' for his enterprise, which was a fully functioning retail outlet he 'opened' at the front of the building. Oldenburg stocked his *Store* with hats, dresses, lingerie, shirts and all manner of other things including cakes: all of which could be purchased just as well from other retailers around the neighbourhood.

Except that no other store could quite match the Unique Selling Point of Oldenburg's offerings. They were all unwearable, unusable or inedible. They were not made from delicate cotton, or the finest ingredients, but out of chicken wire, plaster, muslin and glutinous dollops of paint. He hung his crudely made merchandise from the ceiling, stacked it up against the wall, and left it free-standing in the middle of *The Store* – the effect of which was to make the place look like Satan's grotto: a place full of useless, offensive items being mis-sold as objects of desire. Which, of course, was one of the points the artist was making about the stuff that filled the 'normal' stores. He priced his products, or perhaps I should say 'sculptures', in the vernacular of the high street. A 'dress' might sell for $349.99 or a 'cake' for $199.99.

This was a form of Pop Art that had taken the philosophy of the movement to its logical conclusion. He had mixed real commerce, with real products, on a real high street, with real art. And it worked a treat. Oldenburg's was a very successful venture, as curators, collectors and artists piled into *The Store* to browse, and – needless to say – to buy. After all, here were genuine artworks, being made by a highly respected artist, at what amounted to knock-down prices. And the art world, like everybody else, can't resist a bargain.

A year later in 1962 – the same year in which Warhol and Lichtenstein broke through and established Pop Art in the mainstream – he made a sculpture called *Two Cheeseburgers, with Everything (Dual*

Hamburgers). It is another quintessential piece of Pop Art. It's funny, it's banal, it elevates junk food to high art, and it is the epitome of consumer culture (note the order was 'with everything'). The ironies are plentiful, such as lots of time spent making something that takes seconds to consume, and a sculpture that looks good enough to eat but is made of plaster and enamel. It attacks and celebrates materialism by laying bare the madness at the heart of a consumerist way of life, but also magnifying its attraction. As a piece of food it is an illusion; satisfaction is guaranteed but ultimately unobtainable. But as an artwork it lives up to, and delivers on, its promise to amuse and nourish.

The Store was a theatrical set in which our interaction with what curators call an 'environment' or 'installation' makes us the lead player: the star of the show. The idea of creating a real-time human drama as part of an artwork goes back to Oldenburg's earlier artistic life in the late 1950s, when he was part of an experimental group who presented 'Happenings'. These were live performances by artists in which their actions were both the event and the artwork. Happenings stem from Marinetti's Futurist rants, Dada's wild-eyed poetic nonsense, and the Surrealists' determination to access the unconscious by effrontery and weirdness.

The Happenings in which Oldenburg was involved were fringe events, often billed as 'installations', that had the Pop Art sensibility of the here-and-now and ephemeral. These live events were radical by their nature – or daft, depending on your view of people behaving extremely oddly – but they represented a sober and serious advance in the ongoing quest to define what is and isn't art. Robert Rauschenberg was involved with this nascent movement along with Oldenburg, but the man at the heart of the action was Allan Kaprow (1927–2006). It was the relatively unknown but enlightened Kaprow who said to Roy Lichtenstein, when the Pop artist was undecided about pursuing his Ben-Day dot style, that 'art doesn't have to look like art to be art'.

It was a good piece of advice which Kaprow took himself, leading to the creation of a whole new art movement.

CONCEPTUALISM/ FLUXUS/ ARTE POVERA/ PERFORMANCE ART: MIND GAMES 1952 ONWARDS

C onceptual art is the area of modern art about which we tend to be at our most sceptical. You know the sort of thing: a large group of people gathered to scream as loud as they can (Paola Pivi's *1000*, performed at Tate Modern in 2009), or a dark room full of talcum powder lit by a single candle in which we are invited to pad about (an installation by the Brazilian artist Cildo Meireles called *Volatile*). Such works are often entertaining, even thought-provoking, but are they art?

Yes. They are. Because that is their intention, their sole purpose, and the grounds upon which we are being asked to judge them. The difference being that they are operating in an area of modern art that is first and foremost about ideas, not so much the creation of a physical object: hence conceptual art. But that doesn't give artists the right to serve up any old rubbish. As the American artist Sol LeWitt pointed out in an article for the magazine *Artforum* in 1967, 'Conceptual art is good only when the idea is good.'

The father of conceptual art is Marcel Duchamp, whose ready-mades – most notably his urinal of 1917 – caused the decisive rupture from tradition and forced a re-evaluation of what could and should be considered art. Before Duchamp's provocative intervention, art was something man-made, typically of aesthetic, technical and intellectual merit, which had been mounted in a frame and hung on a wall, or presented on a plinth to look splendid. Duchamp's contention was that artists should not be limited to such a rigid range of media through which to express their ideas and emotions. He argued that concepts should come first and only then should consideration be given as to what might be the best form in which to express them. He made his point with a urinal and changed art from being seen only in terms of paintings and sculptures, to being pretty much whatever the artist decreed it to be. It was no longer necessarily about beauty, but more about ideas – and those ideas could now be realized through whatever medium the artist chose: from 1,000 screaming humans, to a room full of talc. Or, as an alternative, through the medium of the artist's own body, in a sub-genre of conceptual art that came to be known as performance art.

In the spring of 2010 the Museum of Modern Art in New York held a Marina Abramović (b. 1946) retrospective, covering over four decades of the performance artist's career. An interesting, but niche show, one would have thought. The kind of specialist art-world exhibition that large institutions such as MoMA put on to counter-balance their programme of crowd-pleasing, money-spinning displays of 'Picasso's Greatest Hits' or 'Monet's Masterpieces'. MoMA had never mounted such an exhibition before, which, given the nature of performance art, is not surprising.

It is the type of art that tends to suit small, intimate venues, or that is commissioned as a wacky 'intervention' out in the world: not as a main event at one of the world's largest modern art museums. Performance art is the guerrilla arm of fine art, with a habit of popping up unexpectedly, making its strange presence felt, and then disappearing

'And don't forget to feed the artist in residence.'

into the unreliable annals of hearsay and legend. Only recently have museums started to make it part of their schedules, with full retrospectives such as Abramović's still extremely rare. Partly, it should be said, because they're tricky things to pull off. How, for instance, is an art form based on the artist being present at all times going to fill miles of white-walled gallery spaces with content? However talented Abramović may be, she can only physically be in one room at a time. And how do you mount a retrospective of ephemeral artworks that were intended as one-off performances designed for a certain time and space? The whole point of such events is that you had to be there – that's part of their allure.

But then if artists and their promoters let prevailing logic dictate their actions, modern art, as we know it, wouldn't exist. MoMA kept to the spirit of its founders, defied convention and put on the Marina Abramović show. The artist got around the one-place-at-a-time problem by hiring a group of stand-ins to re-enact her previous works, which were duly performed throughout the museum. Meanwhile she concentrated her efforts on producing a new piece called, appropriately, *The Artist is Present* (2010). The work consisted of Abramović sitting on a wooden chair in the middle of MoMA's vast atrium with a

small table in front of her. On the opposite side of the table, facing her, was an unoccupied wooden chair.

She committed to sit on her chair in the atrium for the seven and a half hours the museum was open without moving or taking a break (not even for a restroom visit). What's more, she undertook to subject herself to this ordeal for the entire eleven-week run of the exhibition. Visitors, if they so wished, could sit in the chair opposite Abramović on a first come, first served basis, watch the artist as she underwent her daily vigil, and in doing so, be considered part of the artwork. The visitors could stay as long as they wished, but they had to remain silent and still throughout. How many people would actually bother, nobody knew – but it wasn't likely to be very many.

But then art is constantly surprising. Abramović's *The Artist is Present* became the hottest ticket in town; it was the talk of New York, with people queuing round the block for a turn to sit in silence with the artist. Some visitors stayed for a minute or so, one or two for the full seven and a half hours – much to the increasing fury of those patiently waiting in the queue behind. Abramović was there throughout, wearing a long flowing dress and remaining as silent and inscrutable as one of the museum's statues. Those who sat with her reported having deeply spiritual experiences; of breaking down in tears, and discovering a part of themselves they never knew existed.

It turned out that Marina Abramović's retrospective was not a niche show at all; it was one of the most successful exhibitions Manhattan's high temple of modern art had ever presented. It was right up there with the Picasso, Warhol and Van Gogh retrospectives on the institution's list of all-time mega-blockbuster exhibitions. Which is remarkable given that the artist is hardly a household name, and that performance art has typically been viewed as an arcane sideshow aimed at contemporary art aficionados. In fact, if you had asked most modern art museum directors about Marina Abramović ten years ago, the majority would have responded with a blank stare. Her planet has only entered the art world's mainstream orbit in the last few years.

Which begs the question, why? What has propelled Marina Abramović, in particular, and performance art in general, into the consciousness of public? And why did so many people (A-list celebs included) rush down to MoMA to see her show?

Fashion is a factor. Performance art is currently cool at the avant-garde end of the entertainment spectrum. Björk, Lady Gaga, Antony Hegarty, Willem Defoe and Cate Blanchett have all been involved or cite it as an influence. At the less hip end there are the pantomime stunts of the actor-comedian Sacha Baron Cohen. In the guise of one of his alter egos – Borat, Ali G or Brüno – Baron Cohen confronts and provokes ordinary people in an attempt to cause a reaction or elicit a truth. It is a theatrical approach that can be traced back to the offbeat actions of the 1960s practitioners of performance art. Even today's catwalk models who parade up and down the runway in crazy hairdos and couture costumes are, to an extent, performing in a manner that is related to the work produced by Abramović and her cohorts.

At the same time that those working in popular culture were getting into the performance art groove, so were the world's major modern art museums. In the early 2000s, institutions such as the Tate in London started to take on young curators specifically to research, develop and present a performance art exhibition programme. It was motivated partly by a realization that they had overlooked this area of artistic practice, and also as a response to the surge in popularity of mass-participation event-culture epitomized by the burgeoning festivals market. Live arts gatherings had become big business, be they a pop festival or a book fair, with punters young and old queuing up for some 'artertainment'.

This was fertile territory for the big museums, which over the past decade or two have transformed themselves from cold, dusty academic institutions into bright, airy, family-friendly visitor attractions. Performance art gave them the opportunity to boost their visitor numbers further by presenting a fresh take on live entertainment. Those consumers looking for something a bit different and a little quirky to fill their leisure time might now find what they were looking for in their

nearest modern art museum. It was all part of the 'experiential' market, a fast-growing area of the entertainment industry that already included participative theatre, flash-mobs, and weekend-long festivals where sleeping in a muddy field was all part of the 'experience'. Soon museums were full of visitors clambering over obstacle courses and taking part in immersive art, fun for the public and an important platform for performance artists wanting to create communal events.

It is a long way from the movement's roots, which can be found in the bizarre Happenings staged at the Black Mountain College, North Carolina, in the early 1950s. These were multi-artform live events that started out as collaborations between students and teachers, and included some notable participants. The artist Robert Rauschenberg, his friend the composer and musician John Cage, and his lover, the choreographer Merce Cunningham – who was then teaching at the college – were leaders of the Happenings pack. In 1952 they invited an audience to an evening of activities and events. There was dancing from Cunningham, an exhibition of paintings by Rauschenberg, who also played a Victrola (an early record player), and a lecture given by Cage from the top of a ladder, which in true John Cage style included passages of complete silence.

Today the event sounds like a typical student review, but with those three involved, 'typical' was never an option. They structured the event around John Cage's lecture, using it as a framing device for all the other various activities, which they insisted had to occur within the lecture's duration. To complicate matters, none of the many performers were given specific times or slots to do their bit; instead they were told that they would simply have to take their chance. Chaos ensued, the event was a blast, and performance art had taken its first step tentative step into the limelight.

After the success of the event, Cage, Cunningham and Rauschenberg began working together on other projects. Cunningham would dance to Cage's music in front of stage sets designed by Rauschenberg. Cage, in particular, felt inspired by the mood of the time, and in

the same year as the Black Mountain show he presented one of the most notorious concerts in the history of music. The legendary occasion took place in 1952 at the Maverick Hall, Woodstock, New York. It began when a pianist by the name of David Tudor walked on stage and sat at the piano. The atmosphere in the theatre was one of excited expectation, as the audience waited to hear the latest work from Cage, a maverick composer who was beginning to make a name for himself. But even this crowd of free-minded New York hipsters was left bewildered and angry by Cage's new composition 4′33″, in which ... absolutely nothing happened. Tudor sat at his piano for 4′33″ like a spaced-out zombie. He didn't move a muscle or strike a key. The only time he sprang into action was to get up and walk off the stage.

How, the audience asked, could Cage have the temerity to present to a paying public – who were on his side – a piece consisting of nothing but silence? How could he be so disrespectful? Cage's reply was that 4′33″, was not silent; that there is no such thing as silence. He said that during the first 'movement' he could hear the wind blowing outside followed by the patter of raindrops on the roof. The work, he said, wasn't about silence; it was about listening. Much later I saw the piece 'performed' with a contribution by Merce Cunningham, Cage's long-time collaborator and partner. Cunningham by this time was one of the most revered figures in the world of modern dance, famous for his radical choreography and movement. Except when it came to 4′33″, when he sat perfectly still in a comfy red armchair.

Word of Cage's antics of 1952 soon spread, and the composer found himself with a dedicated fan club of artists who were quick to recognize an original voice. Among his admirers was Allan Kaprow, an American painter and intellectual who had attended Cage's compositional course at the New School for Social Research in New York. Kaprow was taken with the musician's interest in Zen Buddhism and his willingness to use chance as an organizing principle for making art. He also admired Cage's belief in the creative potential of spontaneity and his willingness to draw inspiration from everyday life.

Kaprow's imagination was fired as he attempted to set out on his own adventure to define a new age in art.

He expressed many of his ideas in an article, 'The Legacy of Jackson Pollock', which he wrote in 1958, two years after Pollock's death. Kaprow had trained in Abstract Expressionist painting techniques and had singled out Jackson Pollock as the one artist coming out of the movement who he felt was blessed with true genius. Kaprow praised Pollock for his vision and 'outstanding freshness', and said that when he died 'something of ourselves died too. We were a piece of him . . .' He followed that with the assertion that 'Pollock destroyed painting'. When Pollock splattered, dripped and threw paint down on to the canvas beneath his feet, others had called it 'action painting'. But Kaprow contested that Pollock was a performance artist who just happened to use paint.

The problem, as Kaprow saw it, was that Pollock's 'all-over' paintings left the viewer in the lurch, wanting more drama but finding themselves cut off by the physical restrictions of the four-sided canvas. The solution, Kaprow posited, was to remove the canvas altogether and instead 'become preoccupied with and even dazzled by the space and objects of our everyday life, either our bodies, clothes [or] rooms . . .' Kaprow replaced canvas and paint with a shopping list of sensory alternatives including sound, movement, odours and touch. To which he added a seemingly never-ending roll-call of recommended art materials including chairs, food, electric and neon lights, smoke, water, old socks, a dog and movies. In the future, Kaprow said, one does not need to say 'I am a painter' or 'a poet' or 'a dancer': simply 'an artist'.

In the autumn of 1959, at the Reuben Gallery in New York, Allan Kaprow presented an event that encompassed his many ideas. He had constructed three interconnecting spaces inside the gallery, divided by semi-transparent panels. The performance, *18 Happenings in 6 Parts* (1959), was to be split into half a dozen acts, with three Happenings planned to take place in each. All those participating (audience mem-

bers and artists) were given specific instructions on a piece of card by Kaprow, which he referred to as the 'score'. To add an element of chance to the proceedings, he shuffled the cards before handing them out so that nobody knew what they were going to be asked to do beforehand. The participants then moved about the space following the instructions they had been given and were told to carry on until a bell sounded the end of that part of the event. The actions the participants were asked to undertake were designed to reflect 'situations that came from real life' and not the manipulated hysteria of the theatre, opera or dance halls. This was about ordinary things like climbing a ladder, sitting on a chair, or squeezing an orange.

Kaprow was experimenting at the same time that Johns and Rauschenberg were pioneering American Pop Art. Their artistic agendas were in many ways similar: an ambition to bridge the divide between art and life. Johns and Rauschenberg were doing it by transforming commodities into art: Kaprow was achieving a similar result by turning ordinary people into a piece of art. Whereas Rauschenberg was selecting an assortment of commonplace objects that when combined would reveal an unfolding story and unexpected interactions, Kaprow was doing the same with his Happenings, based on audience participation in collage-like environments. And while Rauschenberg would stroll around the block near his New York studio picking up odds and ends to include in his art, Kaprow would wander the same streets thinking that *they* were the art: 'A walk down 14th Street is more amazing than any masterpiece of art,' he once said.

Nouveau Réalisme

Kaprow's intellectual curiosity led him to many sources of inspiration, not least among them the French artist Yves Klein (1928–62). Klein was interested in what he called 'the void' – the infinite space that is the sky above us, and the seas below. He expressed his mystical

and philosophical feelings for the 'void' through large abstract mono-chrome paintings, which after a while were all produced in just one colour: ultramarine blue. His affection for a particular mix he made of this colour was such that he named and patented it as International Klein Blue (IKB).

Yves Klein was part of the French Nouveau Réalisme art move-ment. It shared an ambition with other conceptual art genres of that time in aiming to go beyond 'easel painting', which, their manifesto proclaimed, 'has had its day'. Klein's response was to turn his atten-tion to performance art with a series of staged pieces he called *Anthropométries*, a name based on the word anthropometry – mean-ing the measurement of human bodies. Instead of covering canvases in his brand-name blue, he invited three naked young female models to become 'living paintbrushes' by dousing themselves in the stuff. Once blanketed in his paint, Klein walked the models over to a large white vertical board standing on the floor a few feet away, which he had already covered with an enormous piece of paper. He then instructed the women to press their IKB-drenched naked selves against the wall. The resulting imprints of splodged body parts are some-where between prehistoric cave paintings and the bedroom wall of an eccentric art student.

Klein added to the sense of performance by serving the assembled guests with blue cocktails and having a group of musicians play his own musical composition, *Monotone Symphony* (1947–8), which consisted of a single chord being sustained for twenty minutes. When he died of a heart attack in 1962 at only thirty-four years old, it brought to an end an extraordinarily inventive artistic career that did much to set the tone for the future of conceptual and performance art.

The Italian artist Lucio Fontana (1899–1968) had bought one of Klein's early Blue Period monochrome paintings in the late 1950s. He too was interested in the idea of space and the void, and shared Klein's ambition to test and challenge the limitations and power of the art-

ist's canvas. Klein repeatedly painted his canvases in a single colour; Fontana took a razor blade to his. He called it Spatialism (Spazialismo), arguing that it represented art becoming closer to science and technology. His sliced canvases – of which there are many – go under the title of *Spatial Concept* (*Concetto Spaziale*).

They are the sort of examples of conceptual art that have a tendency to annoy people. I have stood shoulder-to-shoulder with many friends and acquaintances in front of one of Fontana's slashed canvases while they jab their finger indignantly at the artwork and demand: 'And tell me then, how is THAT art?!' Well, maybe it isn't, but I think Fontana's work is at least worth some consideration.

Take *Spatial Concept: Waiting* (1960), for instance. The way the diagonal slash opens on the light brown canvas to reveal an inner blackness is not the work of a dilettante or a charlatan, but of an accomplished and skilful artist. The illusion of a deep black void (a reference to the space age) has been created by the insertion of some black backing gauze behind the canvas. The cut, or wound – with its obvious violent, surgical and sexual overtones – has been carefully executed by Fontana to leave no rough edges on the surface, thereby allowing our eye to be drawn without interruption into the black abyss exposed by his gash.

There are several interesting ideas being introduced by the artist in *Spatial Concept: Waiting*. The first is the notion of décollage – where a work of art is made by removing, not adding, elements. In one respect Fontana's intervention has destroyed a perfectly good canvas. But in another it is an act of creation: he has made a work of art. And in so doing he has turned an object that was two-dimensional into one with three dimensions. And a material that traditionally owes its status in art to its superficial qualities as a surface on which to paint has been transformed into the material qualities of a sculpture. The function of the canvas has been changed: we are no longer simply looking at it, but we also peering into it, replacing one kind of illusion with another.

Arte Povera

Lucio Fontana's use of minimal materials to maximum effect was to trigger a new generation of Italian artists who went on to form the Arte Povera movement, which, when translated, means 'poor art'. Not poor in the sense of bad, but poor as in art made using basic materials such as twigs, rags and newspaper – a trait that, as we have seen, has been widely used in the story of modern art from Picasso to Pollock.

The Arte Povera artists were responding to Italy's economic collapse after what had been an all too brief boom following the end of the Second World War. Unlike the Futurists – their Italian modern art forebears – their interests lay with connecting modern life with the past. They were concerned by consumer society's addiction to novelty and its increasing ignorance and disinterest in history. Their approach was not only to try to eradicate the barrier between art and life in the same way as many other modern art movements, but to also remove the barriers between different artistic genres: an idea that had been previously explored by Robert Rauschenberg. In what is now known as a 'mixed-media practice', the Italians thought an artist should be able to move between and merge painting, sculpture, collage, performance and installation art.

Michelangelo Pistoletto (b. 1933) was a founding member of the movement. He wanted to take art out of the hallowed sanctuary of the museum or gallery and out into the real world. In the mid-1960s he gave the idea a go when he took a giant 1-metre ball he had made from newspapers called *Newspaper Sphere* (1966) for 'a walk' through the streets of Turin with assorted members of the public for company, in a bizarre and entertaining piece of performance art called *Walking Sculpture* (1967). It was the same year that he made a sculpture called *Venus of the Rags* (1967) (see Fig. 28), in which he piled a mass of unwanted second-hand clothes around a sculpture of Venus, describing his intentions in a recent interview as bringing 'together the beauty of the past and the disaster of the present'. This comment on the dis-

posable and shallow nature of consumer culture is given added weight by the revelation that his idealized goddess of classical antiquity who has been heaped in a pile of modern rags was actually a cheap reproduction based on a statue he found in a garden centre.

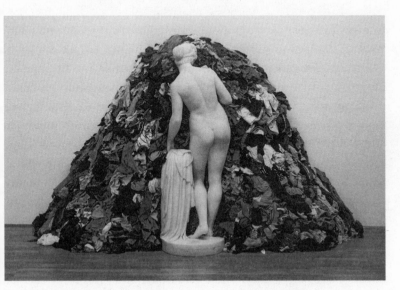

Fig. 28. **Michelangelo Pistoletto,** *Venus of the Rags,* **1967**

His fellow Arte Povera artist Jannis Kounellis (b. 1936) took the movement's anti-capitalist agenda of 'humble materials' to the extremes of Schwitters and Rauschenberg. He was making art from old bed frames, bags of coal, coat racks, stone, cotton wool, grain sacks and even live animals. In 1969 he presented his installation artwork *Untitled (12 Horses),* at a gallery in Rome. It comprised twelve living, snorting, braying horses that he had tethered to the gallery walls and insisted stay there for several days. Kounellis was reacting against the commercialization of art by producing an ephemeral work that could not be sold, and that would dirty the pristine white walls of the modern art space, which he felt had the same look, feel and purpose as a motorcar showroom.

Fluxus

There were not (are not) many car showrooms that would have rushed to put Joseph Beuys's vehicle on public view. The German artist and political activist (1921–86) made an artwork out of a VW camper van, from the back of which twenty-four sledges tumbled, each with a survival kit strapped to it containing a lump of animal fat, a torch and a roll of felt. He called it *The Pack* (1969), a reference to the sledges' likeness to a pack of dogs, and described the artwork as 'an emergency object ... the Volkswagen bus is of limited usefulness, and more direct and primitive means must be taken to ensure survival'. Today the VW camper is a classic car, and *The Pack* a classic Beuys artwork. Once thought by many to be on the wrong side of bonkers, Beuys has now reached the status of art-god among today's avant-garde, who consider him to be one of the most significant artists to emerge in the second half of the twentieth century. I agree.

The Pack contains many of the symbols that would crop up in Beuys's work throughout his career: felt, fat, survival and a sense of rawness. They are all motifs that stem from a story (probably untrue) that he would often tell about his experiences as a Luftwaffe combat pilot in the Second World War (true). Beuys would talk of how his plane crashed in the Crimea and how he only survived his injuries because a group of nomadic Tartars saved him by smearing his body in fat and wrapping him in felt.

There is no doubt that he did indeed suffer physical injuries in the war, but the most profound wound (as Beuys called it) was probably psychological, growing from the guilt he felt for his and Germany's actions. The years that immediately followed the war were a difficult time to be a German artist, particularly one with a deep affinity for the traditions and folklore of his country. Beuys's response was to confront the issues head on through a series of lectures and to maintain a direct interest in politics (he was involved in the formation of the German Green Party). The work he made was the antithesis of the

sterile uniformity and monumentality promoted by the Nazis. Beuys made art out of dead animals, filthy rags and whimsical ideas.

He found a soulmate in George Maciunas (1931–78), a Lithuanian-American artist who was living in Germany and working as a graphic designer for the US Air Force. Maciunas had gone to New York during the late 50s and early 60s, where he had met many of the leading art-world characters, most notably John Cage, who made a lasting impact on him. He also took a keen interest in Marcel Duchamp, Kaprow's Happenings, Nouveau Réalisme and the Zurich Dadaists. All of which led him to develop his own concept for a Neo-Dada art movement that he called Fluxus, meaning 'flow'. He wrote a *Fluxus Manifesto* (1963), demanding that the world be purged of 'bourgeois sickness, intellectual, professional and commercial culture'. He promised that Fluxus would 'Promote living art. Fuse the cadres of cultural, social and political revolutionaries into a united front and action.' Joseph Beuys signed up.

Beuys was a man who was happy to 'fuse' everything and anything in the name of art, and saw the potential of achieving the aims of Fluxus by fusing himself into his work. Performance art had established that an artist could be the medium for his or her art; Beuys moved this idea on and became the artwork. His persona when performing and his 'off-stage' self were one and the same. And because his work had no readily identifiable style (unlike Warhol, whose own investigations into the world of mass consumerism ended up with him becoming a brand), Beuys as a character became the unifying factor.

And a 'character' is what he was. His eccentric lectures, debates and performances became renowned among critics and art-world insiders for their sense of energy, imagination and chaos. In one of his performance art 'actions' called *I Like America and America Likes Me* (1974), Beuys imprisoned himself in a cage for a week with only a coyote for company. Quite strange. But not as strange as the performance for which he is most readily remembered: *How to Explain*

Pictures to a Dead Hare (1965), which is one of those events I dearly wish I had been around to attend.

Beuys sat quietly on a chair in the corner of the Galerie Alfred Schmela in Düsseldorf; his head was covered in honey and a generous sprinkling of gold leaf. In his arms he held a dead hare that he stared at fixedly. After a while he stood up and walked around the room looking at the paintings on the wall. From time to time he would hold the dead hare up and show it a picture, and then whisper inaudibly into one of its ears. Sometimes he would break off and sit down again, but at no point did he address or acknowledge the audience. This went on for three hours.

The audience was transfixed. Beuys later noted that he had captured their imagination, saying, 'This must be because everyone . . . recognizes the problem of explaining things, particularly where art and creative work are concerned.' Maybe. I would have thought they were just baffled and amused. Beuys was an animal lover who thought that even dead animals have 'more powers of intuition than some human beings with their stubborn rationality'. His view was that explaining things to a dead animal 'conveys a sense of secrecy of the world'. Beuys's performance art – all performance art – was not limited to his actions and ideas, but also encompassed the audience's response. It was due as much to their own awkwardness as Beuys's interventions, which shifted them out of their usual semi-oblivious mindsets and into a state of vivid self-awareness and heightened perception. The 'art' in his 'performance' was a joint venture.

A point that Yoko Ono (b. 1933), another Fluxus artist, made with profundity in one of her early pieces of performance art. *Cut Piece* (1964) is an alarming and powerful work that demonstrates with troubling consequences how the audience can be an intrinsic element to an artwork. *Cut Piece* began with Ono sitting alone, emotionless and silent, on the floor of a stage, with her legs underneath her and pushed out to one side. She was wearing a simple black dress. A couple of feet in front of her, also on the floor of the stage, was a pair of scissors.

Once the audience were settled, they were invited to come up, one by one, and pick up the scissors to cut into Ono's dress. At first they were slow to respond and tentative when they did so. But gradually they became more and more confident and bold as, cut by cut, the artist's dress was shredded.

To watch recorded footage of the event now on the internet is to witness a violating event that has the atmosphere of a sexual attack. It exposes truths about human nature and relationships, about assailants and victims and sadism and masochism, that few paintings or sculptures I can think of achieve. It is not theatre – there is no preconceived story with specific outcomes or any timed action to ensure that they occur. But like some, but not all, performance art there is a narrative: a conversation provoked by the artist with an audience whose actions are unpredictable, the outcomes of which unknowable. If art is there to awaken our senses, to challenge us, to help us understand, to make us look afresh – then Ono's *Cut Piece* is a superb work of art.

Conceptual Art

'I sometimes wish I was less conceptual and more site-specific.'

Conceptual artists, who tend not to work in front of an audience, still use performance and their bodies as a medium for their message. Artists like Bruce Nauman (b. 1941) have made a career out of documenting their own performances and then displaying them in galleries and museums as photographs or videos. It is an approach to conceptual art that Nauman decided upon soon after arriving home, having graduated in 1966 with a Masters in Fine Art. He sat down to have a think about what he should be doing, what sort of art he should make.

Later he recalled the moment. 'If I was an artist and I was in the studio, then whatever I was doing in the studio must be art.' Why, he asked himself, should art be a product as opposed to an activity? So, Nauman became as interested in the process of making art as he was in the end product. Shortly after having this thought he made a photographic work called *Failing to Levitate in the Studio* (1966), which documents the artist's frustrated attempt at levitation between two chairs in his studio, which he had placed a few feet apart. The image shows Nauman in two states: one with him horizontal between the two chairs, being supported by their structures, and another superimposed on top of it revealing the artist sitting slumped and defeated on the floor. It is a record of his process of trying and failing to achieve the impossible: a comment on his life, perhaps on all our lives. It is an absurd work of art that has the cheeky grin of Marcel Duchamp buried somewhere among the overturned chairs and his heavily bruised bottom.

In the following year, 1967, he made the video *Dance or Exercise on the Perimeter of a Square (Square Dance)*, which was a ten-minute film played on a continuous loop. In it Nauman is barefoot and dressed in a black T-shirt and jeans. On the floor he has made a metre-wide square out of white masking tape. On each side of the square is another bit of tape marking the side's mid-point. Nauman starts in one of the corners and takes a step to the mid-point, thus measuring the length of half of the square. He does this repeatedly, moving around and around the perimeter of the square to a rhythm set by the metronome. It is very repetitive.

Which is the purpose, of course. That's life. Nauman is the object representing humanity: never learning, never moving on; forever repeating itself. The metronome marks the relentlessness of time, which dictates our lives. The studio is the space that time and object inhabit. Nauman has turned his idea of filming a simple, everyday movement – stepping to one side – into an intriguing artwork. Repetition is an important component – it is about obsessions, about process and, ultimately, about the human condition. It is a story without a beginning or an end; life just goes on. Nauman wants the seeming pointlessness of the artwork to draw us in, slow us down, stop us in our tracks and make us look and think – until we get it.

We all spend too much time visiting art galleries in drive-by mode, glancing at a Van Gogh painting and tripping over a Barbara Hepworth sculpture on our way to grab a coffee and a postcard. Nauman isn't going to let that happen. If we walk blithely past *Dance or Exercise on the Perimeter of a Square (Square Dance)* we will get nothing from the work, but if we invest a bit of time it will pay back. Nauman's art is about many things, but at the top of the list is awareness.

It is a subject that has been revisited many times as conceptual art has taken more of a hold on the contemporary art scene. Francis Alÿs (b. 1959) has created a whole body of highly acclaimed 'actions' that involve him taking walks around Mexico City, where he now lives, which highlight the thing that most of us are too busy to notice: our immediate surroundings.

The Collector (1990–92) is a film made by Alÿs that shows him dragging a toy dog with magnetic wheels along a street, collecting metal foil, tacks and coins as it moves along. It is the work of a real-time archaeologist, studying contemporary culture by collecting the artefacts and remains of our busy lives. In *Re-enactments* (2000) he walked into a gun store in Mexico City, purchased a 9mm Beretta handgun, loaded it and went for a stroll through the streets holding the pistol in his right hand in full view of the public. At this stage it was an exercise in documenting the city's relationship with violence

and guns. Would he be ignored, or even go unnoticed, or would he be challenged immediately? The answer was that he wandered the streets for eleven minutes without anyone taking issue with him, until the police challenged him in what one might describe as a suitably robust manner. That was Part 1.

Part 2 was the re-enactment the next day, which the police surprisingly not only allowed, but also agreed to take part in as the film's 'extras'. Events unfolded in much the same way, with a now staged arrest at the end. This time the purpose of the exercise was not to comment on the relationship the citizens of Mexico City had with crime, or even the police's willingness to allow someone to stroll the street gun in hand. The point of the re-enactment was to highlight the spurious nature of documentary films in general, and those capturing performance art in particular. Alÿs is making us aware that as we stand in the gallery watching his surreal antics, or watch a documentary on television, there is always an element of mediation, subjectivity and staging involved.

A partially hidden truth that the sculptor Richard Long (b. 1945) exposes with his conceptual art. Long, like Alÿs, has a penchant for walking and observing the effects that we have on our surroundings. While the Mexico City based artist makes films of other people's reaction to his work, Richard Long takes photographs of barren landscapes. These are not in the style of reportage snaps, but meticulously planned and staged events. When he was only twenty-two, Long made a work called *A Line Made by Walking* (1967) on his way home from art college. He had stopped off en route and decided to walk up and down the middle of a field until he had trodden a visible path, which he then photographed. It is a simple but affecting work, carefully designed to show Man's existence. It is at once strikingly original while at the same time being reminiscent of so many other previous modern art movements, from Jackson Pollock's forceful brushstrokes made instead with his feet, to Barnett Newman's 'zip' paintings, and the austerity of Bauhaus design.

It is an early example of Land Art, a branch of conceptual art that came to prominence in the late 1960s and early 70s. The best-known example of the genre is probably *Spiral Jetty* (1970), by Robert Smithson (1938–73). It is a monumental earthwork sculpture on the Great Salt Lake in Utah, made out of the black basalt rocks that already existed on the site. It measures an incredible 460 metres long by 4.6 metres wide. It is a sublime road to nowhere that looks like a cross between a human ear, a musical note and a snail's shell. The anti-clockwise spiral has mystical and mythical qualities; it is ancient and modern, abstract and literal. Smithson was of the opinion that exhibitions in museums had 'run their course' and, like Richard Long, chose to make art outside from and in nature.

The inspiration for the work was as varied as Smithson's many interests. Anthropology, entropy, natural history, cartography, movies, thermodynamics, sci-fi and philosophy all fed into a work that is timeless and considerate while being fresh and ominous. Smithson said that 'the artist seeks . . . the fiction that reality will sooner or later imitate'. A plane crash in 1973 while photographing another piece of Land Art that he was working on meant that Smithson didn't live to see his prophecy come true. But we have. *Spiral Jetty* is fundamentally about man's relationship with his environment, and about how the structures around us affect our behaviour. In the forty-plus years since Smithson created his monumental earthwork it has spent most of its time out of sight, submerged under water. It usually takes a drought to encourage its salt-encrusted ridges to break through the surface-water, like a sacred monster rising from the deep. He made it when the lake was low – it stayed low for years. For three decades it has been under water.

Spiral Jetty has become the world's largest barometer: a giant gauge providing a reading as to the state of our relationship with our environment and how the structures around us – consumerism, globalization – are affecting our behaviour. As Sol LeWitt said, 'Conceptual art is good only when the idea is good.' And Robert Smithson's *Spiral Jetty* was a very good idea.

MINIMALISM:
UNTITLED
1960–75

We've all seen them, been in their presence: those quiet, thoughtful types. You know, the ones with the inner strength of Kevlar, who never feel the need to show off or to compromise strongly held principles, and have a certain aura that demands respect. In my experience they are never flashy, always well presented, and have a reserved style that turns everyone around them into jabbering idiots. They have a slightly cold, unknowable quality.

I am, of course, talking about Minimalist sculptures. Those straight-edged, relentlessly austere, three-dimensional cubes and rectangles made out of industrial materials that sit in the middle of a gallery floor, or wall, dominating the space, and you. They are a product of the 1960s, like student protests and free love. Except that these terse artworks were more about thoughtful contemplation than arousing emotions. They have a restrained matter-of-factness that

was the antithesis to all the froth and babble going on in the world about them.

Minimalism is the product of many influences, ranging from the Pennsylvanian Railway to the Surrealism of André Breton. There's plenty of the cool modernist aesthetic of the Bauhaus in the Minimalist mix, as well as a large dollop of Russian Constructivism. And for all their apparent passivity, these sculptures are actually closely related to performance art, with you, the viewer, cast as the performer. Because in the minds of the artists involved, their stripped-back artworks were only truly 'active' or alive when we, the audience, were in the room. Only then could their sculptures perform the task for which they had been created: to affect the space they are in, and crucially, those within it. It wasn't a case of us simply admiring their angular elegance, but of recognizing how their presence changed us, and the space we were in.

I use the word 'sculpture' with some trepidation to describe the three-dimensional Minimalist works, as it is a term that was largely banished by the artists involved due to its association with the art of illusion. Which, in their eyes, was traditional sculpture whereby raw materials are manipulated to look like something else (e.g. a piece of marble shaped into a human figure). This was an abomination to the Minimalists, who were a literal bunch. If they made an object out of wood or steel or plastic, then that was what it was, an object made out of wood or steel or plastic, and no more. They came up with a variety of alternative words that they felt better described their creations. An early favourite was 'objects'. Not unreasonable, but not very descriptive either; after all, a sculpture is an object. The next two suggestions suffered from the same problem of being overly literal. The first was 'three-dimensional work' and the second 'structure'. Finally (in desperation surely) the term 'proposal' was proffered. Other than being a rather humble, speculative word in any circumstance, it was utterly meaningless when presenting a 2.5-square-metre metal cube.

That's not a proposal; it's a statement. So for the sake of expediency, I'm going to go against their wishes and file all the Minimalists' spatial creations discussed in this chapter under the same heading: sculptures.

The art produced by the Minimalists is, in a way, no different from any art produced at any other time. Art is always to an extent about trying to create order out of chaos. It might be the methodical organizing principles of De Stijl's grid systems, or the interlocking flat planes of Cubism. Even the anarchic nihilism of Dada was designed to rid the world of decay and decadence to allow a new world order to be established. The objective is always the same: a desire to bring life under control. With the Minimalists it was simply a case of wanting to bring life into order that bit more than art movements had done before. The cast-list is all-American, all male, and all white, which you could say within its regularity, rigidity and reductive nature is rather Minimalist.

It is mainly another of modern art's gentleman's clubs, which in this instance is fairly easy to detect when looking at the art associated with the movement, which is obviously male. The artists involved had a predilection to make severe artworks that have a cold mechanical quality to them; that have been made with an obsessive attention to detail. And yet the artists' hand and presence is almost imperceptible. They are aloof, their art often assembled like an industrial product. When the Minimalists were making sculptures – which was most of the time – the pieces they produced had none of the romance associated with the human endeavour required to carve a piece of stone. Their hands did not bleed, nor their brows sweat. Somebody else's might have – the person welding, bolting or installing their work – but not the artists'.

They operated more like architects: drawing up plans, issuing orders and overseeing production. There's nothing wrong with that; the great Flemish master Peter Paul Rubens had plenty of assistants making his paintings for him. But he enlisted help to increase produc-

tivity (evidence that the artist-cum-businessman is not a creation of Warhol, Koons, Hirst) and therefore taught his staff to mimic his style. The Minimalists were trying to do the opposite. Like the American Pop Artists, they wanted to remove all evidence of themselves, to rid their work of any sense of personal expression, subjectivity or authorship.

Their objective was to compel the viewer to deal with the physical object in front of them, not to be diverted by the personality of the creator. Some, like Donald Judd (1928–94), even stopped giving their artworks titles in case they acted as a distraction from the artwork. Hence we are faced with vast quantities of Judd artworks with the same name, *Untitled*, usually with only the date when the work was made as a guide for narrowing down any search. This may appear obtuse, but Judd, like the other Minimalists, believed in removing all extraneous detail, saying, 'The more elements something has, the more the ordering of those elements becomes the central point of the work and therefore takes away from the form.'

Judd emerged as an artist painting large Abstract Expressionist pictures that would often feature a rich blood-like colour called cadmium red. In due course he would give up Abstract Expressionism and easel painting, but he would never stop using cadmium red. His reason for moving away from the canvas was based on his Minimalist philosophy. The problem with painting pictures for Judd was the viewer's inability to see a canvas and the image painted on it as one entity. When we look at a painting – even when it is a flat monochrome abstract work – we think only of the image. We do not think about what it has been painted on, why would we; it's not the point. But when we put on a shirt in the morning, or dry ourselves with a towel, we think of the material and whatever is printed on it as one integrated property. And it was that notion of 'oneness' or 'wholeness' that Judd was after to unify his art as a single, all-encompassing object. He found his answer in sculpture.

Untitled (1972) (see Plate 27) is an open, polished copper box,

measuring just under a metre in height and a little over a metre and a half in width. Judd has painted the inner base with his favourite cadmium red enamel. And, er . . . that's it. *Untitled* symbolizes nothing and suggests nothing. It is a copper box with a red inner base. But then it is a work of art. So what's its purpose? The answer is to simply be seen, enjoyed and judged purely on its aesthetic and material terms: how it looks and the way it makes you feel. There's no requirement to 'interpret' the work – there is no hidden meaning to look for. Which, to my mind, makes it rather liberating. For once there are no tricks or specialist knowledge required, just a decision to be made: do you like it or not?

I like it.

I find its simplicity beguiling, the textured surface of the copper case warm and resonant, and the sharp angles of its outline rather graceful as they cut into the surrounding space with a laser-like precision. Step towards the copper box and you'll see a red volcanic vapour rising like mist from its open top – emphasizing the box's razor-edged outline. If you lean over and peer down into its void you'll see that the mist effect created by the cadmium red base has filled the volume with a hazy light, like a late summer sunset. The inner walls of copper appear to have been dipped in red wine. Which is how you will feel after staring into its reflective interior for a while, as at first you see two cubes, then three, and then a corridor of the things as the copper's shiny surface works its optical magic.

At which point you'll probably stand back and take a decent look at how it was made (by technicians to Judd's specifications). And you will see all the little imperfections, the pitted texture of the copper, the dents and the scratches. The way the sides don't quite line up, and a couple of the bolts that have been screwed in too far. Those are the imperfections of life that cannot be hidden no matter how hard we try. Step back and walk around the box and you'll be amazed by how the copper intensifies your awareness of the changes in the ambient light, which in turn increases your sensitivity to your entire physical

environment. And then as you wander off to look at something else – and I guarantee this – you will take one last look before leaving. And you will always remember seeing Donald Judd's copper box, because it is simply beautiful.

Judd has resisted anything that could interfere with the nature of the materials, or could detract from the viewer's purely visual experience. What this work does, what all of Judd's sculptures do to a greater or lesser extent, is force the viewer into the present tense. There are no stories or allegories to work out. There are no distractions. Judd thought that the whole idea of artists exploring the notion of chance had been fully realized by Pollock, with his fortuitous splodges. He was taking it for granted that the 'world is ninety per cent chance and accident'. That was his starting-point. Which is why he had simplified his work – to remove chance.

He took a chance though with his 'stack pieces', such as the 1967 *Untitled (Stack)*, which resembles a dozen unsupported shelving units jutting out from the wall one above another. To make a fragmented sculpture when your primary aim is to present one single uncomplicated object is risky. But the artist pulls it off with aplomb. Each stack, or step, is made from galvanized iron and covered in green industrial paint. The twelve units, all of which have been made in a metal workshop in New Jersey, are identical. Judd couldn't be doing more to distance himself from the grand painterly gestures of the Abstract Expressionists.

He was reacting against the romantic myth that the sweep of an artist's brush could somehow communicate some mystical inner truth. Judd was an arch-rationalist. He was using repetition to undermine the idea that each and every painterly motion was somehow significant and noteworthy. That, he thought, could only be found in abstract unity. With *Untitled (Stack)*, Judd has successfully made twelve individual elements appear as one. Actually, there are twenty-three separate elements. There are the twelve steps and the eleven spaces between them. Each step is 22.8 centimetres deep, separated by

22.8 centimetres. Unlike traditional sculpture, there is no hierarchy to this work; the bottom step (the plinth) has the same value as the one at the top (the crowning glory). Everything is held together – and this is Judd's brilliance – by something invisible. He called it polarization; I'd call it tension.

A similar idea can be found in the paintings of Frank Stella (b. 1936). He was nearly a decade younger than Donald Judd, but had followed a similar path by starting out as an Abstract Expressionist, and shared many of Judd's frustrations about the limitations of the art of their time. By the age of twenty-three Stella had settled on the pared-down version of Abstract Expressionism that would establish him as a major artist. Dorothy Canning, a highly respected curator at MoMA, had spotted young Frank's *Black Paintings* at a studio in New York in 1959, and was taken by their simplicity and originality.

One was called *The Marriage of Reason and Squalor, II* (1959), which consisted of two identical black and white images set side by side. In the middle of each image was a thin line of unpainted canvas running down the bottom two-thirds of the picture, providing its centre point. Around this, in the shape of a doorframe (or an upside down letter 'U'), Stella had painted a thick black line. And then, building outwards concentrically, he had repeated this process: one broad black painted line in the shape of a doorframe, followed by a thin area of blank canvas that ran around the painted shape. The result was a pattern not dissimilar to a pinstriped suit.

Canning decided to include Stella's work in an exhibition she was planning for the museum to showcase emerging trends in American avant-garde art. Alongside his paintings Canning had included Rauschenberg's 'Combines' and Jasper Johns's *Targets and Flags* (which had been an inspiration for Stella), as well as the work of several other artists. The exhibition, *Sixteen Americans* (December 1959 to February 1960), was to become part of art-world folklore; seen as the moment when modern art broke away from the grip of the emotional paintings of the early Abstract Expressionists. The critics were

not overly enthusiastic, particularly towards Stella's paintings, with one describing them as 'unspeakably boring'. Judd didn't think so. He knew exactly what Stella was trying to achieve, because he was attempting to do the same thing with sculpture. It was a literalness, a directness; or, as Stella said, 'What you see, is what you see.' Judd's solution was to reduce the elements: to simplify. Stella's answer was 'symmetry – make it the same all over'. It was a Minimalist's approach.

Stella, like Judd, wanted to eradicate all sense of illusion in his paintings. He did this both in black and white and in colour, with works like *Hyena Stomp* (1962). He has used eleven colours (tones of yellow, red, green and blue), applied sequentially in a maze pattern, which spirals out from the centre to an end point in the upper right-hand corner that subtly upsets the symmetry of the composition. It shows Stella playing with the idea of syncopation, where the rhythm shifts unexpectedly from its own uniformity. It is named after, and inspired by, a track by the jazz musician Jelly Roll Morton. It also demonstrates just how far Stella had moved from the origins of Abstract Expressionism. Although his paintings are entirely abstract and expressive, they have clearly been premeditated. Pollock believed in letting his unconscious rip and latching on to the automatism of the Surrealists. Stella was closer to conceptual art. He didn't do anything without planning and a great deal of rational thought. For him it really was the thought that counted; the painting could be done by anybody. Stella's impact on Minimalism was sizeable. He provided Judd with intellectual stimulus, and made a comment to the sculptor Carl Andre (b. 1935) that changed the artist's life.

The incident occurred when Stella and Andre were sharing a studio in New York during the late 1950s and early 60s. Andre was already enamoured of Stella's symmetrical, concentric pictures. He was also a fan of Constantin Brancusi and was working on a wooden totem-pole in the primitive style of the Romanian sculptor. Andre was busily carving some suitably modern geometric shapes into his timber when

Stella wandered over and told Andre that his efforts looked 'damn good'. He then walked around to the back of the piece, which was completely untouched by Andre, and said, 'You know, that's good sculpture too.' Now, some people would have been a little angry at having spent hours chiselling away on one side, only to be told that the bit they hadn't touched was just as good. Not Andre, who agreed, saying, 'It's really much better than the cut side, you know.' On reflection, he felt that his handiwork had actually diminished the object as an artwork. He recalled the moment later when he said, 'From that time I began to think, well, the next timbers I get I'm not going to cut . . . I'm going to use them as cuts in space.'

Which is what he did. For Andre, his sculptures became more akin to what we now call installations; that is, artworks designed to physically react to, and affect, the space in which they have been installed, and those who occupy it. If possible, he prefers to be present when one of his sculptures is being prepared for display in a gallery. The precise location of the sculpture is an important part of the artwork for Andre, as is the way in which it 'cuts' into the gallery space, thus determining its overall composition. It is surprising, therefore, for someone who produces work to interact with its environment, that his sculptures are so easy to miss. Like the other Minimalist sculptors, Andre did away with the idea of using a plinth and instead placed his works directly on the floor. This was to add a sense of 'directness' and to distance the work from the figurative sculptures of the past. Which is fine in principle, but for an artist who makes work out of small or flat pieces of industrial material, it creates a bit of a problem. He was, in effect, making his sculptures part of the floor, which while being innovative and unconventional can result in people overlooking them altogether. I've seen many a museum visitor meandering through gallery spaces in which one of his floor sculptures is being exhibited and unknowingly walking over the piece as if it were a doormat.

Carl Andre is probably best known for *Equivalent VIII* (1966), the 120 firebricks arranged in two layers in the shape of a rectangle, for

which the Tate got such a pasting from the media in 1976 when it put them on display. The sculpture typifies Andre's Minimalist works in as much as it is made out of an industrial material, has no hierarchy between the individual elements, or within the composition itself, and is based on imperial measurements. It is totally abstract, bluntly concise, symmetrical, premeditated, and devoid of any flamboyant touches. The artist has made it as impersonal as he possibly could, ensuring that the viewer is not given any indication of his personality, or the opportunity to 'read' the sculpture. He does not want us to think that *Equivalent VIII* might be anything other than what it is: 120 firebricks arranged in the form of a rectangle.

Unlike the other Minimalists, and unlike almost any other artist, Andre didn't bolt, glue, paint or bind together the separate elements that formed one of his artworks; they remained loose. But at the same time, they were attached; not physically, but together in the same sense as Judd's *Stack* sculptures were. It was the case with both artists that their work was about the sum, not the parts. By not fixing the constituent parts together (he did place them side by side or on top of each other), Andre was, in effect, creating the same tension between his individual elements as Judd was in the space he left between each of the painted units in his *Stack* artworks. The gaps make the separate pieces appear more, not less, cohesive as a single entity.

Andre's approach to 'wholeness' did have its problems. For example, it is not unheard of for a visitor to walk away with a piece of an Andre sculpture stuck up his or her jumper. Amusing to them, infuriating for Andre (and the museum or gallery in question). Especially when he was starting out in the early 1960s, when money was tight and materials were expensive and hard to come by. A lack of money forced him to supplement his modest income as an artist by taking a job as freight brakeman and conductor on the Pennsylvanian Railroad. It was a job that would lead to fame and, if not fortune, then certainly a comfortable lifestyle.

We commonly associate sculpture with vertical forms. Not so with

Andre. As we know, he was more of a horizontal man: a taste he developed during his spell working on the railways. It was when he was riding in the driver's cab that he saw the potential for sculpture, in the miles of rusty railway track with its equally spaced, horizontal wooden sleepers acting like the repeating standard units he would come to use as the basis for his art. Take, for instance, *144 Magnesium Square* (1969), which consists of twelve rows of twelve square magnesium tiles (he made five other versions in aluminium, copper, lead, steel and zinc), making 144 in all. The tiles are all 12 inches (30 centimetres) square and have been arranged into one large square, measuring 12 feet (3.6 metres) across and down. We are back in the territory of Carl Andre equivalents. Except that this time he is asking the visitor to trample on his floor-base sculpture so that it 'becomes its own record of everything that's happened to it'. He had an ulterior motive, though. He hoped the experience of walking on the magnesium tiles would help the visitor gain a feeling for the physical qualities of the material.

It's an idea that goes back to the Russian Constructivists, and most particularly to Vladimir Tatlin, of whom Carl Andre was a fan. In his *Corner Counter-Reliefs*, Tatlin was stripping the artwork of all symbolic meaning, to encourage the viewer to consider the materials from which the object was made and the effect they had on the space around them. It was an approach to art that was very close to the one taken by America's Minimalists fifty years later. For which they would readily credit the Constructivist for his part in the development of Minimalism. None more so than Dan Flavin (1933–96), who dedicated thirty-nine sculptures to the founder of Constructivism.

While Tatlin constructed work from the elements used to make a modern building in the early part of the twentieth century (aluminium, glass and steel), Flavin chose commercially available fluorescent light tubes as the medium for his sculptures. Tatlin's choice of materials was an act of support for the revolutionary aims of a new Russian republic. Flavin's was a combination of art-historical reference and

contemporary comment. Light, of course, has always been an intrinsic part of an artistic practice. At a basic level an artist can only see and create when there is light. Caravaggio and Rembrandt produced their remarkable paintings using the dramatic *chiaroscuro* technique of accentuating the contrast between light and shade. Artists from Turner to the Impressionists spent their life attempting to capture light's fleeting effects. Man Ray described his Rayographs and solarization photographic innovations as 'painting with light'. And then there are the religious and spiritual connotations of light: 'Let there be light and there was light./And God saw the light, that it was good.' 'I am the light of the world.'

Flavin considered his fluorescent light 'anonymous and inglorious' in comparison: an icon of the age that would only 'bring limited light'. He liked it for its impersonal, mass-manufactured nature, seeing it as material connecting art with the 'daily concerns' of life. But as with the other Minimalist artists he insisted that there was no hidden meaning to his work; 'It is what it is, and it ain't nothing else,' he said. The fluorescent tubes were a way for him to 'play with space', change the way a room appeared, how people acted, and from 1963 onwards they became the overriding tool for him to make art. His multiple tributes to Tatlin, made over the course of two and a half decades, were his most well-known series, the first of which was made in 1964, and the last in 1990. They all shared the same title – *Monument for V. Tatlin* – although there are some variations in design.

Monument 1 for V. Tatlin (1964) (see Fig. 29) was the first in the series and consists of seven fluorescent tubes fixed against a wall, with the tallest one (2.5 metres) acting as the centre point of the sculpture. The other six are divided symmetrically, three either side of the tall central tube in a descending order based on height. The result looks like a 1920s Manhattan skyscraper, or the pipes of a church organ. But not much like Tatlin's famous unbuilt leaning tower, *Monument to the Third International* (1920), on which it was supposedly based. Not that Flavin minded. In a rare light-hearted moment for the super-serious-minded

Minimalist movement, he said that calling the sculpture a monument was meant as a joke, as it was a monument made from something as disposable and perishable as domestic lighting equipment.

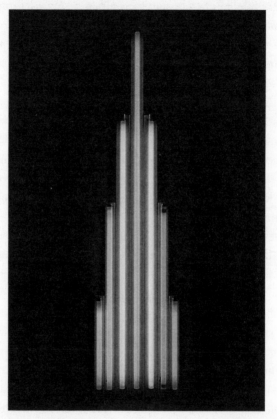

Fig. 29. **Dan Flavin,** *Monument 1 for V. Tatlin,* **1964**

Regardless of the poor-quality materials, when the work is installed and the fluorescent tubes are switched on and emitting their bright white light, it has the desired effect. Gallery-goers who walk into a room and see it against the wall immediately make a beeline towards the piece. It is as if Kafka's novel *Metamorphosis* has sprung to life, as visitors turn into insects drawn to Flavin's warm, bright light. Which

makes the artwork a notable success. Flavin intended his fluorescent light sculptures to affect the space in which they were displayed, just as Judd did with his pieces. It was the Minimalist mission.

It was Dan Flavin who helped Sol LeWitt (1928–2007) discover the pared-back Minimalist philosophy while LeWitt was working in the MoMA bookstore in the early 60s. It was there that he had bumped into several emerging artists with odd jobs in the museum, one of whom was Dan Flavin. Flavin had talked about art and New York and how the Abstract Expressionists were too egotistical and 'present' in their work. He had shown LeWitt the light, and a way in which the bookstore assistant could progress his own artistic ambitions.

For LeWitt, the idea was paramount: it was the concept that was the work of art, its realization merely a passing pleasure. He didn't mind if a work of art he had instigated was destroyed, he could live without it – the thing that mattered was the piece of paper that he had in his drawer with the concept written down on it. In which case, why bother overseeing the production of his works as Judd, Flavin and Andre did? He could simply issue a set of written instructions and let others get on with it.

If those artists and artisans he had employed to make his grids and series of white cubes were unsure what to do should his notes not be sufficiently precise (they would often have ambiguous phrases such as 'not touching' or 'straight line'), LeWitt was happy for them to interpret his intentions as they saw fit. In fact, he encouraged it – seeing such interference as part of the creative process. Such was his support for the artistic contribution made by those producing his works that he would often credit them as collaborators on the walls of the gallery where the piece was being displayed, and in so doing help them establish their own artistic careers. LeWitt did it partly because he was a self-effacing, generous man, and also as a statement regarding his own view on art.

For all his inherent warmth and kindness, his sculptures could be chaste to the point of being bone dry. In 1966 he presented *Serial*

Project, I (ABCD) (see Fig. 30), a sculpture of several white and rectangular blocks, some of which were solid, others an open frame design reminiscent of scaffolding. The cubes were of varying sizes, with none being much more than knee-high. They were all placed on the floor, on top of a large square grey flat mat on to which a grid of white lines had been painted. The cubes were arranged within the

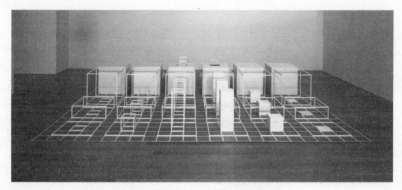

Fig. 30. **Sol LeWitt**, *Serial Project, I (ABCD)*, **1966**

grid, giving the sculpture a composition reminiscent of an aerial view of New York.

LeWitt's concept in this case was to work out how something could look well organized and tidy in one context and a total mess in another. Which seems an odd concern for an artwork that consists of a landscape of white cubes. But then LeWitt said his aim was 'not to instruct the viewer but to give him information', from which he hoped that his thinking would become as clear and straight as his open cubes. His personal manifesto was to 'recreate art, to start from square one', which seems a good place to begin with *Serial Project, I (ABCD)*.

He initiated the artwork, as he promised, at square one. He drew one cube on a piece of paper. And then another, and another and another until the sheet was full of them. These he found to be pleasingly organized and coherent. Until, that is, they were made into

three-dimensional objects and arranged as a sculpture, at which point all he saw was disarray, causing his mood of serenity to turn into one of anxiety. LeWitt was now facing a tricky visual puzzle of his own design. The solution to which, he ascertained, was to walk slowly around the sculpture and observe it from different angles and perspectives. As his eye adjusted to the confusion and gathered increasing amounts of information, the once impenetrable mass of random cubes gradually untangled into something he considered to be an attractive system. He found that the sight lines through the artwork provided by the open cubes lightened the whole room, making it feel bigger than it actually was. Meanwhile, the solid cubes acted as visual roadblocks, which had the effect of dragging his eye and mind back into the sculpture.

Serial Project, I (ABCD) is an archetypal piece of Minimalist art which you could argue was the art of the Space Age: mathematical, methodical and unrelentingly clinical. The Minimalist artists were exploring some of the same principles at the same time as the scientists were designing the rockets to put Man on the moon: matter, systems, volume, sequences, perception and order. And, most importantly, how it all relates to us – the inhabitants of this bizarre ball of life called Planet Earth.

The outer calm of their Minimalist artworks betrayed an inner urgency felt by the artists to bring order and control to the world. It wasn't a compulsion that they passed down to the next generation of artists, which budded during the 60s flower-power movement and was then fuelled by the consequences of the oil crisis in the 70s. They were to take art in an altogether different direction.

Minimalism had marked the end of Modernism. Art was now moving into a new era of Postmodernism.

POSTMODERNISM:
FALSE IDENTITY
1970–89

The great thing about Postmodernism is that it can be pretty much anything you want it to be. But then, the really annoying thing about Postmodernism is that it can be pretty much anything you want it to be. Which is the freewheeling paradox at the heart of this movement; one that has a unique ability, even in terms of modern art, to baffle and infuriate. Which, without being too fancy, is typically postmodern.

On the face of it, this is a simple movement to grasp. It is post – as in after – Modernism, which is generally agreed to have ended in the mid-1960s with Minimalism (although its legacy lives on today). And like Post-Impressionism, it is a development from, and critical reaction to, its forerunner. The French philosopher Jean-François Lyotard described Postmodernism as 'incredulity toward grand narratives'. Meaning that Modernism's constant quest to find a single, all-encompassing solution to humanity's problems was considered to be silly,

naive and delusional by the Postmodernists. They thought any new Big Ideas were as doomed to fail as all the other twentieth-century 'grand narratives' had, like Communism and capitalism.

For them, if there was an answer – which there probably was not – it was to be found in the bits and pieces of what had gone before: a 'best of' collection lifted from previous movements and ideas. From these fragments they would create a new visual shorthand full of art-historical references and allusions to popular culture; an indigestible mix that they made more palatable with playful affectation and ironic diffidence. Take, for example, Philip Johnson's AT&T (now Sony) Building at 550 Madison Avenue, New York. The 1978 design (completed 1984) reveals a regular Modernist skyscraper in the classic Louis Sullivan/Walter Gropius/Mies van der Rohe style, but with a Postmodernist twist. Instead of the expected sober squared-off roof, Johnson has topped his building off with an ornate split pediment – a final flamboyant flourish, like the hat worn by an otherwise demure mother at her daughter's wedding.

To many critics, this seemed unnecessarily ostentatious and out of step with the austere flat-topped aesthetic of Modernist Manhattan. In their eyes Johnson's AT&T Building was a throwback to the frippery of Art Deco design as exemplified by the Chrysler Building (1930); a visual reference of which they saw in the skyscraper's upper façade. Johnson had placed a row of tall, closely spaced vertical windows just beneath the rising shoulders of the pediment, which to the many objectors made his crowning glory look a little like an old-fashioned motorcar grille.

Johnson was in a similarly playful mood when it came to the building's base. Instead of a formal rectangular doorway, as had been the accepted norm for skyscrapers for some time, he designed a huge, arched entrance that he said recalled the Renaissance dome on the Basilica di Santa Maria del Fiore cathedral in Florence, Italy. To this he added other architectural embellishments, with details that included allusions to Romanesque columns, and elevations that recalled the

eighteenth-century bookcase designs of the English cabinet-maker
Thomas Chippendale. He clad the building in unpolished pink gran-
ite, a nouveau but slightly gaudy choice.

The AT&T Building is a classic Postmodernist patchwork, where
witty art-historical references are mixed with an enthusiastic embrace
of contemporary culture. Sampling, hip-hop, mixing and an acute
awareness of public image all became part of the Postmodern palette:
self-conscious knowingness and biting irony the lingua franca. And,
as there was no single answer to anything, it meant that everything
merited consideration and, if so desired, could legitimately be
included. Distinctions and definitions were blurred: fact and fiction
indistinguishable. With Postmodernity the surface image was all-
important, but it would often turn out to be fake or contradictory.

Cindy Sherman (b. 1954) was an early exponent of the Postmodern
art of parody and impersonation with her *Untitled Film Stills* series
(1977–80) (see Fig. 31). The target for her mocking eye was the male
chauvinism of Hollywood. Over the course of three years she pro-
duced sixty-nine black and white photographic portraits in the style
of the publicity stills that movie studios produce to promote their
leading actors. Sherman is always the star of her *Untitled Film Stills*,
but they are some way off being self-portraits. In typical Postmodern
fashion, ambiguity reigns supreme. The artist has raided her dressing-
up box to create a cast of archetypal fictional female characters as
conceived and promoted in B-movies. There's the femme fatale, the
prostitute, the sex kitten, the housewife and the ice-maiden. Sherman
plays it straight in each photograph, all of which mimic the style of
the images she is parodying. So familiar are the characters that Sher-
man created in her photographs that film critics have been known to
'recognize' the movies to which they refer, although none actually
relates directly to any particular film. She said she only stopped the
series when she had 'run out of clichés'.

Sherman is the quintessential Postmodern artist. There is the mag-
pie-like way she mines the work of others and plays with the notion

of identity, coupled with the Postmodern habit of adopting the meth-
ods of other artistic movements. Which, in her case, was in and
around the area of performance and conceptual art. Throughout

Fig. 31. **Cindy Sherman**, *Untitled Film Still #21*, **1978**

Untitled Film Stills Sherman has made herself the medium for her
own ideas, just as the conceptual artist Bruce Nauman had done a
decade earlier in his *Dance or Exercise on the Perimeter of a Square
(Square Dance)*. The strength of Nauman's piece is that it initially
appears superficial and light but turns out to be deep and meaningful.
The same goes for Sherman's *Untitled Film Stills*, which mine a Warhol-
like seam of mirages and manipulations.

The movie publicity stills that Sherman produced depict fictional
characters from films that never existed, which, even if they had done,
would also be fictitious, as would the way in which the studio had
styled its 'beautiful' female stars in an attempt to entice us to the cin-
ema. With her photographs, Sherman is making a broader comment

about the nature of contemporary culture, where a constant stream of doctored images designed to manipulate the consumer has led to a society no longer able to tell the difference between fact and fiction, truth and lies, real and fake.

She does all this in the Postmodern language of subtle hints and casual suggestions, avoiding as much as possible the Modernist trap of being definite and explicit. *Untitled Film Stills* might feature sixty-nine different pictures of Cindy Sherman, but are we any closer to knowing who Cindy Sherman is? For a work that is about identity, she gives precious little away about herself. She is the star in all the images but is also non-existent, which is the sort of existentialist contradiction Postmodernists adore. It harks back to the mind games of Surrealism, and to the philosophical symbolism of 1960s comic novels by the likes of Kurt Vonnegut (*Slaughterhouse Five*) and Joseph Keller (*Catch 22*).

Sherman's removal of all traces of her own character from her photographs is reminiscent of the Minimalists' reluctance to allude to themselves in their work. The motivation of Judd and co. was to focus the viewer's attention solely on their art without having the distraction of the artist's personality to worry about. Sherman's reasoning was different. By absenting herself she is able to take on the persona of anybody she liked: to play any role. It gave her complete freedom to change character at will because the viewer had no pre-existing image or knowledge of her on which to fall back. Sherman's chameleon art is a reflection on the way the media and celebrities manufacture and manipulate a public image that is not based on the true character of the individual in question, but on what the market wants that character to be.

It might come as no surprise, then, to learn that the sole sponsor of the Cindy Sherman exhibition at MoMA in 1997 was Madonna – the ultimate Postmodern icon and image fabricator: the mother of re-invention. The pop star had already demonstrated her knowledge and appreciation of Sherman's work in her book *Sex* (1992), a publication

that owes something to the artist's *Untitled Film Stills*. Madonna, like Sherman, has cast herself as the star in a series of archly staged black and white photographs that (in her case) mimic the clichéd portrayal of women in the world of soft porn. And, like Sherman, she looked to Hollywood's golden age when creating an on-camera alter ego for herself, which she named Mistress Dita – a 1930s film starlet. The result is a Postmodern work of a Postmodern work, which is all very . . .

Cindy Sherman and Madonna weren't alone when toying with the idea of false identity and allusion in the medium of photography. In the year after Sherman began her *Untitled Film Stills* series, the Canadian artist Jeff Wall (b. 1946) produced *The Destroyed Room* (1978) (see Fig. 32), his first billboard-poster-sized backlit photographic transparency. While Sherman and Madonna turned to Hollywood as a source for their subject matter, Wall raided the work of the great European painters of the seventeenth, eighteenth and nineteenth centuries, like Diego Velázquez, Édouard Manet, Nicolas Poussin and, in the case of *The Destroyed Room*, Eugène Delacroix.

Wall recreated his Postmodern version of Delacroix's painting *The Death of Sardanapalus* (1827) (see Fig. 33) in meticulous detail. The colour palette, composition and light are a near-perfect match. Both artworks centre on a double bed surrounded by chaos. And both artworks are big, measuring several feet across. Given all that, it would not be unreasonable to think that the two pieces would look similar. But they do not. Even a bit. Delacroix's painting depicts a horrific boudoir scene as naked women are stabbed to death on the order of Sardanapalus, the oriental king of antiquity, who decreed that his slaves, women and horses be massacred following a humiliating military defeat. Delacroix has depicted a mass of writhing bodies and rearing horses, as the King looks on dispassionately from his sumptuous bed knowing that he too will soon die in the pyre to follow.

Wall, on the other hand, has depicted a scene without any people. What's more, his picture doesn't feature any examples of the copious

wealth and finery portrayed in Delacroix's painting. Instead, he shows a cheap, modern, featureless bedroom belonging to a prostitute, which has been recently ransacked and vandalized. It is into this

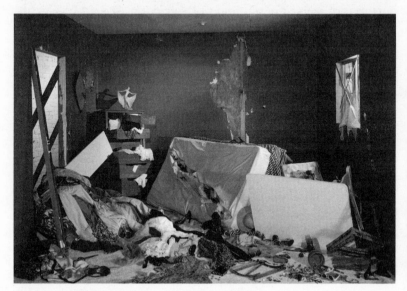

Fig. 32. **Jeff Wall,** *The Destroyed Room,* **1978**

vision of contemporary carnage that Wall has woven his many references to Delacroix's great painting. There is a bed in the middle of the room, as in Delacroix's original. Except that in Wall's image it is not sumptuous and bedecked by a king, but upended with the mattress facing us, its foam guts spilling out from a diagonal slash running across its length. It is at once an obvious reference to the violence of the original, as well as a subtle piece of design echoing the compositional line of Delacroix's painting. The burgundy-painted wall and white Formica table in Wall's photograph recall the dominant colours in the French master's painting, just as the red satin sheet among the jumble reflects the luxurious material on the King's bed. The little plastic topless dancer Wall has positioned on the chest of drawers points to Delacroix's nudes pleading for their

lives. Both images portray a once optimistic and heroic society in a
state of disenchantment and decay.

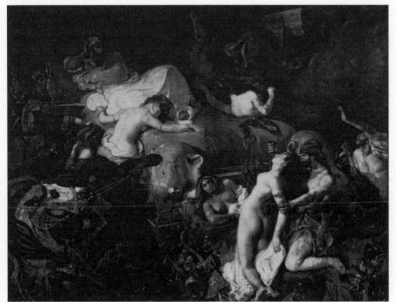

Fig. 33. **Eugène Delacroix,** *The Death of Sardanapalus,* **1827**

Obviously knowing about the allusion adds to the enjoyment of
Wall's photograph. But what if you don't? What if you've popped
into a gallery and happen upon the work, unaware of its relationship
to Delacroix's *The Death of Sardanapalus*? Well, it is still a powerful
image and comment on modern life, with an intriguing composition
and use of colour. But the truth is that Postmodernist art rewards
knowledge much like a cryptic crossword, where comprehension
comes from solving the puzzle. To do that requires a process of
deconstruction as you unpick the elements the artist has taken from
various sources, which offer the insights to the work's meaning. And
like a cryptic crossword, the better you know an artist's way of work-
ing, the quicker you will get the clues that he or she has provided.

Which doesn't mean you cannot enjoy the work of Jeff Wall with-
out knowing all the in-jokes and innuendo, just that there is always

more to Postmodern art than meets the eye. Take *Mimic* (1982) (see Fig. 34), one of Wall's more famous works. It features three twenty-somethings – two men and one woman – walking down a suburban street in North America on a hot and sunny day. One of the men is bearded and is holding his girlfriend's hand. They are both Caucasian. To their right is an Asian man. Wall has captured the moment the couple are about to overtake him. The white guy turns in the Asian's direction and raises one of his fingers to the edge of his eye in a racist 'slanty-eyed' gesture. The Asian man glimpses the insult in his peripheral vision; the girlfriend looks away.

Wall has photographed an act based on stereotype and mimicry: hence the artwork's title. And it's a very striking and aggressive image. All the more so given that it is nearly 2 x 2.3 metres and back-lit, making the three characters close to life-size. After a minute or two of looking at the image most of us would probably notice that the centre of the picture – the area of an image to which artists have traditionally drawn the viewer's eye – divides the three protagonists. The white couple are a few inches from the centre on one side, and the Asian man at the same distance away on the other. The design is intentional. Wall is commenting on the racial divisions in the West. And there we have it, a fairly straightforward Postmodern image to decipher. Next.

Except, there is much more to this picture – and its title. Starting with the fact that this is not a piece of reportage documentary photography, but an elaborate fake. The people in the picture are actors who have been dressed, lit and made up as if they were appearing in a film. The photograph was not taken in a moment, but after many hours of rehearsal. Wall is taking the rules of cinematography and applying them to photography, and then displaying the work using the technology of backlit billboard advertising, which he had seen when travelling in Europe on a bus. Everything about this Postmodern artwork is constructed from fragments taken and copied (mimicked) from elsewhere: it is a collage of touchstones and influences.

Take a proper look at *Mimic*. Think about its title and look at the

three characters. Look at their bodies. Look particularly at the shape and position of the Asian man's legs. They are the mirror image of the white man's legs, which are then mirrored by his girlfriend's,

Fig. 34. **Jeff Wall**, *Mimic*, **1982**

whose then mirror the Asian man's. Now who is mimicking whom? Well, Jeff Wall is certainly mimicking the painter Gustave Caillebotte (1848–94), an artist associated with the Impressionists. A quick glance at his *Paris Street: Rainy Day* (1877) would elicit a smile of recognition. Both pictures are framed by a commercial building on the right and a road to the left that disappears into the distance towards a central vanishing point. Both have three central characters that respond to the others' body positions. And both use a lamppost as a device to divide the main characters from the rest of the picture. That Caillebotte's painting chooses the open new boulevards of Paris created by Baron Haussmann would not have been lost on Wall either. Caillebotte was from the late nineteenth-century

Parisian generation that was full of excited optimism about modern urban living. Walls's setting of his image – a desolate suburban North American street where weeds grow and ambition dies – is a satirical Postmodern review of what happened to the Modernist dream. One that migrant workers helped realize, a contribution for which they are routinely abused.

Modernism had straight edges; Postmodernism had no edges. Modernism rejected tradition; Postmodernism didn't reject anything. Modernism was linear and systematic; Postmodernism was all over the place. The Modernists believed in the future; the Postmodernists didn't believe in much at all, they preferred to question. The Modernists were serious and adventurous; the Postmodernists were the masters of playful experimentation: artful irreverence and detached cynicism. Or, as Moe said in one episode of *The Simpsons*, Po-Mo is being 'weird for the sake of weird'. Maybe. But that didn't mean the Postmodernists were a toothless bunch, devoid of opinion or political conviction. It was more a shared distrust of anyone proposing absolute truths and easy solutions. And that set them off in the same direction that the Pop Artists had taken a quarter of a century before: to the world of advertising and commerce, upon which the Postmodernists would cast their ironic gaze.

Barbara Kruger (b. 1945) worked as a graphic designer at Condé Nast, the publisher of the world's most upmarket glossy magazines. It is the high temple of consumerism, where a vision of an unobtainable ideal is promoted: an escapist fantasy for readers to aspire to and spend their lives trying to achieve. Kruger felt uneasy about some of the images and articles she was seeing. She began cutting out pictures from the adverts in magazines that caught her eye. She then reproduced them in black and white and placed written slogans over them, such as *I Shop Therefore I Am* (1987) (a subversion of the seventeenth-century philosophical statement by René Descartes, 'I think therefore I am') and *Your Body is a Battleground* (1989). Like Warhol, she was using the methods of advertising (slogans, bold typography, simple

and arresting images) to make her point. Unlike Warhol, she was being overtly critical of the industry and its willingness to peddle false hope.

Kruger uses personal pronouns – I, we, you – to draw us in and implicate us in the assumptive language used by hard-selling business. She typesets her messages in a similarly direct fashion using a distinctive bold lettering, often printed (usually in red) on a plain white background, or over a halftone image, giving her artworks a 'brand identity'. The critique on consumerism is clear; her point is made. But then being a Postmodernist Kruger has embedded many other references into her work. The red lettering is an acknowledgement of Rodchenko's Constructivist posters; the used image from advertising a staple of Pop Art. And the font she uses is no accident either. It is Futura, a geometric design created in 1927 that adheres to the strict Modernist principles of the Bauhaus, an institution that saw mass communication as a unifying organ, not as a means for commercial manipulation and individual selfishness (Futura is the font used by Volkswagen, Hewlett Packard and Shell to sell their products). The Futurists weren't left out either. Kruger always uses the Oblique (italicized) version of Futura to add a Marinetti-like sense of urgency and dynamism to her pithy statements.

And then there is the ironic wordplay in her artworks. Which leads us – inevitably – back to Marcel Duchamp and the Dadaists in general, who liked nothing better than manipulating language to poke fun at authority and the art world. Something Kruger did in 1982 with *Untitled (You Invest in the Divinity of the Masterpiece)*, where she reproduced a black and white copy of the famous section of Michelangelo's Sistine Chapel fresco where God's finger touches Adam's (signifying the creation of Man). Over it she laid out the words 'You Invest in the Divinity of the Masterpiece', in bold white letters on thick black strips. This is a work where Kruger is mimicking the commercial methods of the advertising poster to question the commercial practices of the art world.

Her artworks are unsigned and the typography impersonal, raising questions of authorship, authenticity, reproduction and identity, all of which are central Postmodernist themes. The implicit message behind her statements is a provocation: a jab in our ribs urging us to think twice about believing the messages and methods of the mass media. And they act as a reminder of the power of words in art, which is something I discovered when I worked for the Tate.

For an institution with a global reputation for excellence and quality, the Tate's headquarters are not what most outsiders would expect. The majority of the staff are housed in an old military hospital in Pimlico, London, that still smells of disinfectant and has an ever-present chill, courtesy of broken windows and the ghosts of long-lost warriors. My office was on the ground floor, along from the old mortuary, and behind the garden where once those with tuberculosis lay breathing in fresh air, hoping to stave off a death rattle. It was not a glamorous location.

Yet whenever I had visitors to my office they would cast their eyes around and then fix on an 2.5-metre-high poster I had on the wall, sometimes even asking if they could photograph it. It was a copy of an artwork called *How to Work Better* (1991) by the Zurich-based artists Peter Fischli (b. 1952) and David Weiss (b. 1946), known collectively as Fischli/Weiss. It takes the form of the Ten Commandments, listing what one needs to do in order to work better: 1. DO ONE THING AT A TIME, 2. KNOW THE PROBLEM, 3. LEARN TO LISTEN, and on to 10, which simply says, SMILE.

I suspect, on the whole, that my visitors took the artists' bait, and saw in Fischli/Weiss's ten-point plan a prophetic solution to how they might maximize their own professional potential. Which would amuse the artists. Because the artwork is ironic, designed to mock the motivational speak espoused by large corporations. They originally presented the list as a giant written mural on the outside of a Zurich office building, and only allowed me to have a copy of it if I agreed to display it in my workplace. The artists have taken the propaganda of

business to parody the way businesses try to brainwash employees into thinking success can be achieved by following a simple set of rules: by playing the game.

The American artist John Baldessari (b. 1931) has made similar textual artworks such as *Tips for Artists Who Want to Sell* (1966–8), which lists three practical suggestions for artists wishing to find a buyer for their work, the first of which is: GENERALLY SPEAKING, PAINTINGS WITH LIGHT COLORS SELL MORE QUICKLY THAN PAINTINGS WITH DARK COLORS. Baldessari has said, 'I tend to think of words as substitutes for images. I can never seem to figure out what one does that the other doesn't do.' Which is not to say that he has stuck to text-only artworks, just that he is flexible in his choice of medium and compositional device. In the mid-1980s Baldessari made *Heel* (1986), a collage made out of a dozen black and white movie stills. All the images, in some way or another, relate to the title of the work, either by picturing the heel of a foot or alluding to other uses for the word (a command to a dog, a description of an immoral man). It would appear to be an amusing word and picture game for the viewer. But look at the images again and themes start to emerge. There is pain (injured heels), conflict (student protest, a vicious dog) and identity (the artist has positioned a large yellow dot that obliterates a man's face). It packs a Postmodernist punch underneath its superficial jocularity. As does Fischli/Weiss's *The Way Things Go* (1987).

This is a Postmodern masterpiece, copied by many; bettered by none. My advice is to go online and watch the thirty-minute film. Or, better still, go into a gallery showing the work, where it will be installed to the artists' specification. I don't think you'll be disappointed. The film shows a highly unlikely chain of events that are set in motion when an upright car tyre is set free to roll along a studio floor having been nudged into kinetic life by a twirling refuse sack dangling above it. Cue thirty minutes of domino-effect mayhem, as the materials one might find in the workshop of an eccentric amateur scientist – chairs, stepladders, plastic bottles, tyres, hazardous

chemicals, paint – are propelled into a compelling animated sequence as one moving object (a kettle on roller-skates, a tray of over-spilling molten liquid) collides into another. It is a great watch: amusing, ingenious, and with plenty of jeopardy (an essential element of moving image entertainment) as you watch to see if the sequence will be broken by one of the objects failing to hit its intended target and thus breaking the chain reaction.

So, it's good fun. But there is something troubling about it too. The events don't lead anywhere; it is pointless. And while the whole process looks haphazard and amateurish, the truth is somewhat different. To plan a series of such intricate collisions must have taken months of trial and error – it is an exercise in premeditated precision, not spontaneous chance. We are being fooled into believing that we are watching the work of a nutty professor, and not the meticulous efforts of a couple of highly sophisticated artists. The deception is carried out in every detail, including the 'home video' style of filming, when in fact the sequence was shot on professional 16mm film. It is a production where nothing is quite as it seems. The artists focus on the materials of modern industry, just as the Constructivists had done seventy years earlier. But the optimism is missing. Here Fischli/Weiss show what happens when the materials are not being put to the use for which they were intended: abandoned and ignored, they wreak havoc on what had appeared to be a stable environment. It is a film about consequences, relationships and identity – a living collage: a Rauschenberg 'Combine' brought freakishly to life.

Postmodernism was responsible for bringing the work of such artists to the public's attention. They made their ambiguous art by questioning, imitating and appropriating. Like the conceptual artists and the Minimalists who immediately preceded them, the Postmodern artists produced thoughtful work that rewards those who devote some time and attention to working out its subtleties. Like Duchamp – the man who influenced so much of their work – they loved a joke. Which can make their art appear trivial and silly

and sneering. And sometimes it can be, but on the whole it is not. The best Postmodern art comes from the observations of a smart outsider; one who looks on in admiration and aversion in equal measure. Just like all good art really.

20

ART NOW:
FAME AND FORTUNE
1988–2008–TODAY

There is no generally accepted term for the art that has been produced in the two decades that span the end of the twentieth century and the beginning of the twenty-first. Movements-wise, Postmodernism is the last to be officially recognized, and that ran out of steam towards the end of the 1980s. Which means I should probably end the book now with a couple of short summing-up paragraphs and then update it later when a reputable academic or critic coins a term to describe the art that has been produced from the late 80s to today.

But then again, that would be a bit of a shame. I mean, the last twenty-five years have been extraordinary. Never before has so much contemporary art been made and bought. Never before have the public and the media taken such an interest in the subject. And never before have there been so many places to go and see the stuff. Fabulous new museums and galleries have been built across the world. The

Guggenheim in Bilbao, Tate Modern in London and the Maxxi in Rome have all been created since 1997. We are living through a global modern art boom, the like of which has not been seen before. To gloss over all that just because there is no recognized term for the work produced lately would be a pity. It would also leave this story of modern art frustratingly unfinished. So, what to do?

Well, I'm not about to dip my toe into the treacherous waters of naming an art movement. In due course someone will come up with an official term and that will be that. But in the meantime, and for the purpose of bringing this story up to date, I am going to stick my neck out and suggest a common-dominator that I think unites much of the work that has been produced by the avant-garde of late.

And there have been some fairly obvious trends. The proliferation of monumental, attention-grabbing sculptures, which have popped up in public spaces across the world like daffodils in spring, is one. These giant pieces of contemporary art, which are often commissioned by local councils looking for an image-improving landmark, have caught the public's attention and imagination. That, in turn, has contributed to the unprecedented level of interest in modern art, which has then helped precipitate the emergence of another recent trend: 'Experiential' art.

As discussed in the Conceptualism chapter, these interactive environments are part amusement arcade, part art installation. For museums they are an ideal form of 'artertainment', with something for everyone, from the earnest academic to a young family looking for some fun. A mind-altering mix of expensive cappuccinos and accessible educational programmes is always readily available should any customers want to intensify their art museum experience. These audience-friendly artworks also reflect the degree to which the line has blurred over the past decade or two between modern art – once a niche leisure pursuit for the high-minded – and the more mainstream entertainment-based leisure activities like film, theatre and visitor attractions.

For the artists working in this field, like Carsten Höller (b. 1961), the aim is to challenge the traditional museum experience (quiet, competitive, serious, lonely) by installing spiralling slides and revolving beds that force visitors into social situations with each other. Some curators have filed this approach to art under the rather academic-sounding term 'relational aesthetics'. This is a theory asserting that art-making today is about creating an 'arena of exchange' between an artist and a community of visitors in which they 'share' ideas and experiences. The relational aesthetics argument says that Höller's slides are a response to the anti-social nature of our contemporary urban existence, where automation and technology have removed the 'chance encounter' from our daily lives. Slides and revolving beds, they say, provide a social context for human interaction and are a clear artistic and political comment on the world today. All of which sounds plausible. But from my years of watching hundreds of thousands of people bombing down slides or similar at the Tate, the reality is rather more prosaic. Many of the visitors who line up to have a go in, or on, such 'experiential' installations consider it to be nothing more than a bit of fun; communing with their fellow art-consumers – let alone sharing ideas – isn't really the point. That said, such works definitely do succeed in changing the nature of a museum – whether for the better or the worse is open to question.

Another of the more obvious trends during this period is for artists to question what had been accepted boundaries regarding taste and decency by producing work intended to provoke and shock. The 60s saw the end of the age of deference, while the 70s Punk movement put a sneer on the faces of a newly empowered youth. But it was not until quite late into the 80s that certain social conventions were blatantly challenged. Up until this time depictions of hardcore sex and extreme violence were still the preserve of the top shelf and X-rated movies; any other mention of them was made by way of allusion and innu-endo. And then a new, emboldened generation of artists entered the fray and the gloves came off. There was Jeff Koons's super-saucy

Made in Heaven (1989), a series of paintings, posters and sculptures featuring the artist and his then wife, the Italian porn-star Ilona Staller (know as La Cicciolina), performing a range of explicit sexual acts. And then came the blood and gore of the British artists the Chapman Brothers (Dinos Chapman, b. 1962, Jake Chapman, b. 1966). Their work has regularly featured mutilated bodies and gaping open wounds in pieces such as *Tragic Anatomies* (1996). These scenes of B-movie schlock horror were given a much darker hue by the inclusion of what has become their trademark: grotesque, sexually deformed, troll-like dolls.

All these trends have had an impact on how art is made and encountered since the late 1980s. Attempts have been made to give a collective name to what's been going on. Monumentalism, Experientialism and Sensationalism have all been touted around in the hope of defining an age and an art movement. But they have not convinced. Shock and awe might be the general theme, but there is no overall organizing principle around which the artists have shared a vision or method that would render them as definable art movements.

But I do think there is an identifiable attitude that encapsulates much of the art produced in the last quarter of a century. There is a word that begins to bind the wide variety of styles, ideas and approaches pursued by artists over this period. I fully acknowledge that no categorization is ever satisfactory; there are always anomalies, simplifications and compromises involved. That's why so many artists have distanced themselves from the movements into which they have been placed by art historians and critics. But that doesn't mean categories don't have their uses, even if it is simply to be proved wrong. The word I have in mind is not intended as a name for a movement to define this time, but I do think it's a valid term with which to help us understand the motivations behind what has been created in the name of art.

For the purposes of my argument I am going to impose a time-frame, which is more a useful coincidence for my proposition than a

definitive start and end point. The period I am identifying covers twenty years, starting in 1988 and ending in 2008, and is bookended by two events initiated by the same person, the British artist Damien Hirst (b. 1965). The first was an exhibition that he was largely respon-sible for organizing in a warehouse in the Docklands area of south-east London in July 1988. Called *Freeze*, it was a show displaying the work of sixteen young British artists who had studied, or were studying at, Goldsmiths College in London with Hirst.

Among them were the painter Gary Hume (b. 1962), the conceptual artists and sculptors Michael Landy (b. 1963), Angus Fairhurst (1966–2008) and Sarah Lucas (b. 1962). And, of course, Hirst himself, who was displaying one of his now famous *Spot Paintings* (1986–2011) for the first time (he has since made hundreds of *Spot Paintings*, all fea-turing neat rows of evenly spaced coloured circles on a white background, which he says are made to 'pin down the joy of colour'). This group would go on to form the nucleus of artists that became known as the Young British Artists, or, more commonly, the YBAs, with *Freeze* credited as their epoch-making launch pad. It would soon be seen as the moment that London became a leading player in driv-ing art forward, just as it had been in the late eighteenth and early nineteenth centuries.

At the time, though, it was simply another, albeit notable, art col-lege summer show that happened to be promoted and presented with admirable chutzpah and professionalism by an unknown student from the north of England.

Twenty years later that same student, now the richest artist in the world, instigated another show to promote and sell his new work. This time, though, the location was altogether more upmarket and no other artists were involved. The event took place in the main saleroom at Sotheby's auction house in London in autumn 2008 – on a day that would bring the world to its knees.

Convention has it that artists sell their new work through an art dealer. This is known as the primary market. Later, should the person

who purchased the piece from the artist's dealer wish to sell it, they do so by going to an auction house that will then sell it on their behalf. This is known as the secondary (second-hand) market. What doesn't tend to happen is for an artist to circumnavigate the primary stage and sell his or her own new work at auction. It's not the way it works – there is always an intermediary of sorts between an artist and an auction house. Unless you are Damien Hirst.

In September 2008 he took the highly unusual step of cutting out his powerful British (Jay Jopling) and American (Larry Gagosian) dealers from the process altogether, and instead delivered over 200 shiny new works directly from his studio to Sotheby's in London for the auctioneers to sell. It was a bold and risky move; not least because of the potential offence it might have caused Jopling and Gagosian, who had spent time and money helping to build Hirst's career (none was taken – the event happened with their blessing).

There was also the chance that his new artwork would fail to sell, an outcome that could cause Hirst's image and market value to plummet. If that were the case it would be a public humiliation that could quite possibly end his career (which is one reason why artists avoid this route, preferring instead the hushed tones, commercial secrecy and private sales that are provided by an art dealer). Not that he appeared too worried about such consequences, if the title he chose to give the sale is anything to go by. With typical confidence and bravado he added a sense of theatre to the event by giving it a fancy exhibition-type name: *Beautiful Inside My Head Forever*.

A few days after Sotheby's had put the artworks on public view for interested parties to assess, the auction took place. It started on Monday 15 September, and concluded on Tuesday the 16th. With the room filled with excitable collectors and their representatives – ready and willing to part with fortunes – another, not totally unconnected event was taking place across the Atlantic that had everybody in New York in a similarly frenzied emotional state. While the auctioneer's gavel hammered down to confirm sale after sale of Hirst's expensive lots,

the rest of the world watched as slowly but surely it became apparent that the US government was going to allow the once mighty Lehman Brothers bank to go bust, an action that had every chance of precipitating a global financial meltdown.

The art world appeared to be oblivious to the seriousness of the situation, as pickled animals and brightly coloured paintings sold for their estimated prices or above. On the face of it, the sale was a triumph. According to Sotheby's almost all the lots were sold, for a combined (and staggering) total of over £100 million. Whether everybody paid up (once the effects of Lehman's collapse had come home to roost), or of those who did how many had a vested interest in maintaining the artist's reputation and value, is the subject of an ongoing debate. But the significance of the auction and the financial collapse taking place at the same time is incontestable. It inadvertently marked the end of an era for capitalism, and – for the sake of my thesis – the end of an era in modern art. It represented the culmination of a twenty-year period in which the prevailing attitude among artists, curators and dealers was one of energetic enthusiasm, youthful optimism and a culture of enterprise. It was a mood that permeated the art world and provides the word with which I am going to sum up this late period of contemporary art activity in my final chapter. The word is Entrepreneurialism.

The Postmodernists felt that they had been left adrift by previous generations, who had promised, but failed to deliver a utopian ideal, and whose 'grand narratives' were just that: big talk, with no realizable plan of action. Technology and science had also proved to be a let-down, having fallen short of offering their much-heralded panacea. The Postmodernists were fed up, trying to make sense of a world where uncertainty seemed to be the only certainty. It was an age rife with existentialist anxiety.

Not so the brash, confident generation that was rolling out of the art colleges of Europe and America during the late 1980s and early 90s. They were as assured as the Postmodernists were anxious, their

humour more cheerfully dark than knowingly ironic. And they weren't interested in removing themselves from their artworks to pose some soul-searching question about identity. Not a bit of it. They were up front, in-yer-face, look-at-me types, with a knack for self-promotion. These were children of the go-getting doctrine preached with evangelistic zeal by Margaret Thatcher and Ronald Reagan, Helmut Kohl and François Mitterrand. They were delighted to be the centre of their own existence. Jean-Paul Sartre, the celebrated existentialist philosopher, said that 'Man is nothing else but what he makes of himself', before adding: 'Man is, before all else, something which propels itself towards a future and is aware that it is doing so.' 'Bring it on' was the bullish cry from this new generation of artists. The British crop had grown up with a statement made by Margaret Thatcher in 1979 when she declared that 'There is no such thing as society.' People, she thought, had to look after themselves first and foremost.

It wasn't so much tough love; more tough luck: sink or swim. Which, for a group of working-class teenagers whom the state had generally failed to equip with a decent education, or at least one to match their ambition or intelligence, was bloody annoying, but also oddly invigorating. If that was the name of the game then okay, they'd play it, but, as Punk had done, at the establishment's expense. They'd break the rules, cock a snook at authority, and use any profile they had to stick two fingers up at the world. The 1988 *Freeze* exhibition was the first public statement by these young artists that they would be taking control of their own destinies. It was as much about that attitude as it was about personal politics or money or aesthetics. Theirs was an entrepreneurial spirit that informed the art they produced and, in time, the world we live in.

And nobody personified that spirit more than Damien Hirst. As a young student he discovered the macabre and disturbing paintings of Francis Bacon, the British Expressionist painter. At the time, Hirst was trying to improve himself as a painter, but eventually gave up

because he found that all his canvases 'were like bad Bacons'. Instead, he started to think of his hero's paintings in three dimensions, reinterpreting them as sculptures. In 1990 he produced *A Thousand Years* (see Fig. 35) – a brilliantly conceived and superbly executed work that managed to be both morbid and life-affirming.

It consists of a large rectangular glass case – measuring approximately 4 metres long by 2 metres high by 2 metres wide – with a dark steel frame. At the centre of the case – acting as a divider – is a glass wall into which four fist-size round holes have been drilled. On one side of the divide is a white cube box made out of MDF that looks like an oversized dice, except that all sides are marked with only a single black spot. In the middle of the floor on the other side of the glass partition lies the rotting head of a dead cow. Above it hangs an insect-o-cutor (the sort of ultraviolet light-cum-electrocution device seen in butcher's shops). In two opposing corners of the glass case are bowls of sugar. To complete the piece, Hirst has introduced flies and maggots. The result is something approaching a biology tutorial, a teacher's aid for demonstrating how the life cycle works: fly lays egg on cow's head, egg turns into maggot, which feeds off cow's decaying flesh before hatching into a fly, which then eats some sugar, mates with another fly, lays some eggs on the cow's head, gets zapped by the insect-o-cutor (taking on the role of an apparently indiscriminate God), falls on to cow's head where the now-dead fly becomes part of the decaying organic matter that provides a diet for the newly hatched maggots. Ghastly? Yes. Good? Very. Art? Absolutely.

Damien Hirst is not a science teacher, he is an artist, which means this is a work of art – or at least demands to be judged as one. *A Thousand Years* – or *Fly Piece* as it is otherwise known – fits within an art-historical canon that can be traced back hundreds of years. The subject – life and death, birth and decay – is as old as art itself. The rectangular case and the white box are a little more modern; they are a reference to Minimalism: two parts Sol LeWitt, one part Donald Judd. But there is also something of Joseph Beuys about them. The German

artist was a keen user of vitrines – glass cabinets to display objects – into which he would put all manner of bizarre oddments including battery cells, bones, butter and toenails. The rotting flesh of the cow's

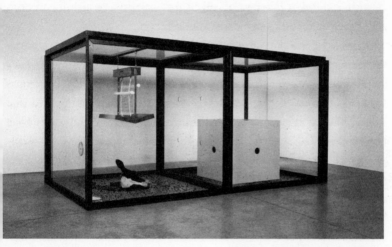

Fig. 35. **Damien Hirst**, *A Thousand Years*, **1990**, photographed by Roger Wooldridge

head is reminiscent of the congealed red and purple oil paint that gave Bacon's paintings their tortuous power. Duchamp is in there too, the Dadaist presence of his 'readymade' sculptures evident in the sugar and insect-o-cutor: 'found' objects from everyday life. And there is something of a Schwitters 'Merz' or a Rauschenberg 'Combine' about the whole piece, not least the inclusion of a dead animal. It can also be defined as a piece of conceptual art, the result of a premeditated and planned idea that dictated the materials and shape of the work.

The list of art touchstones goes on and on. But Hirst is not indulging in Postmodernist cherry-picking or tongue-in-cheek-irony; *A Thousand Years* is not the work of an artist who is anxious and confused. It is by a supremely self-confident individual who, he has said, comes from a generation that 'didn't have any shame about stealing other people's ideas'. His approach to art history is not Postmodernist,

he is not selecting ill-suited combinations that jar in the hope that they will provoke the viewer into thinking about identity and transience: he is selecting what he fancies from the past in order to repackage it with a Damien Hirst twist. His is an enterprising attitude, a positive, fearless, 'I'll do as I please' mindset.

Hirst was one of a group of British artists who shared an entrepreneurial worldview, a savvy bunch who realized that if they were going to succeed on their own terms they needed to build a brand based as much on their individual persona as their work. And that meant having a drink or two with those who have traditionally been thought to be the devil by artists: business types. So, with Andy Warhol's words 'good business is the best art' ringing in their ears (now stripped of its intended irony), they found a man of commerce to help them achieve their goals. Charles Saatchi had made his name as an advertising executive. Along with his brother Maurice he had created Saatchi & Saatchi, one of the world's most successful and respected advertising agencies. These entrepreneurial brothers were not so much Thatcher's children as Thatcher's wingmen, helping the leader into power by producing a series of highly effective posters. Charles was the creative half of the partnership, a talented packager of ideas whose great gift was for producing ad campaigns that generated vast quantities of publicity. This combination of having an eye for visual coherence and a nose for a good press story inevitably led the keen art collector towards a crop of young artists seeking the spotlight's warm glow.

Charles Saatchi had opened an eponymous gallery in suburban north London in 1985, in order to show and promote his collection of contemporary art. It quickly became an essential stop for any young art student embarking on the Grand Tour of London's burgeoning contemporary art scene. Shortly after Hirst's *Freeze* show, Saatchi started to collect work by many of the art graduates who had been in the exhibition. In 1992 he put his haul of recently acquired work by Young British Artists on display at his Saatchi Gallery, which included

Hirst's *A Thousand Years*. It wasn't the only work by Hirst that Saatchi had on display.

There was another large sculptural piece that consisted of a huge rectangular glass case with a (white) steel frame, into which Hirst had placed a dead creature. But this time the beast was whole and big enough to eat you. It was a 4-metre tiger shark which Hirst had suspended in a glass case filled with formaldehyde. *The Physical Impossibility of Death in the Mind of Someone Living* (1991) (see Fig. 36) was a wildly ambitious idea realized with a swaggering assurance and a good eye – for art and publicity. The British tabloid press dived in, with the *Sun* splashing the mocking headline '£50,000 For Fish Without Chips'. But it was Hirst and Saatchi who were laughing, their reputations in the international art world now firmly established.

Six years later their reputations were cemented into art history. The esteemed Royal Academy in Piccadilly, London, mounted an exhibition drawn from Charles Saatchi's collection. It was the right show, at the right time, with the right name: *Sensation*. The title might have referred to the raft of sensory experiences that the art in the exhibition was intended to elicit. But after people saw and heard about what was on display, there was really only one interpretation: it was the description of an event. The show lived up to the hyperbole.

The Chapman Brothers presented scenes of gruesome carnage; Mark Quinn (b. 1964) produced a sculpture of his head called *Self* (1991), which was made from 4.5 litres of his own frozen blood (like a sorbet) that he had collected over the course of five months; and Damien Hirst's old friend Marcus Harvey (b. 1963) showed his painting *Myra* (1995). That caused a lot of fuss. Harvey's portrait was of the British child murderer Myra Hindley, which he had made using the palm prints of children. For some it was a powerful comment on the horrific nature of her terrible crimes, for others it was completely out of order.

Damien Hirst was represented, obviously. The fly piece and the

shark were included, as were assorted other dead animals suspended in formaldehyde from his *Natural History* series, as well as a spin and a spot painting. Looking back now, over a decade later, it was a

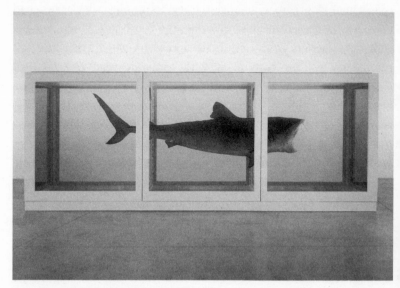

Fig. 36. **Damien Hirst,** *The Physical Impossibility of Death in the Mind of Someone Living,* **1991**, photographed by Prudence Cuming Associates

'greatest hits' of Hirst's work, which lacked only a piece he made later on in 2007. *For the Love of God* is a life-size platinum cast of a human skull, which Hirst arranged to be covered with more than 8,000 diamonds accompanied by a set of human teeth. It is a piece of art bling, an overtly commercial object presented with an over-the-top theatricality: a single item at the centre of a darkened room, placed on black cloth, and spot-lit to make the diamonds sparkle. But for all that, and the accusations of plagiarism from some quarters, it is an interesting work of art. *For the Love of God* could be interpreted as the ultimate object of a death-defying and insensitive age in which wealth and vanity have corrupted Western civilization.

Eight of the other artists from Hirst's *Freeze* show were represented at the *Sensation* exhibition. Among them was Sarah Lucas. She, like Warhol and Lichtenstein before her, looked to the cheap end of consumer media for her source material. Lucas, though, wasn't so much interested in adverts or comics; she preferred salacious tabloid newspapers that interspersed pages of naked women with lurid gossip and rumour. Suitably inspired, she made the sculpture *Two Fried Eggs and a Kebab* (1992) (see Plate 28), a work that has since become a symbol of the YBAs' precociousness. It consists of a table, upon which two fried eggs have been strategically placed to suggest a woman's breasts (fried eggs are a British colloquial metaphor for a flat-chested woman). A couple of feet down the table, and below the eggs, is an open kebab, an unsubtle allusion to a vagina. A photograph of this composition has then been placed at the top of the table in a picture frame, which, in this set-up, suggests a human head. The four legs of the table complete the symbolism (two arms at the top, two legs at the bottom).

A couple of years later Lucas made *Au Naturel* (1994), another sculpture that uses everyday materials to make a crude (in both senses of the word) sculpture. This time an old mattress has been bent double against a wall. Placed near the top on the left-hand side are two melons (breasts), below which is a bucket (vagina again). Over on the right-hand side of the mattress, parallel to the bucket, is an upright cucumber with two oranges placed either side (I don't need to explain this). Both *Two Fried Eggs and a Kebab* and *Au Naturel* were shown in *Sensation*.

Lucas's sculptures can either be taken as puerile, jokey one-liners, or profound comments on how society views and portrays women and sex. Either way, they are artworks representative of their time. Ladette culture was sweeping through Britain. The Spice Girls were about to be launched on the world, and with them came their manifesto of Girl Power. A generation of tomboys had grown up into can-do girls, whose optimism and energy made them believe that they

could have whatever they really, really wanted ('Zig-a-zig-ah'). A good time and a decent career was what life was all about; anything the boys could do, they could do better. They could have more sex and drugs and alcohol. They could be ruder and cruder. They could have bigger jobs, higher profiles and greater aspirations. Dreary England had become Cool Britannia, and the ladettes were drinking to that.

This was the vibe at the time, and whether intentionally or not, it was the vibe of Sarah Lucas's work. She wasn't on her own. She had a friend whose work was also included in the *Sensation* show: the ultimate ladette, Tracey Emin (b. 1963). This is the self-styled 'Mad Tracey from Margate' who rocked up drunk and disorderly on live television, stitched the names of all her past lovers on a tent (*Everyone I Have Ever Slept With, 1963–1995* (1995)) (see Plate 29) and has repeatedly bared her body and soul in the name of art and publicity. In 1993 the two geezer-girls decided to open a shop (called 'The Shop') in the East End of London: a commercial enterprise that they hoped would pay for the art studios on the first floor. They produced a line of slogan T-shirts, including 'Complete Arsehole', 'Sperm Counts' and 'I'm So Fucky'. Hardly Duchampian in the construction of their wordplay, but then again, it was rather a different time . . .

A lot of people knock Tracey Emin, say she is a fraud. History will judge the quality of her art, but she is not a fraud. She has a first class degree from Maidstone College of Art and an MA from the Royal College of Art. Her work can be found in the collections of the world's most illustrious modern art museums (MoMA, Pompidou, Tate); and she was only the second woman to represent Britain at the Venice Biennale. All those supporters in the art world might be misguided and delusional, but she unquestionably deserves to be judged as a bone fide fine artist and not a con artist. The fact that you can recognize her work at a glance – and you can – suggests that she has an exceptional ability in the basic craft of art: draughtsmanship. Forget her publicity machine, the 'look at me stuff'. Instead, consider her ability to connect with so many people, the

directness of her communication. She might not be able to spell, but she has a poet's understanding of clarity.

Tracey Emin, in common with Damien Hirst and many of the other YBAs, is the product of a working-class background. She left her home town as soon as she possibly could and headed for London to seek her fortune. She worked in a store, went to college, got by. She started to write. In 1992 – with the entrepreneurial optimism of a Thatcher pin-up – she invited between fifty and a hundred people to invest in her 'creative potential'. For a £10 investment she would provide any subscriber with four letters, one of which would be marked 'personal'. It showed gumption and imagination and self-belief. But it also was an early pointer to what would become the basis for her work, and her success: 'confessional art'. Letters are intimate and personal: a perfect medium for an artist who would build her career around providing viewers with expressionistic and prurient insights into her private life. She famously didn't win the Turner Prize in 1999 with one such work. *My Bed* (1998) was just that: Tracey Emin's bed, unmade, and dishevelled with stained sheets. It was surrounded on the floor by the detritus of her life: empty bottles of booze, cigarette-ends and dirty underwear.

Tracey Emin's unmade bed 'made' her. She became notorious, a love-to-hate character for the media, which she manipulated expertly, becoming very rich and very famous along the way. She took her chance. Hers was a generation that wasn't going to wait for something to turn up; they'd make it happen. You got on your bike, as one of Thatcher's cabinet ministers famously said to the unemployed of Britain, and made your own luck.

Hanging around in London at the time was another ambitious entrepreneurial type keen to make his name. His background was very different, his outlook remarkably similar. Jay Jopling is a tall, good-looking, suave Old Etonian: the son of a landowner who had served in Margaret Thatcher's government. Jopling had developed a passion for contemporary art while at school (he once persuaded the artist

Bridget Riley to design the cover for the school magazine), which he had carried on to university in Scotland and then down to London. Personal passion had turned into a professional ambition: Jopling wanted to be an art dealer with a gallery in which to display his wares. He had already struck up a friendship with Damien Hirst (both men came from Yorkshire), who had introduced him to many of the artists in his circle. It was a trail that soon led to Lucas and then, inevitably, to Emin.

Jopling paid Tracey Emin £10 for the subscription to her letters, and thereby invested in her 'creative potential'. A short time later he found a small gallery space in which to build his art-dealing business. It was tiny – 4 metres square – but perfectly located in the most upmarket part of London's West End. Unlike the rather grand art dealers in the area who specialized in selling old masters, Jay Jopling did not put his own name above the door. Instead, he chose to reference an influential essay written in 1976 by the Irish-born American artist Brian O'Doherty (b. 1934) called 'Inside the White Cube', in which the author argues that the sterile white walls of the modern art gallery have shaped and manipulated taste more than the art that has been on show. Calling his gallery White Cube was both a literal description of the space and an art-historical in-joke about the manipulative nature of the contemporary art world. A punning quip made all the more pointed because it was made by a thrusting young art dealer.

Jopling wanted to exhibit and sell the art produced by his generation. So, six months after White Cube opened for business in 1993, he presented a selection of the autobiographical work made by his new letter-writing friend, in a show called *Tracey Emin: My Major Retrospective 1963–1993*. Nice title: a tongue-in-cheek joke from an unknown young artist that pokes fun at the pomposity of overblown museum exhibitions featuring the lifetime's work of a grand old painter or sculptor. It also hints at her aspirational nature and makes a statement about her career, which would be all about Tracey Emin. The show presented over 100 objects, from teenage diaries to *Hotel International* (1993), an appliqué blanket covered with felt letters

spelling out family names and personal messages. Misspellings were rife (not uncommon in artworks: see David Hockney's *Tea Painting in an Illusionistic Style* (1961), where he has spelt tea as TAE on the side), as were her disarmingly frank confessions. A star was born.

Actually, two stars were born. One, a limelight-seeking artist living life as if it was a reality TV show; the other, a sharp-suited, quick-witted art dealer who could spot and nurture talent. Jopling was also adept at finding and befriending wealthy customers for his artists' work. Since its inception in the early 1990s, White Cube has become one of the biggest and most influential players in the burgeoning British art market, expanding aggressively even while the world teeters on the edge of financial meltdown. But while Jopling has built his impressive business along traditional lines, Larry Gagosian – the 'Big Daddy' of contemporary art dealing – has established a mighty globe-spanning empire the like of which has never been seen before.

Gagosian started out in the 1970s by selling posters on the sidewalk in Los Angeles. He'd buy a poster for a couple of bucks, then mount it carefully in an aluminium frame before re-selling it for around $15. Soon he was making money with his good taste and ability to hustle. He began to buy more expensive posters, which led to him taking an interest in art, and that meant dropping an early plan of going into the real estate business and trading in a more exclusive commodity.

Which is not the giant step it might seem. Selling high-end art and selling high-end property are actually not that dissimilar. The art dealer is the estate agent of the piece, the artist the client with the intellectual property to sell. Both businesses require an office/gallery with an upmarket address, at which a database of interested parties is managed. Showings (exhibitions) are arranged, particulars are circulated in glossy brochures, and all the office/gallery staff tend to be well-dressed, well-spoken private school types to give the whole grubby sales process an air of respectability.

Property and art also share uniqueness as a selling point, with the buyer relying on the expertise of the agent to set the correct price.

And while the value of a house is dictated by 'location, location, location', the value of an artwork is all about 'provenance, provenance, provenance'. That is: who made it (and incontrovertible proof thereof), who is selling it, and, crucially, in which major modern art museums it (or other examples of the artist's work) has been shown. Collectors need these endorsements to help justify the price tag and to reassure themselves of the soundness of their investment, just as a house's price is dictated by the prestige and popularity of its address. If a recognized, heavyweight art dealer is selling an artist's work and it has also been shown in, say, New York's Museum of Modern Art (MoMA), then it will probably sell for appreciably more than had it been sold by Art-4-U.com, based in a small provincial town after having its one-and-only public airing at the local primary school which the artist's children attend. It wouldn't matter if it were exactly the same work. It has been reported that when an artist jumps ship from their old gallery to join the now hugely successful Gagosian Gallery (and plenty do), it is not unusual for the price of their work to rise ten-fold.

That the American dealer has taken the art-dealing game to a different level is beyond question. From being a start-up business in the 1970s, he ended the decade with a gallery in LA showing and selling the work of major East Coast artists like Richard Serra (b. 1939) and Frank Stella. That though, was just the beginning. In the 80s he moved to Manhattan and made friends with Leo Castelli, at the time the grandee of contemporary art dealing. Having gained the wise old man's trust, help and blessing, Gagosian began to establish himself as the city's premier art dealer. Cool, tough and intelligent, and with empire-building aspirations, he was able to afford plush premises on Madison Avenue by the end of the 1980s. Today he has galleries dotted across the world in New York, Beverly Hills, Paris, London, Hong Kong, Rome and Geneva. It's the sort of upscale list of business locations that we are used to seeing associated with top fashion houses and five-star hotel chains, but no art dealer has ever conquered the globe in such a way before.

On the way to building his business and fortune Gagosian has orchestrated some spectacular deals. In the early 80s the audacious dealer put in a cold-call to a high-powered, art-collecting couple. By the end of the conversation they had agreed to sell Piet Mondrian's *Victory Boogie-Woogie* (1942–3), a jazz-inspired version of one of his grid works (and one of the most prized paintings in their collection) to the publisher Si Newhouse, owner of Condé Nast and a Gagosian client. The picture changed hands for $12 million, a price that was considered spectacular at the time. But it was small change compared to a similar deal in which Gagosian pulled the strings twenty or so years later. Again it was a painting by a European émigré, another Dutch abstract artist who had made New York his home. Gagosian brokered a deal in which an entertainment mogul who owned Willem de Kooning's *Woman III* ended up selling the masterpiece to a hedge fund billionaire for what has been reported as a staggering $137 million. Even the savvy and perceptive Gagosian must be surprised by the degree to which art has become big business, and artists have become big businesses. And he should know, he's seen it at first hand. Not only is he Damien Hirst's American dealer, he also represents two other commercially orientated artists: Jeff Koons and Takashi Murakami (b. 1962).

Murakami is the king of kitsch. He is every inch the artist entrepreneur, embracing commercial opportunities and managing his global empire like a successful business school graduate. And, like most contemporary artists, he has surrounded himself with a slick public relations machine: image and brand are as important to today's artists as they are to any other multinational business. He is unapologetic and determined in his pursuit of making his work a commodity: to do so is part of his art.

Murakami is a sampler of pop Japanese visual culture, just as Warhol and Lichtenstein (major influences) were of American popular culture in the 1960s. Murakami's reference points are Japanese *anime* cartoons and *manga* comics, whose characters and styles he makes

into sculptures, paintings and merchandising. In the late 1990s he produced a series of life-sized sculptures based on some of the candy-coloured characters, which were a comment on an unspoken side of the obsession Japanese teenagers have with them. All of the works were overtly sexual, referencing the fantasies and complexes that young men in particular develop in their heads while watching their computer screens. *Miss Ko* (1997) is a busty waitress in a microdress, *Hiropon* (1997) is naked apart from a miniscule bikini top, with breasts that are far bigger than her head, and which pump out a Mister Whippy-like white ice-cream foam. *My Lonesome Cowboy* (1998) – a play on the title of an Andy Warhol film (a sexed-up satire on a Western movie) – depicts a male cartoon character in the moment of exuberant self-administered sexual release, as his purple penis hoses white liquid above his head, which has been frozen into the shape of a lasso.

Of course on one level it is juvenile and inane: that is the artist's intention. But then a bit of fun can cost a lot. In 2008 *My Lonesome Cowboy* was put up for auction. The guide price was a hefty $4 million. Murakami – ever the businessman – was there in person to act as a physical endorsement of the sculpture's authenticity. The buzz in the room mounted as the two collectors who were vying for the piece pushed the price up to the $4 million mark. A few minutes later spontaneous applause broke out amid an air of disbelief (Murakami probably included) when the hammer came down to close the sale at $13.5 million. That is a lot of money to pay for a fibreglass figure of a masturbating cartoon character. Or is it?

Japanese imagery had played a huge part in the development of modern art. The Impressionists, Post-Impressionists, Fauves and Cubists all looked to the beautifully constructed flat picture planes of the nineteenth-century Japanese Ukiyo-e woodblock prints for inspiration and direction. Then came the two world wars and the art world's shift west to America, leaving Japan as a consumer but not a participator in the contemporary scene. It is the aim of Murakami's work to

redress the balance: to take home-grown Japanese visual culture and propagate it around the world. He is using the tools of globalization – travel, media, free trade – to make a point about the local, the indigenous and the culturally specific. Murakami is being frivolous while making a sober political point: he is attempting to reassert Japanese culture's place in the world. He is serious about kitsch. As is his rather more famous stablemate at the Gagosian gallery.

Jeff Koons is the artist who worked as a commodity broker to finance his early work, married a porn star and set up a Warhol-like studio where legions of assistants make sculptures and paintings to his specifications, while he oversees operations. He is the archetypal artist-entrepreneur. Koons has sought not so much to blur the lines between art and life, but to remove them altogether. He is the artist who picked up where Warhol left off. But with a big difference. Warhol was intrigued and amused by the rise of celebrity culture, and happily played along with it, but when it came to his art, he sought to remove as much of himself as possible. Koons does not.

'Alert! The enemy is deploying its Jeff Koons puppy!'

Trading on the elevated status that society affords an artist, he transformed himself into a manufactured celebrity in a way that foreshadowed the boom in the boy bands and girl groups of the mid-1990s. He produced a series of *Art Magazine Ads* (1988–9), in which he featured prominently, looking like the lead singer from an 80s synth-pop

band. He followed this up a year later with *Made in Heaven* (1989) (see Fig. 37), a billboard for a yet (and, as it turns out, never) to be produced movie. Again Koons casts himself unashamedly as the star, peering directly out to his adoring audience. That, in itself, would

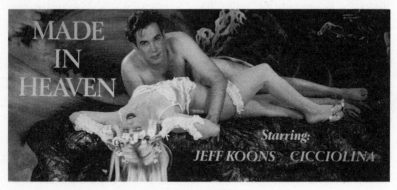

Fig. 37, **Jeff Koons,** *Made in Heaven,* **1989**

probably have been enough to garner a few column inches when it was put up on a huge billboard outside the Whitney Museum in New York. Such blatant self-promotion hadn't been seen since Dalí's dark days when he went to America and sold his soul (though not in the eyes of Koons, who admired Dalí so much that he phoned the Surrealist, who invited Koons to photograph him at the St Regis and Knoedler Gallery).

But Koons guaranteed gossip-column coverage with his *Made in Heaven* series. He is horizontal and naked. In front of him, prostrate and vulnerable, is a beautiful blonde-haired woman dressed in nothing but a white negligée. Her head and arms are flung backwards: she is a picture of erotic submission as Koons leans over her and looks out at us with an unsettling, but strangely innocent stare. The image alludes to the story of Adam and Eve, and Koons's pose and fixed gaze are not unlike that of the prostitute in Édouard Manet's *Olympia*. But the billboard owes most to Henri Fuseli's *The Nightmare* (1781), in which an incubus sits atop a sleeping beauty ready to take, or having taken, advantage of her.

Although for an arch-Duchampian like Jeff Koons, nothing is ever quite that simple. The woman in the picture is Ilona Staller, aka La Cicciolina, a Hungarian-born Italian porn star and politician. She and Koons are human 'readymades' – art, politics and porn united. Or is Koons suggesting they were already one and the same? The poster was likely to make uncomfortable viewing for the Whitney's bourgeois gallery-goers. They had their social hierarchies worked out: artists are like gods; porn stars are the work of the devil. Koons is questioning those assumptions while producing an artwork that, at least for any tabloid newspaper editor, was made in heaven.

Jeff Koons's enterprising approach helped launch his career when it was noticed in 1985 by an adventurous New York art space called International With Monument. They decided to give the young artist an exhibition. The show became the talk of the Manhattan contemporary art crowd, among whom was a young artist from China who shared the American's entrepreneurial outlook. Ai Weiwei (b. 1957) had left Beijing for New York in 1981 with $30 in his pocket and without being able to speak a word of English. Still in his mid-twenties, he was escaping a country that had treated his father, a poet, appallingly, and he suspected that he was next on the authorities' list. Unsurprisingly, his mother was concerned with Ai's voyage into the unknown. But he was not. 'Don't worry,' he told her. 'I'm going home.'

Ai Weiwei is a remarkable man. He is at the centre of his own universe: fearless and determined. All that time he spent while growing up on the edge of the Gobi desert in the north-east of China, without books or school to amuse him, left plenty of space for thinking. While his father went about his demeaning job cleaning toilets – the job and the location his punishment for being a poet – Weiwei would sit and ponder. Eventually the family was allowed to return to Beijing. His father swapped the toilet brush for the poet's pen and started to write again. His son immersed himself in the city's avant-garde and for the first time in his life saw and started to read art books. He devoured tomes on the Impressionists and Post-Impressionists, but threw away

a book on Jasper Johns, unable to understand what the American art-
ist was doing. Even so, his instinct told him that New York was the
place for him, so when the state became suspicious of his interest in
the contemporary art scene, he knew where he should go.

Weiwei is serious-minded but with a sense of humour, a combina-
tion that led to the creation of one of his most well-known works: a
piece originally intended as a joke, not an artwork. He has used
4,000-year-old neolithic pottery Chinese vases to make several of his
works, often decorating these ancient and revered objects in gaudy
modern colours, or painting the Coca-Cola logo on to their side. On
one occasion he thought it would be amusing to take a series of pho-
tographs of him dropping one of these vases on to a concrete floor
and record the moment when it smashes. He duly did this and
thought nothing more of it until an exhibition of his work was being
assembled at an art gallery. The curator contacted him to say they
didn't have quite enough for the show and asked if he had anything
else. Ai Weiwei went off and had a rummage in his studio and came
up with the set of photographs documenting the dropping of the
vase. The images were then hung in the gallery under the title *Drop-
ping a Han Dynasty Urn* (1995) (see Fig. 38) and became a famous
artwork. Proving Ai Weiwei correct in his belief that his every action
is part of his art.

Ai Weiwei's entrepreneurial approach has led him to take on duties
as an architect (he co-designed Beijing's Olympic 'Bird's Nest' stadium),
curator, writer, photographer and artist. In business they call it 'going
plural', when an executive leaves full-time employment to pursue a
diverse portfolio of interests from consultancy to strategic invest-
ments. In the art world it is called being 'multi-disciplinary', which
has become very fashionable for artists-cum-brands who find they are
able to sprinkle a little of their magic dust on a whole host of projects.
For some it is about making yet more money, for others the motivation
can be intellectual curiosity, while in many cases the artist is simply
flattered to be asked to do something different by someone he or she

admires. Ai Weiwei's enterprising activist approach has one single, important and relentless aim: to change China.

Ai Weiwei's work, based on a powerful political conviction, has

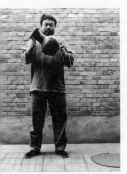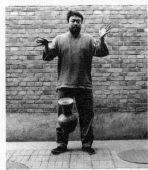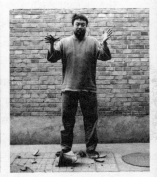

Fig. 38. **Ai Weiwei,** *Dropping a Han Dynasty Urn,* **1995**

been an exception, not the rule, for the art produced in the recent past. For the most part, contemporary art has been devoid of a hard political edge, save for the odd intervention that has generally had the look of a bandwagon hastily being jumped upon. On the whole, even when the avant-garde artists of our age have been at their most aggressive and challenging, they have tended to present their work with a cheeky grin rather than an angry scowl. The inclination has often been to entertain, not to campaign. The big shifts in society that have taken place over the last twenty-five years have been largely overlooked by high-profile artists. An era of winner-takes-all capitalism, in which fame and fortune matter above all else, has been little commented on: the effects of globalization and digital media hardly mentioned. As for environmental issues, political and media corruption, terrorism, religious fundamentalism, the disintegration of rural life, the alarming divisions in society as the rich get richer and the poor get poorer, and the spectacular greed and heartlessness of bankers; well, it's as if it never happened, if you were to rely on contemporary art displayed in museums as your source of information.

Maybe the eyes and minds of artists have been elsewhere. Maybe they've felt compromised. One of the consequences of being an artist-entrepreneur is that you are as prone as anybody else in business to fall in line with the philosophy of expediency, to accept that deals occasionally have to be done with the devil. And once you've supped from the same spoon as the pointy-tailed one, it makes the avoidance of hypocrisy very difficult. How do you make a profound and heart-felt anti-capitalist work of art, for example, if you've spent the previous evening at a swanky museum dinner sitting next to the head of some investment bank, who also happens to be one of your major collectors/clients? Or how do you make a work about the environment when your own carbon footprint is far larger than most? Can it be possible to produce a painting or sculpture that seeks to illuminate an unfairness in a society from which you are so obviously benefiting? And how do you go about criticizing the establishment, when you are a fully signed-up member of its inner circle? The answer is, you don't.

Unless, that is, you are operating entirely outside the market and have nothing to lose, which is the case with street artists. Once dismissed as the idle actions of a criminalized underclass, street art and graffiti have come to be recognized as part of the modern art canon. In 2008 the huge northern façade of Tate Modern was covered in six colossal pieces of street art produced by artists from around the world, including a young Frenchman known only as JR (d.o.b. unknown). He calls himself a 'photograffeur' as a way of describing his politically skewed black and white photographs, which he pastes on to buildings like murals.

Much of his work is displayed without establishment approval, has not been officially commissioned, and has not 'been made possible' through the good offices of a rich patron. It is not for sale. In 2008 he covered properties in one of Rio's infamous *favelas* (shanty-towns where crime is rife) with a variety of black and white images of people's staring eyes. It was said to be in response to a series of murders in the locale. Which makes sense. JR's art is site-specific, reflecting the issues of the location in which he is working. It is an

approach from which his art benefits. His *favelas* installation, for instance, would have achieved none of its international impact had it been shown on the white walls of an art gallery: it was the antithesis of the corporate-sponsored commoditized art of the modern museum.

The directness of JR's overtly political and social commentary is a common factor of street art. But poverty is not. The widely held romantic belief that all street art is a cry of rage from an abandoned urban underclass is wide of the mark. Perhaps the most famous piece of street art ever created was produced by a very successful middle-class graphic designer called Shepard Fairey (b. 1970). Fairey fits right in with the artist-entrepreneur spirit of the age, running his own graphic design studio, from which he has rolled out a range of branded clothing. When at college he designed a series of stickers aimed at his skateboarding friends, which he stuck on walls around the place. Within a short space of time the plump face of his cartoon-like character, OBEY Giant, became a street art phenomenon that was copied around the world. The young designer had learnt the power of using the public space for his artworks.

In the run-up to the 2008 presidential campaign he made a poster in support of Barack Obama, the then Democrat candidate. It featured a pre-existing head-and-shoulders photograph of Obama looking thoughtfully up into the middle distance. Fairey had appropriated the image before simplifying and stylizing it in a Pop Art manner not dissimilar to an Andy Warhol screenprint. He then applied a grey-blue vertical wash to one side and a red wash to the other, and added a lighting effect by way of a yellow-white section on the would-be president's face. Underneath the image, in bold simple type, is the word HOPE (originally PROGRESS). Fairey (and his collaborators) printed thousands of copies of the image and unofficially pasted them up on walls around the USA. Obama privately approved, but could not publicly endorse the image until it was distributed legally on official poster sites. By the time the next batch rolled out, Fairey's piece of street art had become the icon of Obama's campaign, and one of the most famous images on the planet.

Street art's roots can be traced back to the prehistoric primitive cave paintings that inspired so many modern artists, from Picasso to Pollock. But it was not until the late 1960s and early 1970s, when cities like New York and Paris (and famously the Berlin Wall at the beginning of the 1980s) became the canvas for a generation of unauthorized guerrilla visual artists that the notion of street art started to gain some traction. Since then the power and popularity of the street art movement has increased alongside the emergence of digital social media, both of which rely on viral networking to gain prominence and attention. Today, a postcard-sized piece of street art in Nairobi could turn into a global sensation within an hour of being completed: a potency that made it the art form of choice during the Arab Spring of 2011 and the Libyan civil war that took place in the same year.

It has become a familiar and increasingly welcome presence in urban environments throughout the world. In Britain an artist operating under the name Banksy (d.o.b. unknown) has become a national celebrity for his bitingly satirical wall stencils, which have included kissing policemen and a trompe l'oeil of a hotel maid sweeping dust from the street under a brick wall (2006) (see Fig. 39). He, like many street artists, has kept his identity hidden, as the majority of his work has been displayed illegally and the authorities would probably be only too happy to prosecute him for vandalism. It is not unusual for one of his stencil pieces to be removed or painted over by state officials, often against the wishes of large parts of the local population. When a museum in Bristol, in the south-west of England, gave him the run of the place in 2009, the artist chose to embed his presence throughout the gallery rooms, often making stencil pieces that interacted with the museum's existing artworks. The public reaction was overwhelmingly positive, leading to the museum's previous attendance record for an exhibition being easily broken. Many of the people who visited from the local area had never previously been to the museum. They patiently queued for hours waiting to get in, and, once inside, stayed for hours more. Of course, Banksy might have been there too, but then nobody would have known.

I suspect if Marcel Duchamp were alive today he would be a street artist. He'd certainly be lauded wherever he went. So much of the art produced today has the Frenchman's iconoclastic attitude. He is the man whom I hear most contemporary artists cite as an influence. It

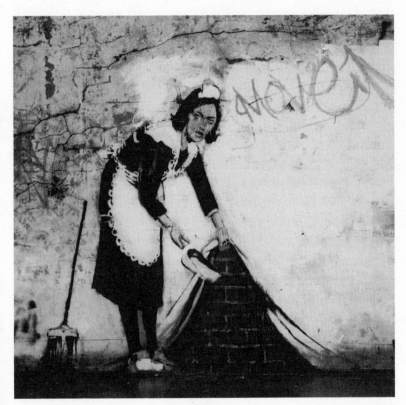

Fig. 39. **Banksy,** *Maid Sweeping,* **2006**

was Picasso's painterly personality that dominated the first half of the century, but there is no question that the second half has increasingly been played out against a backdrop of Duchampian mindgames.

It appears that a figure of their stature – or of Cezanne's or Pollock's or Warhol's – has yet to emerge this century. But one will.

Or has already . . .

ARTWORKS BY LOCATION

The list that follows shows the present locations of many of the artworks featured in the book, though this does not necessarily mean that they will be on display there. For more information, contact the relevant gallery or consult the website (a few online sources are mentioned below). Art works in private collections have not been included.

Chicago Institute of Art (www.artic.edu)
Guggenheim (www.guggenheim.org)
Louvre (www.louvre.fr)
Metropolitan Museum of Art (www.metmuseum.org)
MoMA (www.moma.org)
National Gallery (www.nationalgallery.org.uk)
Pompidou (www.centrepompidou.fr)
Tate (www.tate.org.uk)
Walker Art Centre (www.walkerart.org)

AUSTRIA
VIENNA
 Belvedere
 Klimt, *The Kiss*

DENMARK

COPENHAGEN

Ny Carlsberg Glyptotek

Manet, *The Absinthe Drinker*

GEORGIA

Georgian National Museum

Kandinsky, *Picture with a Circle*

FRANCE

PARIS

The Louvre

Delacroix, *The Death of Sardanapalus*

Delacroix, *Liberty Leading the People*

Géricault, *The Raft of the Medusa*

Kahlo, *Self Portrait: The Frame*

Musée d'Orsay

Degas, *The Dance Class*

Manet, *Le Déjeuner sur l'Herbe*

Manet, *Olympia*

Vlaminck, *Restaurant de la Machine à Bougival*

Musée Picasso

Picasso, *Still Life with Chair Caning*

GERMANY

BERLIN

AEG Turbine Factory

Bauhaus Archiv Berlin

Brandt, tea set

DESSAU
> Bauhaus School

DÜSSELDORF
> Kunstsammlung Nordrhein-Westfalen
> > Kandinsky, *Composition IV*

MUNICH
> Städtische Galerie
> > Kandinsky, *Impression III (Concert)*

TÜBINGEN
> Kunsthalle Tübingen
> > Hamilton, *Just What Is It That Makes Today's Homes So Different, So Appealing?*

THE NETHERLANDS
AMSTERDAM
> Van Gogh Museum
> > Van Gogh, *The Bedroom*
> > Van Gogh, *The Potato Eaters*

THE HAGUE
> Haags Gemeentemuseum
> > Mondrian, *Evening, Red Tree*
> > Mondrian, *Flowering Apple Tree*
> > Mondrian, *The Grey Tree*
> > Mondrian, *Victory Boogie-Woogie*

NORWAY
OSLO
> National Gallery
> > Munch, *The Scream*

RUSSIA

MOSCOW

 State Tretyakov Gallery

 Kandinsky, *Composition VII*

 State Russian Museum

 Malevich, *Black Square*

 Malevich, *Cow and Violin*

 Tatlin, *Corner Counter-Relief*

 State Russian Museum

 Malevich, *Cow and Violin*

 Tatlin, *Corner Counter-Reliefs*

SPAIN

BILBAO

 Guggenheim

 Koons, *Puppy*

SWITZERLAND

BERN

 Kunstmuseum

 Braque, *Houses at L'Estaque*

LUCERNE

 Galerie Urs Meile

 Weiwei, *Dropping a Han Dynasty Urn*

RIEHEN

 Fondation Beyeler, Riehen

 Rousseau, *The Hungry Lion Throws Itself on the Antelope*

UK

EDINBURGH

National Gallery of Scotland
Delaunay, *The Cardiff Team*
Gauguin, *Vision After the Sermon, or Jacob Wrestling with the Angel*

UK

LONDON

Chalk Farm
Banksy, *Maid Sweeping*

Courtauld Gallery
Cézanne, *Mont Sainte-Victoire*

National Gallery
Constable, *The Hay Wain*
Monet, *The Thames Below Westminster*
Seurat, *Bathing at Asnières*
Turner, *Rain, Steam and Speed*

Saatchi Gallery
Emin, *My Bed*

Tate
Andre, *144 Magnesium Square*
Andre, *Equivalent VIII*
Boccioni, *Unique Forms of Continuity in Space*
Bourgeois, *Maman*
Brancusi, *The Kiss*
Dalí, *Lobster Telephone*
Degas, *Little Dancer*
Duchamp, *Fountain*
Epstein, *Rock Drill*

Ernst, *Celebes*

Ernst, *Forest and Dove*

Fontana, *Spatial Concept: Waiting*

Hepworth, *Pelagos*

Hepworth, *Pierced Form*

Hockney, *Tea Painting in an Illusionistic Style*

Judd, *Untitled*

Kandinsky, *Murnau, Village Street*

Lichtenstein, *Brushstroke*

Long, *A Line Made by Walking*

Moholy-Nagy, *Telephone Picture EM1*

Mondrian, *Composition C (No. III) with Red, Yellow and Blue*

Morris, *Untitled 1965/71*

Paolozzi, *I Was a Rich Man's Plaything*

Picasso, *The Three Dancers*

Pistoletto, *Venus of the Rags*

Rodin, *The Kiss*

Rousseau, *Portrait of a Woman*

Stella, *Stomp*

Warhol, *Marilyn Diptych*

V&A Museum

Mackintosh, *Ladder-back Chair*

White Cube Gallery

Hirst, *For the Love of God*

USA
BALTIMORE

Baltimore Museum of Art

Man Ray, *The Primacy of Matter Over Thought*

BOSTON

Museum of Fine Arts

Degas, *At the Races in the Countryside*

BUFFALO

Albright-Knox Art Gallery

Balla, Dynamism of a Dog on a Leash

Miró, Harlequin's Carnival

CAMBRIDGE, MA

Fogg Art Museum, Harvard University

Ingres, *The Golden Age*

CHICAGO

Art Institute of Chicago

Caillebotte, *Paris Street: Rainy Day*

Gauguin, *Why Are You Angry?*

Hopper, *Nighthawks*

De Kooning, *Excavation*

DETROIT

Detroit Institute of Arts

Fuseli, *The Nightmare*

IOWA CITY

University of Iowa Museum of Art

Pollock, *Mural*

LOS ANGELES

Broad Contemporary Art Museum

Baldessari, *Tips for Artists Who Want to Sell*

Getty Museum
 Man Ray, *Belle Haleine*

LA County Museum of Art
 Baldessari, *Heel*

NEW YORK
 AT&T Building
 Flatiron Building

Guggenheim
 Braque, *Violin and Palette*
 Mondrian, *Composition No. 1*
 Mondrian, *Tableau No. 2 / Composition No. VII*

Mary Boone Gallery
 Kruger, *I Shop Therefore I Am*

Metropolitan Museum of Art
 Brancusi, *Sleeping Muse I*
 Carracci, *Reciproco Amore*
 Carrington, *Self Portrait: Inn of the Dawn Horse*
 El Greco, *The Opening of the Fifth Seal*
 Flavin, *The Diagonal of May 25 1965*
 Hiroshige, *Station of Otsu*
 Hokusai, *The Great Wave off Kanagawa*
 Klee, *Hammamet with its Mosque*
 Monet, *La Grenouillère*
 Picasso, *Portrait of Gertrude Stein*
 Renoir, *La Grenouillère*
 Seurat, *A Sunday Afternoon on the Grande Jatte*

MoMA

Arp, *Collage with Squares Arranged According to the Laws of Chance*

Boccioni, *States of Mind*

Breuer, *B3/Wassily Chair*

Dalí, *The Persistence of Memory*

De Chirico, *The Song of Love*

De Kooning, *Woman 1*

De Kooning, *Painting*

Flavin, *Untitled*

Hesse, *Repetition 19 III*

Giacometti, *Spoon Woman*

Gris, *Still Life with Flowers*

Johns, *Flag*

Judd, *Untitled (Stack)*

Kandinsky, *Improvisation IV*

Kruger, *Untitled (You Invest in the Divinity of the Masterpiece)*

Kupka, *First Step*

Lichtenstein, *Girl with Ball*

Magritte, *The Menaced Assassin*

Malevich, *White on White*

Newman, *Onement 1*

Oppenheim, *Object (Le Déjeuner-Fourrure)*

Picasso, *Les Demoiselles d'Avignon*

Picasso, *Ma Jolie*

Pollock, *Full Fathom Five*

Pollock, *The She-Wolf*

Pollock, *Stenographic Figure*

Rietveld, *Red-Blue Chair*

Rodchenko, *Pure Red Colour, Pure Blue Colour and Pure Yellow Colour (The Last Painting)*

Schwitters, *Revolving*

Sherman, *Film Stills* (1977–1980)

Stella, *The Marriage of Reason and Squalor II*

ACKNOWLEDGEMENTS

I could not have written this book were it not for the support and self-lessness of my wife, Kate. While I have spent weekends, holidays, early mornings and late evenings stowed away in a quiet room tapping at a keyboard, she has taken care of our four children and all of our lives. I have been an inattentive husband and absent father, but not once has she complained, nor resented my indulgence. Added to which, her intelligent and precise criticism of my writing has been invaluable. The passages in the book that work well can be put down to her wisdom, those that don't are the ones in which I foolishly ignored her advice.

I would also like to thank colleagues at the BBC who have tolerated – with more good humour than I deserve – several periods of my prolonged absence. I am particularly indebted to Bernadette Kitterick and Hilary O'Neil, both of whom have covered for me by picking up a chunk of my workload on top of their many pre-existing commitments.

The book would never have come about if it were not for Sir Nicholas Serota giving me the opportunity to work under him at the Tate. I learnt much during my seven years stationed on the banks of the river Thames, not least that Nick is a remarkable man, a great boss and a brilliant curator to whom I will always be indebted.

As I am to Rich Flintham, Chris Head, Charlie Wood and many other friends who helped shape my Edinburgh Fringe show *Double Art History*, which was the genesis of *What Are You Looking At?* That the show became a book is down to the team at Penguin, who encouraged me to expand an hour's light-hearted romp into a fleshed-out history of modern art.

It has not been an easy task, and would not have been possible without Ben Brusey, my editor at Penguin. He has cajoled and corrected, listened and suggested. I could not have had a more committed and companionable collaborator. A number of other wonderfully talented individuals at Penguin have helped bring the book to fruition. Special mention must go to Tom Weldon, for his support from the very beginning of the project, Venetia Butterfield, Annie Lee, Keith Taylor, Ellie Smith, Catriona Hillerton, Richard Bravery, Claire Mason, Lisa Simmonds, Caroline Craig, Matt Clacher, Charlotte Humphery, Marissa Chen, Amy Orringer, Joe Pickering and Gesche Ipsen. I would also like to thank Pablo Helguera, who has provided the splendid cartoons.

I have drawn on many great minds during the course of writing the book. Ernst Gombrich's *Story of Art*, Robert Hughes's *Shock of the New* and Calvin Tompkins's *Duchamp* are all extremely well thumbed. As are various exhibition catalogues from the Tate, MoMA and the Pompidou among others. Particular thanks go to Achim Borchardt-Hume, Ann Dumas, Matthew Gale, Gregor Muir, Catherine Wood and Simon Wilson, all scholarly art historians who generously agreed to read over certain chapters and share their expertise with me. I am also fortunate to have Eric and Poppy Anderson as my parents-in law. They have supported my efforts in many ways, not least by reading the manuscript and making numerous valuable suggestions.

And finally, thanks to my children: Dad's back!

ILLUSTRATION CREDITS

Gallery, Buffalo, New York / The Bridgeman Art Library; **Pl. 21**: ©
2012. Banco de México Diego Rivera Frida Kahlo Museums Trust,
Mexico, D.F. / DACS / Photo: Jorge Contreras Chacel / The Bridgeman
Art Gallery; **Pl. 22**: © The Willem de Kooning Foundation, New York
/ ARS, NY and DACS, London 2012 / Museum of Modern Art, New
York, USA, Giraudon, The Bridgeman Art Library; **Pl. 23**: © 1998
Kate Rothko Prizel & Christopher Rothko ARS, NY and DACS,
London / Courtesy of the Phillips Collection, Washington, DC, USA;
Pl. 24: © Estate of Robert Rauschenberg. DACS, London / VAGA,
New York 2012 / The Bridgeman Art Library; **Pl. 25**: © The Andy
Warhol Foundation for the Visual Arts / Artists Rights Society (ARS),
New York / DACS, London 2012; **Pl. 26**: © The Estate of Roy Lichten-
stein /DACS 2012 / © Tate, London 2012; **Pl. 27**: © Judd Foundation.
Licensed by VAGA, New York / DACS, London 2012 / © Tate, London
2012; **Pl. 28**: © Sarah Lucas, 1992. Courtesy of the artist and Glad-
stone Gallery, New York and Brussels. Image courtesy of the Saatchi
Gallery, London; **Pl. 29**: © Tracey Emin. All rights reserved, DACS
2012 / Image courtesy of the Saatchi Gallery, London.

INDEX

Page references in *italic* indicate black and white illustrations. These are also listed in full, along with the colour plates, after the Contents.

WILL GOMPERTZ

THINK LIKE AN ARTIST

Why do some people seem to find it easy to come up with fresh, brilliant ideas?
And how do they turn them into something worthwhile?

After spending years getting up close and personal with some of the world's
greatest creative thinkers, the BBC's Arts Editor Will Gompertz has discovered
a handful of traits that are common to them all. Basic practices and processes
that allow their talents to flourish, and which we can adopt - no matter what
we do - to help us achieve extraordinary things too. It's time to Think Like An
Artist and ...

Become Seriously Curious

(Caravaggio's discovery of optical lenses changed art for ever.)

Think Big Picture and Fine Detail

(Turner transformed a masterpiece with a tiny dab of red paint.)

And realize ... It's Nearly Always Plan B

(Mondrian spent years painting trees before becoming a master of abstraction.)

'Will Gompertz is the best teacher you never had' *Guardian*

ALASTAIR SOOKE

POP ART: A COLOURFUL HISTORY

Pop Art by the BBC's Alastair Sooke - an essential but snappy new guide to our favourite art movement

Pop Art is the most important 20th-century art movement. It brought Modernism to the masses, making art sexy and fun with coke cans and comics. Today, in our age of selfies and social networking, we are still living in a world defined by Pop.

Full of brand new interviews and research, Sooke describes the great works by Warhol, Lichtenstein and other key figures, but also re-examines the movement for the 21st century and asks if it is still art? He reveals a global story, tracing Pop's surprising origins in 19th-century Paris to uncovering the forgotten female artists of the 1960s.

'A clear and lively outline of the history of pop art ... a pleasure to read' *Sunday Times*

'A well-researched and authoritative introduction to the movement ... a hugely engaging read' *The Observer*

'A great introduction to what reveals itself to be a shifting and elusive movement' *Time Out*

CHRIS BARÉZ-BROWN

FREE: LOVE YOUR WORK, LOVE YOUR LIFE

Life and work are intrinsically linked. They are not separate; they are one.

If we want to live an extraordinary life, we have to make our work equally extraordinary.

When your work resonates with purpose, you jump out of bed every morning, excited by the possibilities the day holds for you. Everything else in your life seems to have a glow about it, and you exude much more personal shine.

My aim in writing this book is to help you feel like that every day. To help you make your work work for you. To feel truly free.

Put you in the driving seat and show you a route to freedom.

'Buy this book and free your mind, life and career' Shaa Wasmund, bestselling author of *Stop Talking, Start Doing*

'FREE is a burst of energy in book form - it gives you the inspiration and tools to take control of your own destiny' Mark Hix, chef and restaurateur

'People shine more brightly as a result of Chris's work. FREE will help you be more extraordinary everyday' Maria Eitel, President and CEO of the Nike Foundation

EDWARD DE BONO

SIX THINKING HATS

The classic work about meetings and decision-making

Meetings are a crucial part of all our lives, but too often they go nowhere and waste valuable time. In Six Thinking Hats, Edward de Bono shows how meetings can be transformed to produce quick, decisive results every time.

The Six Hats method is a devastatingly simple technique based on the brain's different modes of thinking. The intelligence, experience and information of everyone is harnessed to reach the right conclusions quickly.

These principles have been adopted by businesses and governments around the world, ending conflict and confusion in favour of harmony and productivity.

The Six Hats strategy will fundamentally change the way you work and interact.

'An inspiring man with brilliant ideas. De Bono never ceases to amaze with his clarity of thought' Richard Branson